Los Caprichos

Francisco Goya
Caprichos: Their Hidden Truth

Photographs and layout by Max Seidel

Text by Oto Bihalji-Merin

Translated by John E. Woods

A Helen and Kurt Wolff Book
Harcourt Brace Jovanovich, Publishers
New York and London

Contents

Idioma universal

Goya, a nightmare full of the unknown,
Of fetuses on skewers, the sabbath roast,
Of naked girls, and at her mirror a crone,
Adjusting stockings, tempting demon hosts.

Baudelaire, *Les fleurs du mal*

Francisco Goya was not an artist who achieved maturity early. A long and difficult road led him to mastery over his art and to himself. He needed decades to attain the awareness of his own age which enabled him to be a contemporary to following ages.

His talent was manifest from the beginning. The cartoons for the tapestries are excitingly beautiful; in them one senses the first quick breaths of genius. His religious paintings and frescoes are youthful promises. The portraits reveal his gift for psychological observation and his sensitivity to color. But even the best of the portraits and tapestry cartoons could not foreshadow an art that would go beyond its own time and place.

Only through his encounter with sickness and death were the creative powers that had been pent within him set free. It is to our benefit that he was not spared such darkness.

Here was a vital, gregarious artist, a man open to life's diversity, who was now pushed to the periphery of existence. In soundless isolation, menaced, haunted, and surrounded, he sought within the depths of his own ego for some chance to endure, for some possibility by which he might go on creating.

The language of solitude was attuned to the monody of pencil, pen, brush, and stylus. His perceptions were enhanced by the very austerity of the means. Through his own suffering he came to understand what mankind suffers.

The frescoes in the church of San Antonio de la Florida and the Caprichos, engraved at about the same time, are authentic masterworks of a mature artist.

In 1792 Goya was so ill that it was uncertain whether he would ever again pick up a brush. His will to live and his natural vigor enabled him to ride out the crisis and the temporary paralysis that followed; but he was left deaf. Bitter and depressed, he had arrived at the outposts of existence. Perhaps he sensed that in the dissolution of the unity between the visible and the audible, other, more intense, powers might be called forth. When they are once detached from sound, gesture and motion resemble some mysterious pantomime; they seem at times the kinesis of madness. In perceiving this reality Goya found for his painting the possibility of new sights and insights, probings and configurations.

In a letter dated January 4, 1794, Goya wrote his friend Don Bernardo de Iriarte, the Vice Protector of the Academy of San Fernando:

"In an attempt to divert my tormented powers of fantasy from a preoccupation with my

sufferings and to recover some of the expenditures that have attended my illness, I have begun a series of smaller paintings in which I have been particularly successful in allowing for the faculty of observation which normally is missing from commissioned works, where both mood and invention can be developed only with the greatest difficulty. . . ."[1]

It has often been noted that there is a certain analogy here with the case of Beethoven, Goya's junior by twenty-four years, whose early deterioration of hearing eventually led to total deafness. The art historian Joseph Gantner speaks of a "kinship of the spirit" between what Goya's letter to Iriarte describes as his *imaginación mortificada* and the dramatic confession Beethoven made in Heiligenstadt on October 6, 1802, when he wrote: "But how humiliating was it, when someone standing close to me heard a distant flute, and I heard *nothing,* or a *shepherd singing,* and again I heard nothing. Such incidents almost drove me to despair; at times I was on the point of putting an end to my life—*art* alone restrained my hand. Oh! it seemed as if I could not quit this earth until I had produced all I felt within me, and so I continued this wretched life . . ."[2]

Goya did not perish in that dark maze, but afterward he perceived the world and the people in it with other eyes. The field of his vision had expanded. Since he could no longer hear, he had both to understand and to explain everything on a purely visual level, even things opaque and masked. Wearied by his battle with sickness and by life itself, the artist spent much of the time from 1796 to 1797 as the guest of the Duchess of Alba at her country estate, Sanlúcar de Barrameda.

Not only in the matter of deafness—the effects of which were much more tragic for the musician Beethoven than for the painter Goya—but also in their common temperament, in their highly personal way of expressing themselves, and in their spontaneous and natural sense of life, is it possible to find parallels between these two artists.

Both of them transformed traditional forms of art into a creed whose tenets were uniqueness and unrepeatability.

In a world that was defined by the power of the nobility, the artist had to assert and maintain his sense of himself as a member of the middle class. He did this in uncompromising, unbending works of art.

Although it is not known for certain which paintings Goya submitted to the Madrid Academy of San Fernando in 1794, it is now assumed that we are dealing with the fourteen pictures painted on tin and entitled *National Diversions;* these portray various phases of the bullfight, a troop of itinerant actors before their tent, dramatic scenes of shipwreck and conflagration, an attack on a post coach by highwaymen, and a scene from a madhouse.

In 1797–1798, parallel to the first pages of *Los Caprichos,* Goya worked on the Witch Portraits for the Alameda, six pictures for the study in the summer residence of the Duchess of Osuña. What was the meaning of such an excursion into this purgatory of demons and specters? The commission came from a cultivated family with whom Goya was on friendly terms. Concurrent with the ideas of the Enlightenment and perhaps as its inevitable shadow side, there arose a lively interest in the numinous kingdom of magic. Side by side with sober practicality there existed an infatuation with the machinations of necromancers, astrologers, and alchemists. Casanova, Goya's contemporary, was not only a famous seducer of women, but also a man familiar with all kinds of witchcraft and sorcery.

Popular religion, still medieval if not archaic, and the world of witches alive with Luciferian temptations, rituals of rejuvenation, love gone beserk—it was all captured in the works of two important artists of the same period: Goethe wrote his *Faust,* Goya painted the witch scenes for the Alameda.

Goethe's inspiration for his Faust epic was found in popular medieval legend, puppet shows and ballads, and in Christopher Marlowe's depiction of the renaissance magician Dr. Faustus; similarly, Goya was surrounded and influenced by the very real superstitions of the people, by literary works, and even more by paintings of figures from the world of demons, especially by those strange mutations of men and animals in the pictures of Hieronymus Bosch which the bigoted King Philip II had collected with such passion for the Escorial.

Goethe's Walpurgis Night had a classical, enlightened background. Things nebulous and mystical were foreign to the philosopher-poet. His Faust is a Promethean figure. If we should react to witchcraft with a shudder, Goethe would have considered our response as a sign that we had not yet been able to transcend our origins. Through critical reason and simple human activity, sorcery and magical arts—like all things transient—are resolved as parables, as metaphors.

Goya's Blocksberg was located in his Basque homeland, where the belief in witches was still alive in his day. *Aquelarre,* the great witches' sabbath, had an intense visual reality for the eyes of an artist like him.

In contradiction to the sharp light of reason, idealistic notions of marvels, of presentiments and dreams, of the fantastical developed. Virtually during the same period when Goya was active, the visionary painter and poet William Blake was etching and fashioning his own naïve, oneirocritical phantasmagoria and Johann Heinrich Füssli was weaving his demonic, nightmarish fusions of man and beast.

Goya had been witness to such beliefs and superstitions among his own people. His hybrids of idols and divinities from both pagan mythology and medieval religion were derived from this spiritual landscape.

The Enlightenment did not emerge on the Iberian peninsula as the result of indigenous development. It was carried across the Pyrenees by outsiders and took root only in intellectual —or as it was termed in those days, educated—circles.

Goya was familiar with the rational ideas of the Enlightenment, but his art encompassed the ancient memories and fears of his people as well.

Goya the draftsman and graphic artist was as much a genius as Goya the painter. In these works he proves himself even more intense, more aggressive, even more the visionary than in his paintings. The uniqueness of his graphic work lies in its pictorial quality, in its "painterliness." It is as filled with nuance and life as the paintings—and not merely in the gradations of light or in the darkness that swallows up space. It has a rich sense of pictorial reality about it, just as the paintings—especially those of the black period—bear many traits of the graphic works.

In whatever technique he chose, Goya was an artist of the highest creativity: when he drew, he conquered. Each picture was a birth; in the synthesis of awareness and inspiration he found a form of resurrection. His graphic art is unique, yet it too had its sources of inspiration: Giambattista Tiepolo's *Scherzi di Fantasia* were issued in the period from 1735 to 1740, and his *Vari Capricci* were published by A. M. Zanetti in Venice in 1749. In 1762 the artist brought

both series with him to Madrid, where Goya surely would have seen them. While Goya's first etchings were still derivative, the series done in the manner of Velázquez demonstrates how difficult Goya found it to rein in his own spirit in order to capture the cool elegance of Velázquez's compositions. In the technical adaptation, in the translation of what were originally color compositions into graphics, however, he showed a sensitivity for spatial texture and for the richness of nuances between light and dark. As a graphic artist he was not content with purely linear expression. He required a method by which the dramatic qualities of his vision might be accented by elements inherent in painting—through gradations of shading and clean space, through the half-tone effects of glazes, through sharp reflexes of light in contrast to profound darkness. All of these possibilities he found in the technique of aquatint etching.

In the Romance languages the word *capricci* is applied to those works of wit, fantasy, and temperament which place no constraint on the imaginative powers of the artist. In 1617 Jacques Callot had produced a series of etchings for Lorenzo de' Medici under the title *Capricci di varie figure*. Elements of the *capricci* are likewise to be found in Alessandro Magnasco's miniature scenes, vibrant with flashes of subjective fantasy. Tiepolo's *Capricci* and *Scherzi* were etchings that led directly to Goya's work.

Los Caprichos grew out of personal experiences and intense artistic preparation. Their beginnings can be dated back to the sketchbooks from Sanlúcar and Madrid. During the long period of convalescence following the acute phase of his illness, Goya turned to the most immediate and direct form of artistic vision, the drawing. In the drawing, with its ability for directly rendering an encounter, visual and sensual experience are more spontaneous, less controlled, than in the etching.

Goya divided the eighty plates of his Caprichos into two main divisions; each division is introduced by a self-portrait and each is characterized by different, although at times overlapping, themes or ideas. The resulting arrangement is neither chronological nor expressly thematic. Just as each plate betrays the spontaneous impulse that shaped it, so too the sequence of the images rests on a principle that might best be termed rhapsodic. Fragmentary chords of shared motifs are broken off precipitously, are taken up once again, only to be again interrupted —and then to return in the rondo.

There were presumably other, less clearly artistic, reasons for this shuffling of the plates, for disguising their meaning, even for omitting several of them. A few days after their publication, the etchings were withdrawn from the market; and ultimately the plates were presented as a gift to the king. By this clever and probably necessary act of self-defense Goya rescued both his own person and the endangered, and dangerous, etchings from the zealous hand of the Inquisition.

While planning for an edition of the Caprichos in 1797, Goya ordered the individual plates into thematic sequences and provided the whole with the title *Sueños*: dream motifs, the distillation and accentuation of his criticism of both the ecclesiastical and temporal powers. When he did publish them in 1799 he omitted several of the more aggressive plates from the edition and broke up the sequences. Did the artist think he might be able to disguise his thoughts, thus blunting the assault and lessening the danger to himself? It was not enough. The etchings were still too radical and inflammatory.

The Caprichos have as their subject the depiction of the manners of the society of Goya's

day; intrigues, lies, matchmaking and pandering, bribes, the affairs of immorality. It is certain that Goya knew Hogarth's engravings and their critique of English society, for they were circulated throughout the first half of the eighteenth century in four series: *A Harlot's Progress, A Rake's Progress, Marriage à la Mode,* and *Industry and Idleness.* There is, however, no more than a certain correspondence in theme here—none whatever in style.

As sergeant painter to the king, Hogarth was the first independent English artist who, by means of a realistic, critical depiction of society and by his unconventional style, ushered English art into modern times. Despite the dramatic intensity and the intellectual clarity of his vision, Hogarth did not move beyond the optical surface of visible occurrences. Goya's observation of the world has greater depth and background.

The arrangement of the plates of the first and only edition of the Caprichos supervised by Goya himself gives no evidence of a uniform plan. In our own day Sánchez Cantón has rearranged the sequence provided by the artist—not for the purpose of correcting Goya, but with the hope of restoring his original intentions. He has done this by dividing the etchings into five groups: Errors in Education, Erotica, Criticism of the Ruling Classes, Witchcraft, and Hobgoblins.[3]

Although the sequence Goya was forced to employ under pressure from the contemporary situation is generally maintained elsewhere, many experts have concurred in Sánchez Cantón's attempt to trace the inspiration of the pen rather than being misled by the camouflage of arrangement and commentary.

The commentary, written in Goya's own hand, might at times lead one to believe that Goya identified himself with the official moral code, with the governing norms of custom and usage; for now and then the commentary sounds like a moral homily. In both his ideas and his manner of life, however, Goya was most assuredly an independent man. Was all this, then, simply a mask to hide his real intentions, or had Goya been brought to this puritanical understanding of Eros by the illness that had restricted his freedom of movement—or perhaps even by some disappointment in love? The plates themselves speak bitter, discomfiting truths, and where laughter is also to be heard, its satanic echo comes from deeper, hidden levels. The more conventional motivations of the written commentary become less important when juxtaposed with the trenchant artistry of the etchings themselves.

In their pungent, poetic vividness, however, the subtitles have something of the popular Spanish proverbs called *refránes.* The commentary, which was probably formulated by one of Goya's educated friends, is sometimes banal in its moralizings, but it cannot diminish the spirit and intent of the etchings. The written text, though clearly of a piece with the interests of the Enlightenment, often contradicts the statement of the stylus.

The very fact that the commentary blunts the visual edge lends credence to the assumption that Goya's intention was to delude the censor. It is also possible that as Goya set about to create this meditative frieze for his sequence of plates, he himself occasionally became alarmed at their undeniably critical import and—following his intuition—decided to pursue such dangerous ideas no further.

On the basis of extensive research, the Spanish art historian Edith Helman contends that although the commentary preserved in the Prado is indeed in Goya's own hand, in style and in intellectual content it must surely have originated with his friend Moratín. Theirs was most

certainly a very close friendship. Moratín's critical humor displays an enlightened, didactic optimism, the roots of which are French, even though the style of his scenarios is Spanish. Padre Isla's picaresque novel, *Tales of the Famous Preacher, Brother Gerundius de la Campazaz,* which was circulated from hand to hand after it had been forbidden by the Inquisition, was a satire on the backwardness and bigotry of certain segments of the Spanish clergy. This novel, too, has left its traces in several of Goya's etchings. But the etchings are different: in the passion of their statement, in the underlying workings of the subconscious that informs them. Goya's creative technique and his sensitivities as a painter lend his graphic work a deeper, denser sense of reality than his contemporaries possessed. With Goya the visible becomes transparent, the fantastic, believable.

For Goya the positivistic light of the Enlightenment was not sufficient; he could not be entirely persuaded by the rationalist denial of God. His critical acumen and his hatred were directed against the dogmas and institutions of the church. His world of impulse and dreams, however, bound him to the magical sphere of belief and superstition he shared with the Spanish people.

Perhaps it was this that made it possible for him to realize a synthesis of reason and fantasy, of the conscious and the subconscious, in a way that was unprecedented: an absurd and at the same time profoundly true portrait of his time, of his world—and of ours.

In the Spain of his day, no master of the written word could be said to equal, when describing or interpreting the demonization of the world, the eloquence that Goya displayed in his Caprichos.

Today the subtitles and commentary are of chiefly historical interest; they do indeed illuminate the conditions of eighteenth- and nineteenth-century Spain. But we would be better advised to follow the fierce, dark movement of line in the aquatints themselves, the embedding of a pictorial motif in the thunderclouds of the background—the *idioma universal* of the artist's hand. We should heed Goya's own voice, trust no other one.

The first thematic grouping of the Caprichos is comprised by the world of the maja: seduction, temptation, prostitution. With the farsightedness of the explorer, Charles Baudelaire wrote concerning the Caprichos: "Goya is always a great artist, and often a terrifying one. With the gaiety and vivacity of Spanish satire from the good old days of Cervantes he unites a much more modern spirit, or at least a spirit that is much sought after in our time: a love of the inexplicable, a feeling for violent contrasts, for the threat within nature, for human faces strangely brutalized by circumstance. It is remarkable that this artist, who appeared after the great satiric and iconoclastic movements of the eighteenth century but whose only thank-you from Voltaire (for that poor grand man scarcely understood the rest) was for his caricatures of monks— yawning monks, gourmandizing monks, doltish assassins arming themselves for matins, cunning faces, hypocrites, sly and nasty as birds of prey in profile;—it is remarkable, I say, that this hater of monks himself dreamt so often of witches and their sabbaths, of devilries, of children roasting on the spit, and of—how to say it—all the monsters born of the dream, hyperboles of hallucination. And then there are all these pale, slender Spanish girls being washed and dressed up by old hags for the sabbath or for the prostitution of the coming evening, the sabbath of civilization!"[4]

Ill. 1–3 The introductory self-portrait and a detail from "She fleeces him" are followed by the

14

etching "It must fit snugly." The commentary reads: "Oh, 'Aunt Curra' is no fool! She knows quite well that stockings must fit snugly." Ill. 4–6

One of the later plates likewise dwells on the seductive elegance of a young woman pulling on her stockings: "She prays for her." The cool, shrewd glance this beauty throws our way comes close to that of *The Naked Maja*. She has tucked up her long dress so she can prop her stockinged leg on the knee of the bawd who has prepared a footbath for her. A young servant girl is demurely combing her hair for her. The wizened face of the old lady reveals a life of experience in the feminine arts of sensual enticement. Rosary in hand, she is busy praying. The commentary explains: "And it is well that she does: so that God may send her good fortune and keep her from harm and from barbers and bailiffs; and make her as clever and artful, as sharp-eyed as her blessed mother!" Ill. 8

Not only does Goya's etching have a knowing smile for temptation and vice, it also throws a glance down into the precarious depths, into the threatening chasm that gapes alongside the path of venal love.

Two women, wrapped in shawls, being led away by grim, dark male figures: "Poor little things" is Goya's own caption. To which the commentary adds: "They will now mend these women who are tattered and have come all unraveled. They will now repair what has been allowed to go from bad to worse." Ill. 9

"Even so, he cannot recognize her." The cavalier, with the aid of a monocle, ogles his lady— her full bosom, narrow waist, and delicate feet. The commentary reads: "And how should he recognize her? For that, an eyeglass is not enough; one needs, rather, good judgment and knowledge of the world, precisely what this poor gentleman lacks." Ill. 10

Goya makes fun of the affected behavior of the couple. The scene is observed from the rear, lending it a touch of the ridiculous. Beneath his preparatory pen-and-ink sketch Goya wrote: "Just because I told her that she is so charming in her movements, she cannot say a word without wriggling her rear end."

A variant on the same theme: "Who is the more devoted?" The commentary: "Neither the one nor the other. He is a charlatan in love who says the same thing to them all, and she is wondering how to fit in the five rendezvous she has arranged for between eight and nine o'clock, for it is half past seven already." In the foreground are two little lapdogs flirting. Ill. 11

Both of these compositions dealing with rendezvous are static and have been set in the foreground. The line of the drawing itself has a fluctuating intensity inspired by the erotic theme; we are led along the half-light of horizontal and vertical hatching back into the rich contrasts of the depths behind.

"Birds of a feather." The cavalier and the beautiful young lady approach one another; she wears a floor-length black dress of tulle and a black veil cast over her head and eyes. She throws him a daring glance, but the cavalier looks instead off to one side, as if he wanted to see what the audience thinks of all this. They converse. The commentary is very detailed: "It has often been disputed whether men are worse than women, or whether the reverse be true. The vices of both come from bad upbringing. Wherever society will have its men perverse, the women will be likewise. The young lady pictured in this print is just as knowing as this young fop engaging her in conversation, and as regards the two old women, why, the one is just as vile as the other. . . ." Ill. 12

Why the text should speak of perversity here is rather difficult for the modern observer to comprehend. Does the artist mean to imply that all love relationships are immoral in and of themselves? Or does he wish us to understand that the old women have peddled the girl off to the cavalier?

Ill. 13

"God forgive her: it was her mother." A poor old woman whom we see only from the rear is trying to beg from the elegant young girl. Fan in hand, the girl merely lifts her long skirt a bit and gazes somewhat arrogantly at us from the drawing. The old woman, leaning on her cane, was once young and beautiful as well; she too has had her admirers. Now she must go begging for alms. The commentary says: "This young woman left her home town as a girl. She did her apprenticeship in Cádiz, then she came to Madrid, where she 'won big.' She goes down to the Prado and hears some filthy wrinkled hag begging for alms; she waves her aside; the old woman persists. The hardhearted girl turns around and discovers—who would have expected it!—that the poor old woman is her mother." A melodramatic tale invented by the artist, or perhaps one that he heard somewhere. The spirit of the etching and the commentary is reminiscent of many illustrations from the eighteenth century.

Ill. 14, 15

"Good advice." Once again we see a young girl in a black dress of tulle, a Spanish fan in her hand. Her skin is white. She is listening to the advice of an old woman about how to handle men so that she may have good luck in life. The old woman speaks animatedly to her. The woman's face is deeply lined with wrinkles now, her mouth sly and somewhat insistent. The commentary: "The advice is worthy of its listener. The worst is that the young girl will heed every word. Unhappy the man who comes anywhere near her!"

Ill. 24

What is meant by these scantily clad women with chairs set atop their heads being examined by grinning men? "They've already got a seat" is the title of the scene, a play on words with a double meaning. "*Ya tienen asiento*" can mean that they have not only their "seat," but their "judgment" as well. The commentary says: "If conceited girls want to have a seat, there is nothing better than to put it on their heads. . . ."

It can hardly be assumed that Goya wished to allude to archetypal patterns here; nevertheless, the name of the mother goddess in ancient cults, Isis, means "seat" or "throne." As a symbolic transposition the goddess wears her throne as a crown. The sweet, immobile faces—masklike and vacuous—of these girls and the natural poses in which they stand and sit were not drawn without a certain pleasure in the erotic situation. These girls from the fringes of society already participate in the atmosphere that Toulouse-Lautrec would portray beneath tolerant French skies some hundred years later.

Beyond the players in the markets of love—the bawds, the vain old men and the foppish young ones who are "barbered," swindled, and plundered by the majas—there appear these masked beauties, impenetrable to all eyes.

Ill. 18

"They call this reading." An elderly man, probably an aristocrat, is being combed and dressed by his servants. All the while he is busy reading. This ironical scene is reminiscent of the "lever" of princes in France and Spain. The commentary reads as follows: "They comb his hair and pull on his stockings for him, while he sleeps and studies. No one can say that he is not making the most of his time."

A critical comment on the upper classes, it would seem: the rich let others do the simplest chores for them and may even fall asleep while they are being waited on. The servants have to

spruce up their master so that his deterioration will not be all too noticeable.

"She fleeces him." A cavalier, all wrapped up in barber's cloth, is getting shaved by a young Ill. 19, 3
woman. His passions have delivered him into the hands of women. The commentary remarks:
"It is his own fault if he gets skinned after having put himself into the hands of such a barber
as this one."

"Till death." This old woman would at best be employed as a bawd among prostitutes, but Ill. 20, 21
nevertheless she wants to look alluring right up to the end, however much her girlfriends may
laugh at her. Commentary: "She's quite right to pretty herself up. It's her birthday. She's
seventy-five years old and her girlfriends are coming to pay a visit."

Aldous Huxley wrote in his "Variations on Goya": "Much of the satire of the Caprichos is
merely Goya's sharper version of what one can call standard eighteenth-century humor. A plate
such as 'Hasta la Muerte,' showing the old hag before her mirror coquettishly trying on a new
headdress, is just Rowlandson-with-a-difference. But in certain other etchings a stranger and
more disquieting note is struck. Goya's handling of his material is such that standard eighteenth-
century humor often undergoes a sea-change into something darker and queerer, something
that goes below the anecdotal surface of life, into what lies beneath—the unplumbed depths of
original sin and original stupidity."[5]

Although they betray the hand of originality, the Caprichos still show traces of a baroque
sense of form, even though the restless, curving lines are subordinated to the critical statement
and the baroque component is diffused in the growing unity of a more profound view of the
world. A new signature, another style has begun. This newly discovered thrust of his pen—
robust, sharp, and passionate—will be a part of his creative work until the end.

Goya is skeptical about more than just the sort of love that is bought and sold on the market.
Marriage itself is often no more than an ecclesiastically sanctioned extension of venal love.
Goya's important patron, Gaspar Melchor de Jovellanos, the leading intellect of liberal Spain,
provided the painter with his inspiration for the sketches dealing with marriage. For the cap-
tion of the scene "They say, 'I do' . . . ," Goya has employed the first two lines of Jovellanos's Ill. 25, 26
"Epistola satirica a Armesto": "They say, 'I do' and give their hand / To the first man who
comes their way. . . ."[6]

Goya's realism penetrates more deeply than does the didactic light of the Enlightenment. In
this and in the etching that follows, "Nobody knows anybody," the artist depicts the indis- Ill. 27, 28
soluble bonds between and the bondage of the sexes, whether in hate or in love.

The young woman wears a mask and is hemmed in on all sides by sinister figures. Goya
remarks: "The world is a masquerade; face, clothing, voice, everything is meant to deceive.
Everyone wants to appear as what he is not, each deluding the other and not even knowing
himself. . . ."

Masks have a mysterious duality for Goya. They both disguise and double their wearer,
they separate and unite. The magical game of masks and their frozen expressions are symbols
of the ruptured soul, messengers between the worlds of reality and appearance.

In the etching "Nobody knows anybody" Goya is still very close to the Venetian *capricci* of
Tiepolo. With Goya, however, this gallant game of amorous intrigue, enlivened by the baroque
virtuosity of the ink wash, takes on an ominous tone. The intercourse with demons anticipated
here makes a rigid mask of each face.

The grace notes, the allusions to events and personages of the period, can hardly be analyzed and understood in any clear, satisfactory way today. The banality of the everyday, the transience of the seasonal—these belong to and are simultaneously transcended by Goya's etchings. Because of this transcendence his graphic art is more permanent and profound than that of caricaturists and satirists.

The limits of the Enlightenment are breached by Goya's artistic intensity; he is free to invade those regions, those spaces of artistic expression where the tragedy of the human condition is multivalent.

Goya directs his gaze toward the power and the powerlessness of the ruling classes, toward venality and corruption. With these etchings he influenced Honoré Daumier and political satire throughout the nineteenth century.

Ill. 29
"Your excellency—hm, as I was saying—yes, hmm! Be careful, otherwise . . . !" Here we have the picture of stupidity, shallowness, and ignorance embodied in what may be a retired officer, a civil servant, or some representative or other of authority. The commentary explains: "The cockade and baton have given this stupid bore cause to believe that he is a superior being. He abuses the office of commander entrusted to him in order to vex everyone who knows him; he is proud, vain, and insolent to all who are below him, servile and abject with those more powerful than he is himself. . . ."

Ill. 30
"To work, boys!" The commentary: "The faces and uniforms speak for themselves." The populace is subjected to terror and injustice not only from those who govern them; sinister figures gather at society's fringes as well. Here Goya portrays a group of tobacco customs agents turned bandits, busy hatching a raid.

Ill. 31
How to raise a child, how to guide immaturity to maturity, how the old grow childish with greed and avarice—these considerations are given concrete expression in "The pitcher's broken." The weary washerwoman, hanging up her wash at last and hoping to be finished soon, beats her small son out of anger for his having broken the water jug. She picks up her wooden shoe and lays the bawling child over her knee. The commentary adds: "The child is a brat, his mother bad-tempered. Which is worse? . . ."

Ill. 32
"The spoiled child." Just as he can criticize adults, Goya can also denounce spoiling children. This squalling, almost doll-like figure is an example of how not to raise a child. The commentary: "Neglect, excessive tolerance, and pampering make children moody, obstreperous, conceited, greedy, lazy, and insufferable. They grow up and yet they remain children. Here you see Nanny's big little boy." A companion piece to the preceding etching of the broken pitcher.

Ill. 33, 34
"Why hide them?" An old man with his bag of gold, surrounded by grinning figures: Are they the amused heirs? The commentary replies: "The answer is easy. Because he does not want to spend his gold, nor does he spend any. For although he is over eighty now and will hardly live another month, he is afraid that he just might live long enough to end up short of money. So mistaken are the calculations of avarice. . . ."

The explanation of the commentary falls short of the inspired drawing itself. Goya has given shape to more than just the hardhearted laughter of envy and mockery. The principal figure of this etching is not the poor old rich man who still clutches his bag of gold on the very threshold of death, but rather the man with the top hat, whose impish laughter can be heard seeping from the moonlike crescent of his mouth and can be seen in those knowing eyes. He is a figure who

emerges again and again in Goya's drawings and paintings. Sometimes he is a dancing demon with castanets in hand, sometimes a wise fool pointing helpfully at the truth. The laughter that Goya has conjured up here seems to grip him as well. The soft, rounded lines of the portrait vibrate with spontaneity. But only the magnification made possible by the photographic enlargement gives transparency and meaning to the figure's head, which in the original is no bigger than a thumbnail.

"Out hunting for teeth." Surmounting fear and disgust, a woman rips the teeth from the open mouth of a man who is still dangling from the gallows. She holds a scarf to her face, but faith in the efficacy of what it is she is about to do enables her to perform the deed. She seems incapable of sympathy for her victim. The commentary explains: "The teeth of a hanged man are very potent in sorcery. Without this ingredient no charm can work. What a pity it is that people believe such nonsense." Ill. 35, 36

Two etchings, "Love and death" and "Tantalus," are part of the landscape of death. The man has fallen in a duel; the woman weeps for him. The commentary's tone is ironic: "Behold, a figure out of Calderón, who, because he could not laugh at his rival, dies in the arms of his beloved and loses her by his derring-do. It is inadvisable to draw one's sword too often." Ill. 37–39

Ambiguity and paradox are still more forcefully enunciated in the etching entitled "Tantalus." The woman lies dead, her stiff body stretched across the man's knees. In despair he weeps for her, wringing his hands. The diagonal line of the girl's corpse works in counterrhythm to what would appear to be the wall of a pyramid, or perhaps of a cemetery. The artist has mastered rhythm and space, and his use of them shapes our response to the tragedy that has occurred here. The commentary, however, laconically states: "Were he a better lover and less of a bore, she would come to life again."

Goya's line has now become freer. The people he portrays no longer have anything grand about them. Line and form have a bite to them, they have detached themselves from the purely ornamental sweep of baroque harmonies. If Goya's work can be said to be related to that of any other artist at all, then it is to the profound drawings of Rembrandt. Goya's etchings have grown in expressive power until they are brutal and tender, eerie and prophetic.

"And so they carried her away!" has a strange ambiguity about it: two cloaked figures are bearing away a woman who struggles against them, screaming for help into the night. The moralizing commentary does not do justice to this tense, gruesome moment: "The woman who cannot take care of herself belongs to the first man who seizes her. And yet when it is too late for help, people are astounded that she has been carried off. . . ." Ill. 40, 41

Most of Goya's female figures reflect the sensibilities of a society dominated by men: they speak of passion and of passion's disappointment. And nevertheless, or perhaps for precisely this reason, the female figures are so alluring and poetical.

On his return to Paris, Guillemardet, the French ambassador whose portrait Goya had done in 1798, took with him a collection of the Caprichos and presented them as a gift to his godson, Eugène Delacroix. Fascinated by such artistic perfection, Delacroix made copies of them; two of these, "Nobody knows anybody" and "And so they carried her away," which he sketched only fragmentarily, are preserved in the Louvre.

"Now one, now the other" shows a three-man group of lemuriform creatures. A nobleman rides one of them piggyback. Armed with lances, they jab and poke at a man bent over beneath Ill. 42

a straw mask that costumes him as a bull. An underhanded trick? A struggle between those on top and those at the bottom? The commentary: "This is the way of the world. People jest with one another, make a pretense of bullfighting. He who yesterday played the part of the bull is the torero today. Fate presides over the show, and Fate has assigned the roles according to the fickleness of her moods."

Ill. 43, 44 "What a golden beak!" Fascinated monks listen to a parrot's words of wisdom. The commentary speaks, it is true, of the spurious medicines of some physicians, but what is really meant are the prescriptions of divine healers. The subtle gradations of expression, used to depict the audience so realistically, reveal the total devotion with which they hearken to this voice from on high.

Several etchings deal with whores who mercilessly pluck the feathers from birdlike men; others depict birdlike whores being dined upon with relish by lawyers and judges. These drawings are quite possibly variations on themes taken from Juan Riaz's *Libro de buen amor*[7] and from *Arte de las putas*, written by Nicolás Fernández de Moratín, the father of Goya's friend. The latter volume appeared in 1777, was forbidden by the Inquisition, and circulated in manuscript.

On the branches of a high tree a sirenlike temptress has set herself as a decoy; the fashionably dressed cavaliers flutter around her like butterflies. Beneath the tree, men, in the form of birds

Ill. 45, 46 that have plummeted to earth, are being plucked. "All will fall" is the title Goya gave the scene.

Ill. 47 And the one following is called: "There they go plucked." With raised brooms the whores chase the plucked birdlike men from the bordello, to the accompaniment of the bawds' mocking laughter.

Ill. 48–50 It is in the Caprichos that demonic mutants appear for the first time in Goya's work. "You won't escape" is commented on as follows: "She who wants to be caught never escapes." The delicate young beauty is surrounded by demonic birds hovering about her. Four ghastly fellows have joined together to abduct this charming girl. Her slender, agitated figure, with its arms raised in terror and with a quizzically tantalizing expression, underscores the ambivalence of the situation. Her pantomimed gesture of flight almost seems to be a dare—an expression of a subconscious desire for adventure, an intimation of instinctive passion and repressed seduction. With ever increasing frequency in these later years, Goya presents women in an equivocal light.

Ill. 52 "Don't scream, stupid!" yell the two monks, while the girl attempts to ward off their attack. Many of the plates of the Caprichos tell of the bitter experience of falling in love with beautiful young women. Goya presents them as deceitful temptresses of the flesh.

Young women are also pictured as delicate and charming, often as victims enchained in wedlock. A man and a woman are bound together by a heavy rope, while a bespectacled owl

Ill. 54 stands guard. They cannot free themselves. "Will no one untie us?" To which Goya remarks: ". . . Either I am much mistaken or these two have been forced to marry against their will." This can perhaps be taken as a veiled protest against the church's proscription of divorce.

Ill. 60 Two of the plates show an innocent woman suffering in prison: "She was so easily influ-

Ill. 59 enced" and "Sleep overpowers them." Goya adds this explanation: "Do not wake them. Sleep is perhaps the sole blessedness the wretched know." Both the loneliness of the sleepers and the sense that they are released from their pain remind us of the silence of death. All ties to time are broken.

At age fifty Goya added to his representations of feminine beauty something iridescently demonic, an element of witchcraft and sorcery. Is that an echo of an affair he never forgot, of his experience with the Duchess of Alba? Passion and hate are expressions of his subjugation. Again and again he painted love as the determinant and damning force of destiny. He drew women in many variations—now as idols, now as whores. At times he himself plays a role in these emblematic compositions, a role rich in self-irony and melancholy.

In the etching "Volaverunt" he depicts the faithless love of the woman who has left him. She is easily recognizable in her maja costume. Held aloft by three crouching figures, she spreads out her mantilla like a sail. She is enjoying the flight. The half-closed eyes beneath the butterfly design of her scarf, the impassive, proud features, the small, firm mouth: it is the face of the Duchess of Alba.

Ill. 51

Swaggering ignorance, stubborn stupidity, and supercilious arrogance—Goya wraps these in the costume of the ass. There it sits before an opened folio, gazing contentedly at all the other asses pictured in the book. "As far back as his grandfather" is the title. "This poor beast has been driven mad by genealogists and heraldists. He is not the only one," says the commentary. "What if the pupil knows better?" Another large ass with his nightcap pulled down over his ears is teaching the small one his ABC's.

Ill. 65

Ill. 66

Goya drew these in the context of a well-known Spanish literary genre, the *asnerias*, all things asinine. One of the masterpieces of the lampoon in Spain during the second half of the eighteenth century was Juan Pablo Forner's *El asno erudito*, which attacked Iriarte and other literary rivals in the manner of La Fontaine.

In 1792, when Goya lay ill in Cádiz, there appeared a satire called *Memorias de la insigne Academia Asnal*, illustrated with etchings and bearing the pseudonym of one Doctor de Ballesteros. The theme was in the air, but it was Goya's fantasy and artistic power that first presented these figures of asses in such a way that they symbolized the vanity and ignorance of man, his passions and lusts.

The etching titled "Thou who canst not" shows two men, each with the heavy load of an ass on his bowed back. It is the Spanish people who must carry all burdens.

Ill. 67

The physician, an ass, sits importantly at the bedside of a sick man. He takes the pulse with his right forefoot. The picture asks, "What disease will he die of?"

Ill. 68

An ape, perhaps Goya himself, is painting the portrait of a large old ass, who sits there posing like a king—or at the least a prime minister. With tired, jaded eyes he gazes worthily into nothingness. Bright light illuminates his head, while the painter must drudge away with palette and brush in the dark. "Neither more nor less" is the title.

Ill. 69

"Bravissimo!" The ass listens with pleasure to the monkey who plays for him on the guitar. Two men in the background applaud mockingly. The commentary to all this explains: "If ears make the listener, no one could hear more intelligently. But it is to be feared that it is not music that is being applauded."

Ill. 70

Goya observed the world and the people in it with a sharply critical eye. There can be no doubt that specific persons—probably even Minister Godoy, the king, and the royal family— were present to his mind's eye as he created these etchings. At the same time, however, he moved beyond the purely specific and individual and gave to the events he depicted the scope and character of the general and universal.

The Sleep of Reason Brings Forth Monsters

You're all still here! Now that's a blatant outrage.
Well, scat! For ours is an enlightened age.
A devil's pack, where lawlessness is flaunted.
We're smart these days—despite which Tegel's haunted.

Goethe, *Faust,* Part I

No basic change in tone and style can be pinpointed in the etchings that now follow, for they too are depictions of the morals and manners of Madrid society. They tell stories of love, pandering, immoral affairs—of the grotesque ludicrousness of the upper classes.

The visual drama, however, becomes more dreamlike. A demonic world begins to emerge from the background. Devilish and witchlike creatures, beasts who are masters of men, invade our world. There is an alogical absurdity to these etchings which arises from the contrast of ambiguous, enigmatic figures with the drawing by a sure, exact hand.

The element of pantomime in the figures of the Caprichos functions as sign language does for the deaf: crude, mysterious gestures are born to be seen but not heard. The meanings behind the events, the realities hidden beneath the masks, gather and coalesce to form a grotesque carnival, unleash a parade of madness.

One could almost say that the first part of the Caprichos was more concerned with the specters of social conditions seen by the light of day; the second part, however, is concerned with the ghosts of night, with witchcraft, with the phantoms of death and dream.

Goya employs no formal or psychological pattern of classification. The borders between religion and superstition are blurred or are abrogated entirely. Demons from the primal past arise before us in contemporary dress. Whatever it was that separated pagan and Christian divinities from the demons has been removed.

The surreal elements in the witch scenes Goya painted for the Alameda contain no mysteries because the creatures of hell are done in a style similar to that used for the tapestry cartoons. It was only in creating the Caprichos that he discovered that ghosts become ghastly not so much by their visual representation in the scene they haunt, but rather by a change of style and technical processes in their treatment.

Why did Goya retain the traditional, conventional forms derived from medieval notions of witches and devils and their retinue, the bats, owls, goats, and cats, or the tools of their trade, the brooms and spindles? All of them were part of the common alphabet of popular superstition. And the drawings themselves were intended to be legible for all. The transformation was to be in the interpretation of the demonic. Those aquatint curtains in the background, grainy and permeable, arouse our suspicions that behind events visible to us there are other bizarre rooms and chambers. The actors move about in what for the most part is an uncertain twilight

emanating both from themselves and from some external source. The blacks and whites move through all the gradations of color intensity, though at times they are focused with the full glare of a searchlight. There are spotlight effects that alienate us from the ghostly scene—and intensify it. In many etchings the rhythmic strokes of the stylus merge and plunge back into dark shadows. The scale of intensity in the variations of light and shadow reinforces the events portrayed, sharing in and heightening the atmosphere of cruelty, fear, shamelessness, and suffering.

"Pious vows" shows two high dignitaries of hell, very much like bishops; they are borne toward us on the widespread wings of a giant bat. They hold *The Great Book of Magic Spells* with tongs. Supported on the shoulders of an ass-eared demon, a would-be she-devil sits up tall and takes her oath to hell. The commentary provides the text: " 'Will you swear to obey and respect your masters and superiors, to sweep their quarters, to spin tow, to beat the tambourine, to yowl, to screech, to fly, to cook, to grease, to suck, to bake, to puff, to fry, to do everything when and where you are ordered to do it?' 'I swear.' 'Well done, my daughter, I hereby declare you a witch. My congratulations!' "

Ill. 61

In order to make this imaginary world recognizable, Goya employed an unusual mode of presentation. Veiling his own thoughts and the criticism implicit in them, he captioned the etching with popular phrases and clichés.

"Look how dignified they all are!" An etching full of irony, satirizing conceit and attacking the cavaliers of Madrid and the airs they were accustomed to giving themselves. Two mutant figures: one with a vulture's head and talons, the other with ass's ears. Both are riding beasts that are half ass and half bear.

Ill. 62

Goya treated superstition and doctrinaire faith exactly alike: the first, as the spook of the individual soul, the second, as the spook of society.

The accused sits bound before the judge; he wears the tapered hat of the heretic, his head is bowed, and his hands are bound. He has already been condemned before the trial ever begins: "From such dust" is the title. Mankind is indeed as helpless as this, for "There is no help." The sinner, a woman, sitting on an ass, is being led through the town amid the mocking laughter of men; she is most likely on her way to the scaffold.

Ill. 71, 72

"What a tailor can do!" shows us the blind adoration paid to some kind of scarecrow. The faithful kneel before a tree that is cloaked in a monk's cowl. Witchlike figures observe the absurd scene from above. "This is the power of superstition: in fear and trembling an entire nation worships a block of wood wearing the cloak of a saint,"[8] wrote the Conde de la Viñaza, who might possibly have had this interpretation from Goya himself.

Ill. 73

"Here comes the boogeyman." Here we are shown a ghost of daylight. The shrouded figure with the black veil cast over his face is supposed to terrify these weeping, frightened children. Out of pure ignorance the mother seeks to frighten her children. The commentary reads as follows: "A calamitous error in the raising of children: to bring a child to fear some unknown figure of terror more than its own father, to force it to be afraid of something that does not even exist in reality."

Ill. 74

What did Goya think of this world of ours? Did he see only its darker side? The devil most certainly exists. He is the brother of the exorcists. Goya uses the pale light of doubt to illumine the depths of the soul. His gaze is fixed, however, both on everyday events and on the events of

history. He is on the side of his suffering people, even when it is not always easy to differentiate between the face and the mask of progress. His etchings speak not only of the demons of sexuality, but also of the stupidity of blind faith, of the seductive arts of false priests, of the venality of judges, of the gluttony of monks, of the vanity and vacuity of the nobility, of the tyranny and cruelty of the Inquisition, and of social injustice. Above all he never stops speaking of the dignity of man and of the necessary struggle to free mankind of both its interior and its exterior demons.

Ill. 75–78 "Wait till you've been anointed." The goat, a yearling kid of Satan's, is being prepared for duty. Instinctively he is struggling for a speedy escape, even before the ritual of initiation is completed. An ass-eared, naked man and a squinting crone are preparing this candidate for the devil's service. Goya portrays these unholy proceedings, at the same time giving us a look into the deepest level of primitive notions of evil. He painted the witches of superstition who ride through the air on broomsticks, but he also painted balloonists hovering gently in the air, ascending into the realms of science.

Ill. 79–82 He calls this etching "Experiments." Like some mighty altar, the great ram stands there beside the human couple. The cat and skull in the foreground are symbols used in the sexual rituals of witchcraft. "She is gradually making progress. She has managed several leaps, and in time she will know as much as her teacher."

Ill. 83 "Bon voyage." "Where is this infernal company off to, whose wailings echo through the air? . . ." The devil on mighty pinions carries four figures high above the nocturnal landscape stretched out below. All the lines of this etching are bathed in the veiled gray light of the world of demons. The phantomlike skulls take shape as recognizable creatures only by the play of light and shadow.

Ill. 89–91 "Where's Mamma going?" The pudgy mamma is having herself borne above the city by devils. A cat doing maid's duty with her parasol and an owl of the night lend their aid. The heavy, shapeless, almost fluid flesh of her breasts and legs is bedded on the back of the demons who support her. Is she being abducted against her will? Apparently not. She is enjoying her adventure. The commentary's remarks about all this are ironic: "Mamma has dropsy, and she has been sent on a little outing for her health. . . ."

A devil with a menacing eye who rides atop the owl, a fellow with a greedy look who is fascinated by all that ample femininity, and a demon who gazes down upon her with tender and patronizing curiosity—almost like an angel in a painting with a religious subject—all ask the question "Where's Mamma going?"

The very density of the reality in this etching is more powerful than Goethe's classic embodiment of a witch's journey up onto the Blockberg in his Walpurgis Night episode. Perhaps this plate inspired Gabriel García Márquez in 1962, when he wrote his bizarre tale "Big Mama's Funeral."

Should that day ever come when the last witches and devils exist only in some far corner of a lair in the human soul, their grotesque and magic image will have been preserved by Goya, the Grand Master of the black arts.

Ill. 92–94 "Pretty teacher!" Astride a phallic broom two women ride through the air, with the earth in darkness far below them. A young seductive temptress with firm breasts, strong hips, and billowing black hair is being brought to some orgy of love by an old hag.

24

"At daybreak we're off." Is daybreak the dawn of some more modern, more enlightened age, which will drive off these phantoms? A group of warlocks and witches are set off against the starry surface of the heavens. Ill. 96

"Swallow it, you dog!" Here grisly monks administer an unholy enema to the people of Spain. Spectral figures busily spinning and aborting the thread of life rise up out of the woven confusion of the etched lines. Ill. 95

"Time's up." "When dawn comes they flee away, each to his own place. Witches, hobgoblins, apparitions, and phantoms . . ." The things that escape our grasp by the light of day, that lie at the threshold of consciousness, occur here as grotesque reality. Is this meant to signal the dawn of a brighter, happier age? Ill. 105, 106

In the superstitions of Iberia archaic heathen elements were joined with ideas taken from medieval Christianity. The courts and the witch hunts of the Inquisition were still very real in Goya's lifetime. This was the artist's starting point: medieval satanism, the black mass, and exorcism. Goya's world of sorcery achieves believable form by unifying elements of instinct with his own artistic fantasy.

"They spin a delicate thread." A group of old women, above them a cluster of infant corpses. The commentary: "Not even the devil himself can unravel the intrigues they are weaving." Ill. 97

"Homage to the master." Is the massive head at the upper right, which watches everything so impassively, almost contemptuously, that of the master? Is he a prince of the church or his opposite number, the prince of darkness? Is this some pseudobiblical presentation in the temple? In the foreground a woman clothed in white prays or chants her song of adoration, her mouth agape. A sombre figure with a face distorted by piety, the grandmother, presents the naked child. In the background two figures lurk in attendance. Ill. 101–103

"There is plenty to suck on." "It seems that man is born into this world and lives only to have the marrow sucked out of him," says the commentary. A meeting of murderous midwives. On the right is an old woman whose business takes many forms. We see her delightedly licking and sucking on something, while another old woman points at the opened box and says she would like to have some too. Small children lie naked in a basket—the fruits of abortions? The large bats indicate that dark dealings of some sort are afoot here. Ill. 104

"Scandalmongers." A female devil with big bat wings sits astride a catlike creature and is blowing into the old shepherd's ear. Is it wind, dinning uproar, a deadly lie? A second man at his side has covered his ears in self-defense. Both are shepherds out in the barren landscape of the Castilian plateau. The commentary reads: "The witches who huff and puff are the most disgusting of the whole devilish pack and the dumbest at practicing their art. If they really knew anything they would not blow it all about." The Spanish word *soplones*, to blow, also means to spread rumors, to spy upon. Ill. 108

And what sort of phantoms are these who sow evil across the earth? Ordinary, everyday devils and witches just as earlier generations had conceived them? Man himself is the most devilish of creatures. When Hogarth depicts the vices of the bourgeoisie and nobility, his tone is moralistic; but in Goya's etchings, though similar in theme, there is to be found no expectation of mankind's improvement. The world is rotten. There is no amulet that will protect man from either the temptations or the crimes of hell.

Nor is there a good Samaritan to be found in the Caprichos. No one is good. Everyone is

only happy to take what belongs to his brother, to grab whatever he can get. The morals of the poor are no better than those of the rich. The poor are merely helpless, and no one is going to rescue them.

Ill. 109, 110 "Who would believe it!" Two ghastly specters do battle out on the empty plains of some nightmare. Two witches, their faces half rotted away and their bodies knotted in a wild tangle, are placed at center stage. Charles Baudelaire describes them: ". . . a landscape of phantoms, a jumble of clouds and rocks. Is it an unknown spot in the Sierras cut off from the rest of the world? Or a fragment of chaos itself? There, in the midst of this ghastly scene, a frenzied struggle is taking place between two witches who hover in midair. The one rides on top of the other, thrashes away at her, tries to subdue her. The two monsters wheel in the dark air. All the infamies, all the villainies, all the vices the mind of man can conceive are written in these two faces, which, as was the artist's frequent and inexplicable custom, reflect beings who are halfway between man and beast."[9]

Ill. 111, 112 Does Goya want to remind us of the vagaries of fortune in this etching entitled "Ups and Downs"? Man's end is bitter, without consolation. A gigantic satyr, man and goat, squatting at the edge of the globe, has caught a person by the legs—a strange figure of fire and smoke who carries burning torches—and holds him up high. The goat-man is about to fling this imperfect Prometheus into the abyss, just as he has tossed away the other rebellious creatures plunging from overhead. The commentary says: "Fortune deals very badly with those who would court her. She repays those who would rise with hot air, and those who have risen she will cast down in punishment."

Ill. 113, 114 One of the etchings most critical of the hereditary nobility, although somewhat veiled in the transposition, is entitled "The chinchillas." "He who hears nothing, knows nothing, and does nothing belongs to the numerous family of the chinchilla rats, which has always been good for nothing." Two nobles are pictured, each with a coat of arms on his jacket. Their ears are locked shut so that they need not hear, their eyelids lowered so that they need not see. The brains have been removed so that they need not think. But their mouths are wide open, and a blindfolded figure with long ass ears is busy feeding them both. The people, unenlightened as they are, still see to the care and feeding of these parasites!

Ill. 115 "And still they won't go" is the title of the etching that I have chosen—perhaps as Goya might have done—as the penultimate Capricho. Naked, emaciated people are propping up a massive stone slab that threatens to smash down on them. They will not yield. Is there no victory over dark powers of evil and oppression? Goya is content with the universal indictment and his own masterly execution of that indictment. He provides no answers.

Ill. 116 A drawing that was originally intended as the frontispiece to the Caprichos was arranged as Plate 43 in the edition Goya edited himself, with, however, another caption: "The sleep of reason brings forth monsters." The etching shows Goya himself overcome with restless sleep; the artist has sunk down over his workbench. A swarm of batlike owls flutters down upon him. Their eyes shine like spotlights out of the darkness. One of them is holding a stylus in its claws and is trying to hand it to the sleeping Goya. A giant cat with a vicious look in its eye has stretched itself out at his feet. Is it guarding him while he sleeps? The multiple meanings of this composition might well serve as the thread that leads us through the labyrinth of Goya's most private thoughts.

26

When Spain's powers of reason fall asleep, phantoms become the masters of the land and its people. And when the artist awakens, he will put his art to work to battle the delusive world of these necromancers.

"Fantasy, if deserted by reason, brings forth monsters; united with it, she is the mother of all art and the source of its wonders. . . ." Those are Goya's own words.

It is possible that through extended study of Bosch's paintings in the Escorial Goya's understanding of his own creative vision took its shape. A prior of the Escorial, Fray José de Sigüença, wrote in his *Tercera parte de la historia de la Orden de S. Gerónimo,* which he published in Madrid in 1605: "While other artists painted the external appearances of man, only Bosch had the courage to paint man's innermost nature."[10] This same assertion would also apply as a characterization of the Goya of the Caprichos.

In the prospectus that Goya had designed for the Caprichos, but which was never published in its entirety, he wrote:

"I beg the public's indulgence in consideration of the fact that the author has made no use of strange models, nor even of studies from nature itself. The imitation of nature is as difficult as it is worthy of our admiration—if someone can truly achieve and execute it. But praise is also due him who has completely withdrawn himself from nature and has succeeded in creating for our eyes forms and movements which until then had existed only in the imagination. . . . Just as with poetry, painting avails itself of the materials in the universe which are most apt for its purposes. It unites, it concentrates in a single fantastic figure the characters and circumstances that nature offers us dispersed among various individuals. It is thanks to such wise and ingenious combination that the artist deserves the title of inventor, ceasing to be merely a subordinate copyist."[11]

The union of fantasy and nature was not a mechanical one for Goya. The deeper nature of man—and this is what Goya sought—is a synthesis of disjunctive elements; we are each a transcendent unity of genial reason and devilish instinct. Both the fecundity and the distinctively pictorial dimension of Goya's art developed from the junction of the rational spirit of the Enlightenment with his own profound insight into the human psyche.

What moved Goya to devote an important part of his creative activity to the Caprichos and the cycles of graphic works which followed them? It is in the etchings that graphic art takes on characteristics of a mass-art form. The political climate in Spain did not permit these etchings to reach all those for whom they were created.

A considerable portion of the etchings could not be published at the time. Decades passed and Goya saw that there was little use for the democratic medium that he had chosen as the vehicle for his art; but he clung to it, perhaps in the hope of some future realization, perhaps also because he saw that here in this synthesis of the pen, where his fantasy found spontaneous release, and in the technique of the aquatint with all its inherent possibilities, he had found the medium that allowed him to move freely in the stuff of his dreams and reveries.

An artist who is drawing for an etching is in much the same position as a composer. The latter sets down the notes and hears their sound in his head; the etcher scarcely sees what he is scratching into the plate, but he knows what is there. A drawing executed with the stylus is a negative; not until the inking of the first proofs is it fully discernible.

Only in the very first editions, and sometimes then only in the first impressions, were the

transparency and the delicacy of shadings uniformly achieved. The fleeting glaze tones that take on a shadowy shimmer of red against the blinding white of the paper—itself a part of the color composition—are no longer evident in the later, darker pullings with their harder, deeper contrasts. Especially the large editions made in our own century from worn plates are only an imperfect evocation of the polyphony and the acid poetry of the drawings.

Prior to Goya there was no significant printed graphic art in Spain. With the Caprichos he created a work that broke new ground for graphic art—and not just in Spain—putting an end to the domination of motifs from classical mythology and Christianity. In this major cycle of etchings Goya immersed himself in the realities of profane life, in the visible and secret truths of man's circumscribed existence. Dürer's series on the Apocalypse and the Passion were the illustrations of a visionary, based on New Testament texts. Goya's cycles are books that he wrote in the very drawing of them. He not only depicted his times, he shaped them.

Rembrandt expanded the meaning of art by transfiguring the things of this earth. With Goya's etching all our dreams of hope are engulfed by the dark powers of this earth.

Enrique Lafuente Ferrari writes: "He was to show the idleness and ignorance of the privileged classes, the corruption of power and justice, the exploitation of the common people, and the prevailing superstitions. But although his first inspiration came from a number of historic circumstances, his genius led him to denounce man *in genere* for all his sins and vices, lusts, vanities, and follies."[12]

We are still witnesses to the sadistic perversions that accompany witch hunts perpetrated against those who think differently from the rest of society, who worship other gods, or who are dedicated to revolutionary change in that society. The forms those perversions take may be new, but no less ugly for all that. The Jews and Arabs who were driven from Spain were certainly subjected to fewer horrors than the ones committed as a "final solution" in twentieth-century Germany.

In his later years Thomas Mann turned to the materials of the Faust legend—a fact that cannot be explained simply on the basis of the image of himself as the new Goethe which he cultivated with a light touch of irony. The roots of Mann's interest lay in the events that became Germany's destiny. He spoke in this connection of the dangers of the union of a highly developed technology with romantic irrationalism: "Where the arrogance of the intellect copulates with psychic archaism and bondage, there's hell to pay. . . ."[13]

Goya did not use the vocabulary of the Enlightenment or the word "revolution," nor did he speak directly of the equality of men. Nevertheless, he worked creatively to change, to raise, human consciousness. The effect and importance of his works remain, while the fame of David's puritanical, classical paintings of revolution has faded. Goya etched his vision of this world and added graphic glosses on the fate of man. He anticipated Lautréamont's hymns of cruelty and travesties on the divine order; he was the forerunner of Franz Kafka's nightmarish twilight visions of the inaccessible and of Samuel Beckett's atheistic description of man's passion, in which we wait for the apocalyptic end game.

The importance of Goya's graphic cycles for the modern world lies in the power of the imagination that informed them and in the profundity of the artistry that shaped them. He was the first artist who, without conceding artistic integrity, portrayed the social and political conditions of his time with such burning truth and accuracy.

Drawings

In a foreword to Pierre Gassier's *Francisco Goya, Drawings: The Complete Albums*, Xavier de Salas writes: "Goya, then, expressed himself in sequences of works which may either develop an event or an idea, or may come as successive expressions or visions forming a commentary on an idea or an emotion or on related ideas and emotions. It is impossible to appreciate fully Goya's reaction as a man unless one takes into account this highly personal manner of expressing himself."[14]

The insight is clearly a helpful one, but we must remember that Goya was not free to determine how that sequence, that succession, should develop. The unity between the possible and the desirable, in addition to its internal contradictions, was subject to the whims of governmental authorities, censorship, and the Inquisition—and to traditional morals and the prejudices and criticisms of opponents as well as, at times, of friends.

The sketches, which Mr. Seidel's camera has captured with such sensitive precision and interpretive transparence, have been arranged according to their visual and thematic affinities.

"Embozado with a gun hidden beneath his cloak," is a melancholy drawing from memory in Goya's late style. This soldier for the rights of man stands bent forward, deep in thought, his cape draped over his shoulder, reminding us of Goya himself. A sense of the remembrance of a short-lived, futile hope clings to this cloaked figure. The chalky, sinuous strokes are lapidary, expressive, and delicate all at once. Ill. 1

This sketch made in Bordeaux might be considered a drawing done by an émigré yearning for home. It served as the basis for two small etchings.

Whereas the first drawing belongs to Goya's late period, the "Dream of falsehood and inconstancy" is a lover's tryst out of the artist's past. It was drawn after a happy summer at Sanlúcar, and the story it tells is one of unbridled passion that, once disappointed, turned to bitter resentment. Ill. 2

The loved one is double-faced, double-tongued, and faithless—yet she is still bewitching. It is a drawing inspired by Eros and shaped by poetic fantasy. With some slight variations and softening of the portraitlike features, it was later redone as an etching. It was, however, not included in the Caprichos, for which it had been intended.

"They say nothing." Two witchlike women seem to have leaped, or perhaps plummeted, from the sky and are struggling to lift a heavy stone slab. Will they succeed? The demons of Ill. 3

night are always below us, and they try to open the doors to the abyss. A similar theme is dealt with in a red chalk drawing and in an etching in the Caprichos, but in both those instances the gravestone is being shoved up from beneath. The lightninglike ferocity of line corresponds to the inner rhythm of the vision that harries the artist.

Ill. 4 "The lame and hunchbacked dancer." The hunchbacked man with the crooked legs springs and wheels about his elderly partner as if he were young and handsome. Goya's strokes are sprightly, but tremble a bit, lending the sketch a tragicomic note of irony. It is possible that a parody of Andalusian ballet is intended here.

Ill. 5 "Bad husband." The husband beats his wife while sitting on her shoulders and driving her on like some beast of burden. She patiently clings to his legs, and he lashes her with his whip. Goya, it would appear, has employed a hasty line to match the viciousness of the scene.

Ill. 6 The "Monk playing a guitar" portrays a friendlier sort, someone for whom Goya apparently felt some sympathy. Sánchez Cantón, at least, is of the opinion that this is a monk. Sheets of music are fastened onto the back of a chair. The man has a look of concentration on his face, as if he were studying some difficult passage. His eyebrows are tugged together; his right hand has been pulled away from the instrument. It remains unclear whether the layman's coat and hat lying by the chair have been left there as part of a preliminary sketch, or whether they are meant to imply that the monk would gladly lay aside his cowl.

Ill. 7 "Old woman with a mirror." Goya has employed this motif before; in the Caprichos he addresses the topic of the vanity of old women in "Till Death." He himself was by this time an old man; the drawing has nothing of the grotesque. The woman in her black shawl is holding a magnifying glass to her eye in order to see better in the mirror—a bitter illustration of the inevitability of the passage of time. The woman seems to gaze out at us twice, as she was and as she is now. The lines in black chalk are simple, elemental, truthful, and touching.

Ill. 8 "Nothing doing! What tyranny!" Especially in the Caprichos, the male's lust for power was a principal theme for Goya. The woman, sealed tight by the heavy pendant lock, stands opposite the voracious man. Her sad and bitter face pleads with him, while her supplicating hands make clear her reluctance. The dusky flow of the lines and the simplicity of the formal means remind one of Rembrandt.

Ill. 9 "Lots to eat." The glutton tugs his trousers down as he squats above the privy. The bent-over figure striving to expel digested matter is depicted unambiguously, drastically. The round head corresponds to the round backside. A shadowy figure in the background smiles ironically as he watches the proceedings.

Ill. 10 "The hidden treasure." Is this stout, robust fellow hiding his treasure, or has he just found it? The expression of joy on his face would seem to indicate that he has been digging it up. The spade is propped against the wall, and an antique dagger lies on the ground. The desire for wealth is one of man's instinctual characteristics. Goya portrayed misers and people digging for treasure also in the Caprichos.

Ill. 11 "Good advice." Pointing to a skull, a monk confronts a peasant boy who stands before him, his hoe held above his head. The hoe is positioned parallel to the cross, making the implements symbols of the antithesis between the temporal and the eternal, between the daily toil on earth and the promise of eternal life. A bold, poetic composition, which perhaps served as the inspira-

30

tion for Luis Buñuel—whose affinities with Goya are many—when he placed the boy Jesus on the edge of the pilgrim road in his film *The Milky Way*.

The figures are outlined in grand simplicity by a few curving strokes, creating a visionary dialogue that is both aesthetic and philosophical.

"An old-fashioned duel." This is one of six scenes that Goya devoted to the morals and immorality of times past. It shows a duelist in a white shirt and his opponent, the latter about to collapse after just having had a dagger thrust into him. The ritual of death and honor is executed with fine, graceful strokes of the pen. The terror of death is mirrored in the face of the victim. Only a few prints of this drawing are known, and they have all been retouched with pen and ink or with black chalk. Ill. 12, 13

"She is looking for a doctor." This is presumably a scene from the confessional: on the left a monk in black robes, who points a didactic finger at the woman who has entered through a door or archway. The priest's overweening, sly features reflect the critical insight of a liberal artist who is concerned with the gullibility of simple people, especially women, who are only too ready to yield up more than just their souls. The rich structure of shadows creates an atmosphere tense with psychological insight. Ill. 14

"Paternal embrace." The scene takes place at the gates of a cloister. The old nun who keeps the gate has just let the young girl out. The reunion with her father is the moving center of the composition. The daughter is about to return home; the wide portal has released her into the bright light of freedom. At the right a figure stands in the shadows ready with the burro she will ride home. Ill. 15

"They love each other very much." Pictured here are two witchlike creatures who float through the air on bat wings. The emaciated body of the woman is embraced by the man's arms. The grainy lines of the black chalk are appropriate to this phantom scene, though there are only dark hints of what precisely the artist meant to convey. Is Goya making fun of the demonic power of love's passion, which has so visibly taken hold of these two old creatures? Ill. 16

"This smacks of magic." A man playing with a glove flies along with robes aflutter and spurs on his boots. His face is energetic, the lower lip pouted. Sánchez Cantón interprets the figure as that of Pope Pius VII. Ambition and political machinations drive him on. His eyes are fixed expectantly on the globe, lending some suggestion of cabalistic magic. We are also reminded of Chaplin's grotesquely dramatic game with the globe in *The Great Dictator*, or of the journey through the air by Münchhausen atop his cannonball. This drawing of Goya's, in which the brush moves freely and lightly yet with intense power, probably dates from the brief period of liberalism's ascendancy in Spain. Ill. 17

There follow two graphic works executed with statuesque simplicity and perfection of line: "What sort of work is that?" and "How many yards?" A man in monkish garb against a white background, his face almost totally hidden by the hood—there he stands all alone, his chilled hands shoved up into the wide sleeves. A mendicant, a loafer, a fool? Ill. 18, 19

The other plate shows a representative figure in a full, pleated robe. His back is turned to us. The vertical rhythm of the folds and the bald head towering up out of the shawl collar intimate that this is some ecclesiastical dignitary. The massive white figure set against the blackness is perhaps a symbol of the wealth of the religious orders in the poverty-stricken Spain of the period.

III. 20 "Phantom dancing with castanets." We find this corpulent, merry goblin in several variations in the Caprichos, Disparates, and in many paintings. A monk, a cross between jester and sinister idiot, dances and laughs, shaking his castanets. His face and habit are bright against the dark background. The picture has, however, a menacing undertone.

III. 21 "Deadly struggle!" The murderer and his victim look almost identical. One is reminded of Cain and Abel or of two madmen. A ghastly vision of man slaying his neighbor? The murderer sits atop the vanquished opponent; he spreads his legs and points the dagger at him. Two faces, one grinning, the other wrenched with pain—nevertheless, almost mirror images. The killer's hands are coarse, his face laughing like the moon on the banner in "The Burial of the Sardine." Or is it an act of castration? The composition is done with an easy, free hand; the interior lines are without shading, almost bright, despite which the whole is dark with cruelty.

III. 22 "You won't find it." Goya has drawn the Greek philosopher who went out, lantern in hand, to find an honest man, but in the end found nothing but his own shadow. This may be an allusion to his own life, a veiled self-portrait that tells of vain and misplaced hopes in humanity. This parable of the skeptic is drawn with a vibrating line and large black-gray fields of shadow.

Most of these drawings belong to Goya's later years. But however much the early drawings may differ from them, they still form an unmistakable unity. The theme throughout is man himself, suffering and building but also causing others to suffer and destroying what was built.

Goya's graphic works are equal to those of the masters in the great epochs of art. With stylus and brush he penetrates the merely visible and shows us the very structure of being, how it comes into existence, and how it dies.

Caprichos

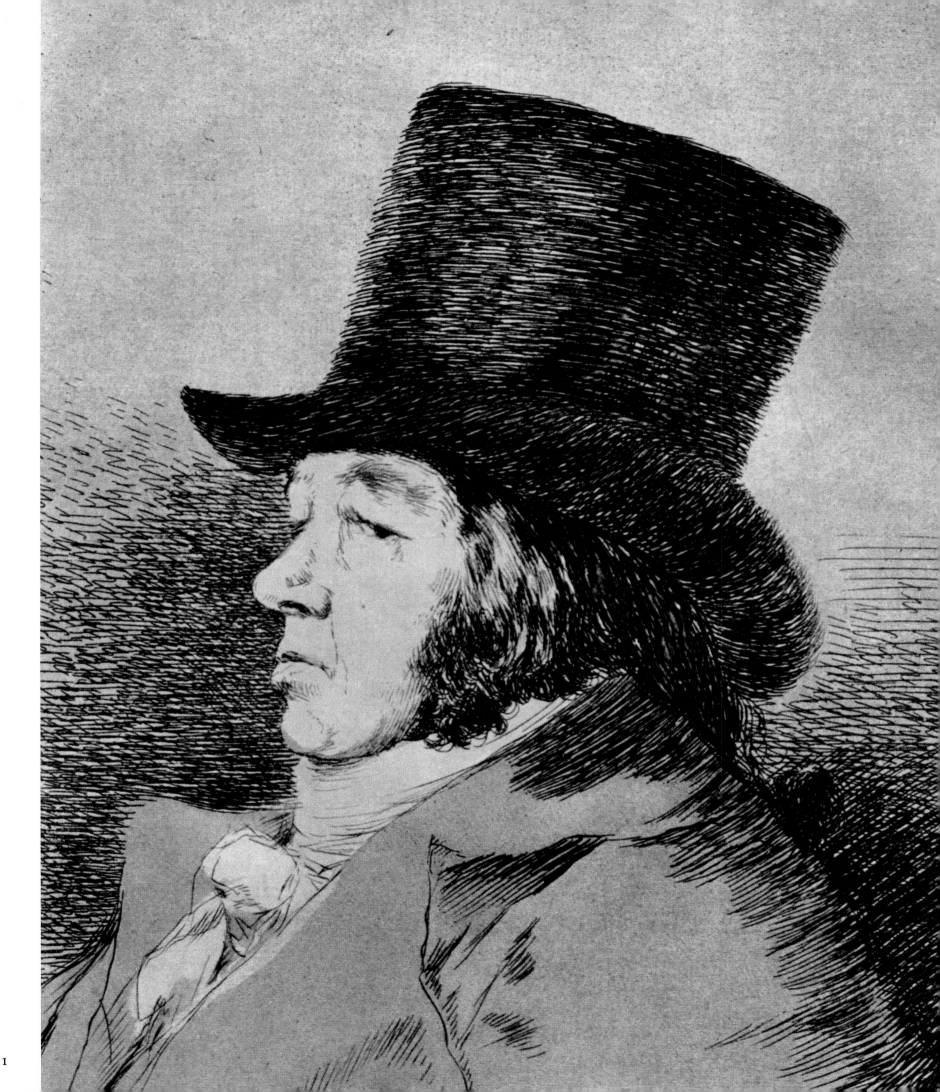

I

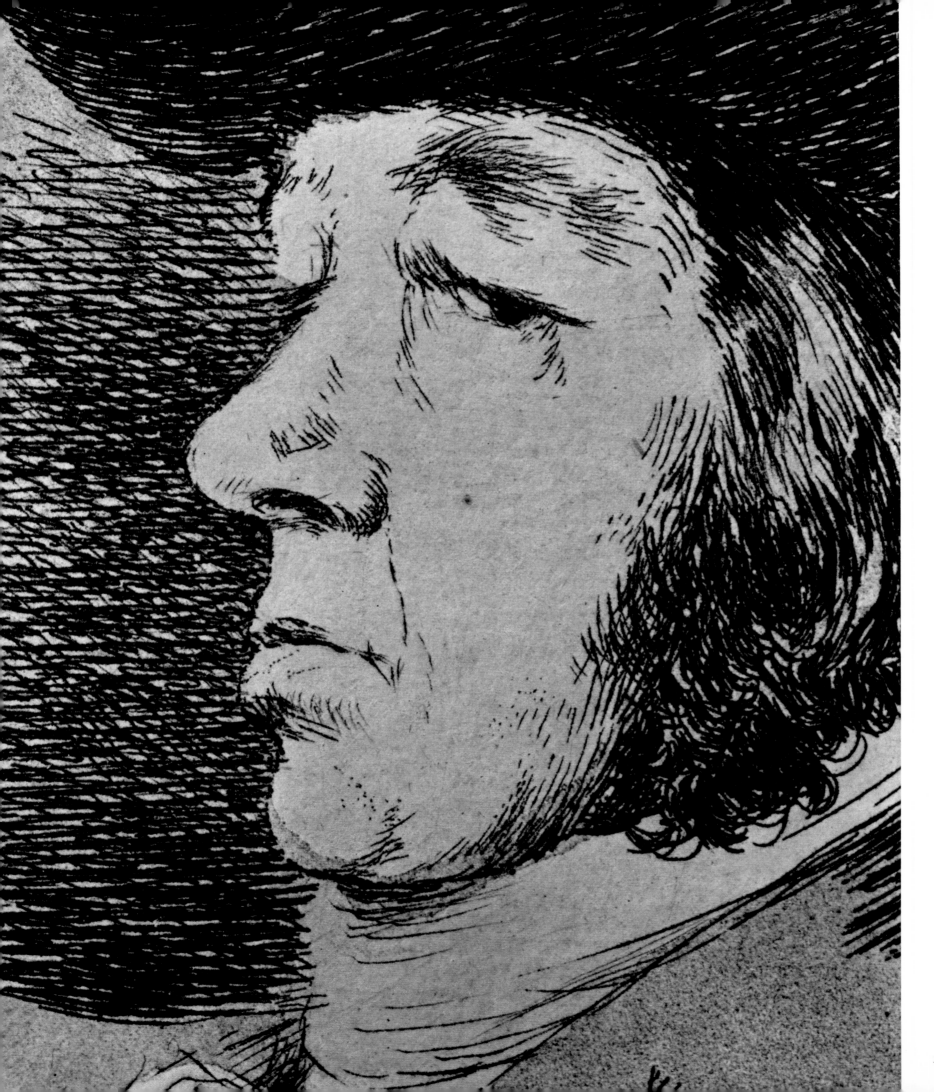

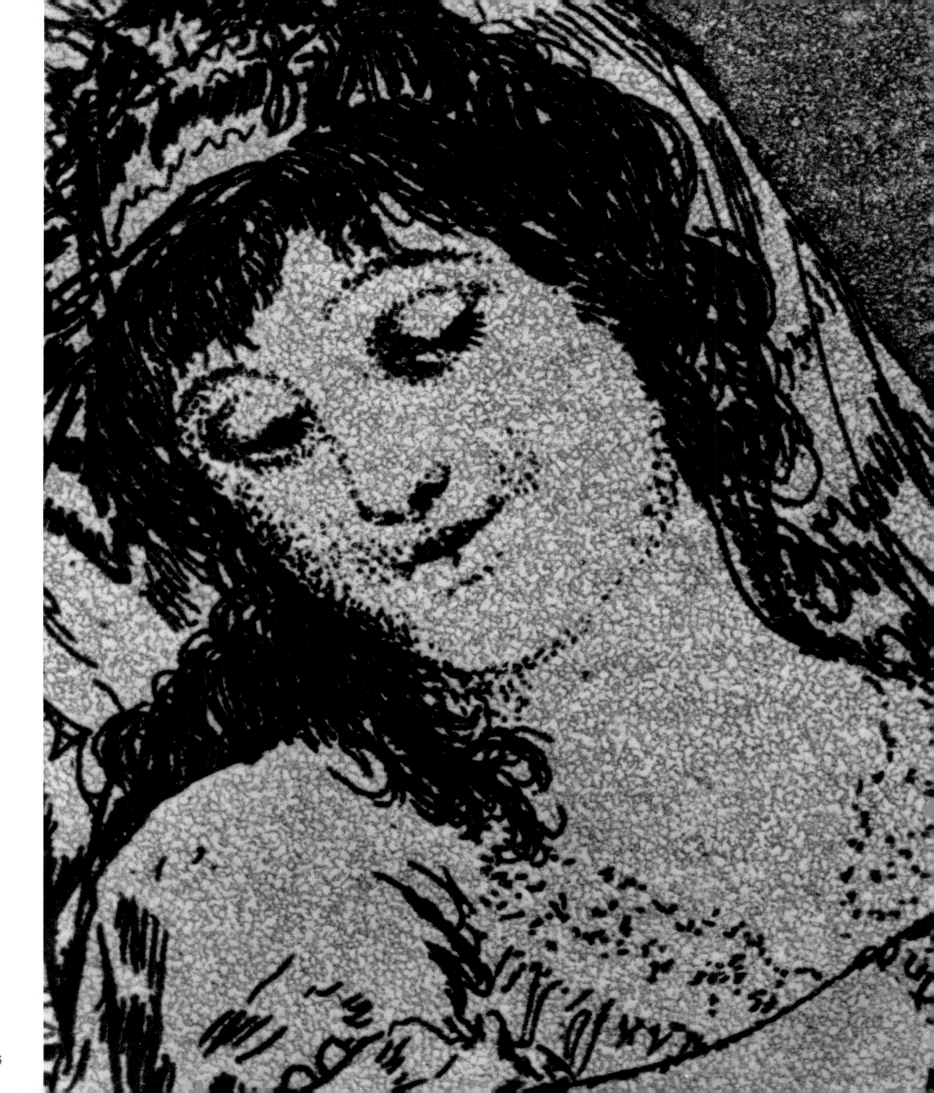

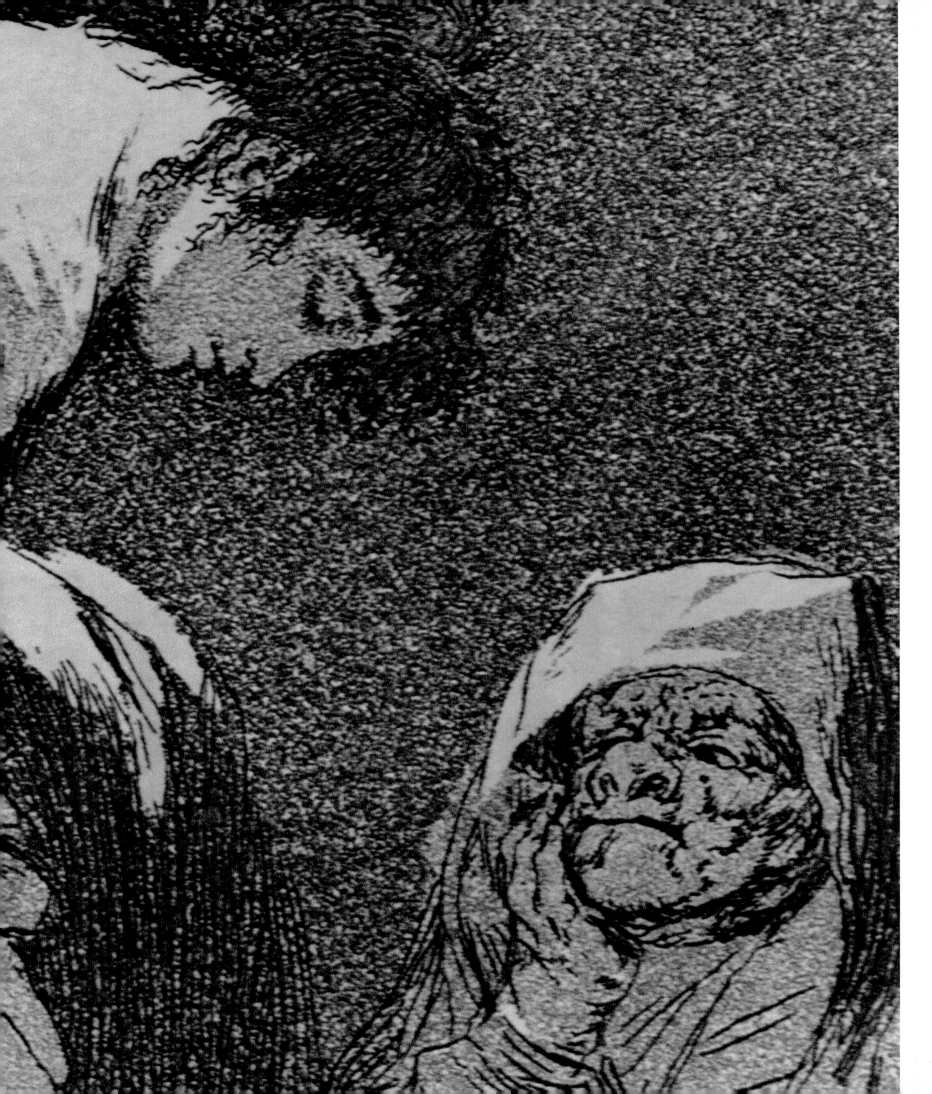

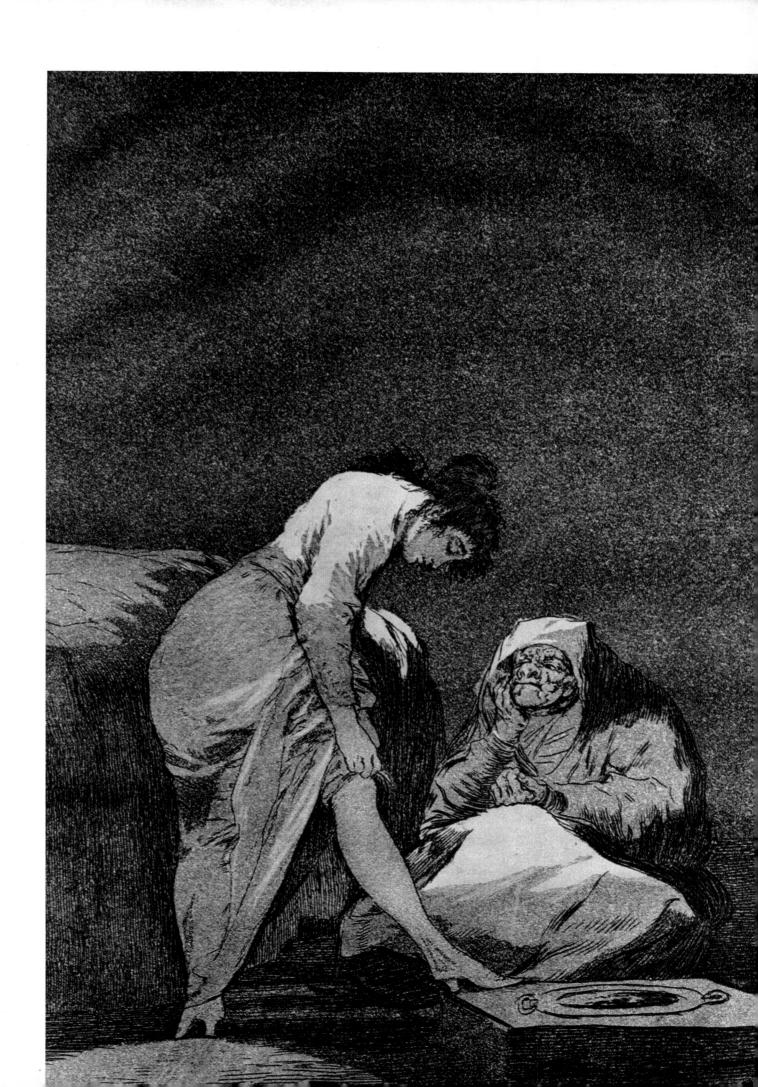

5

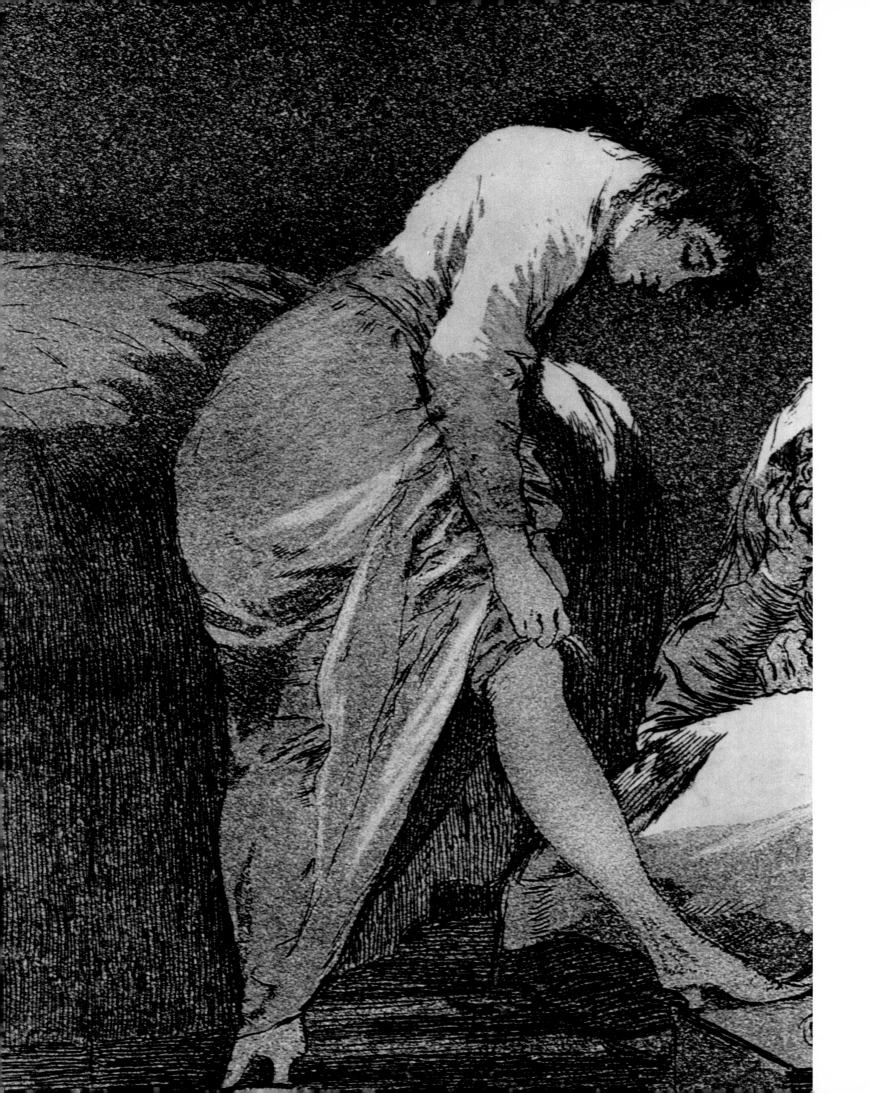

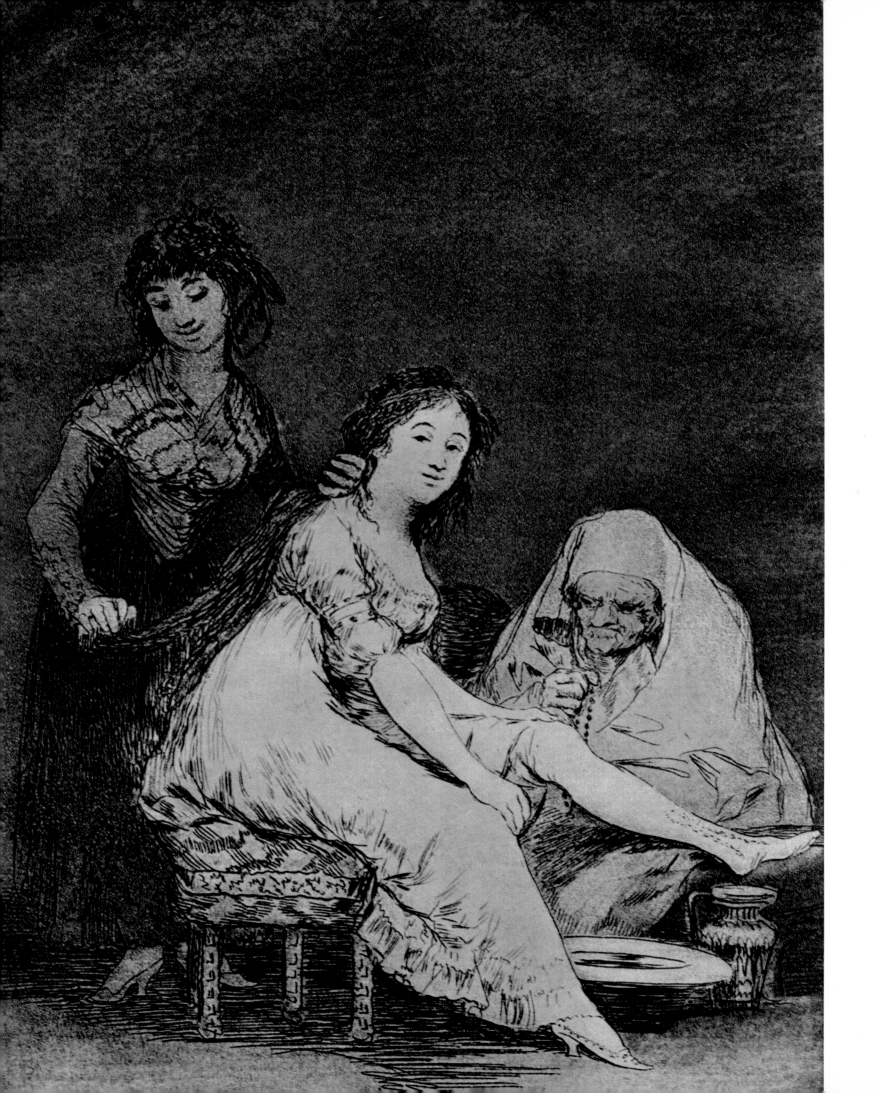

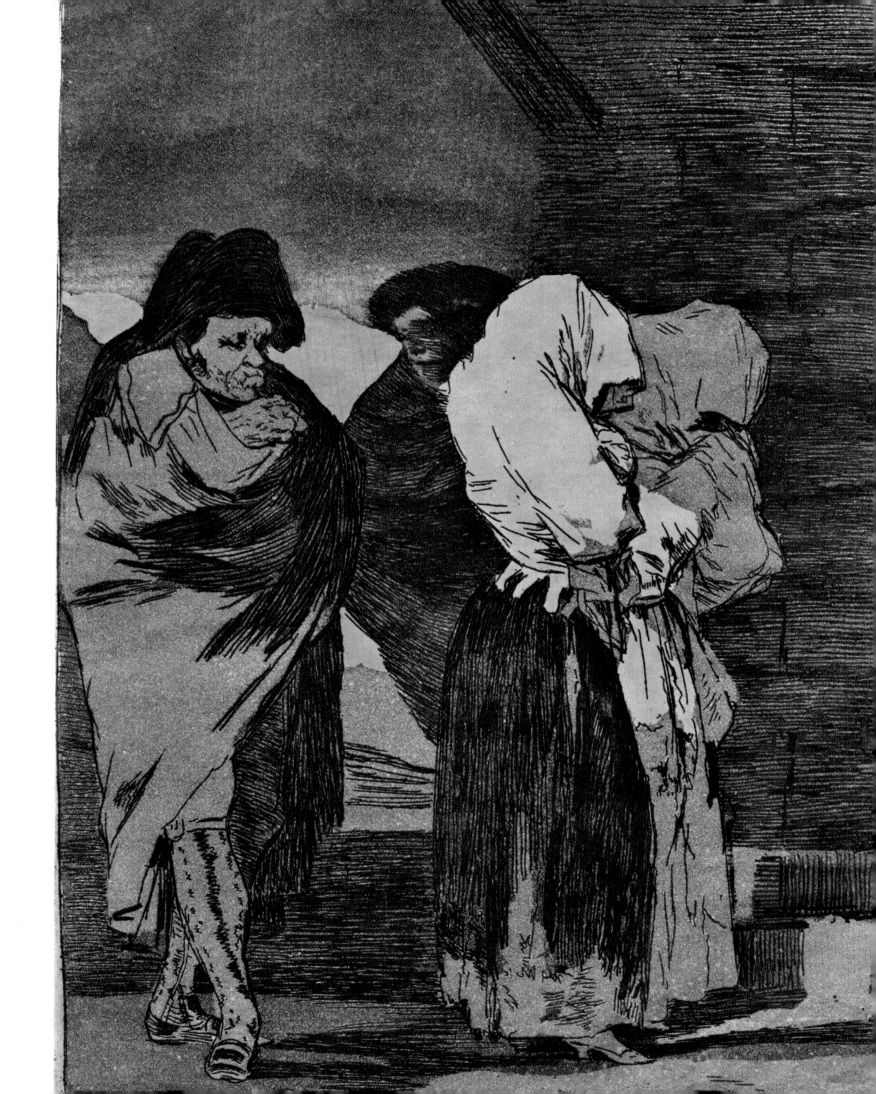

9

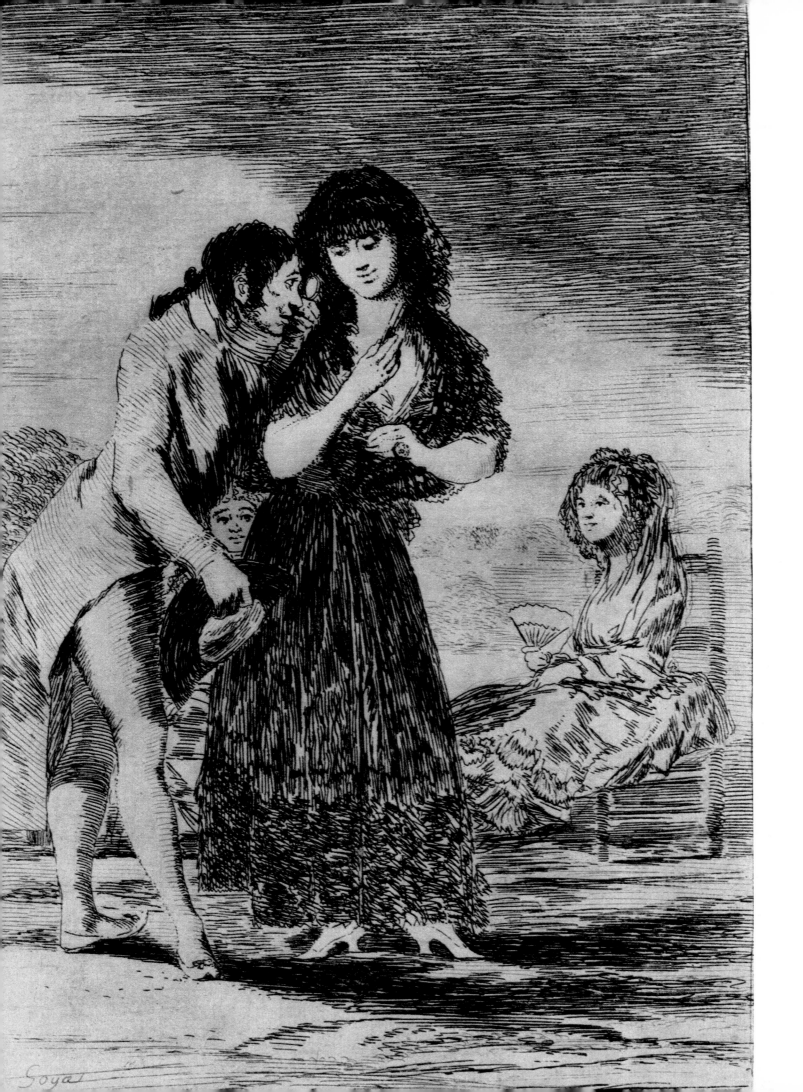

Goya

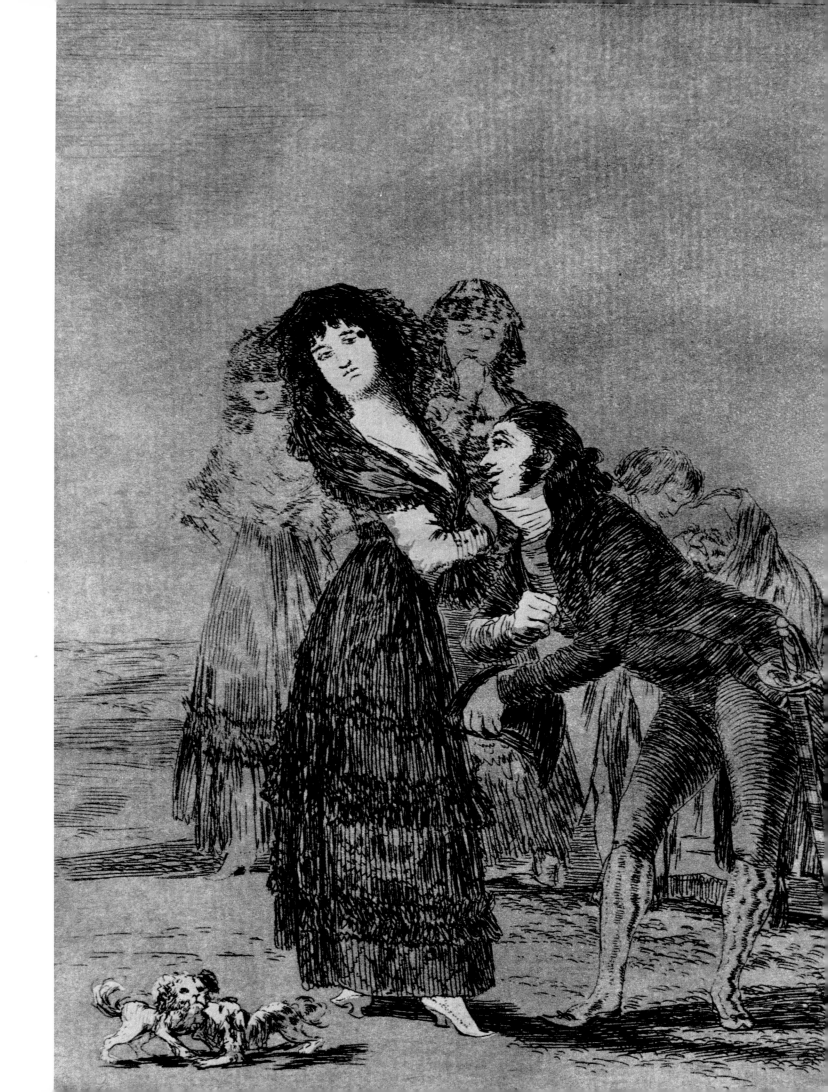

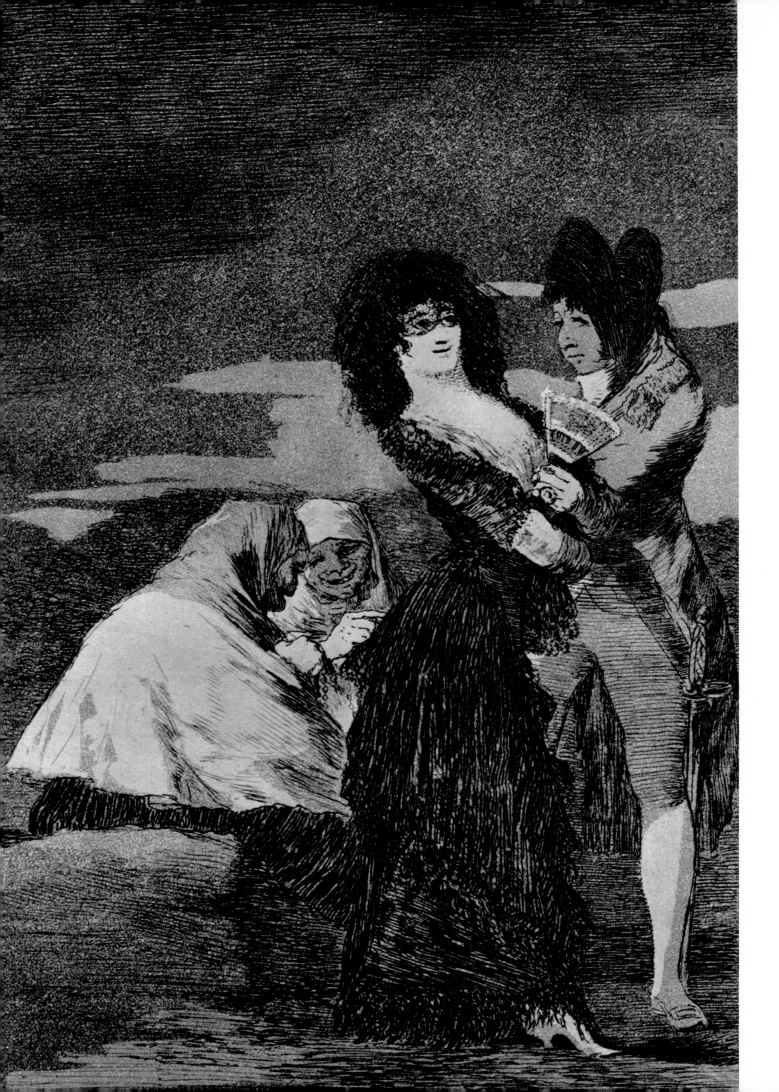

12

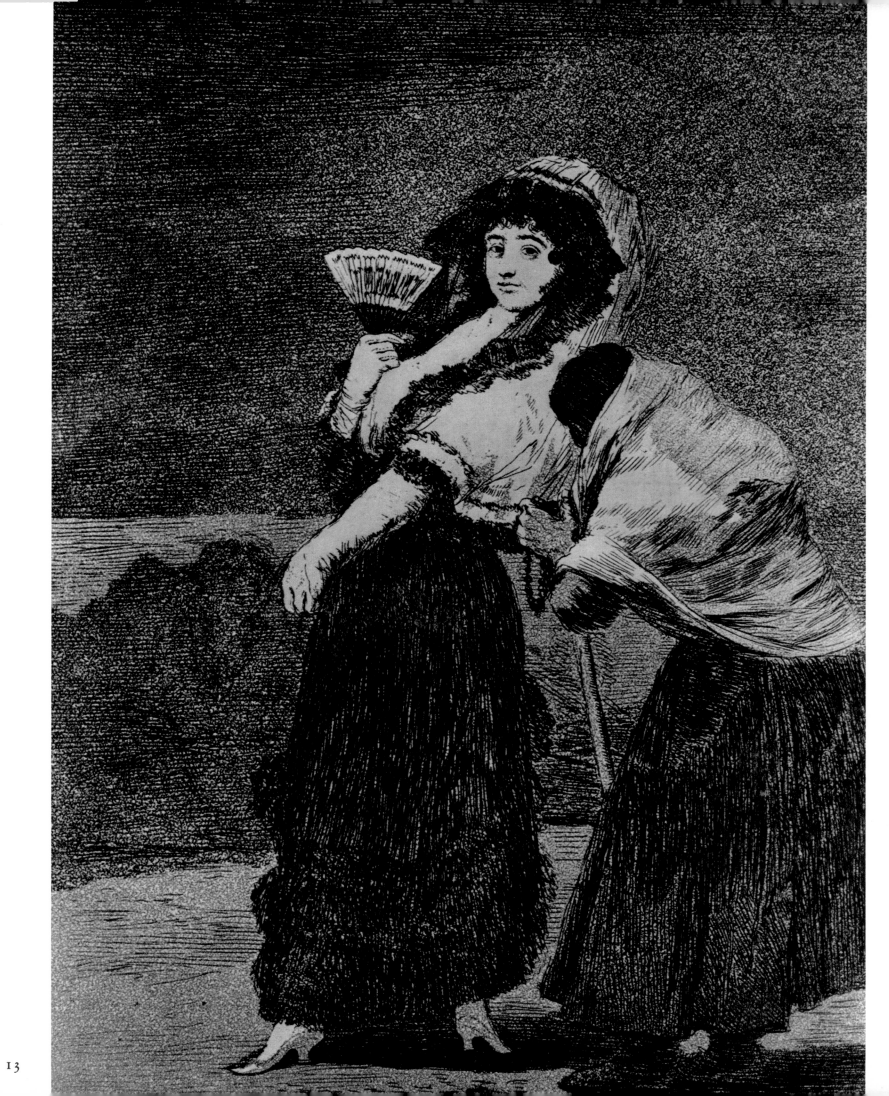

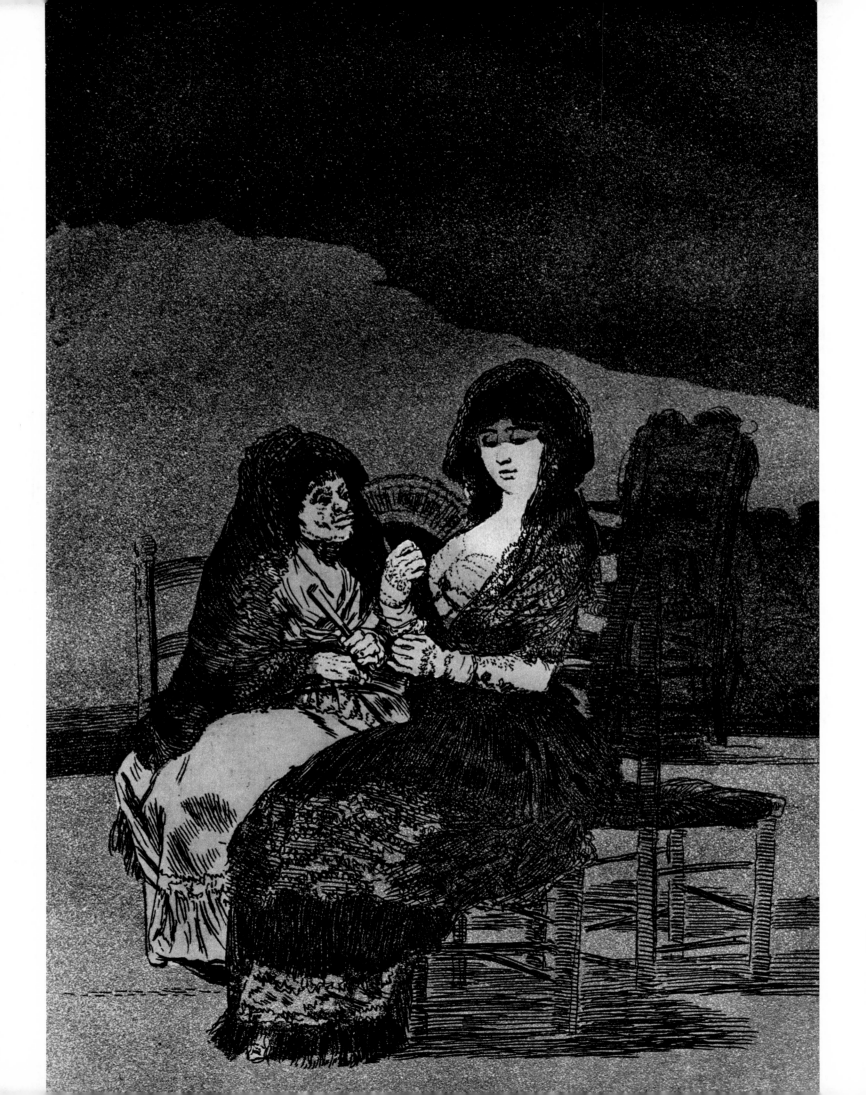

14

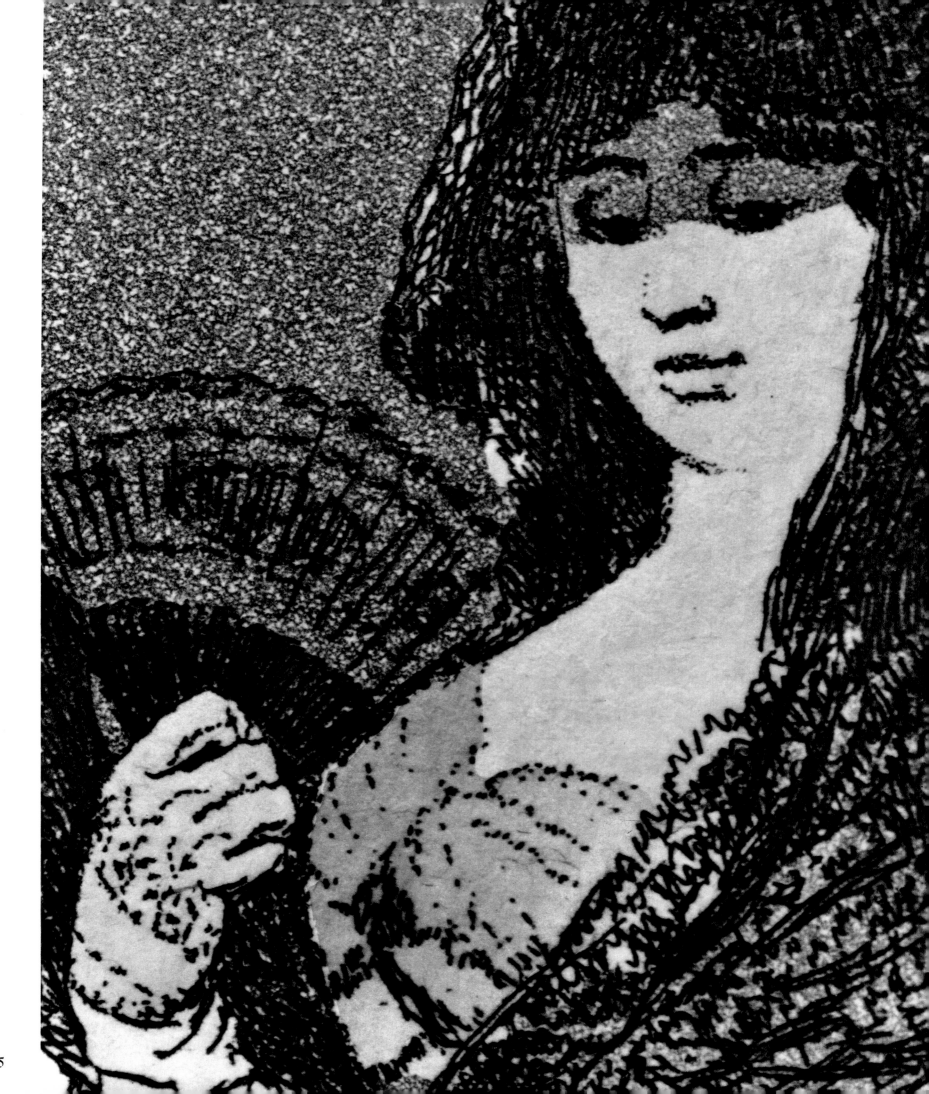

15

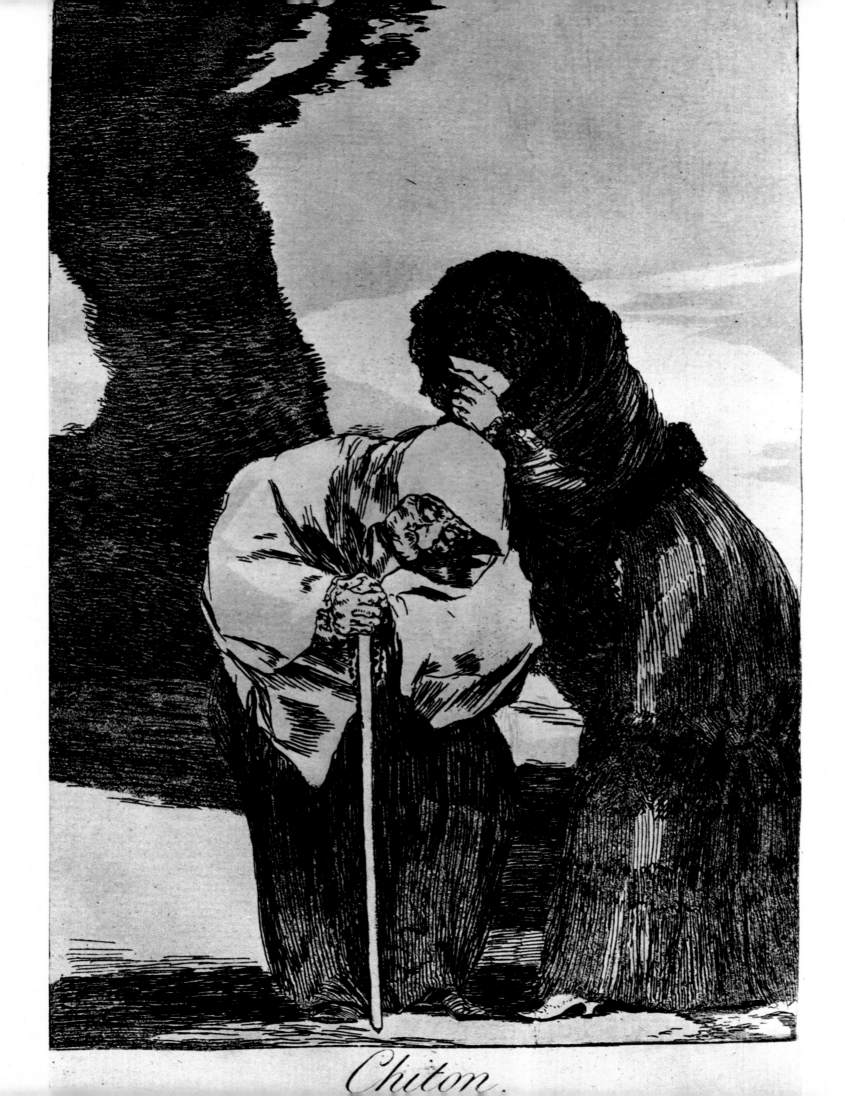

Chiton.

16

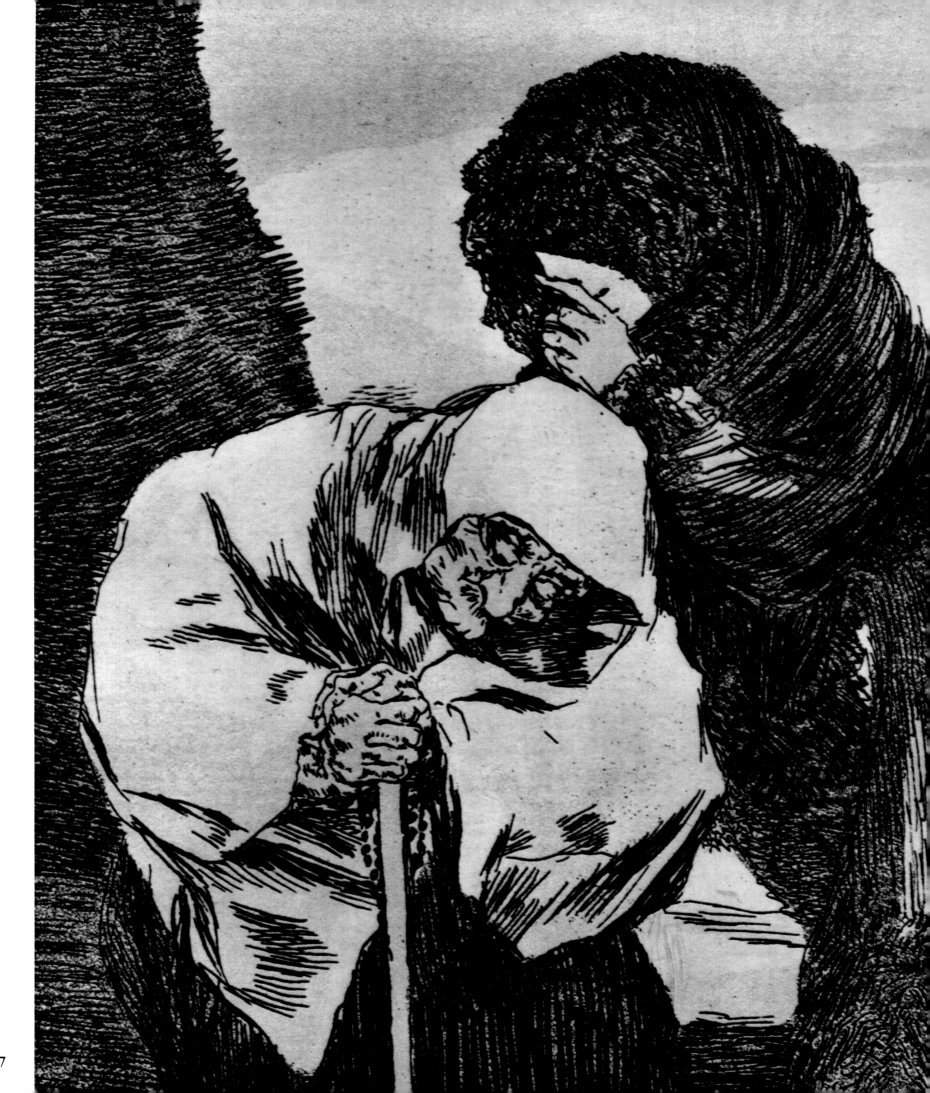

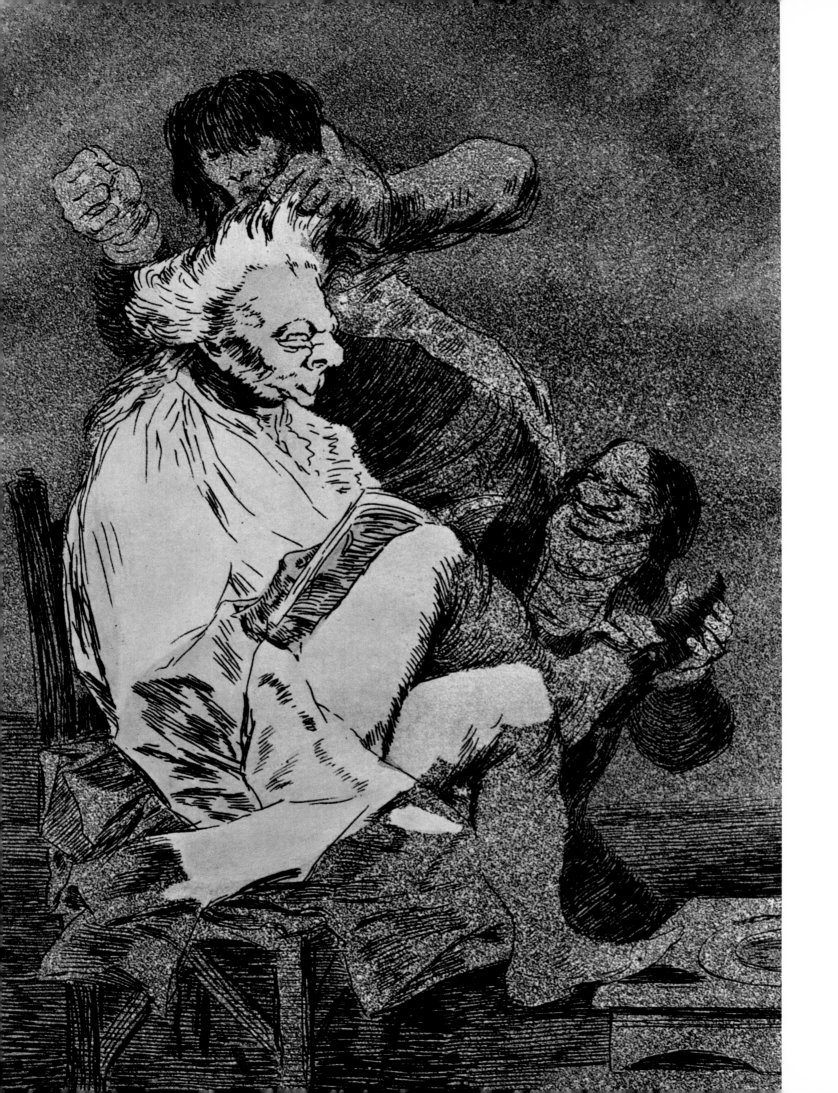

18

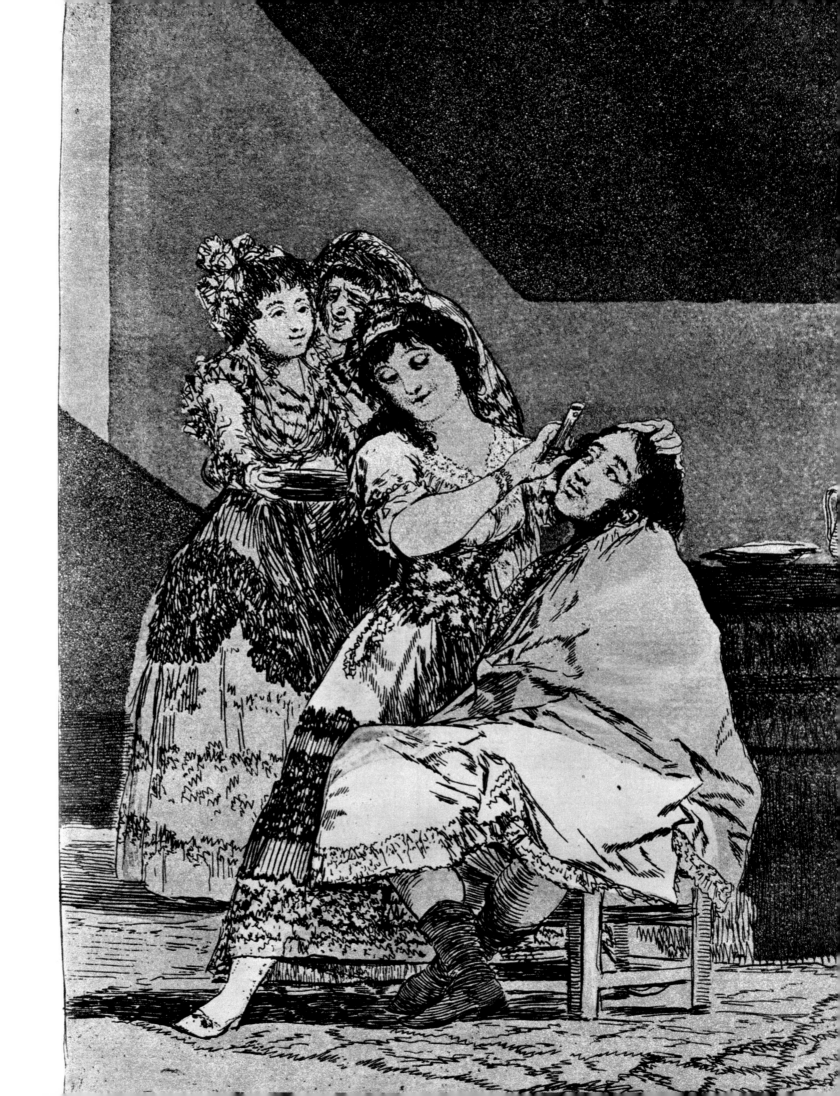

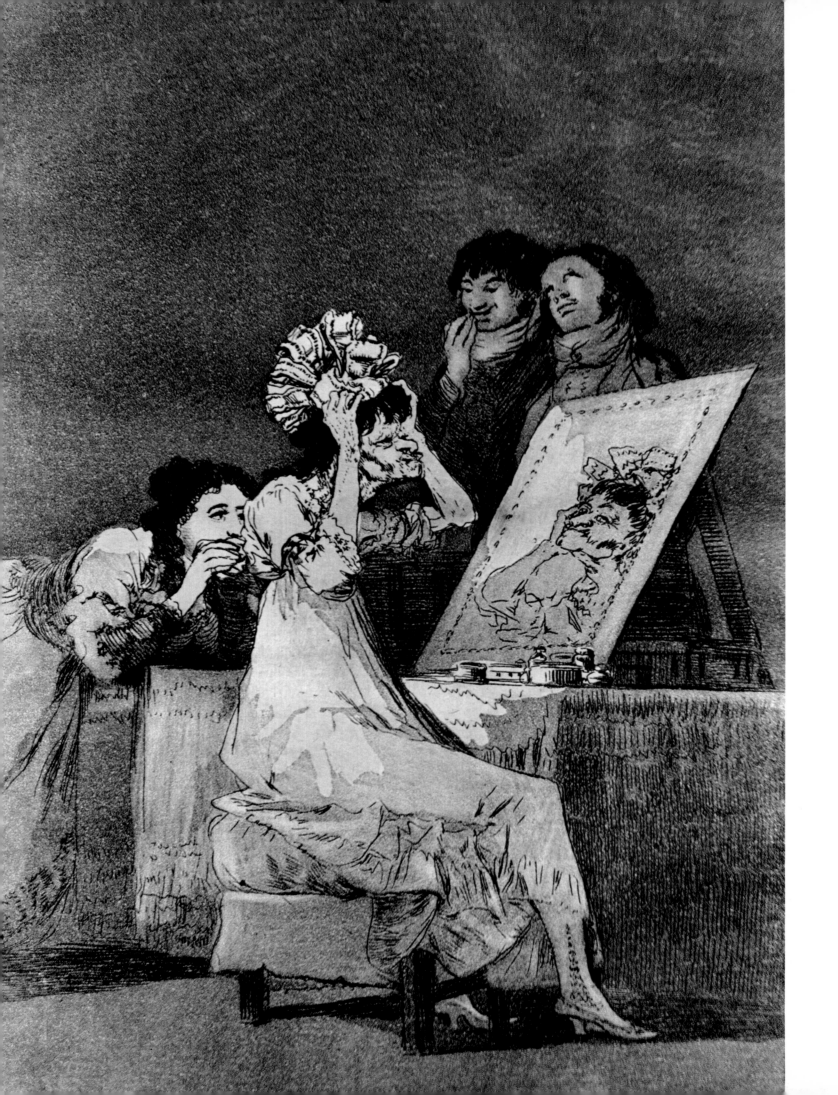

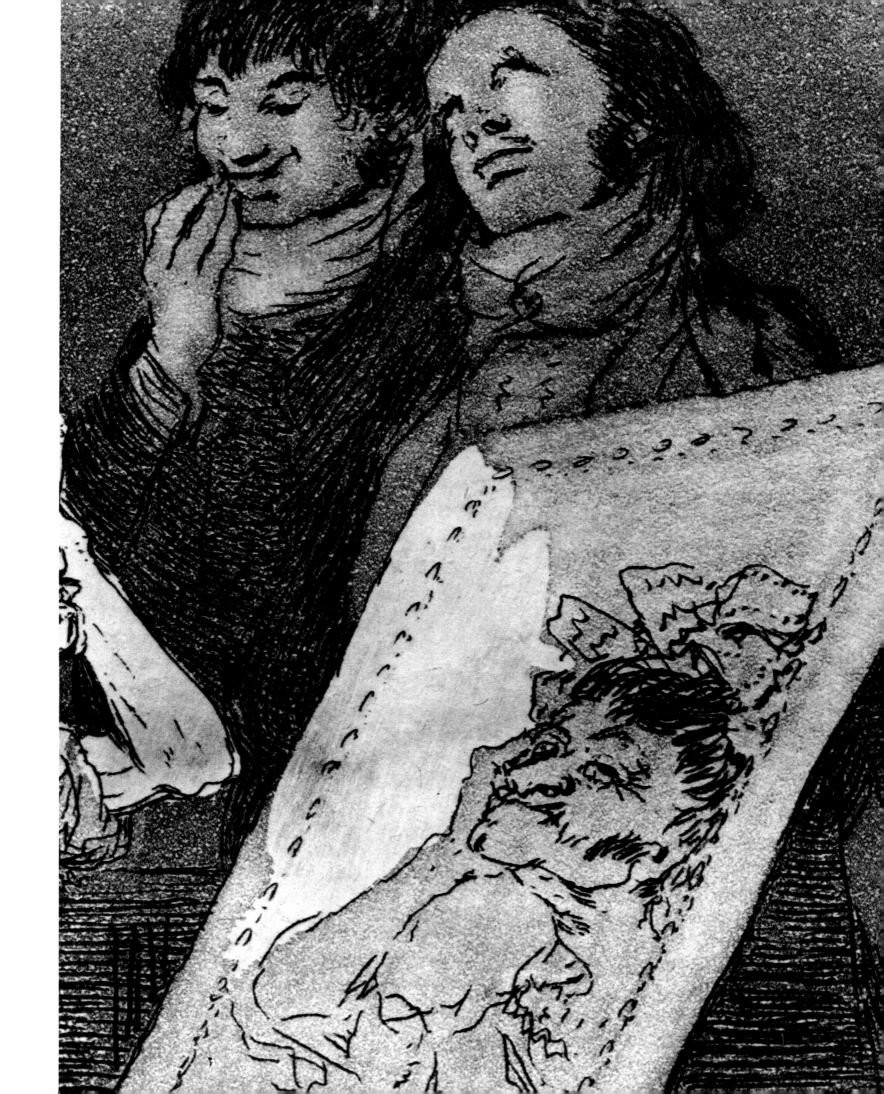

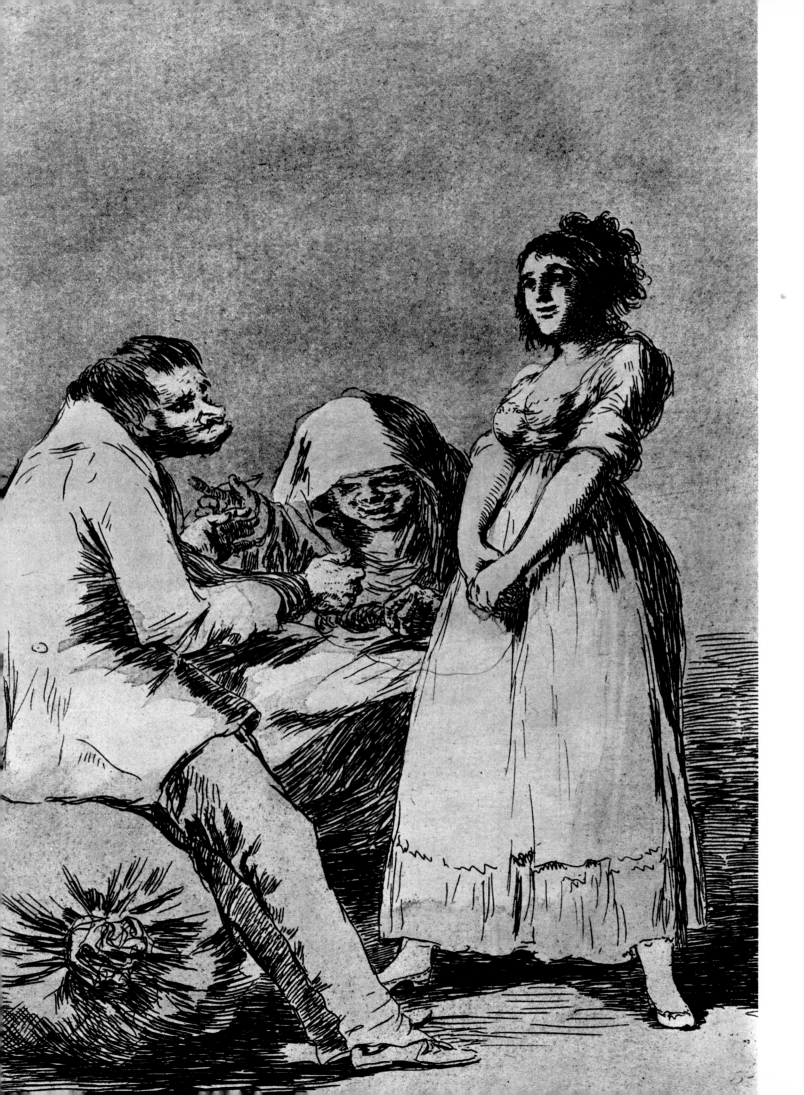

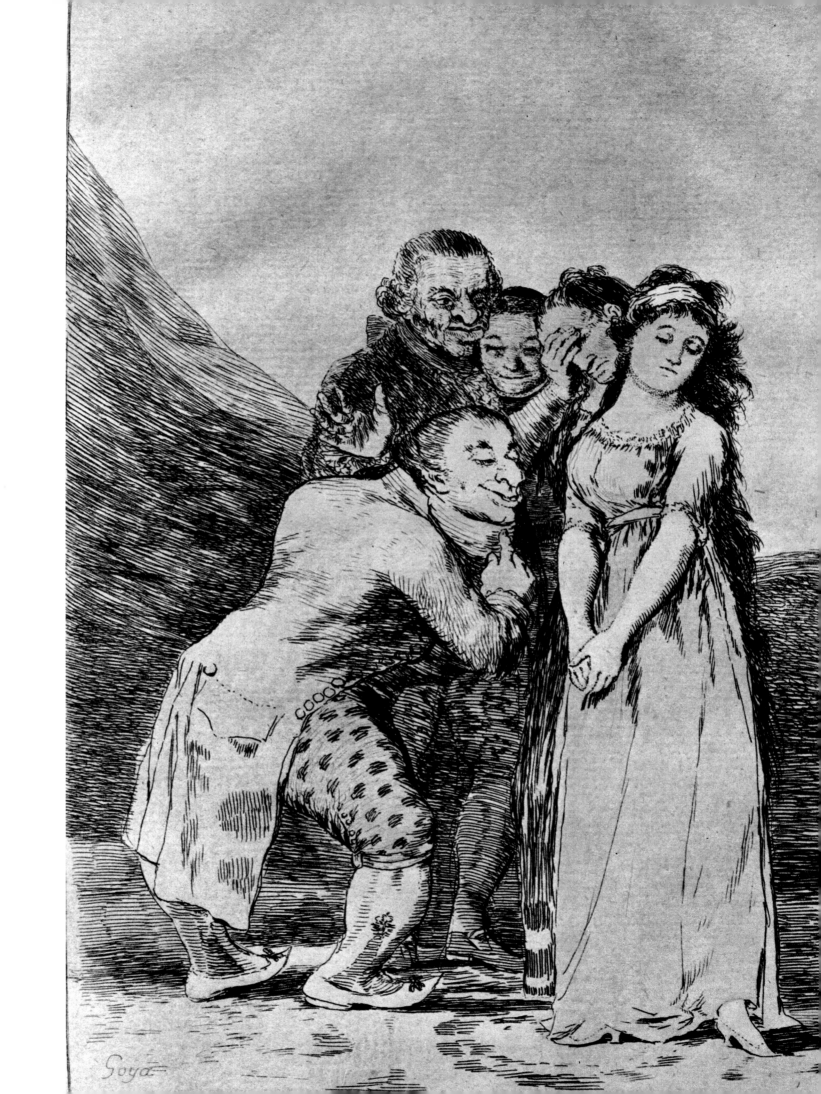

Goya

23

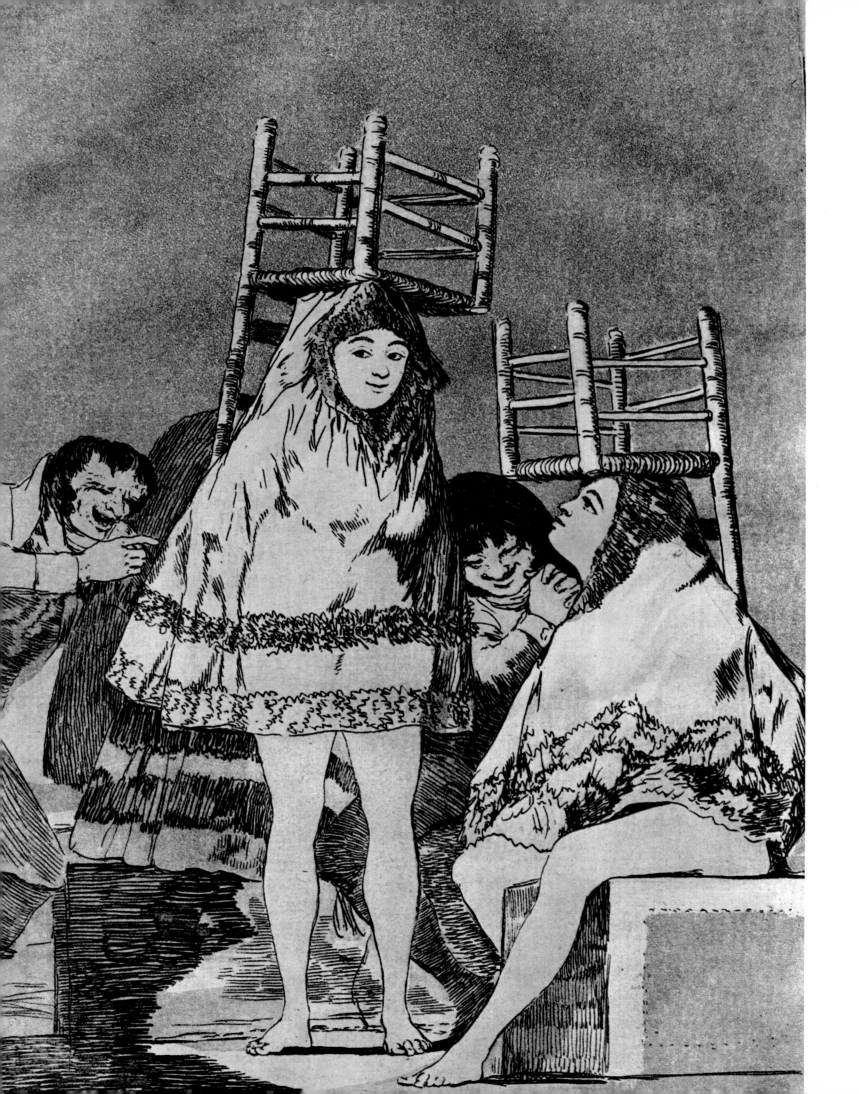

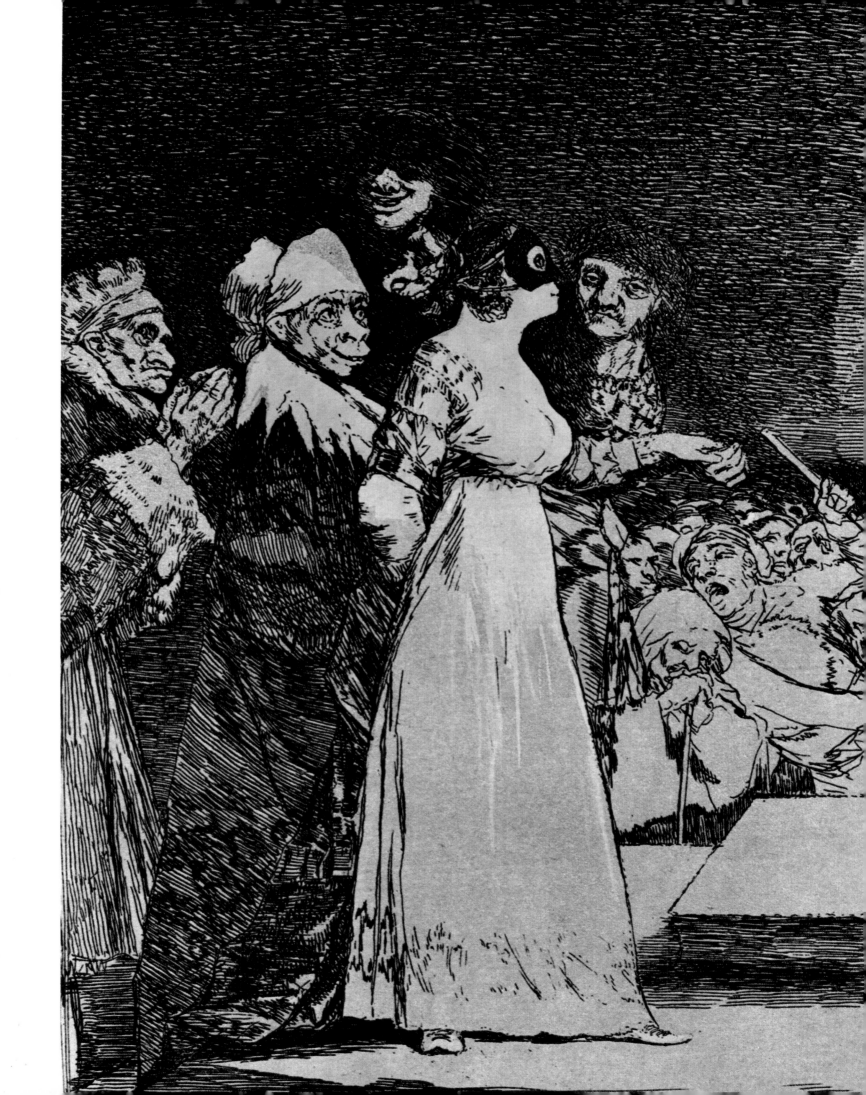

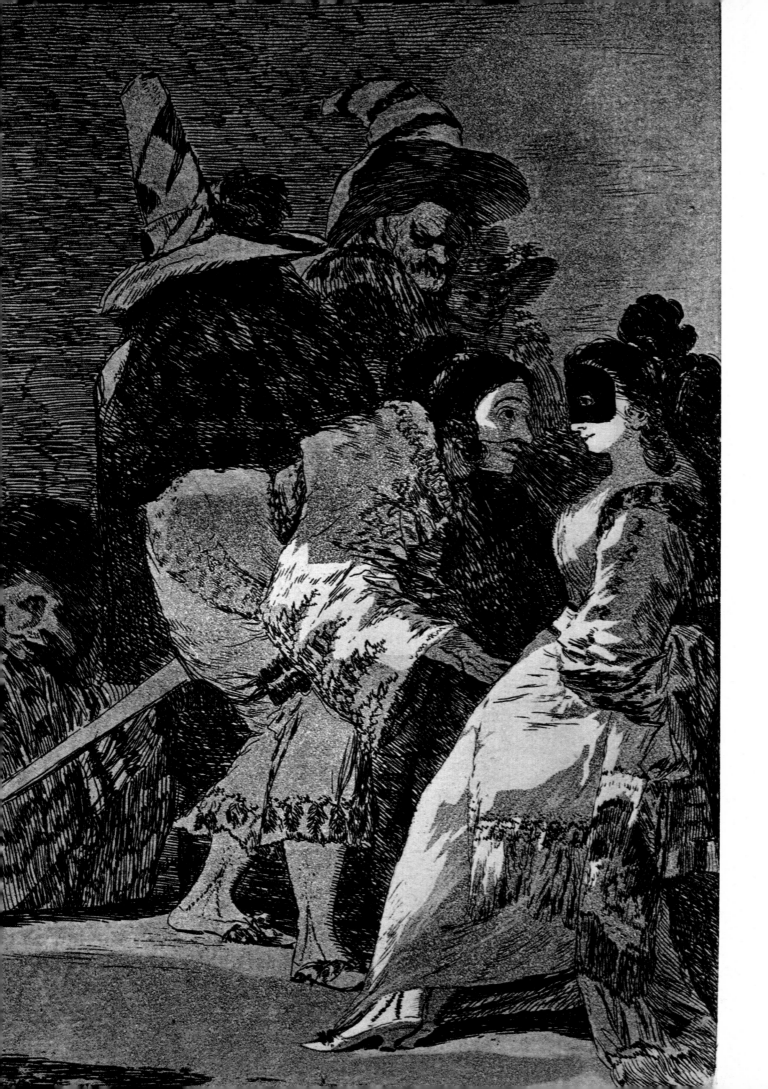

27

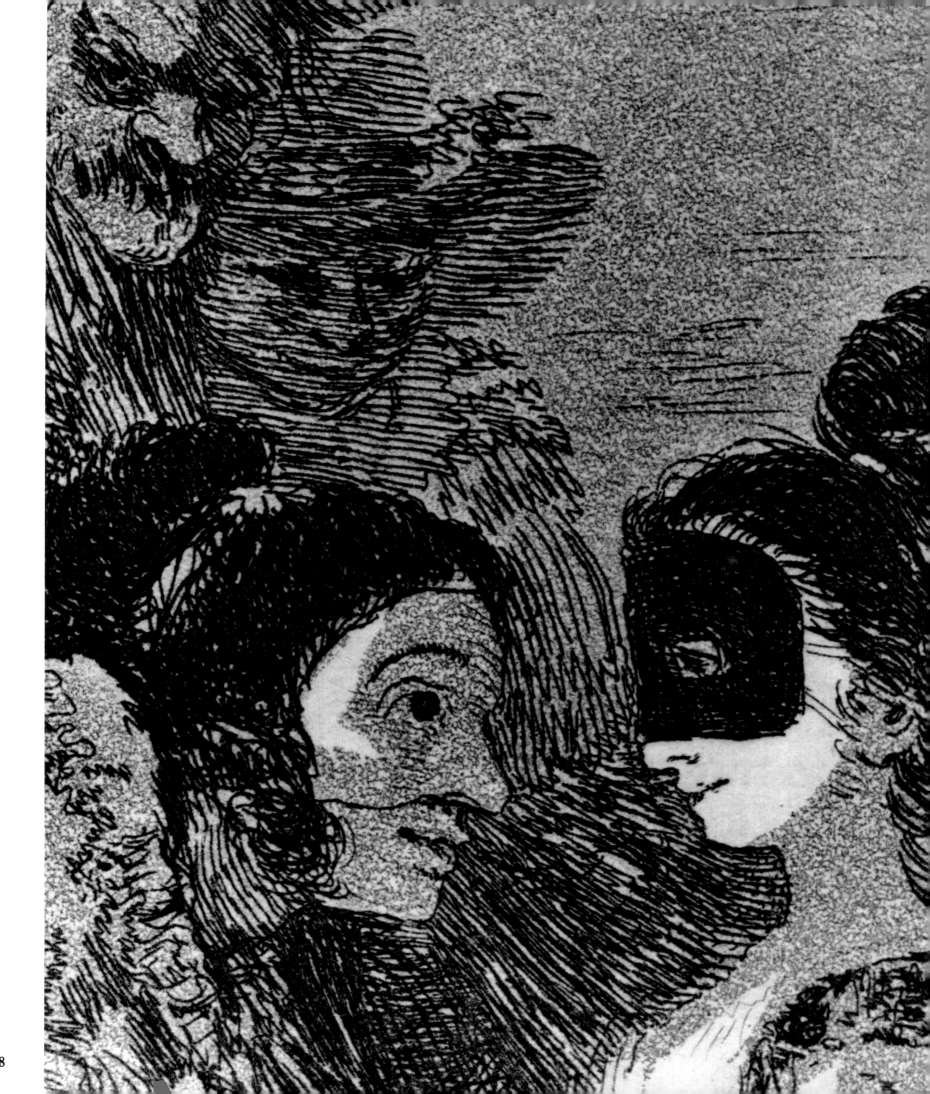

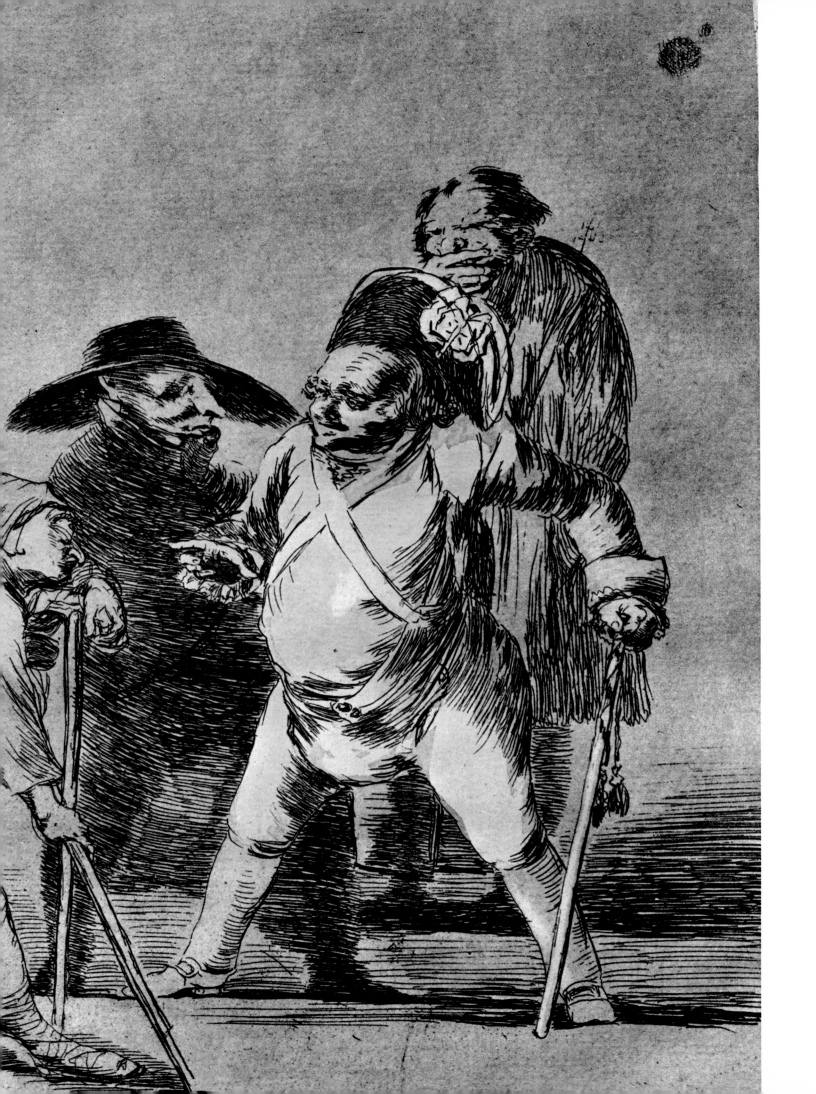

29

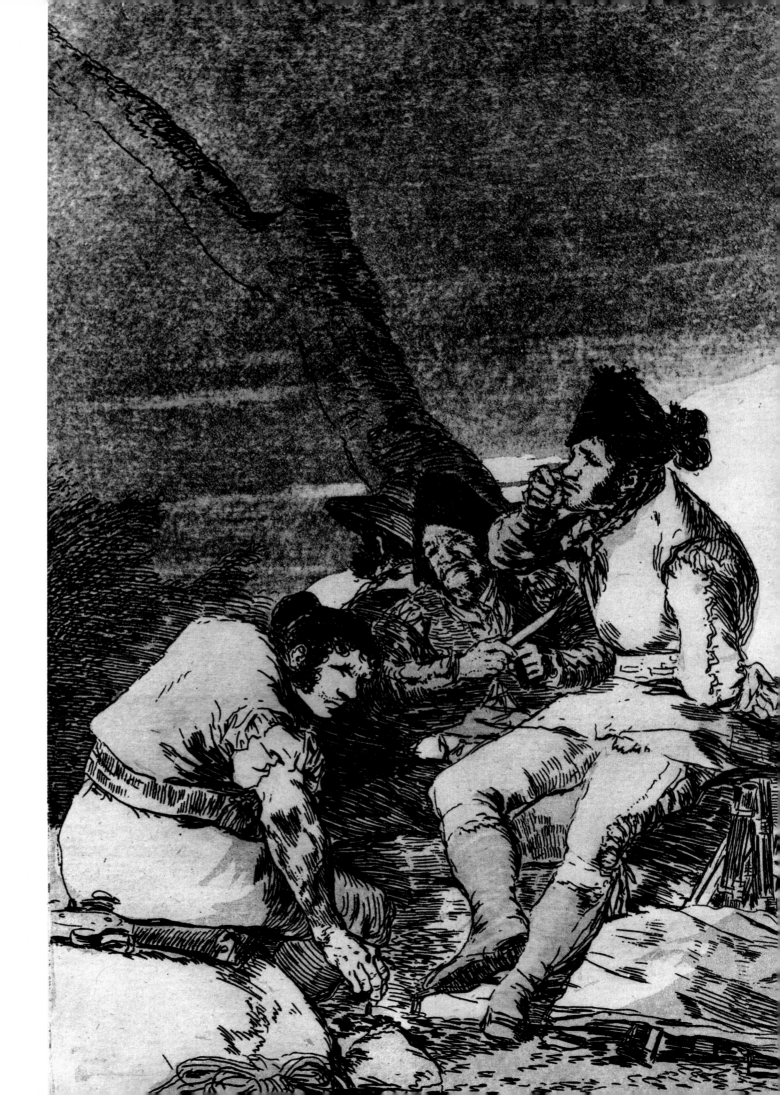

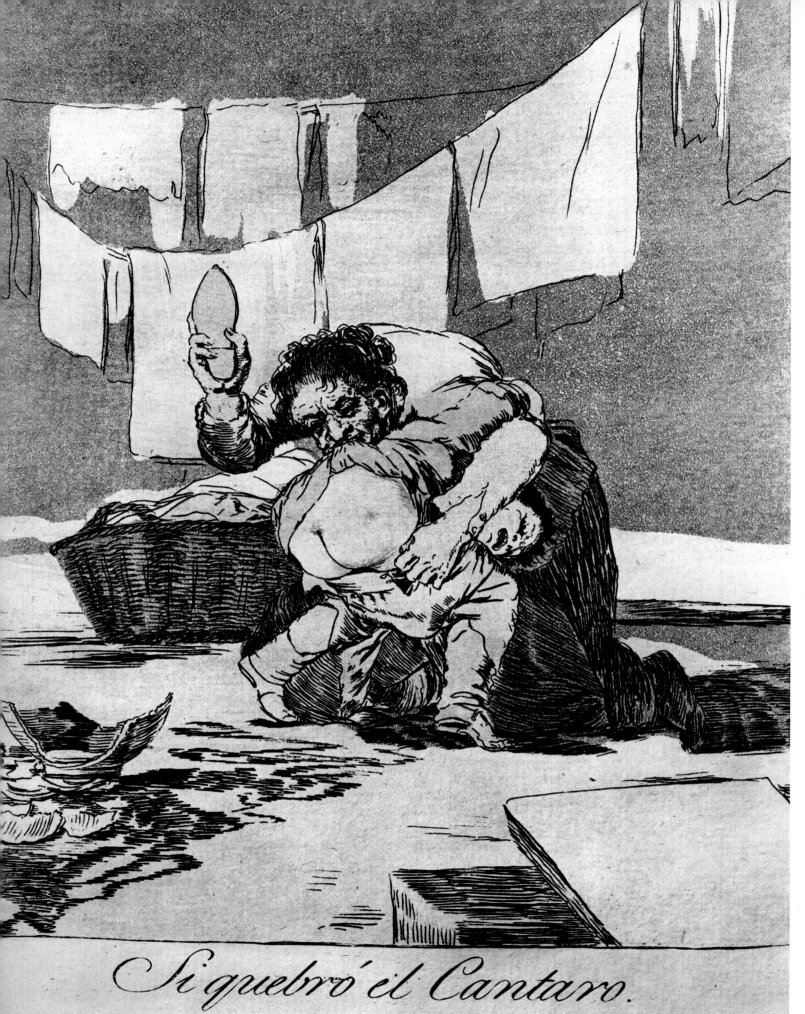

Si quebró el Cantaro.

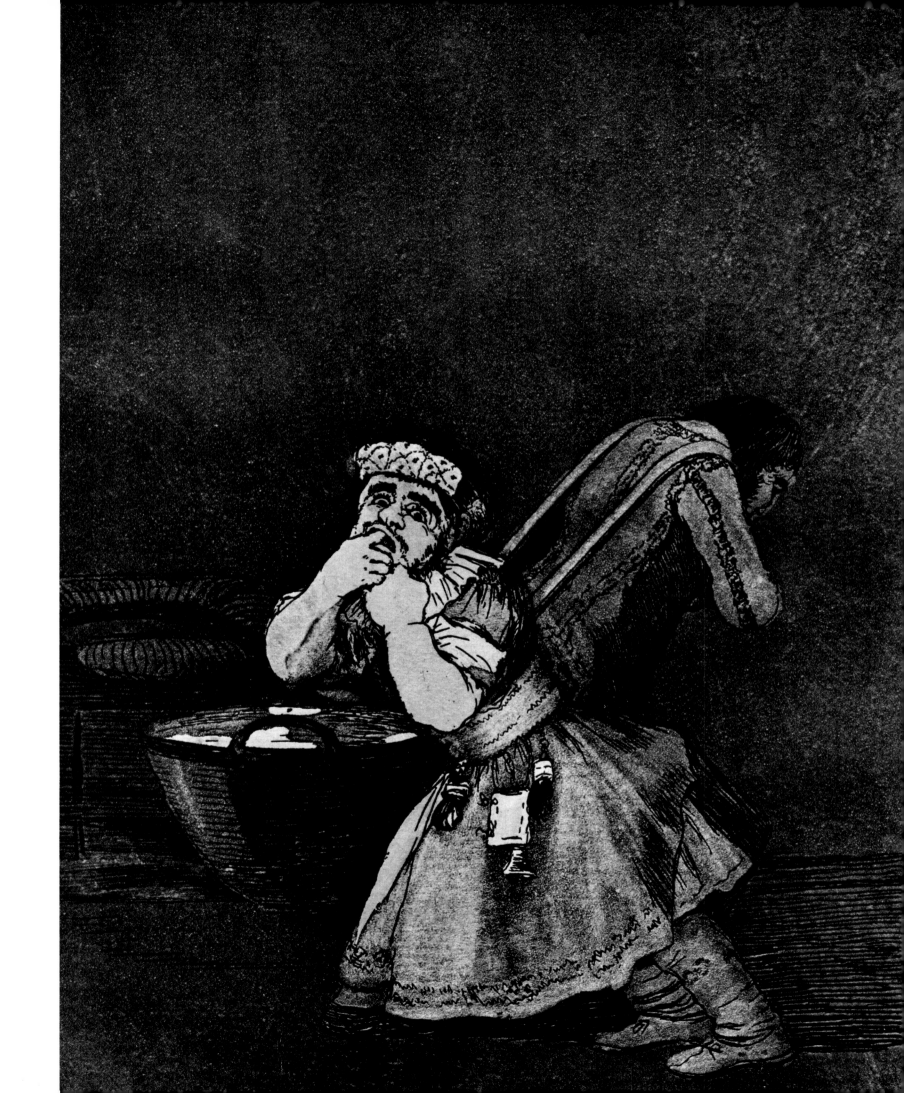

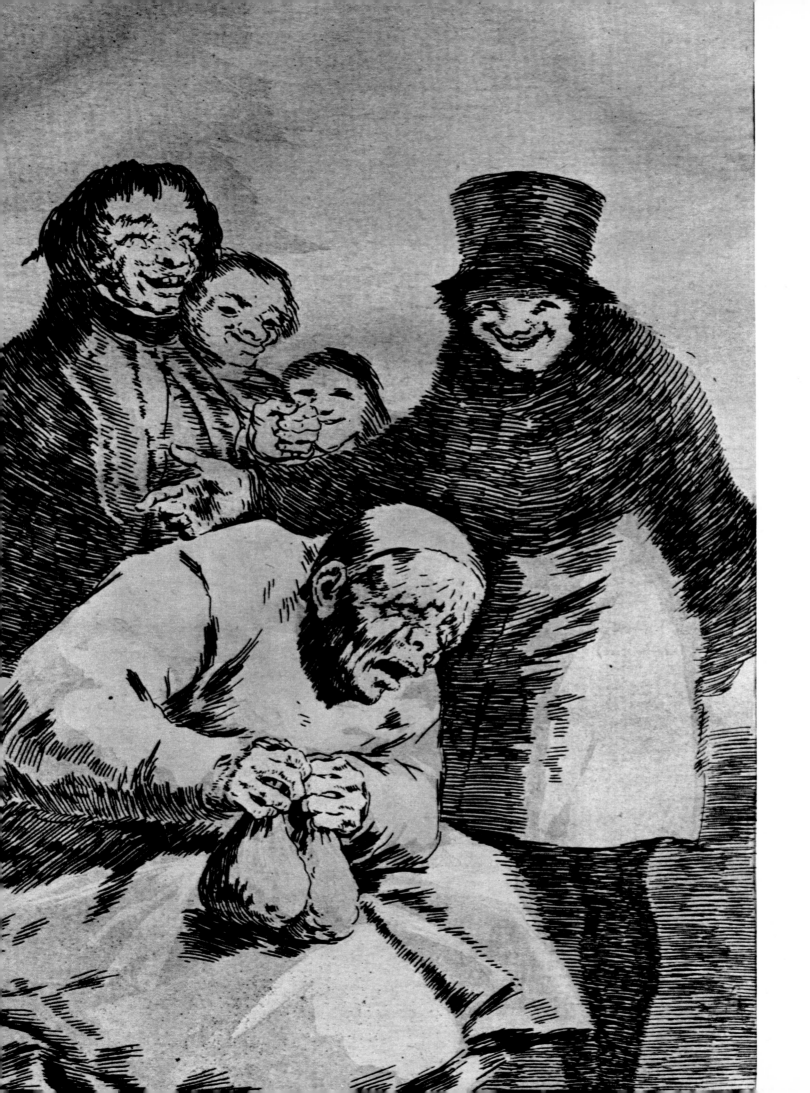

33

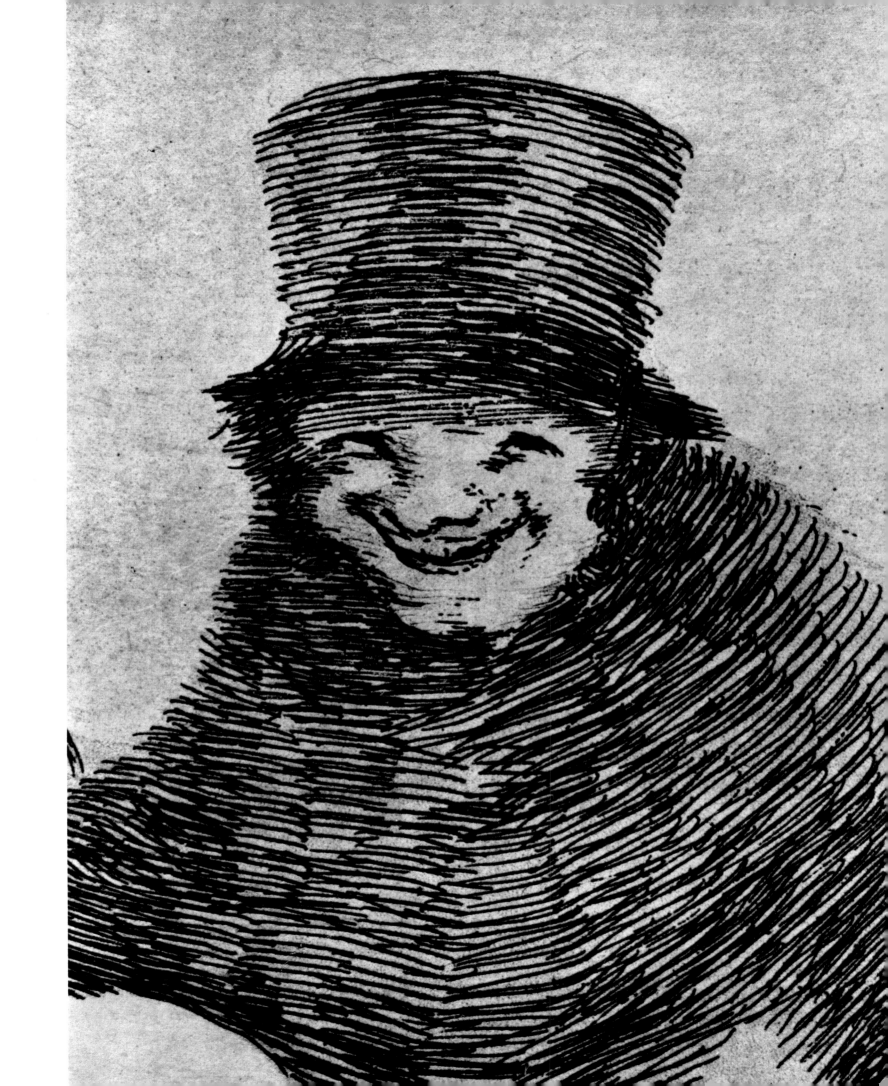

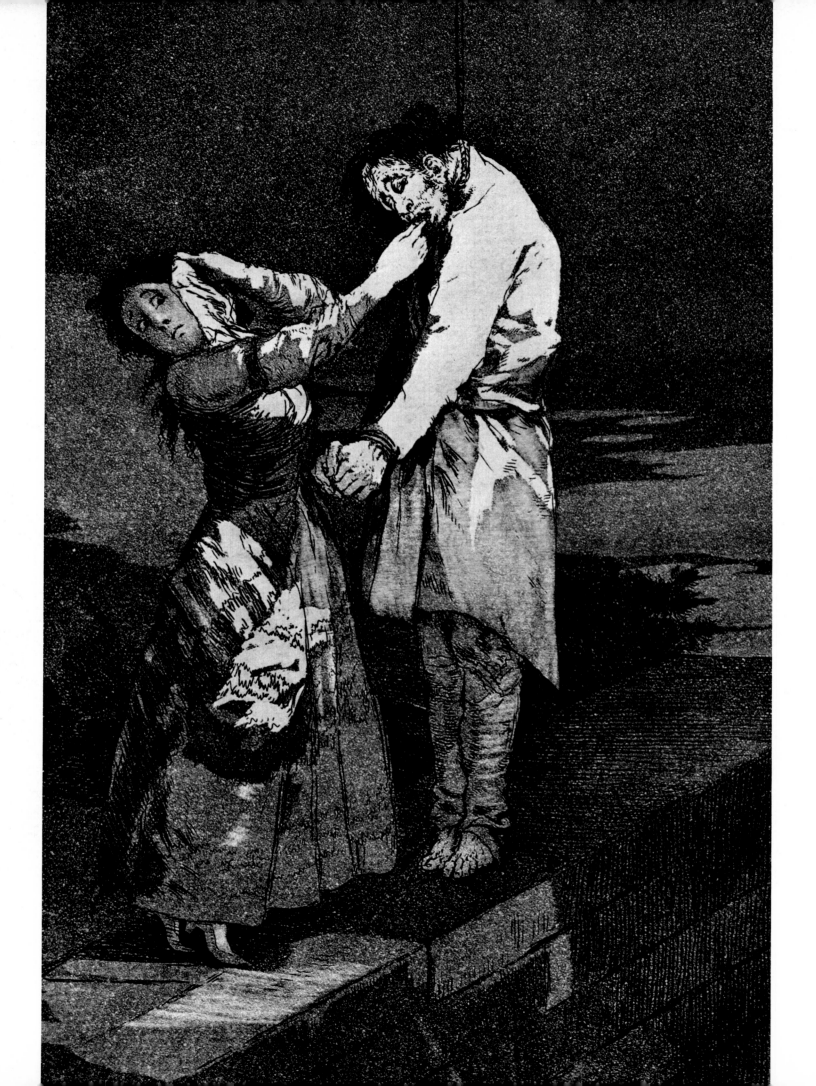

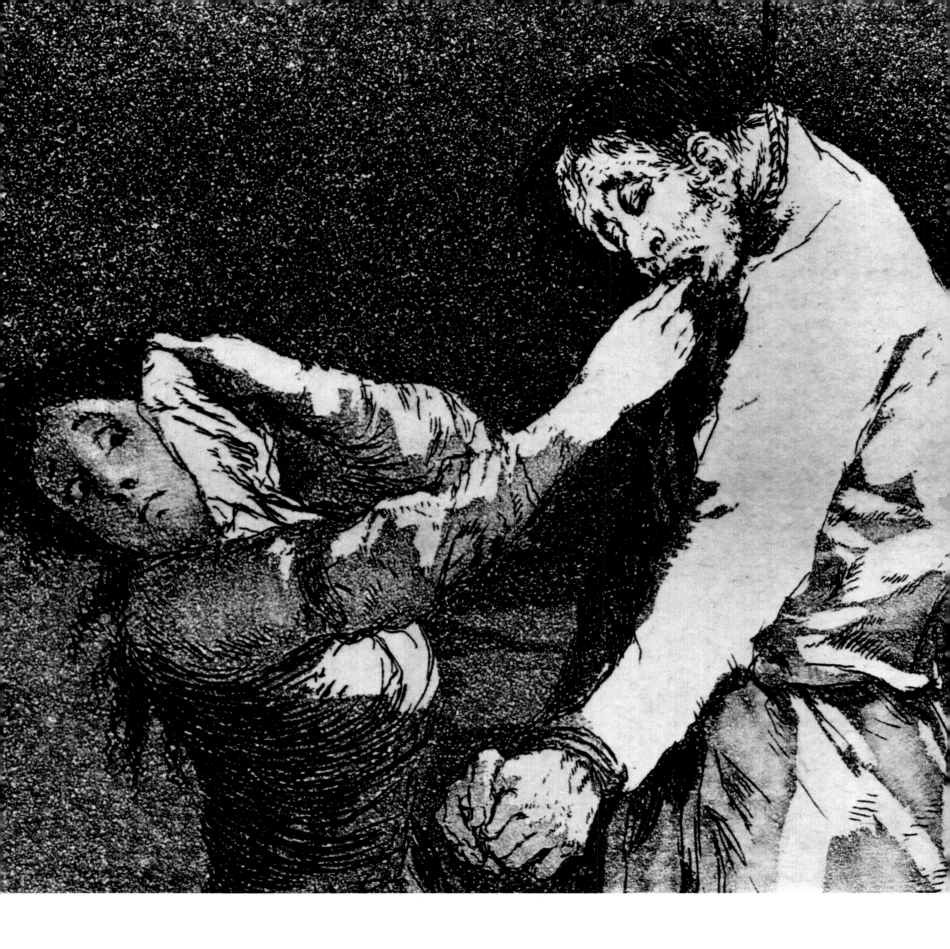

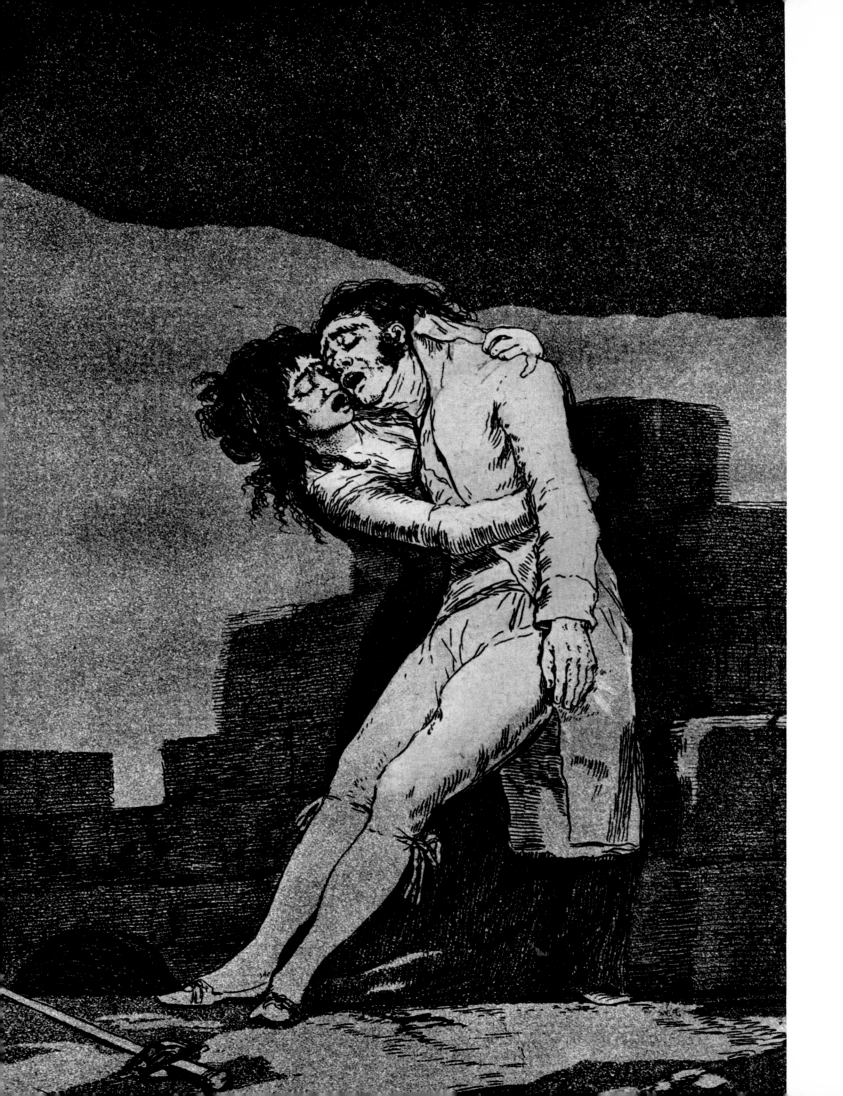

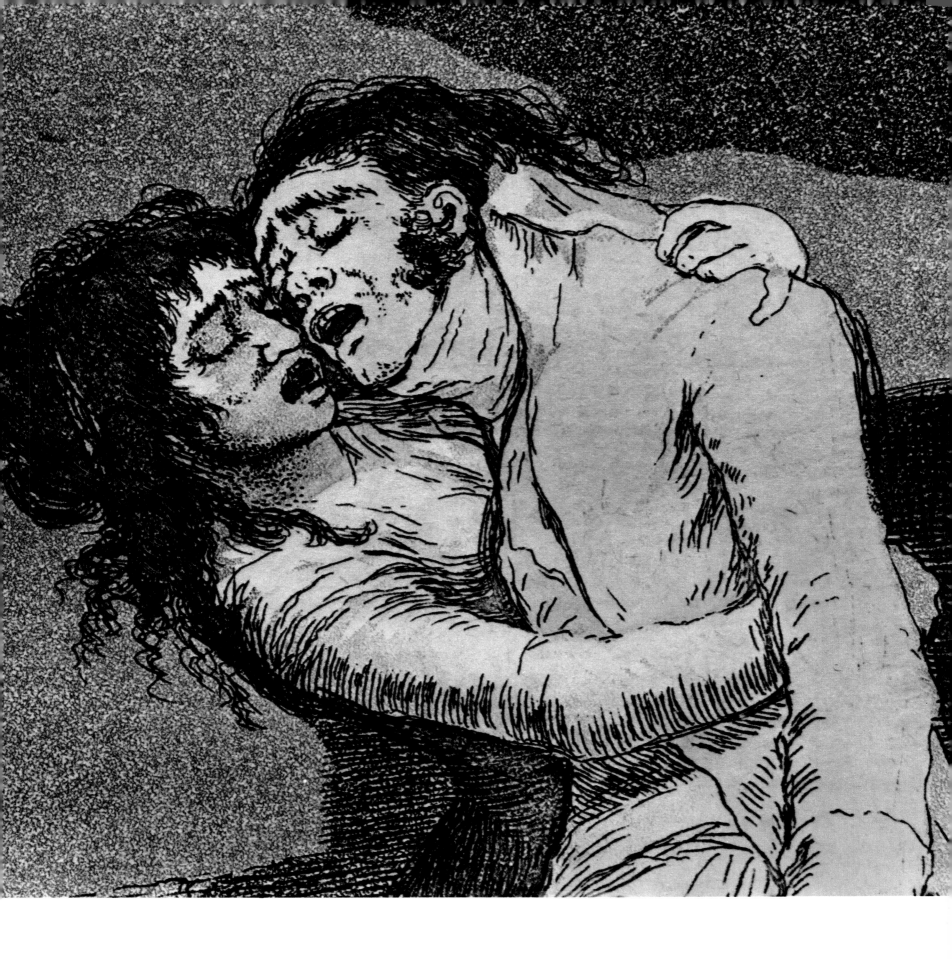

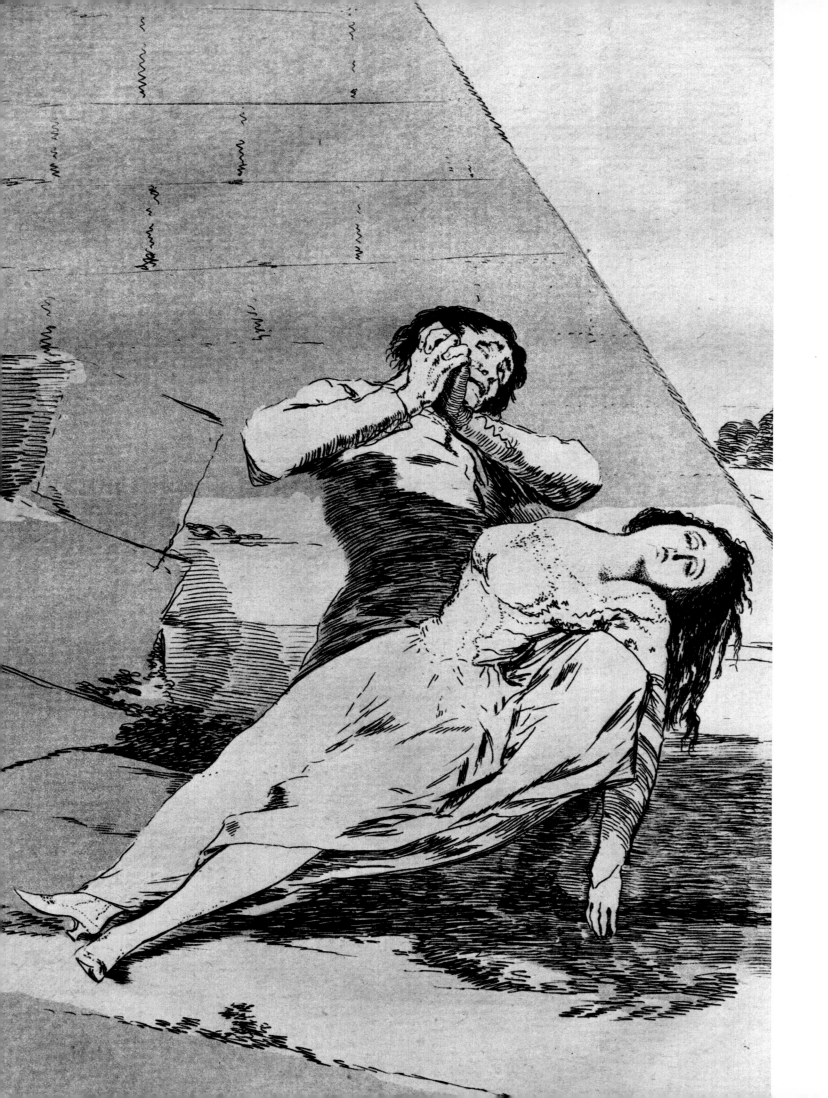

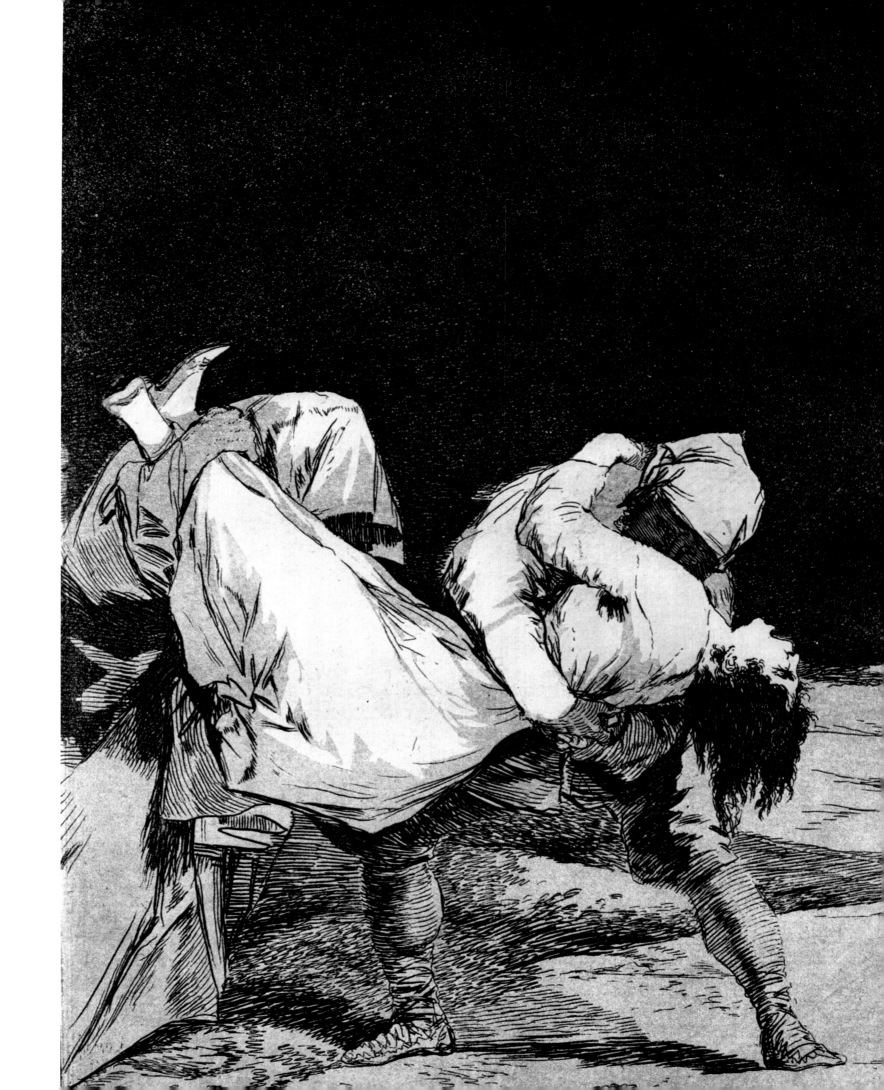

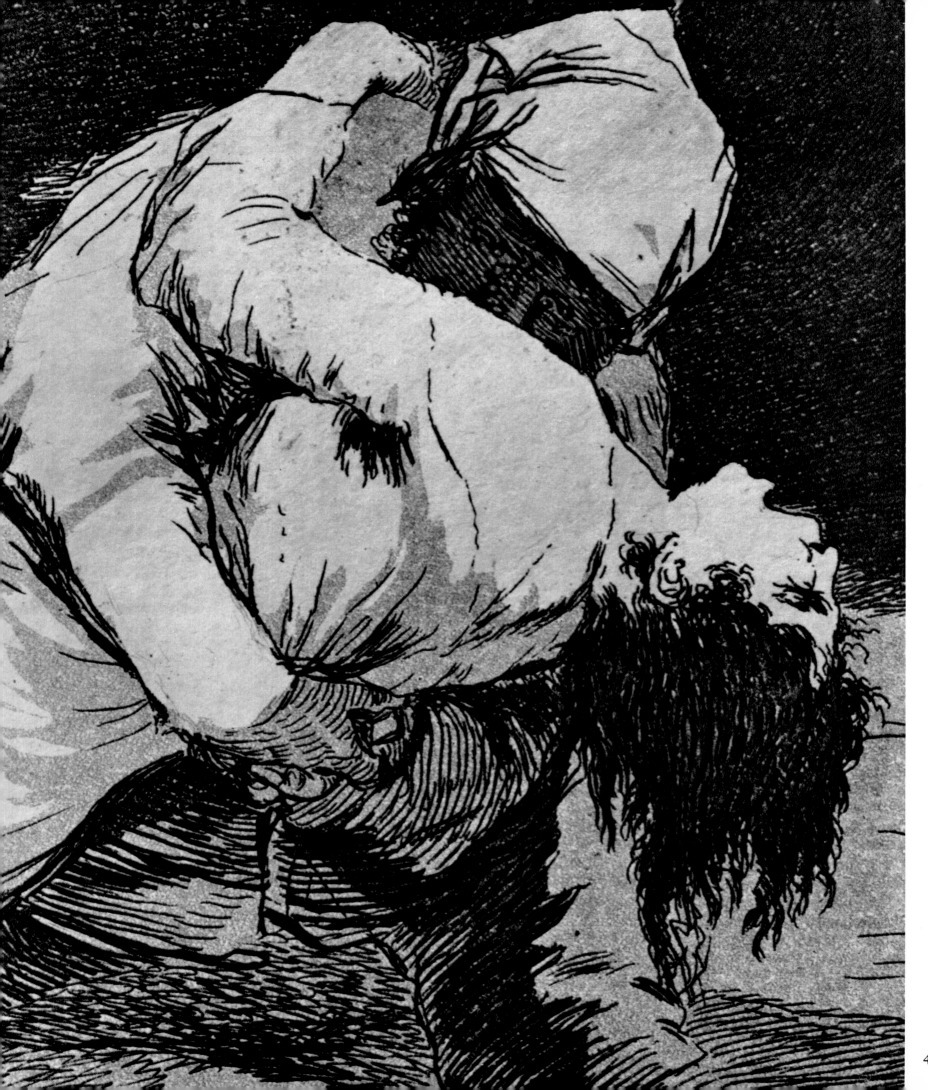

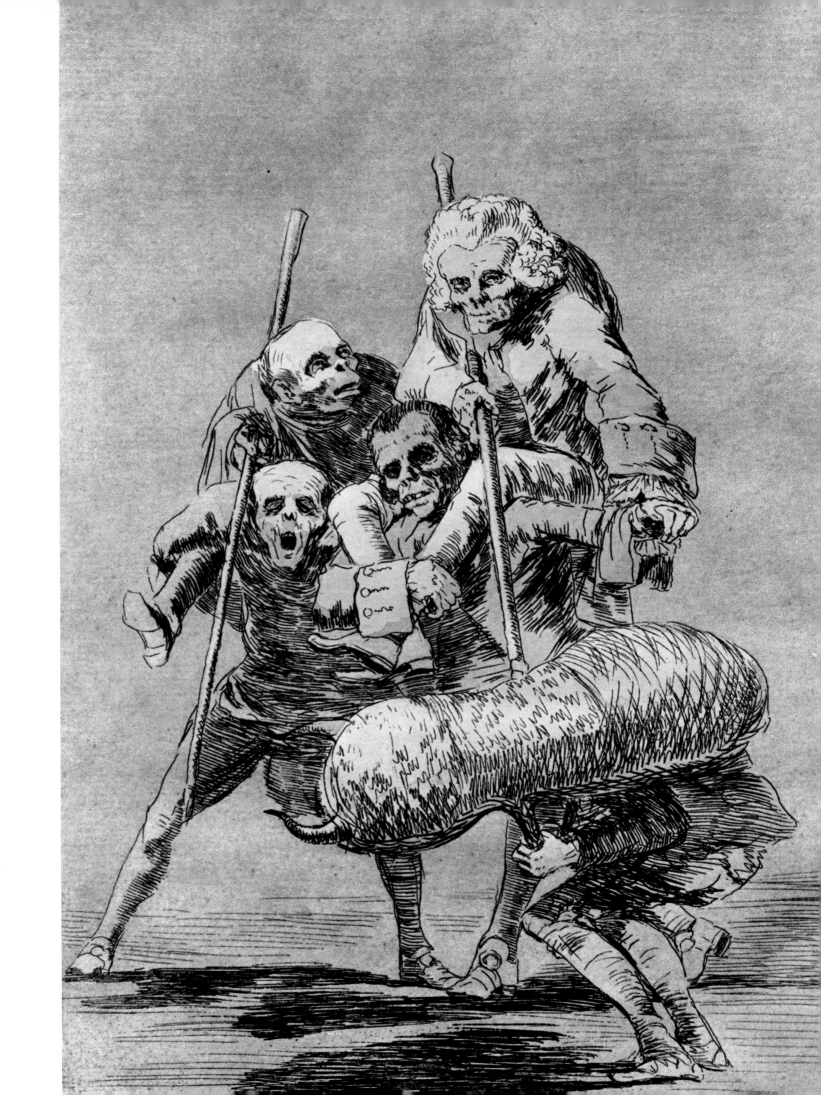

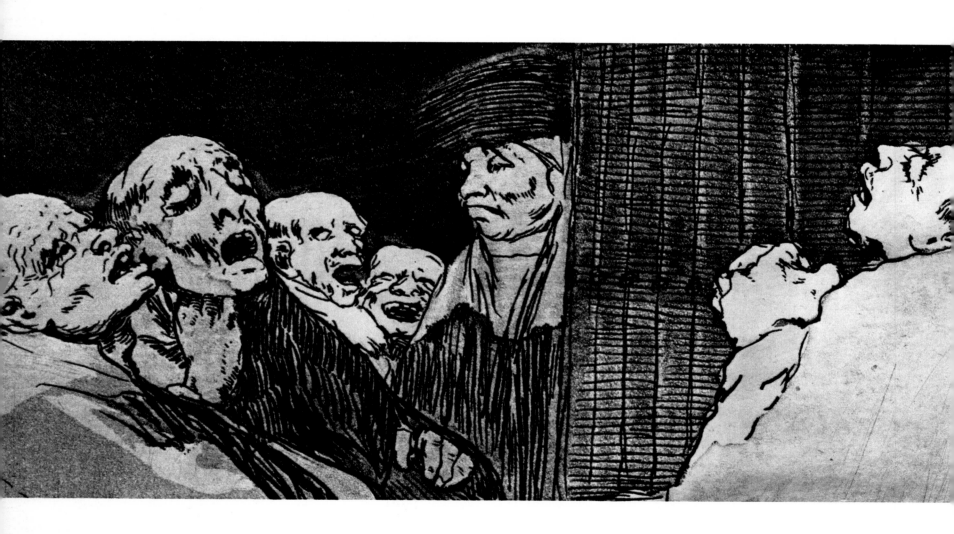

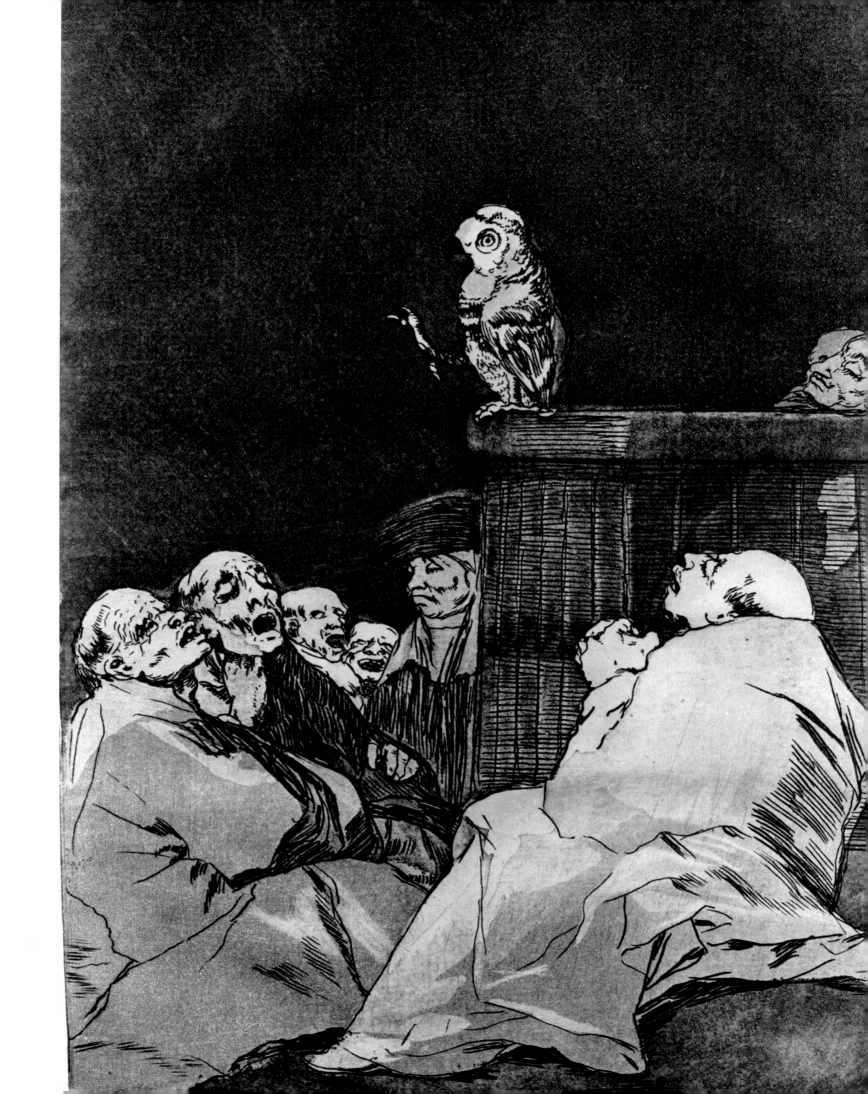

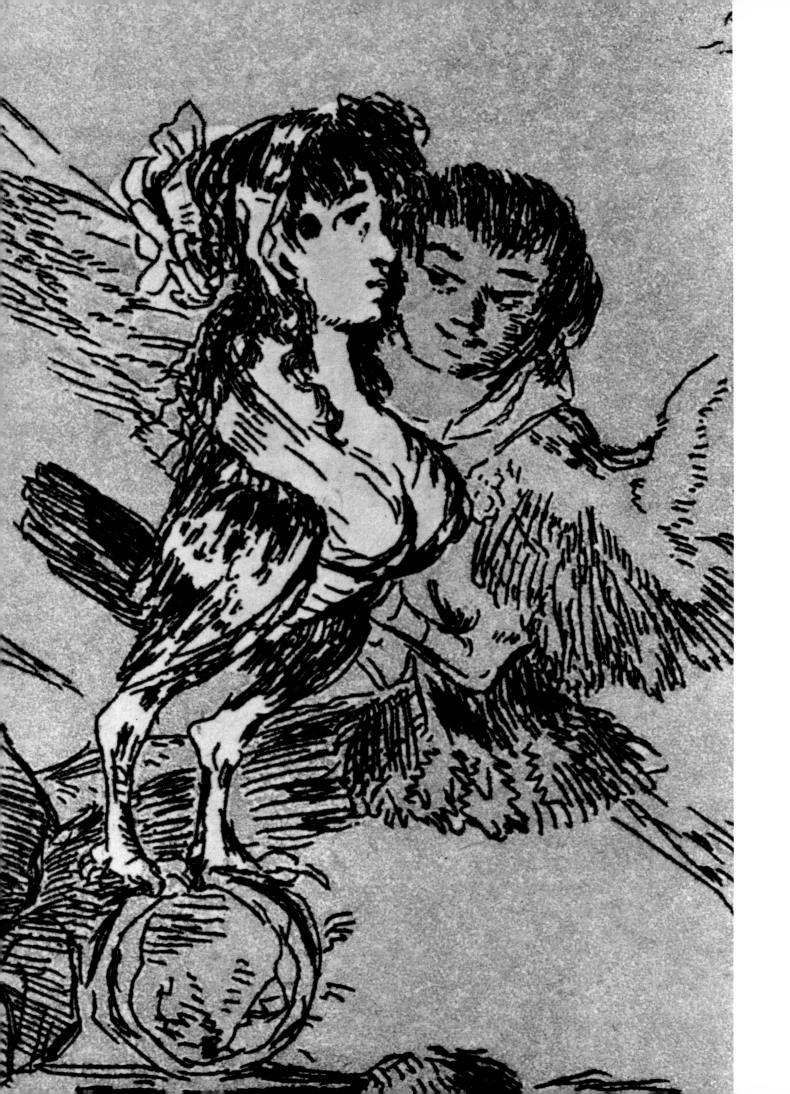

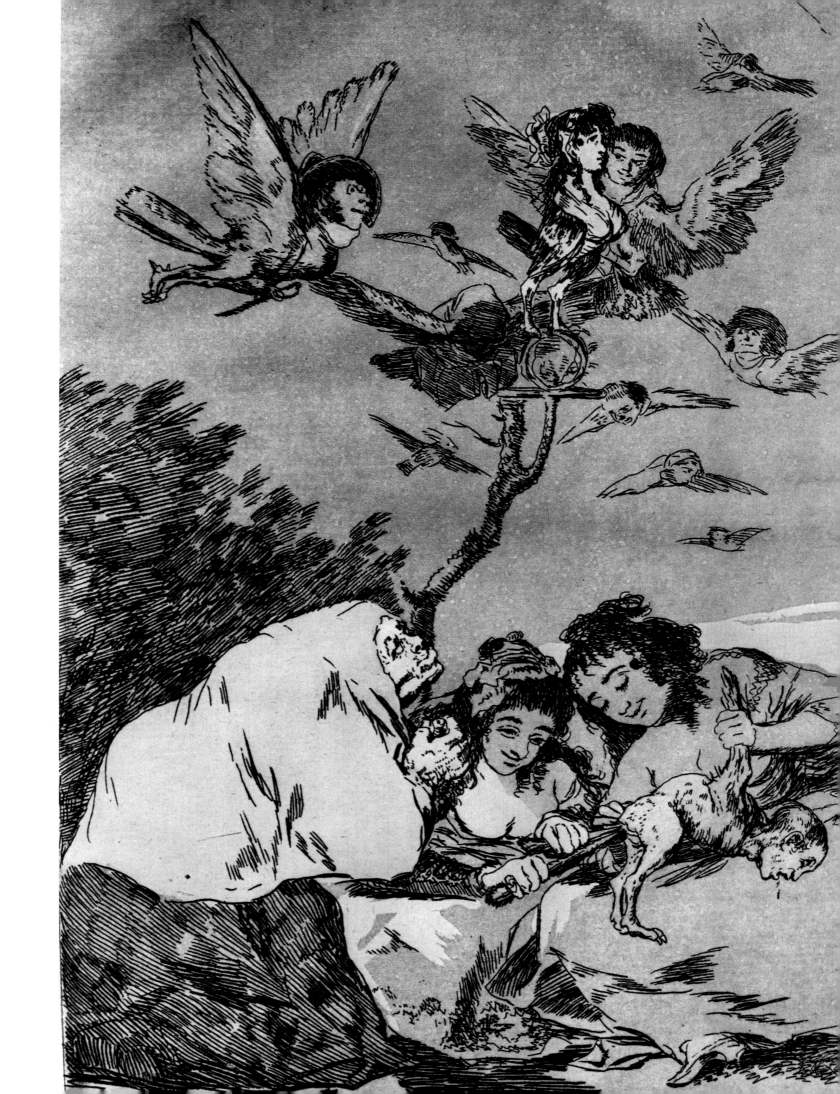

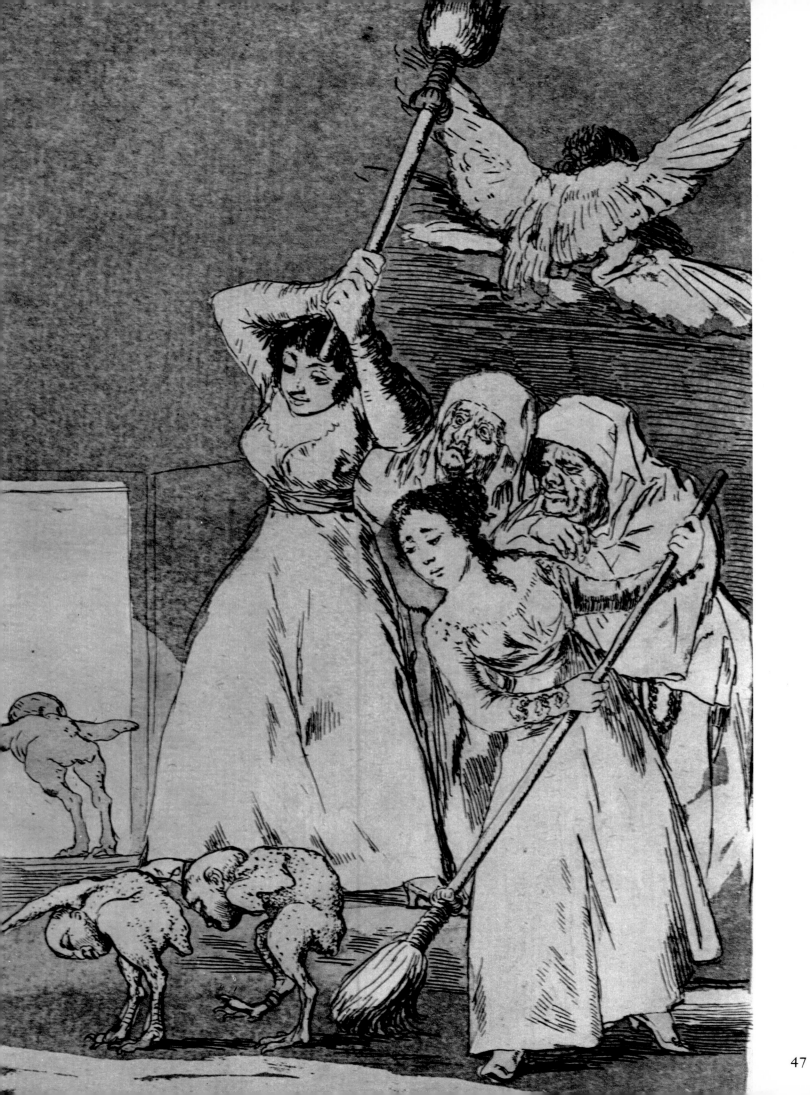

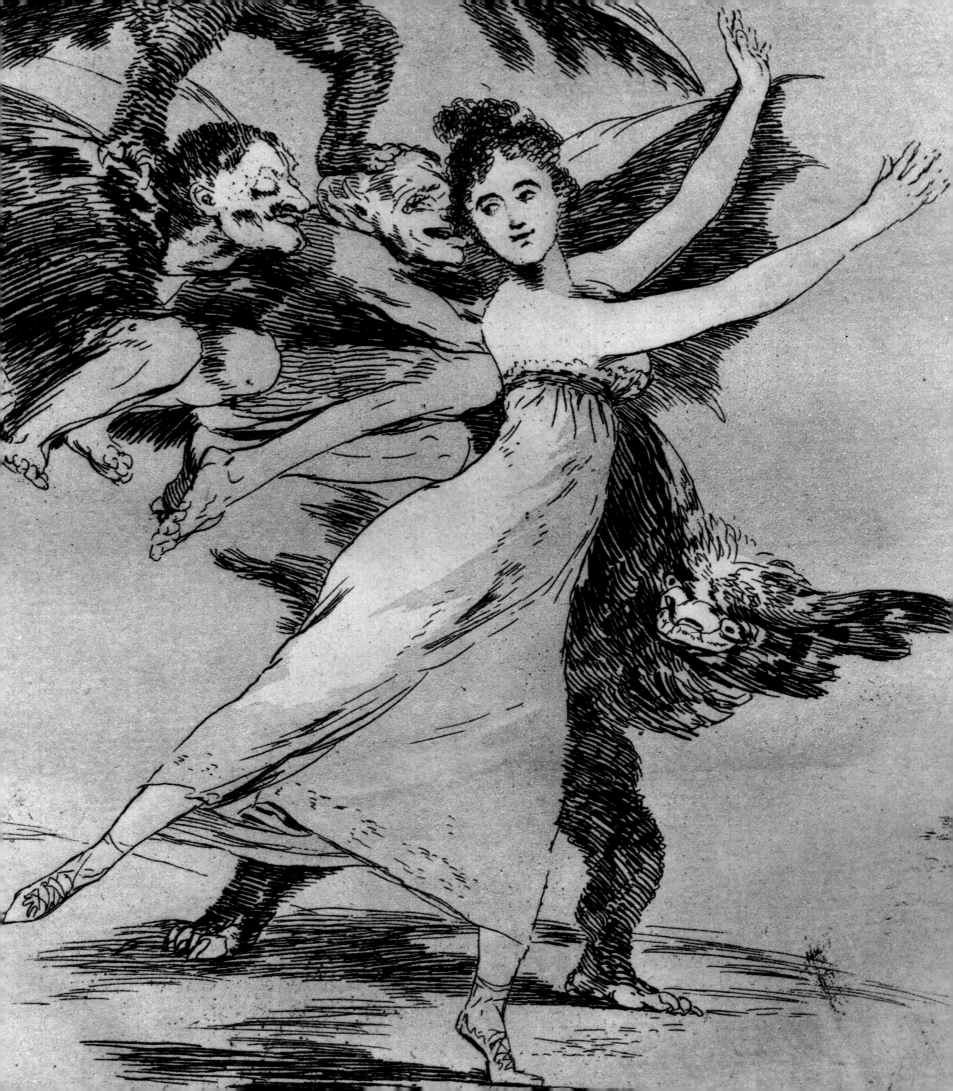

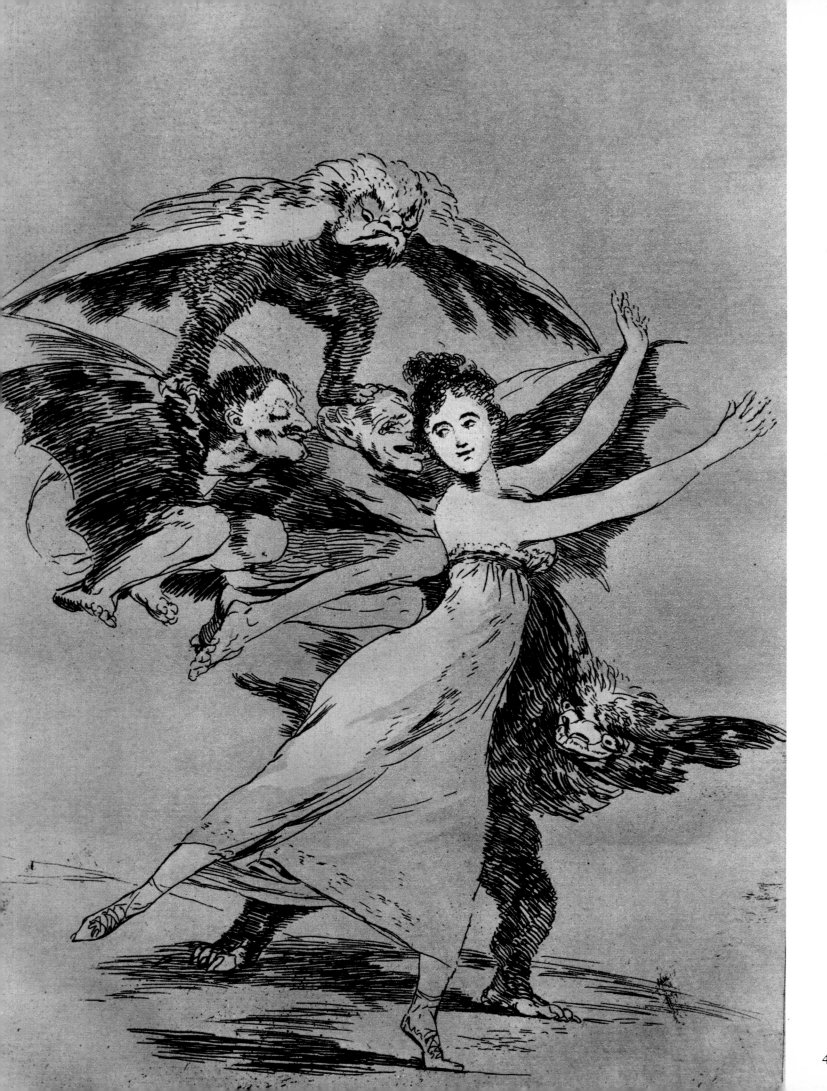

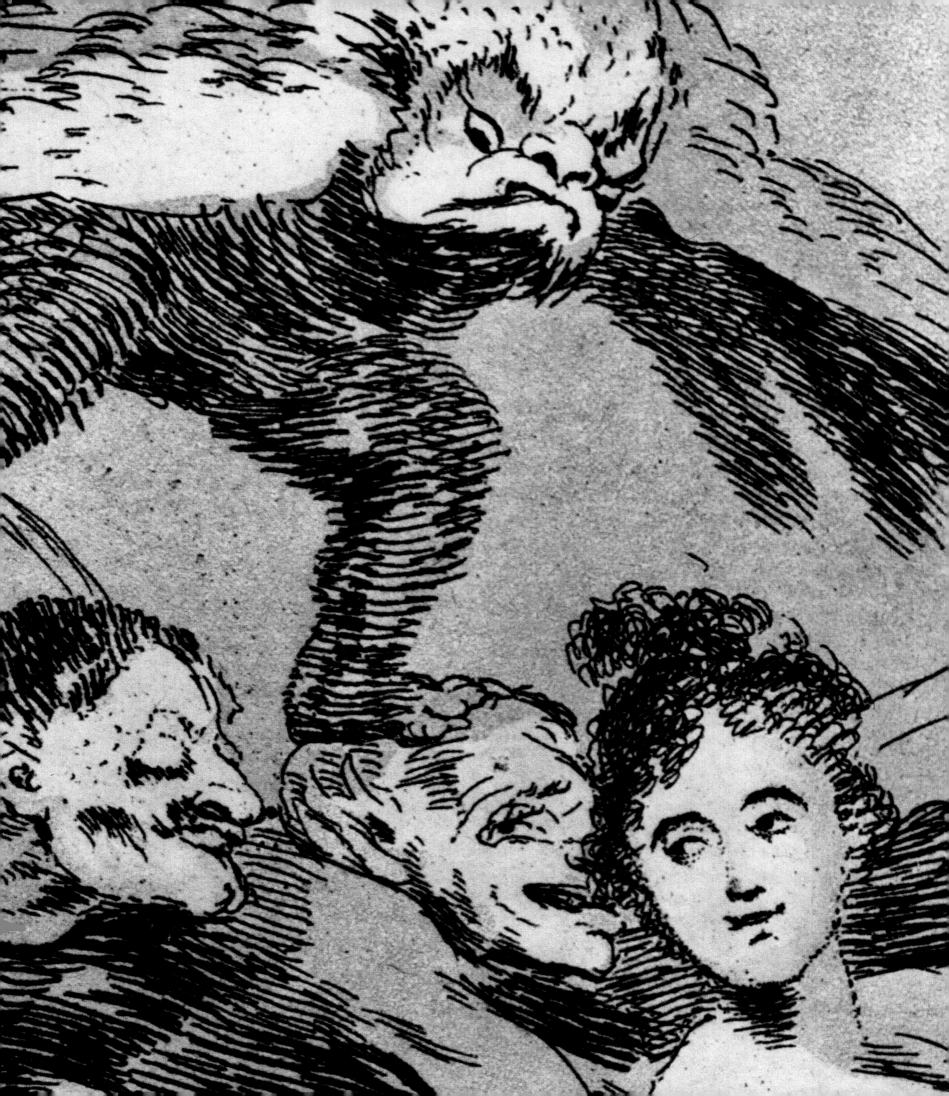

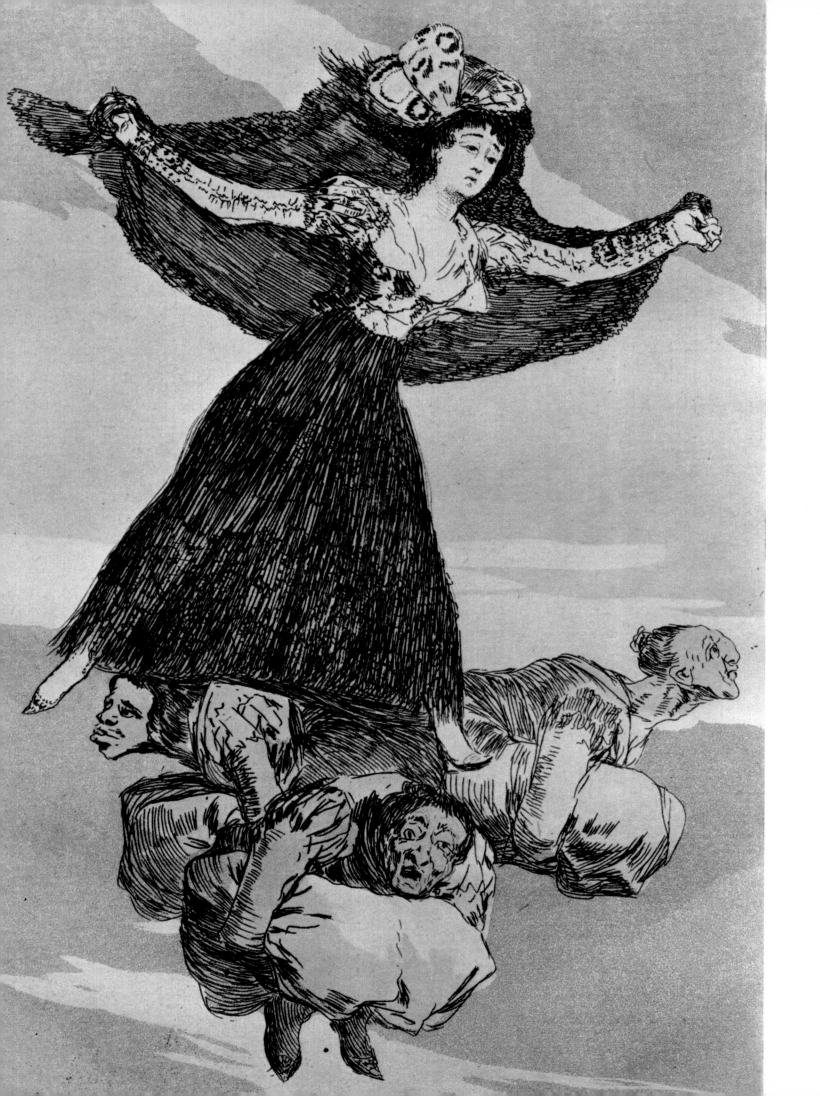

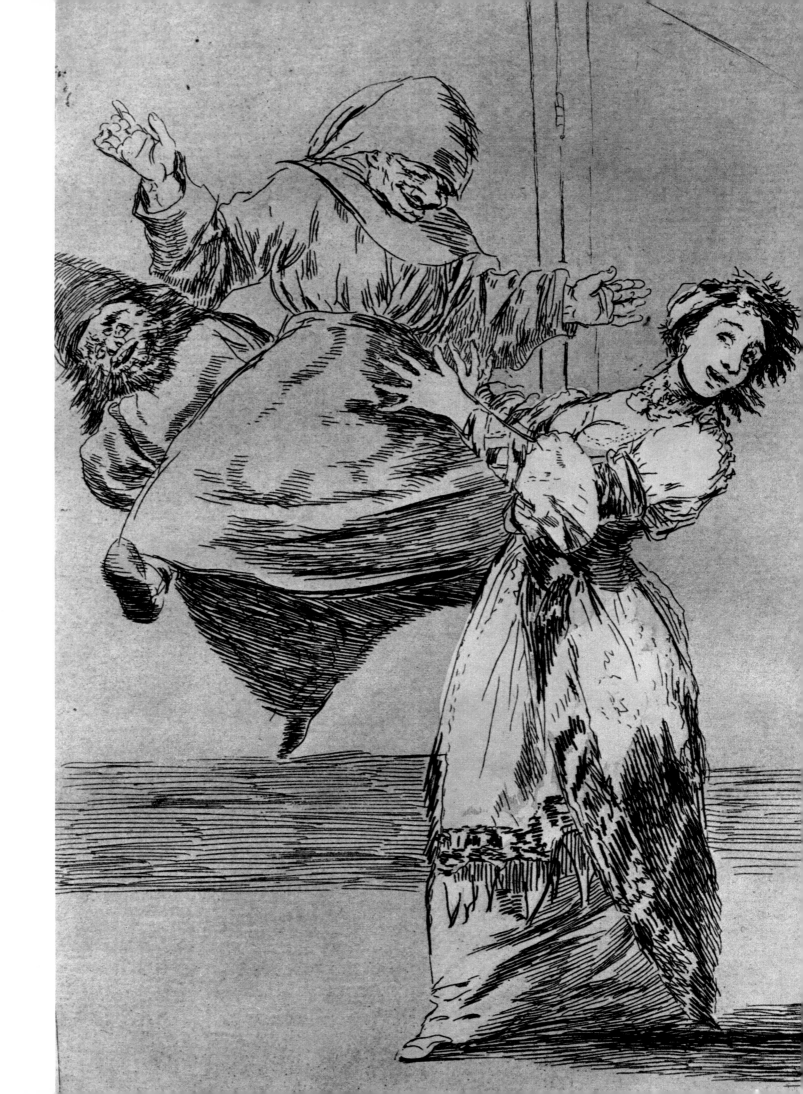

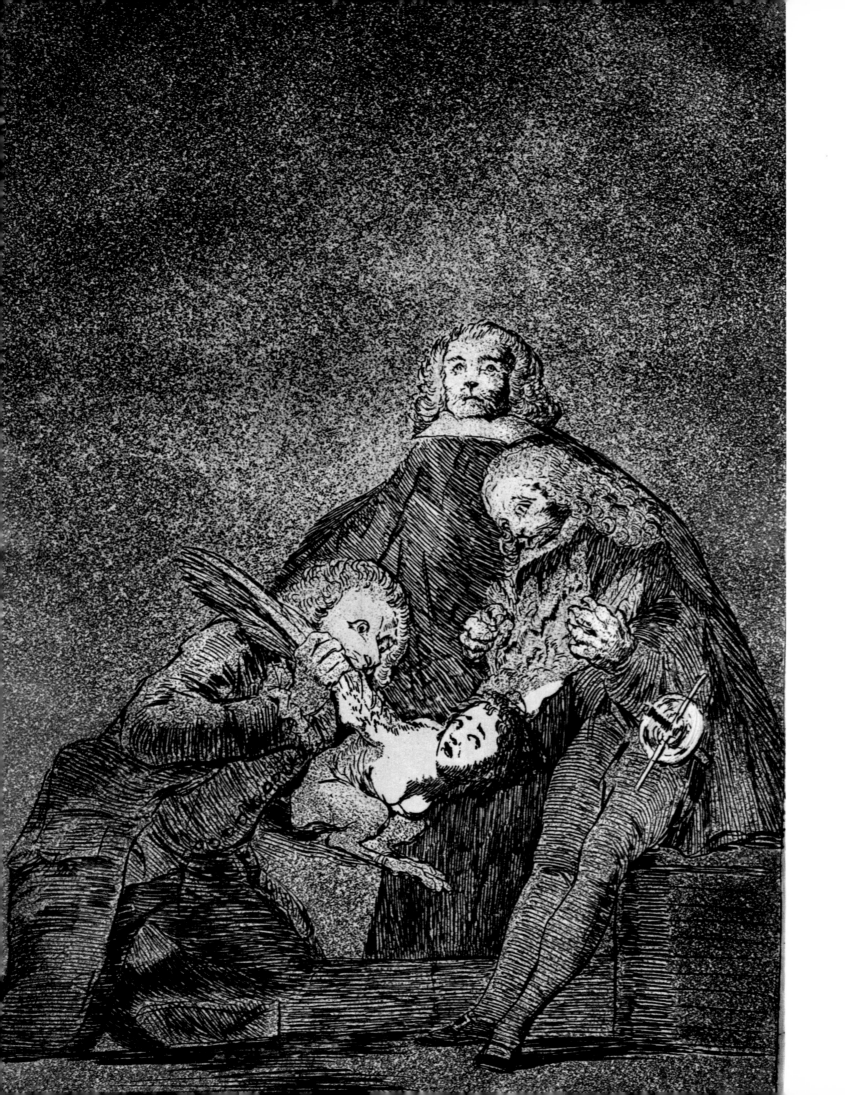

53

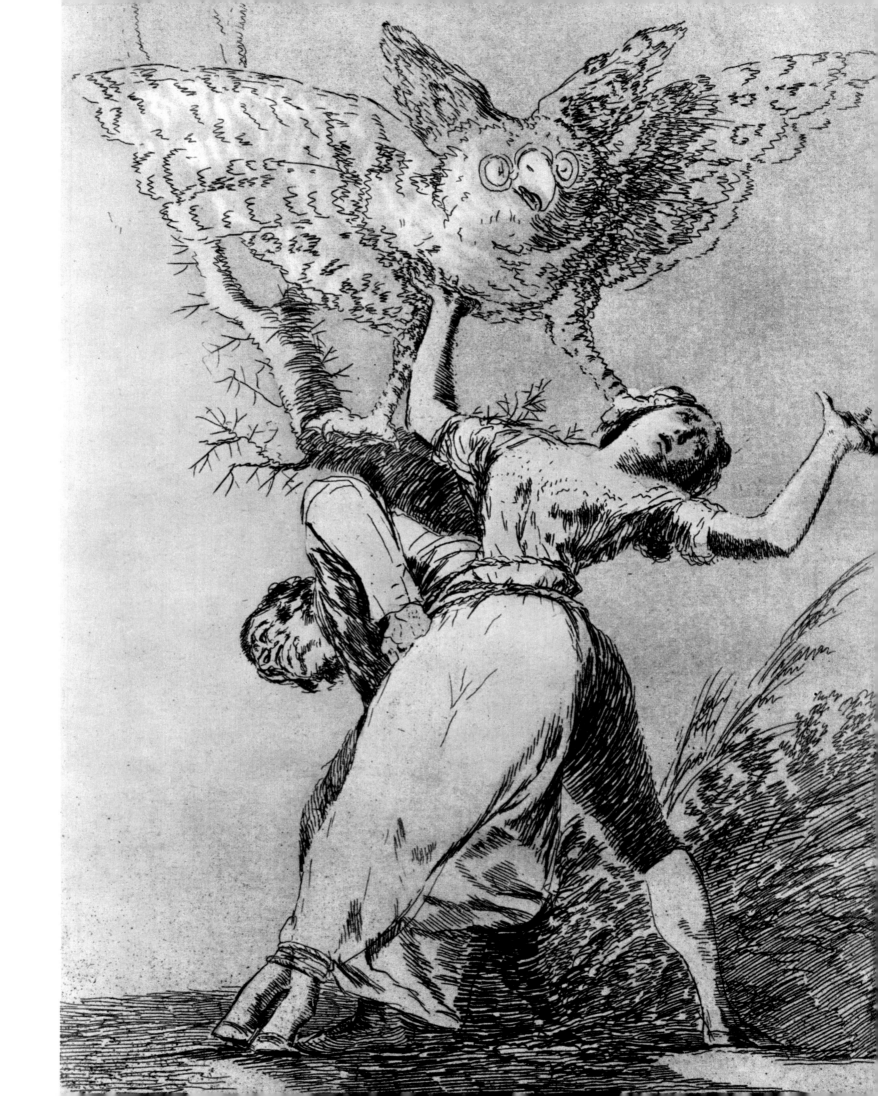

54

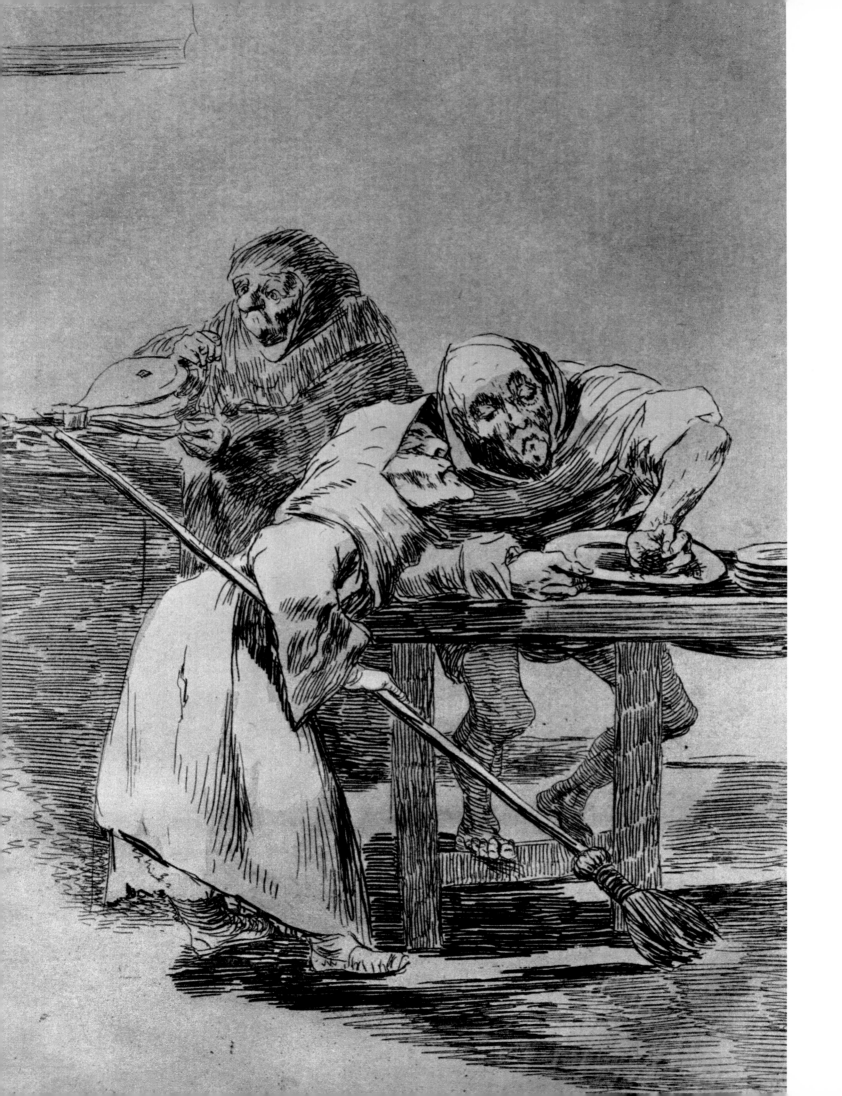

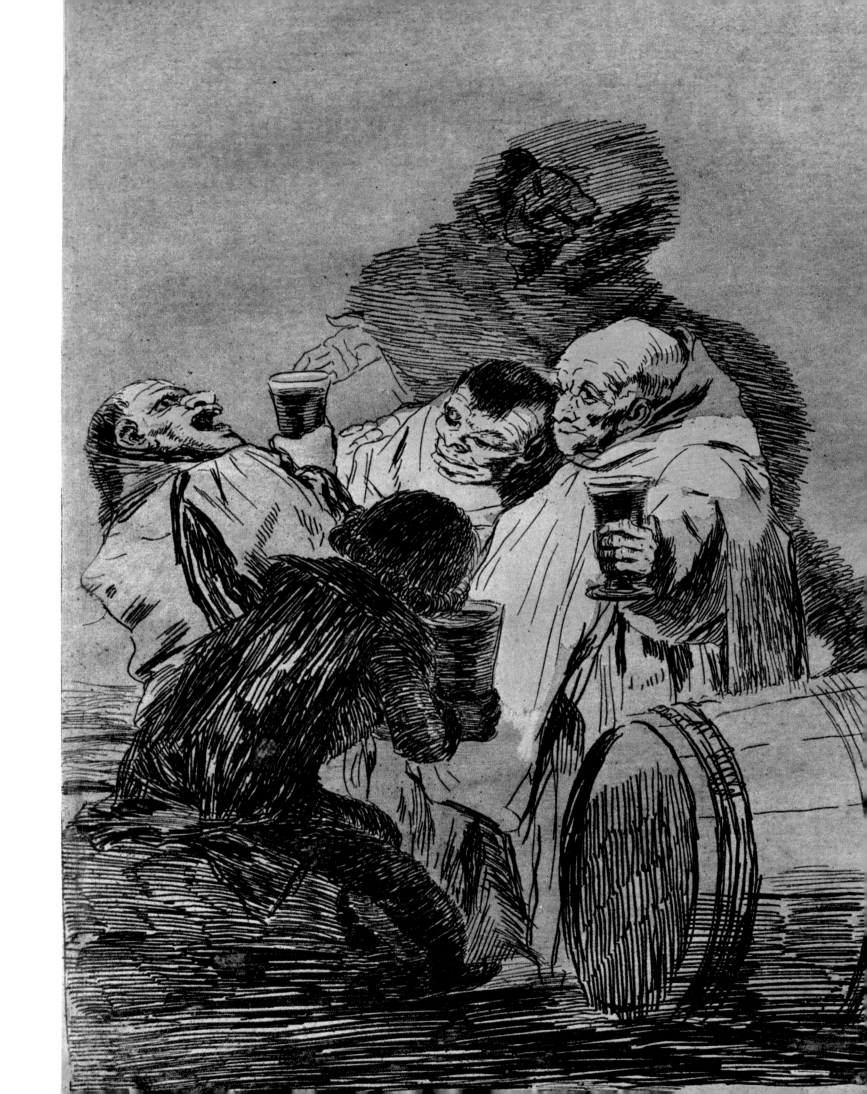

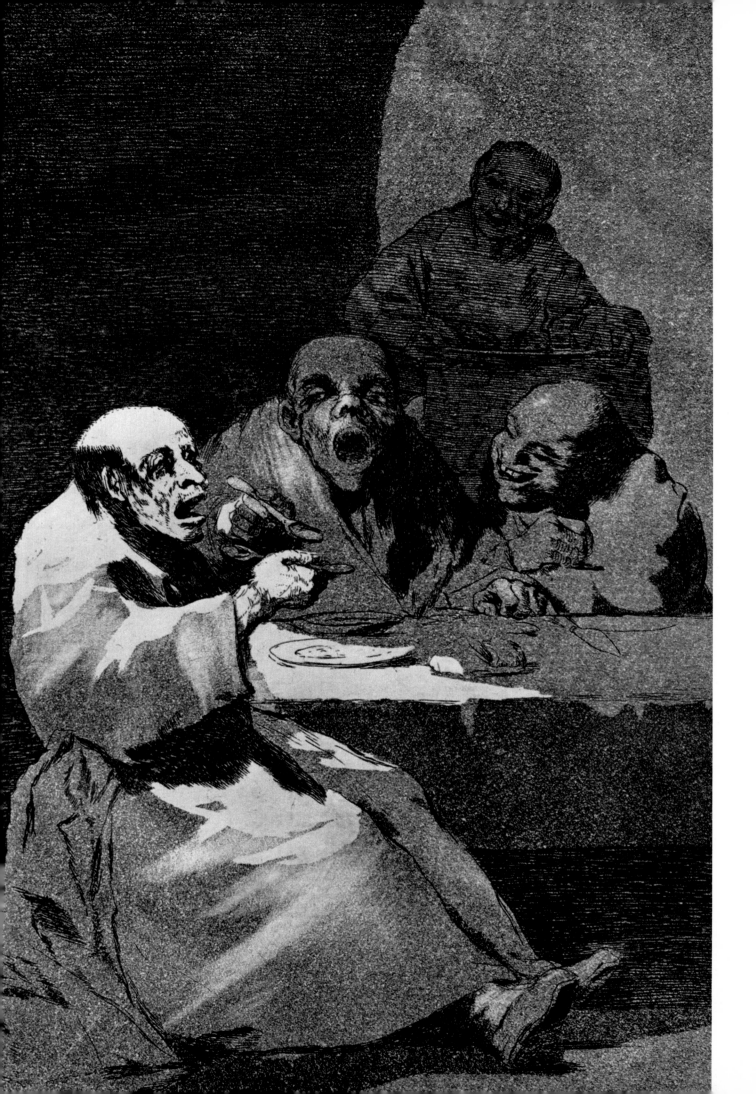

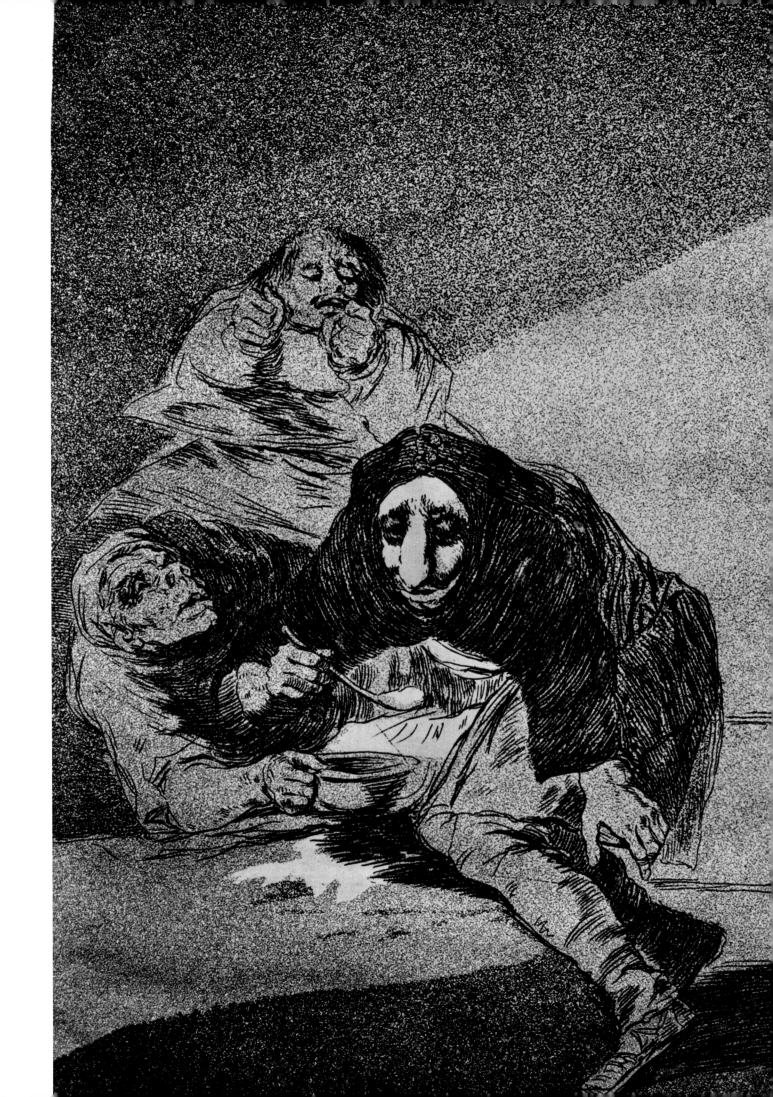

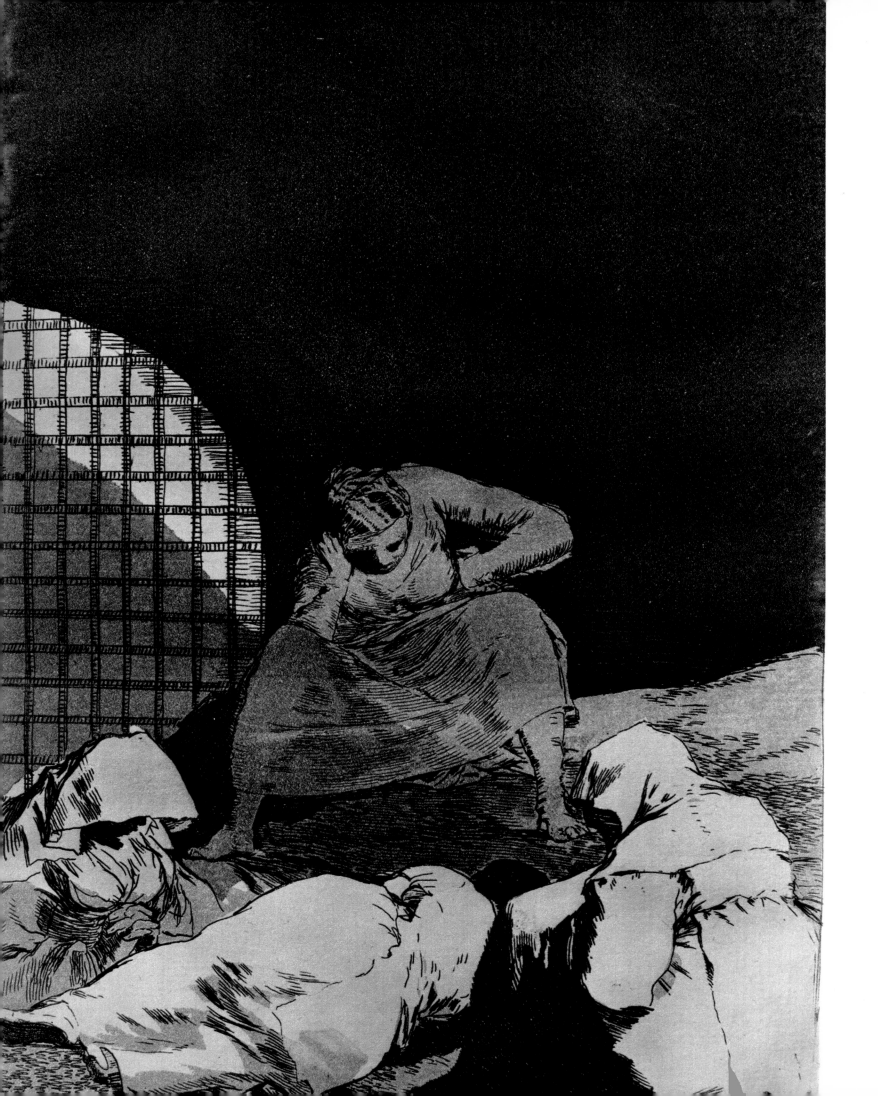

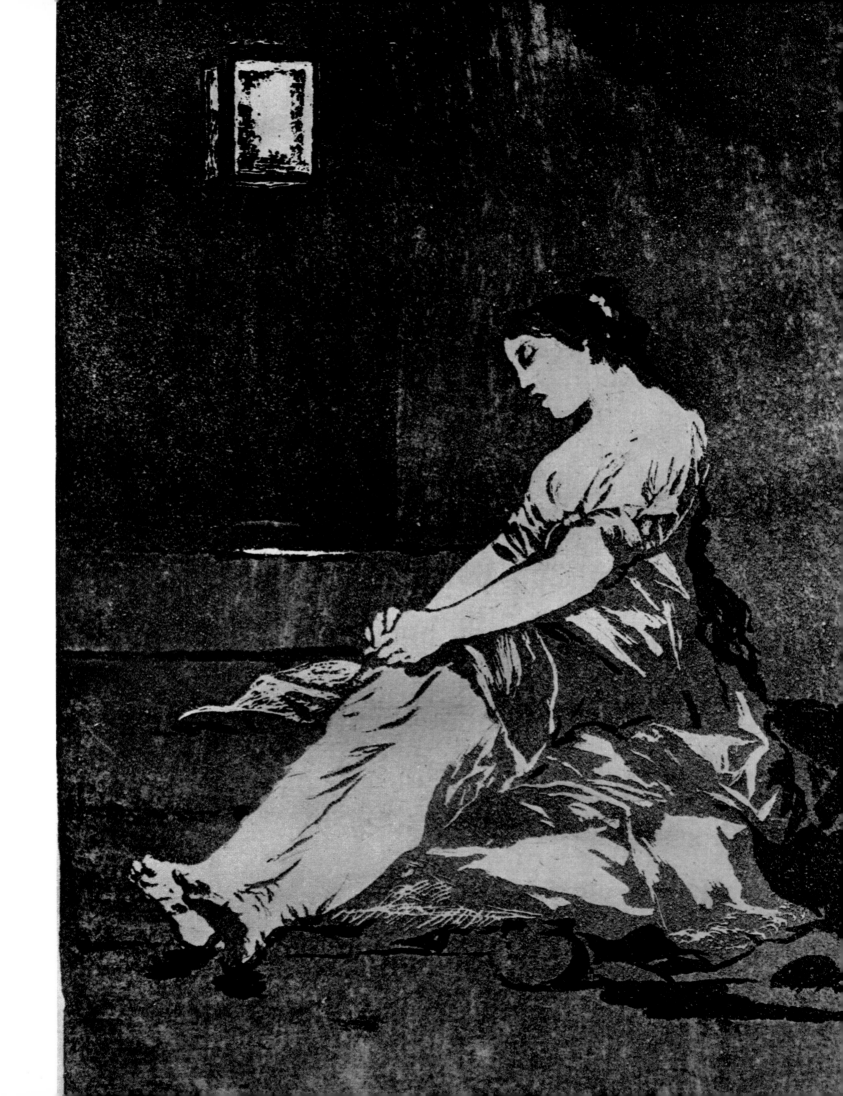

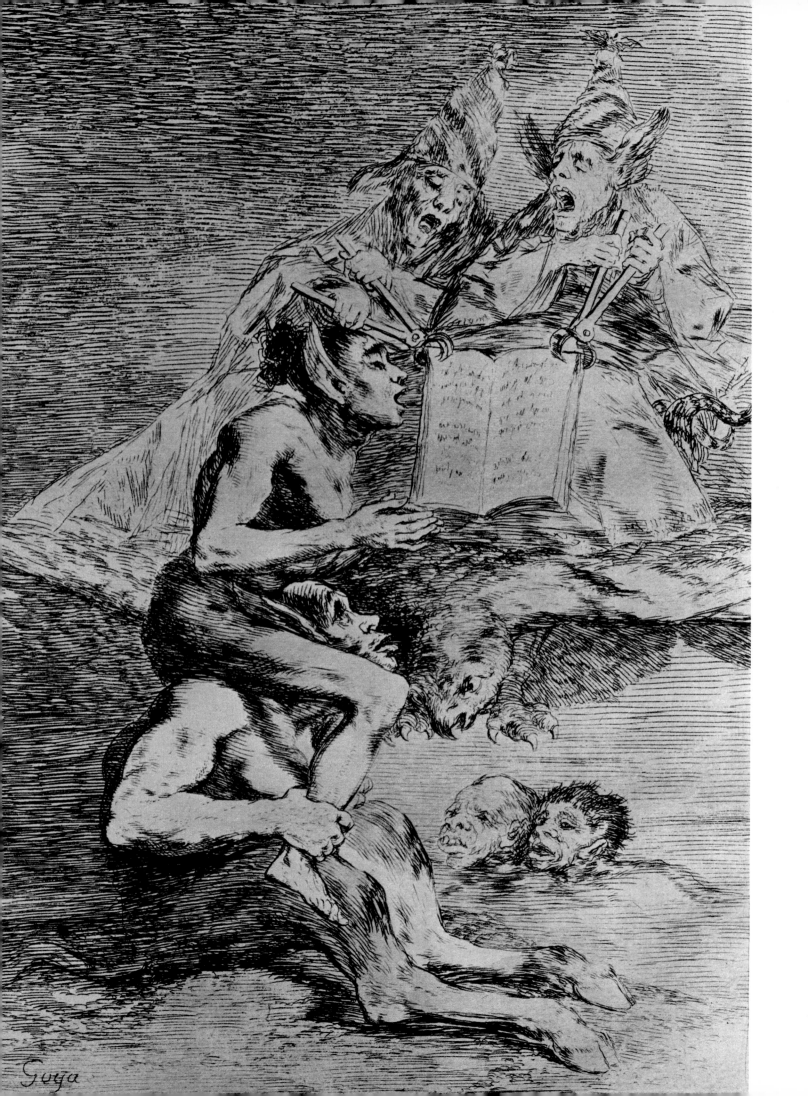

Goya

61

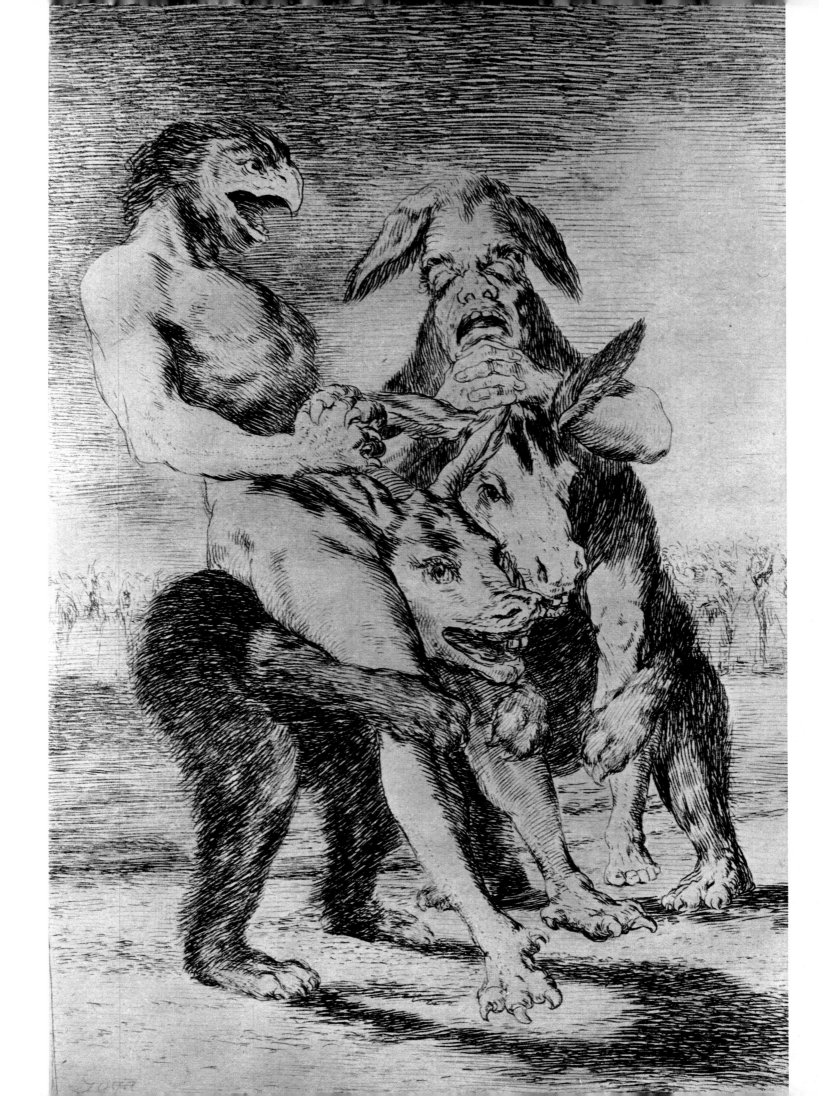

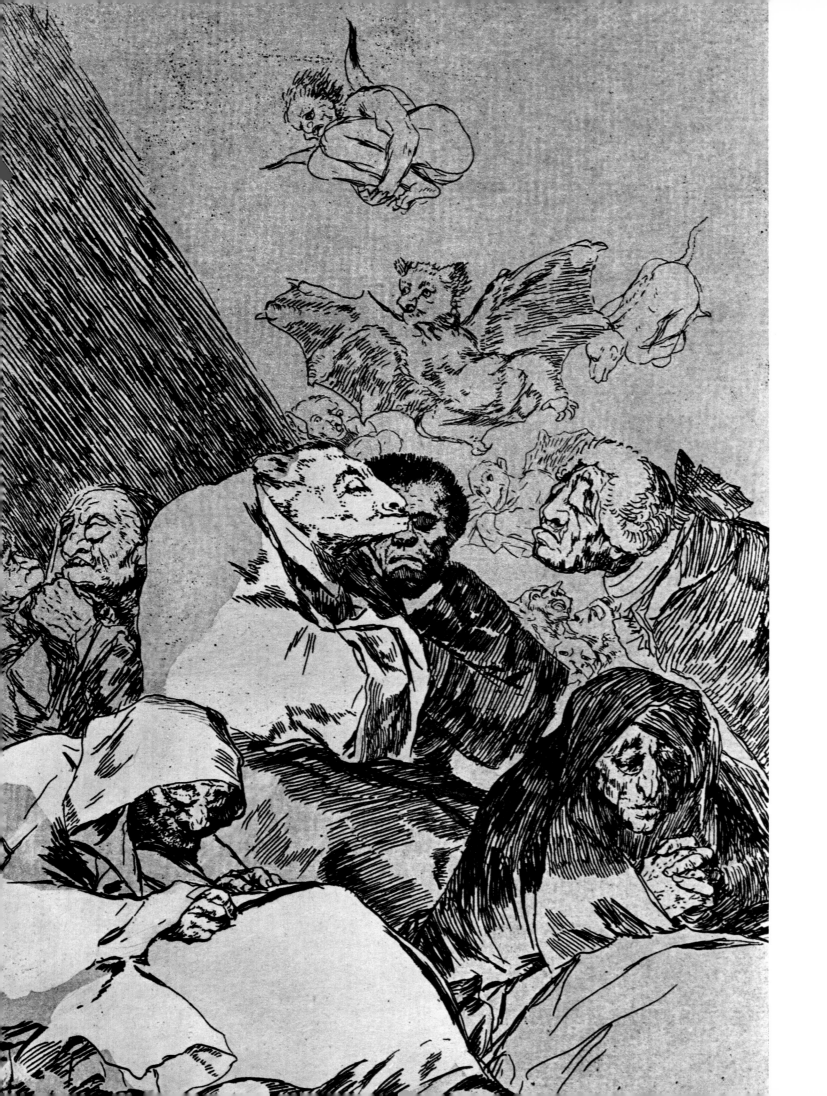

63

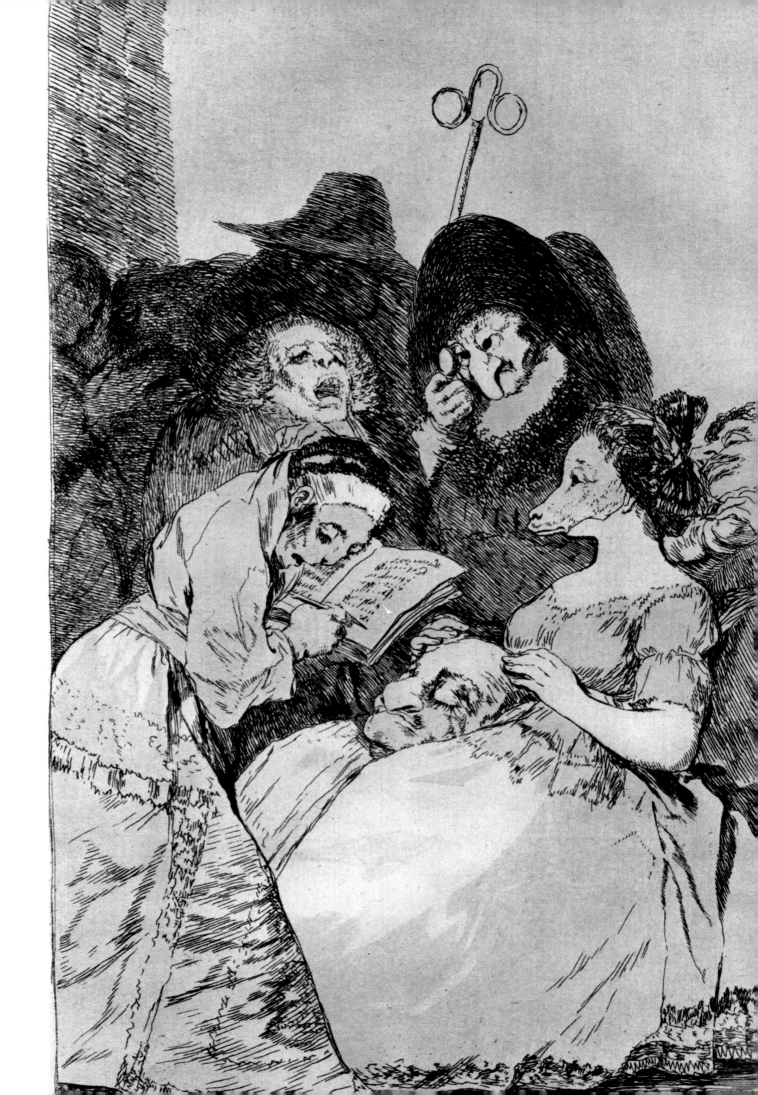

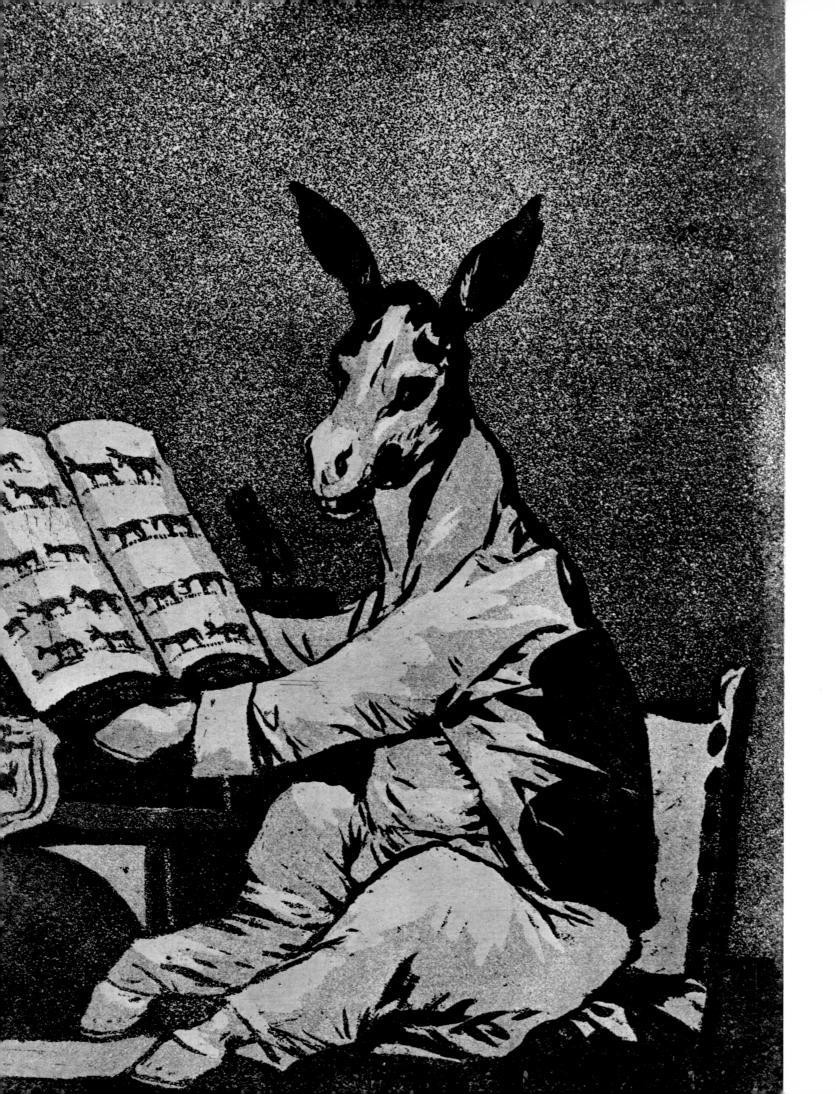

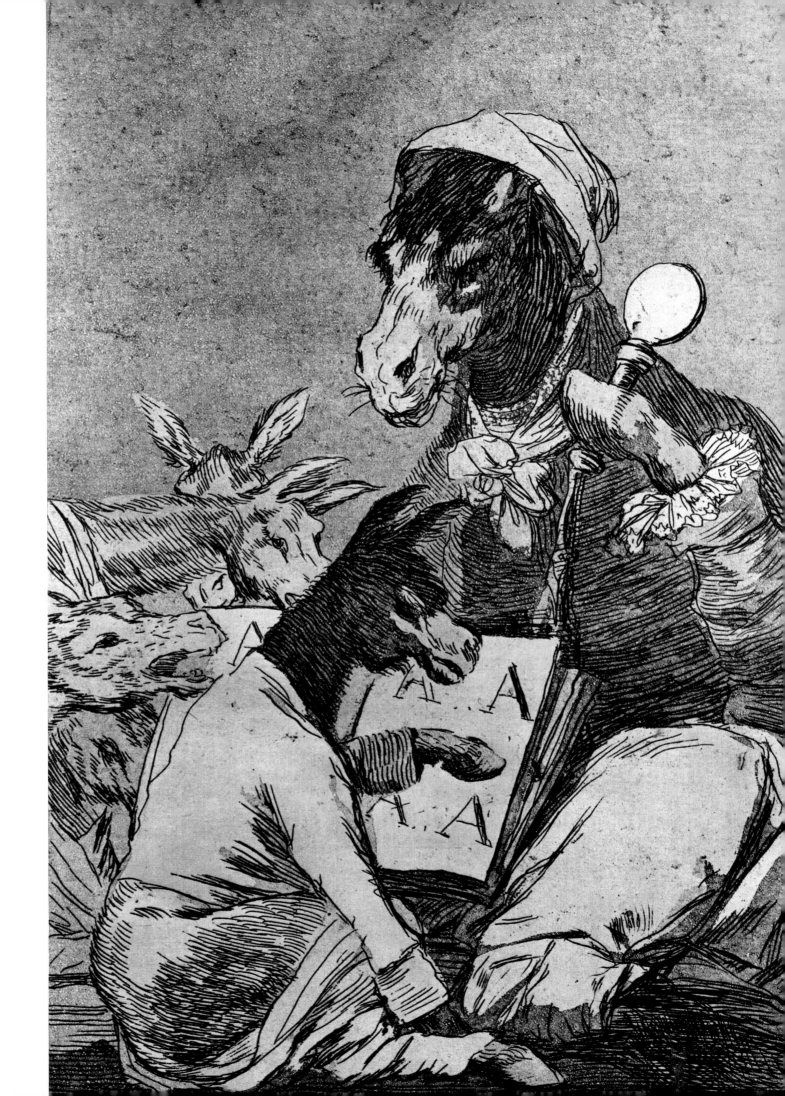

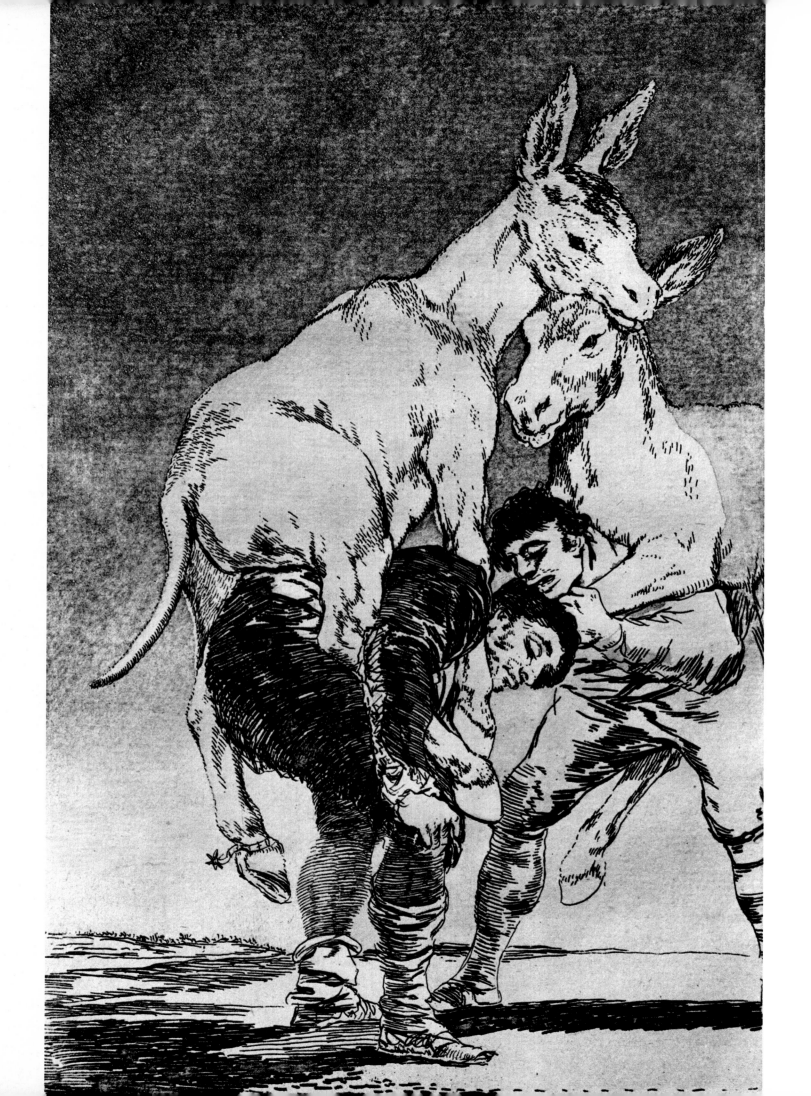

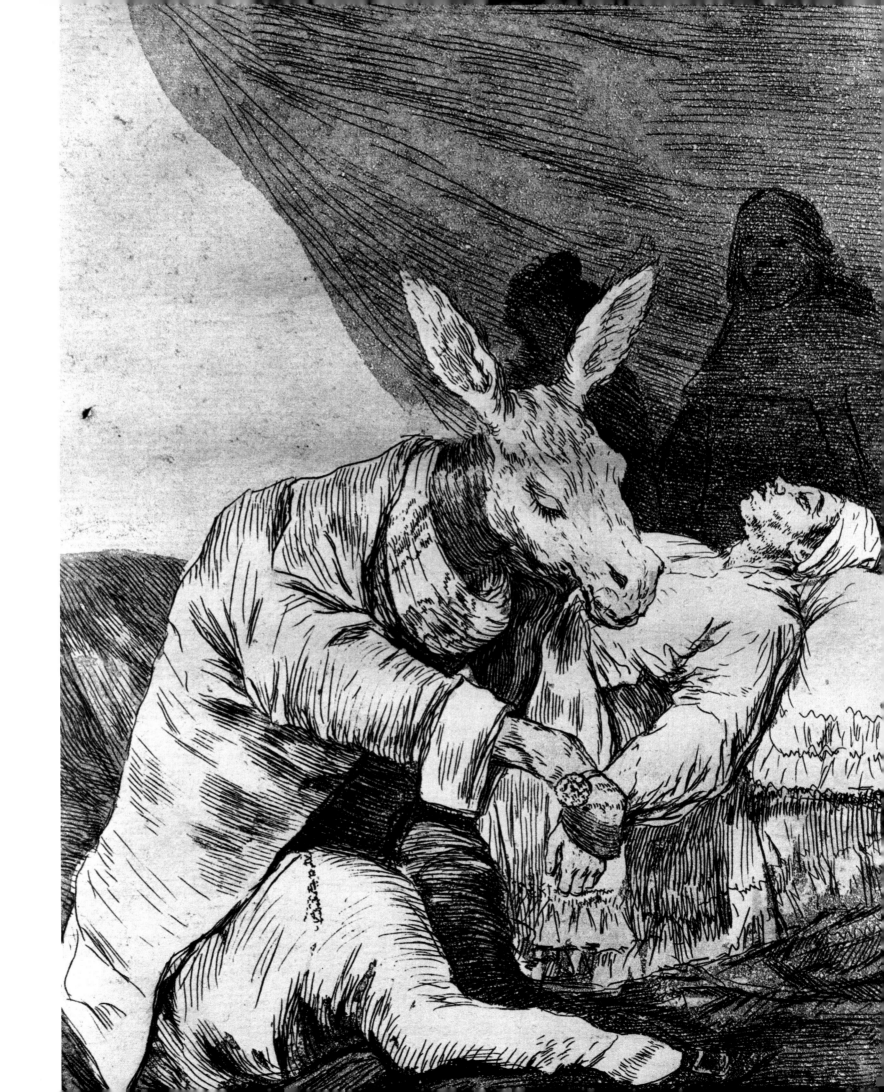

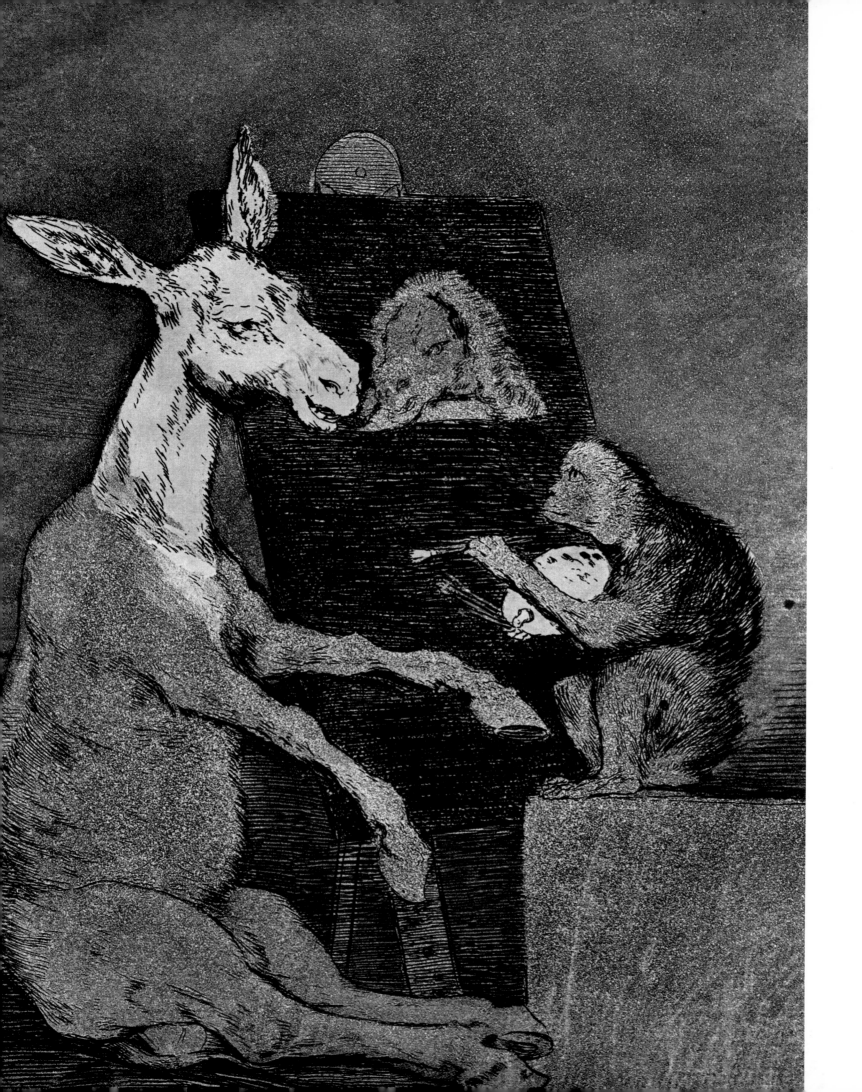

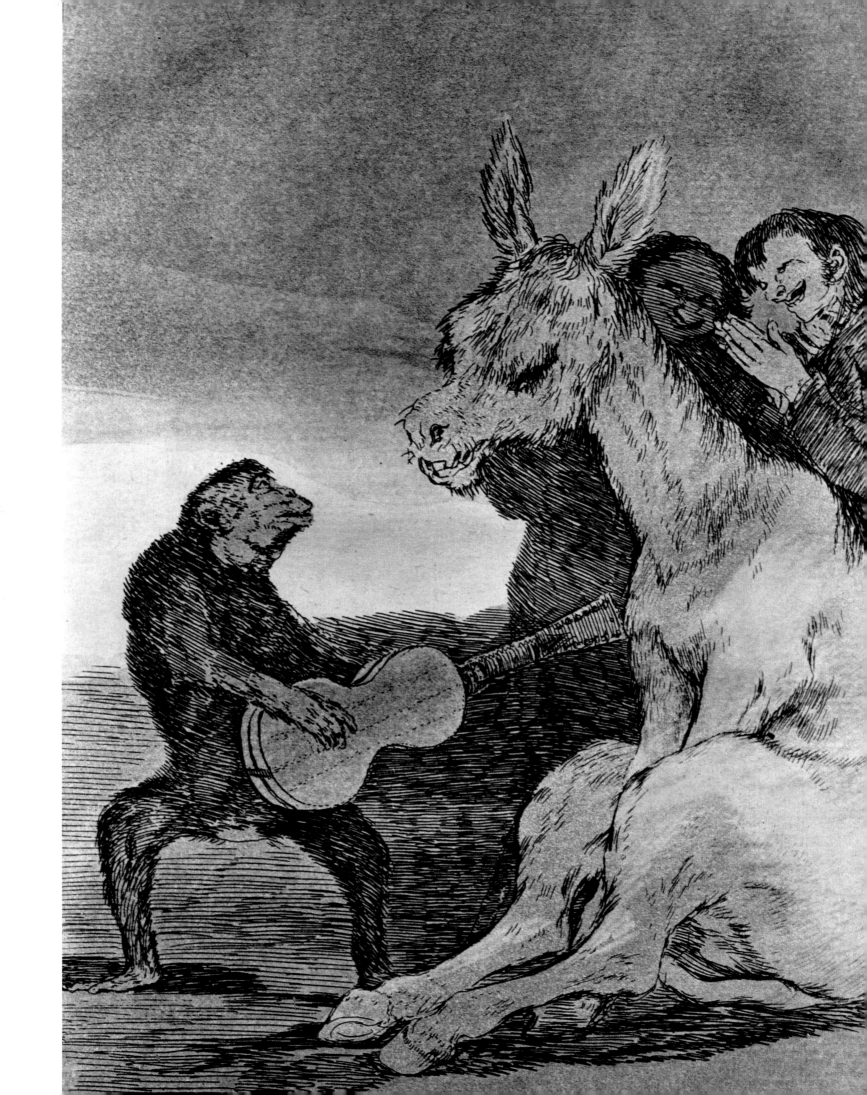

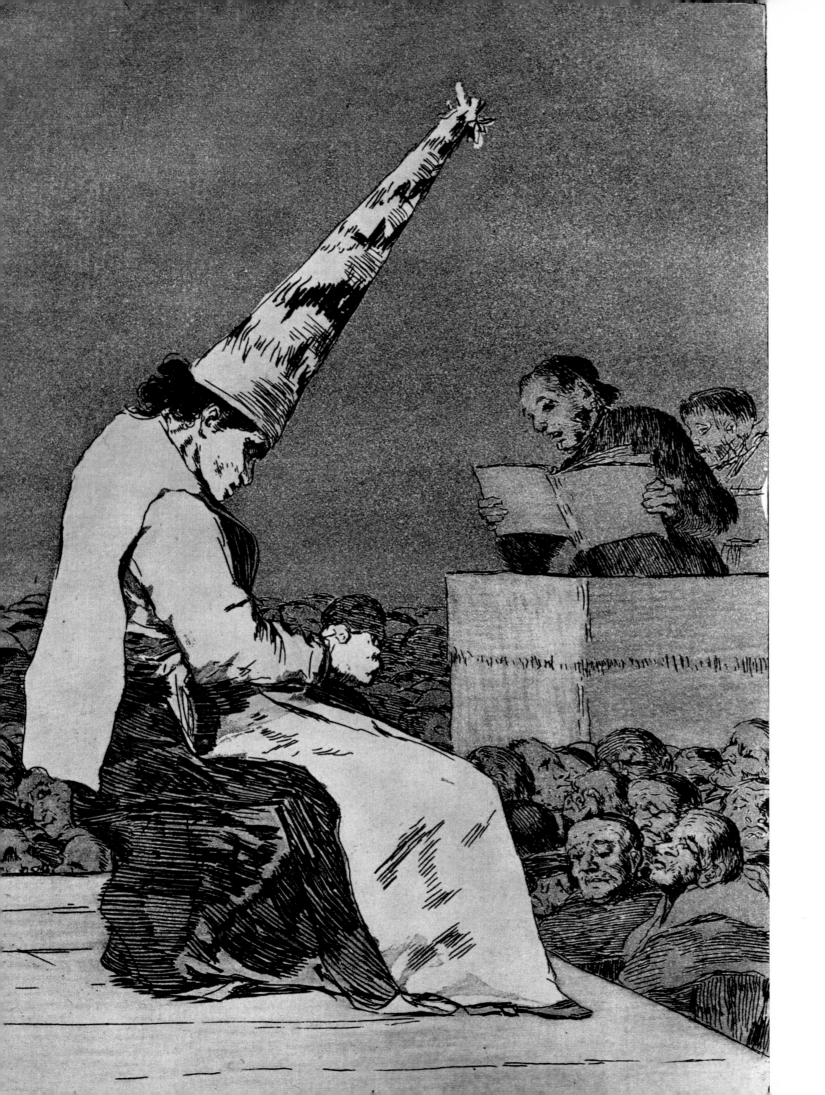

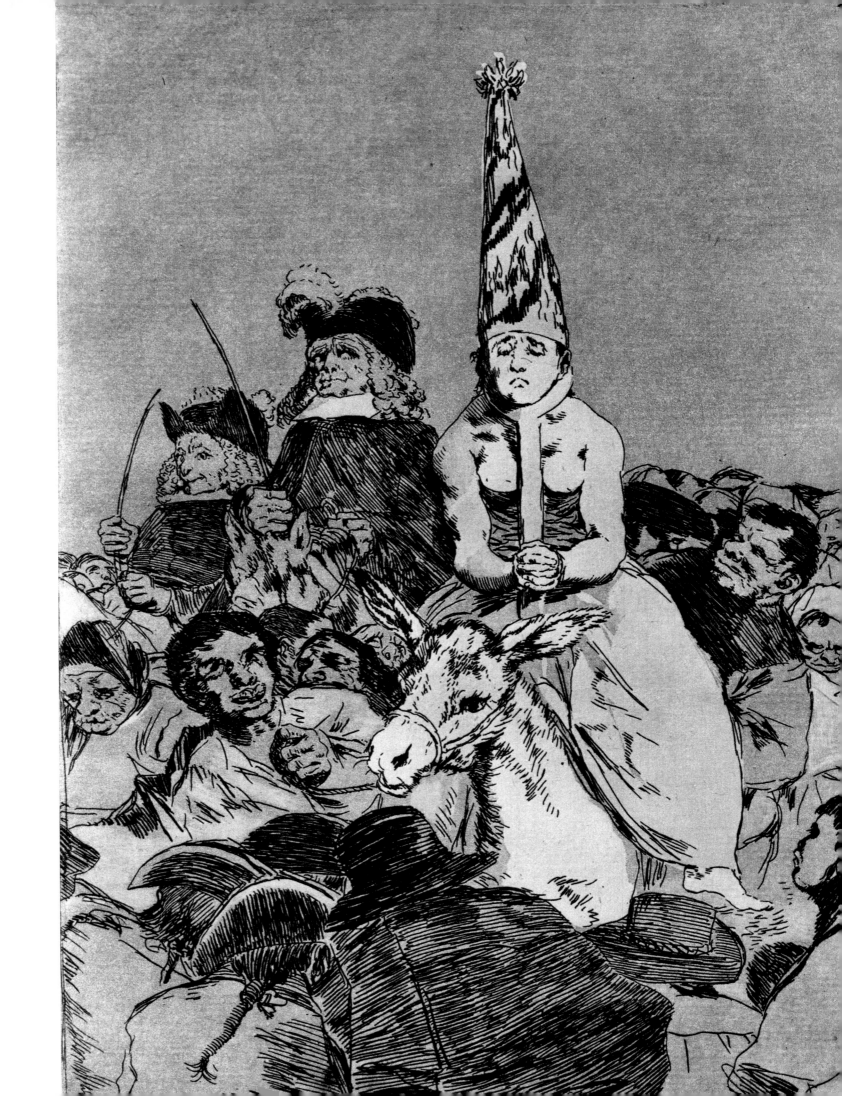

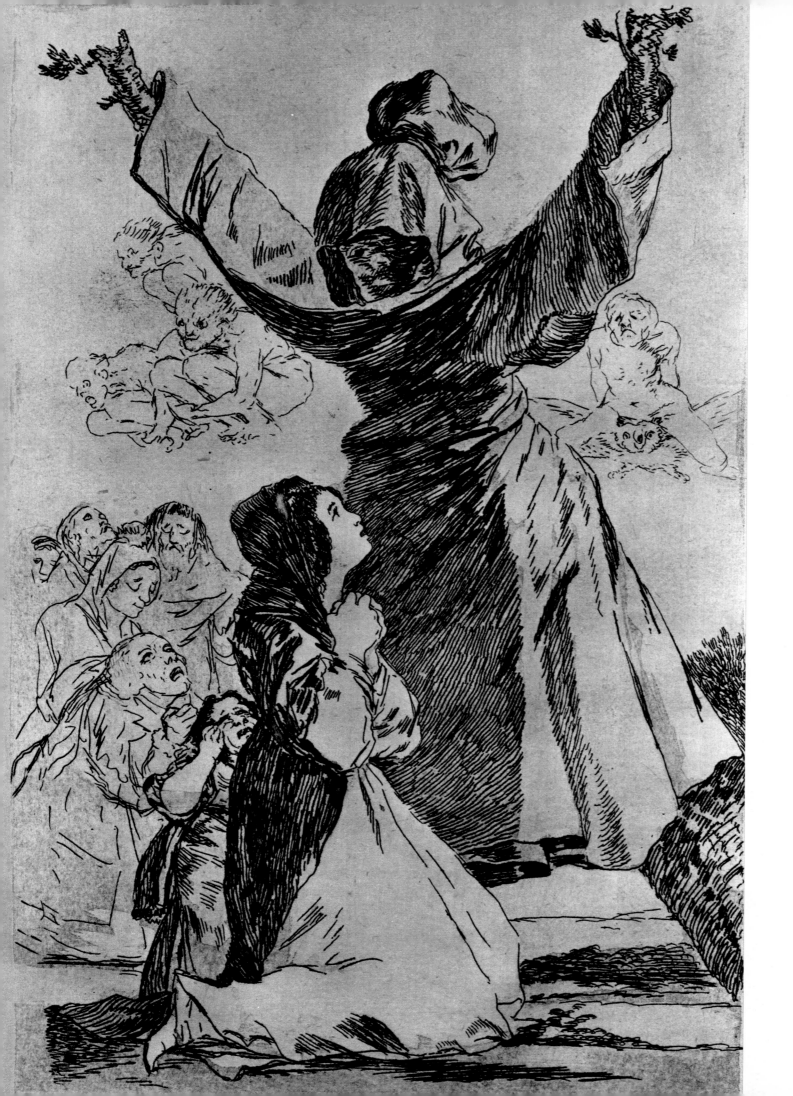

73

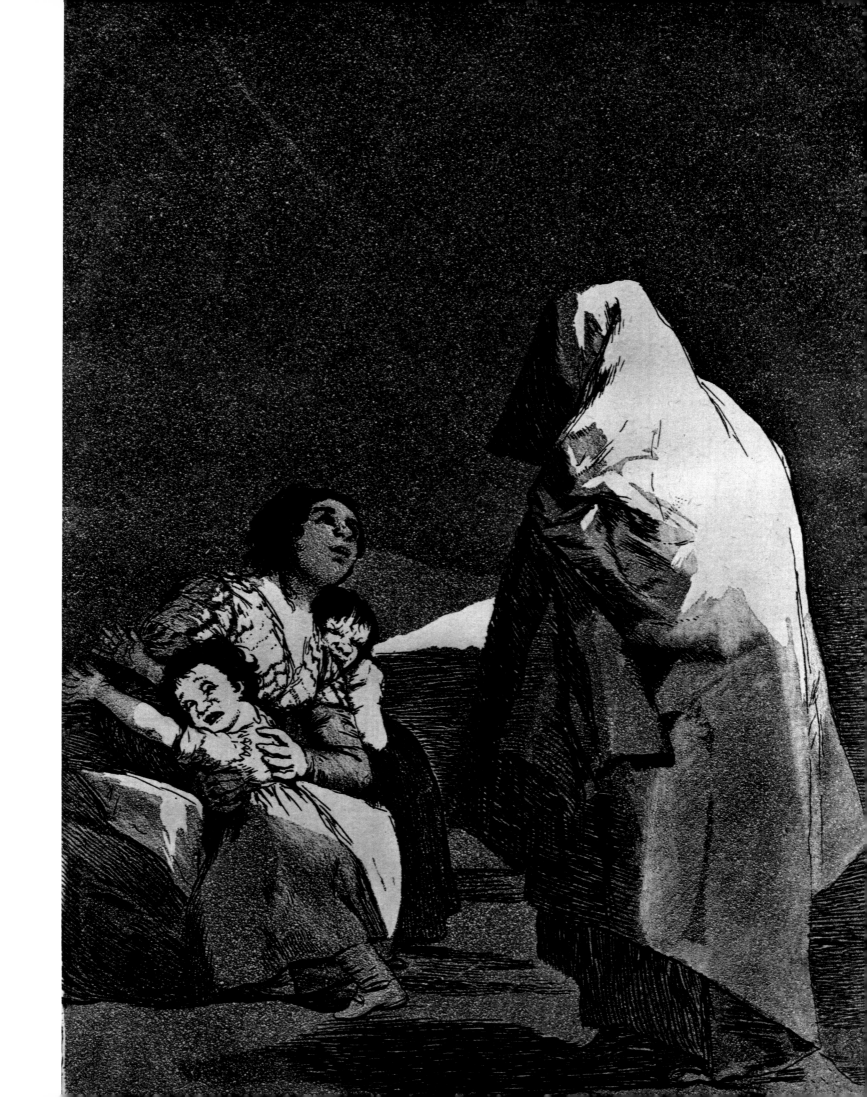

74

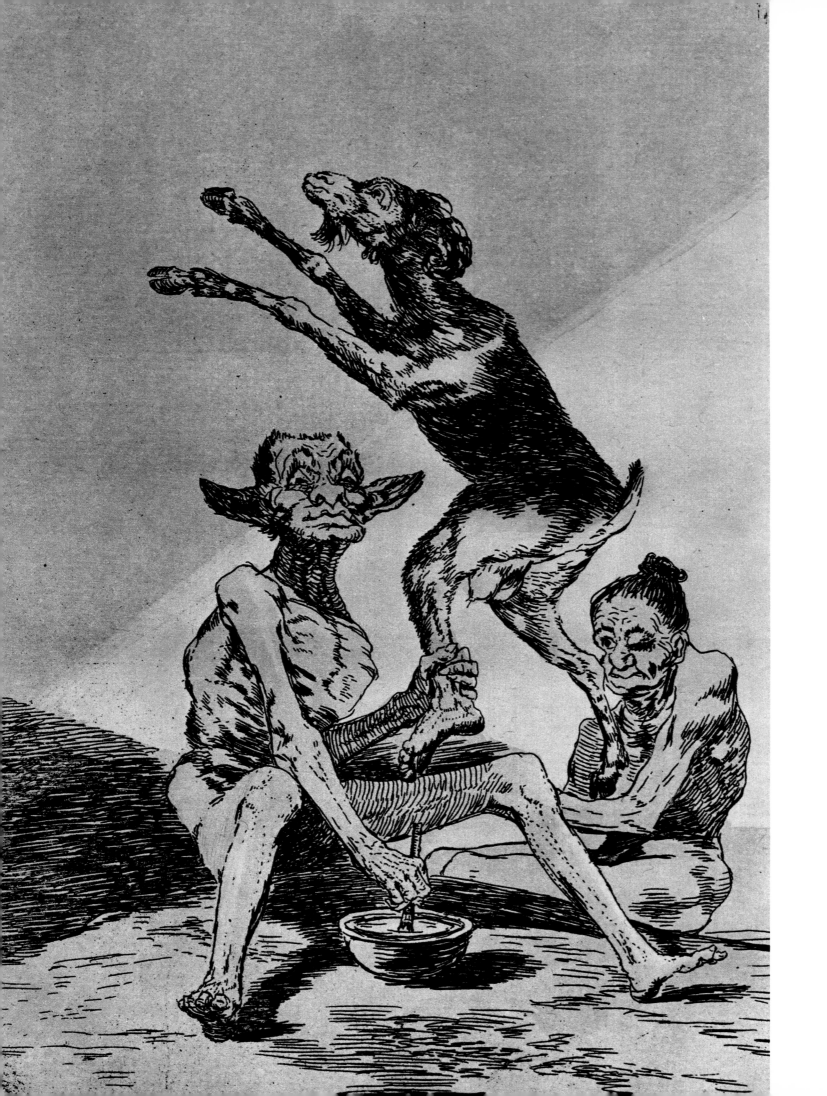

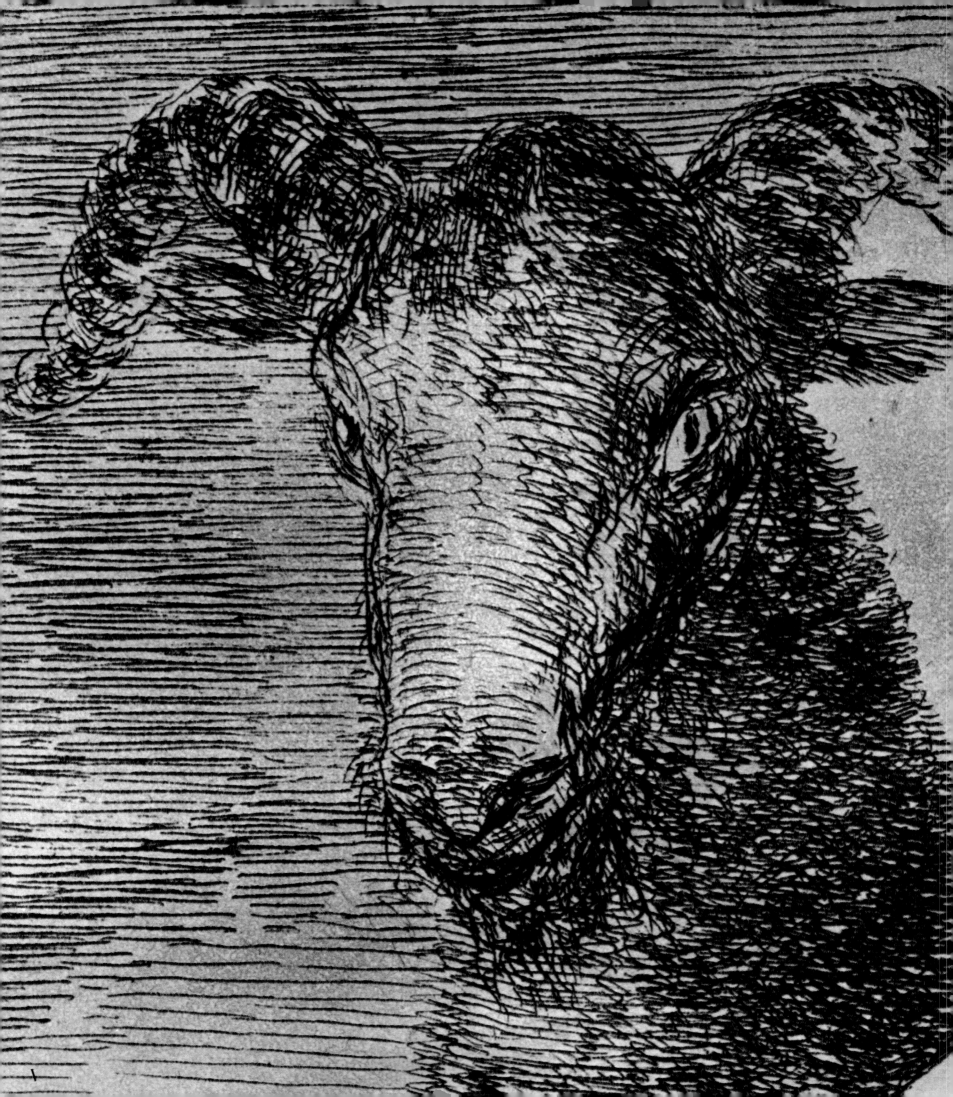

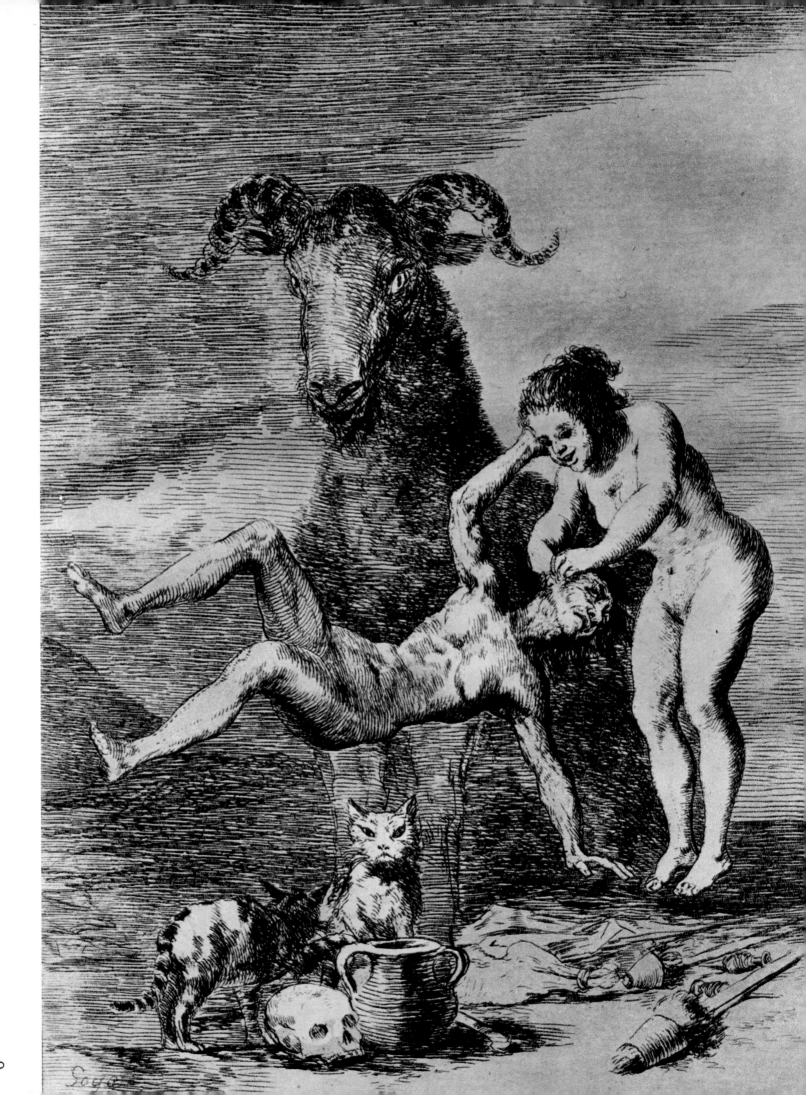

Goya

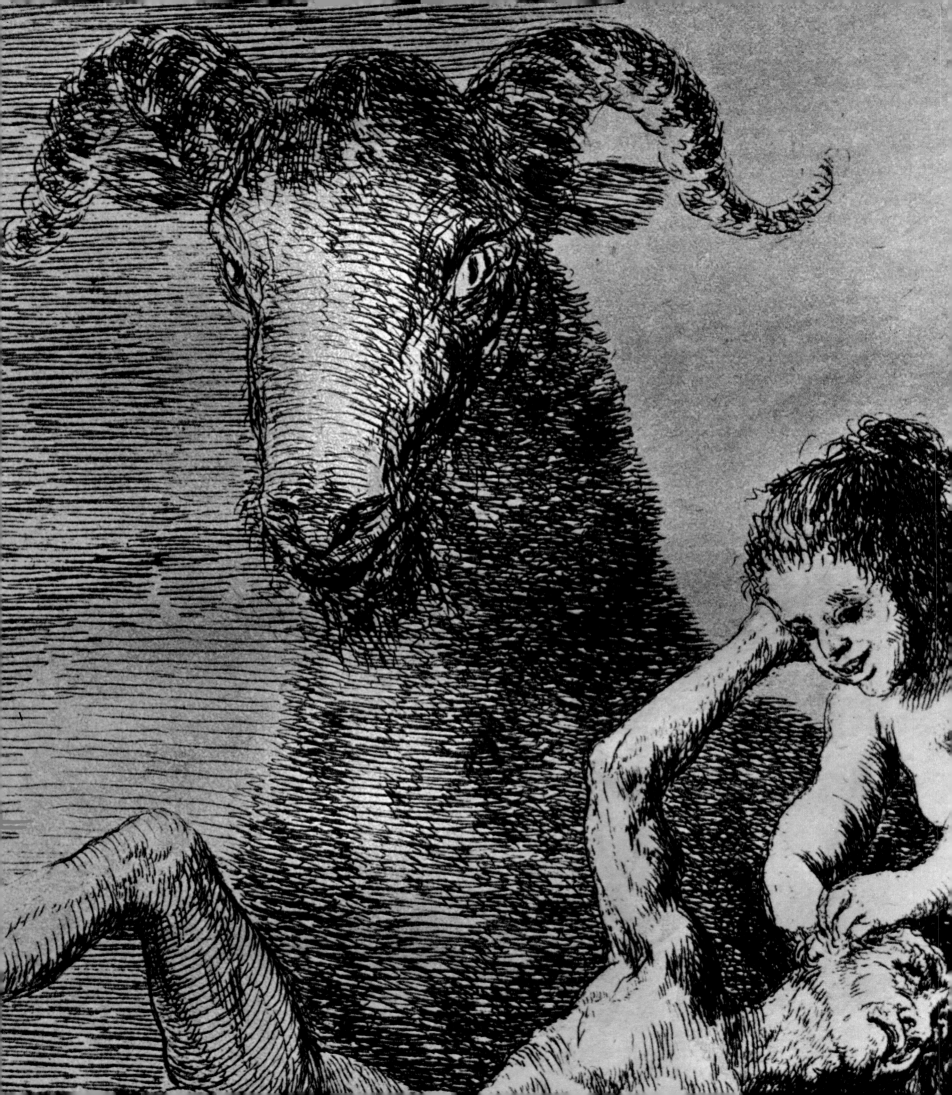

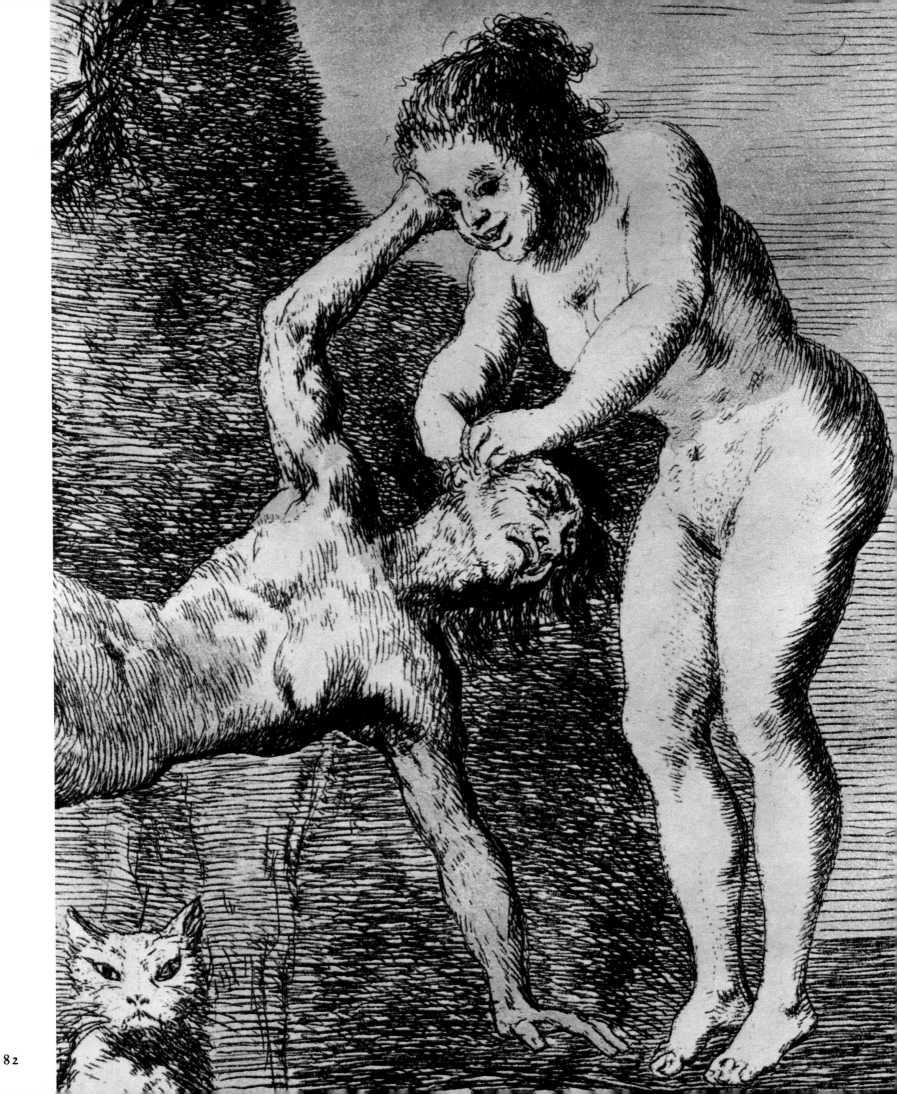

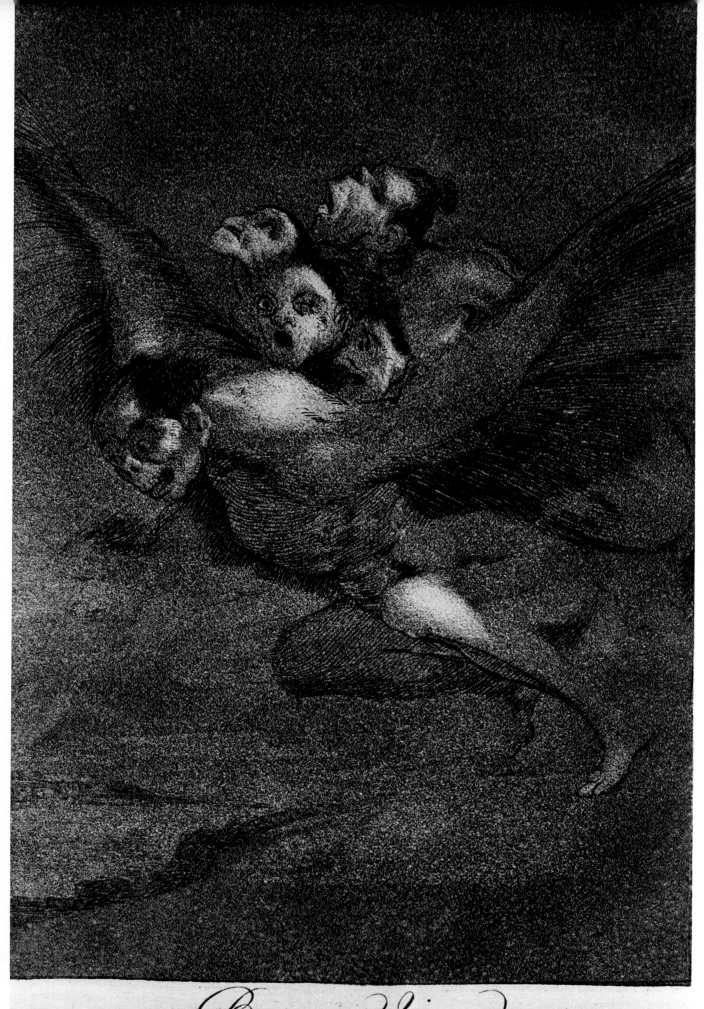

Buen Viage.

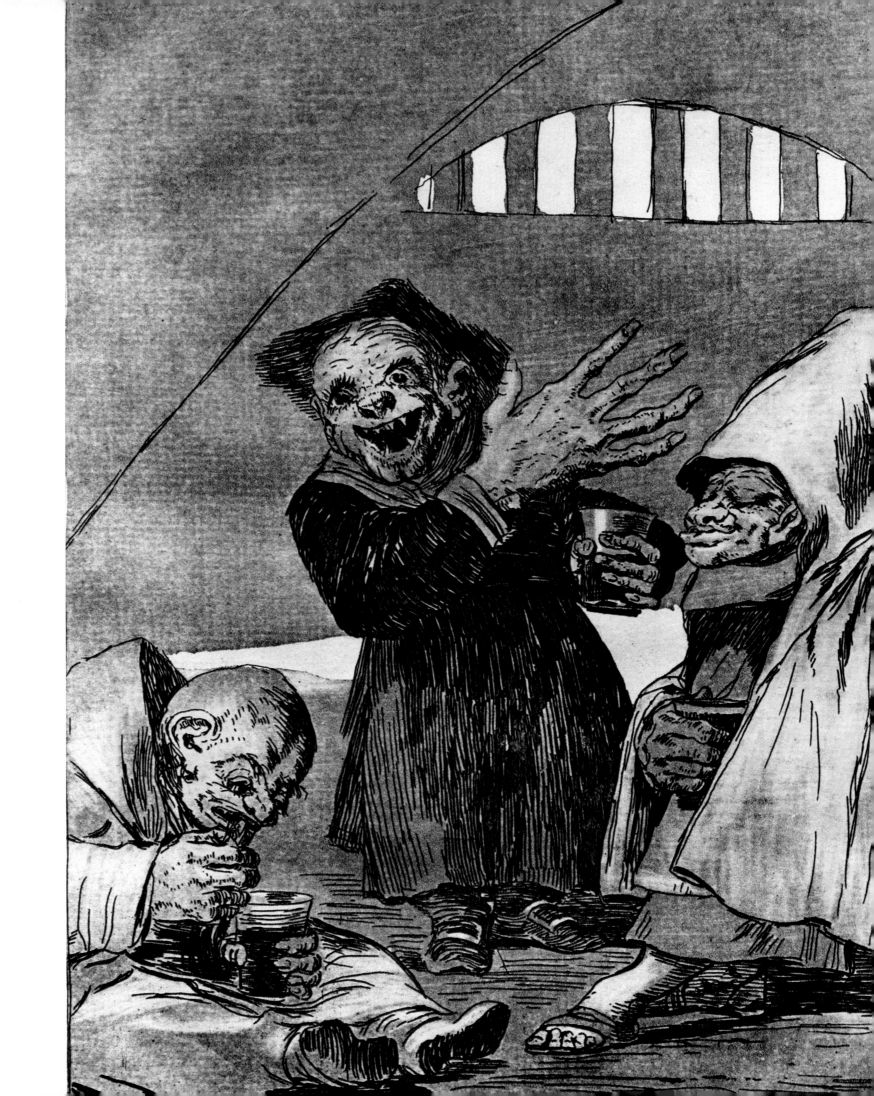

84

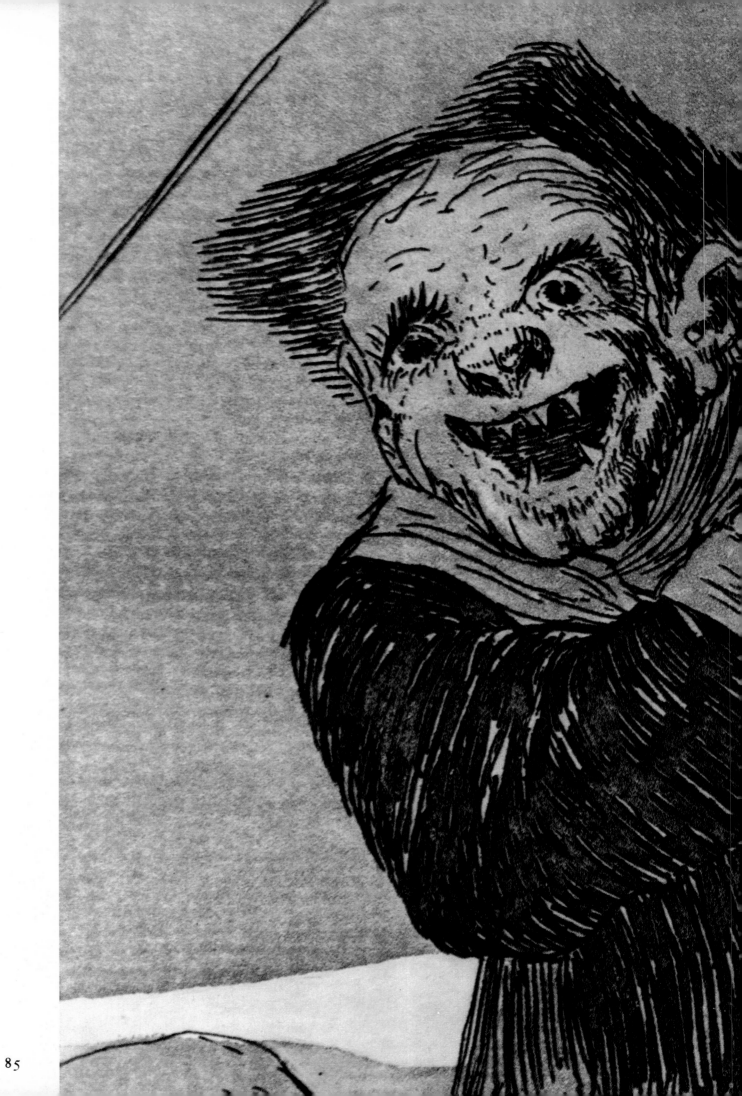

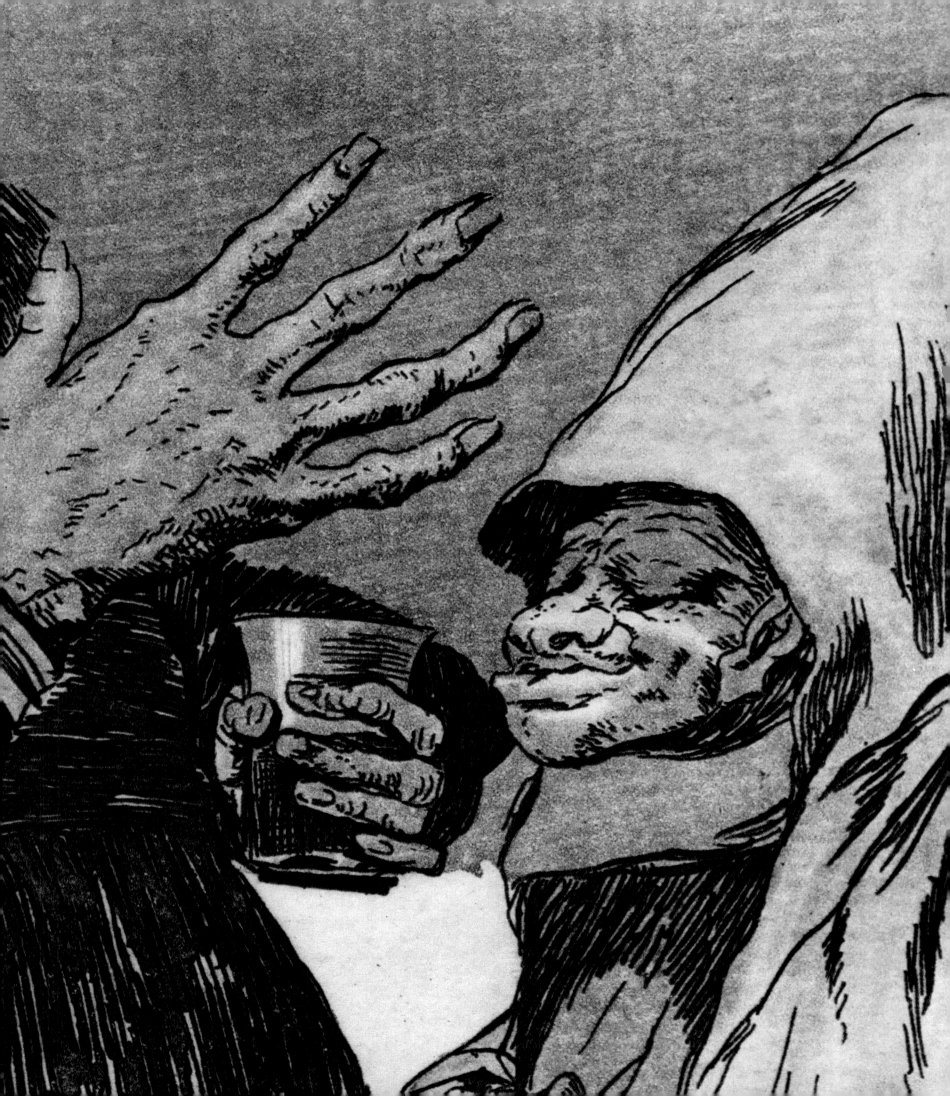

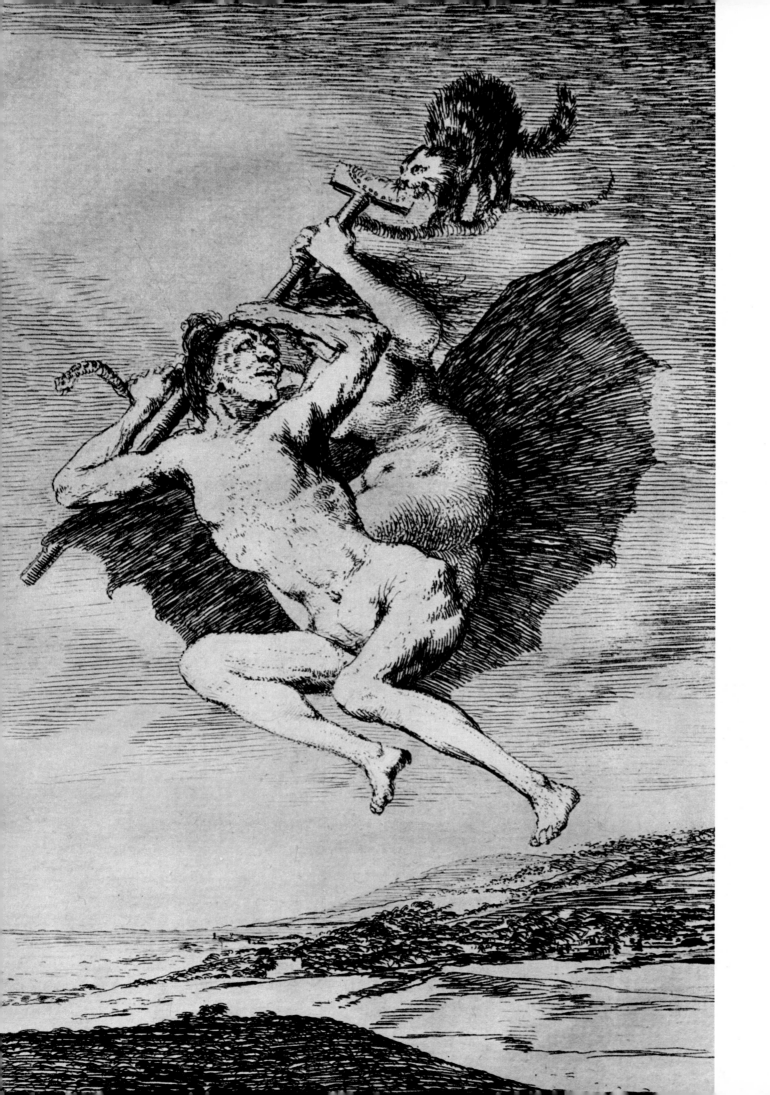

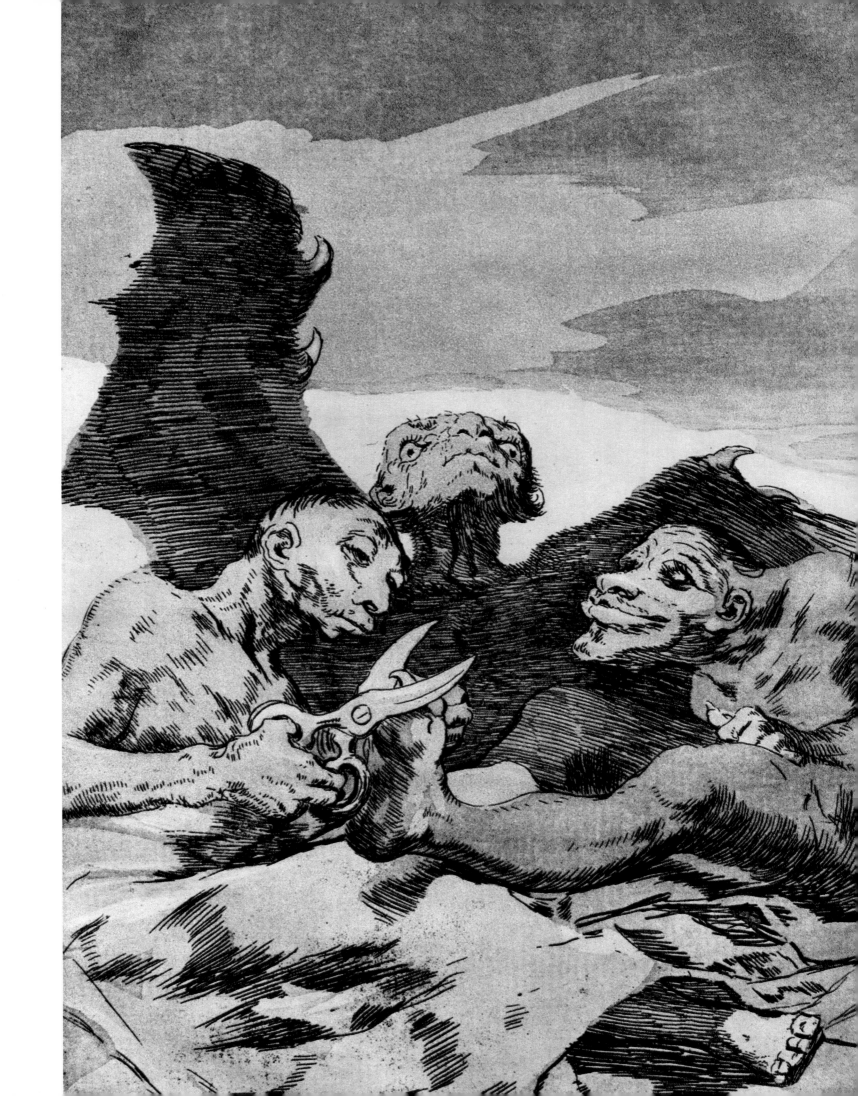

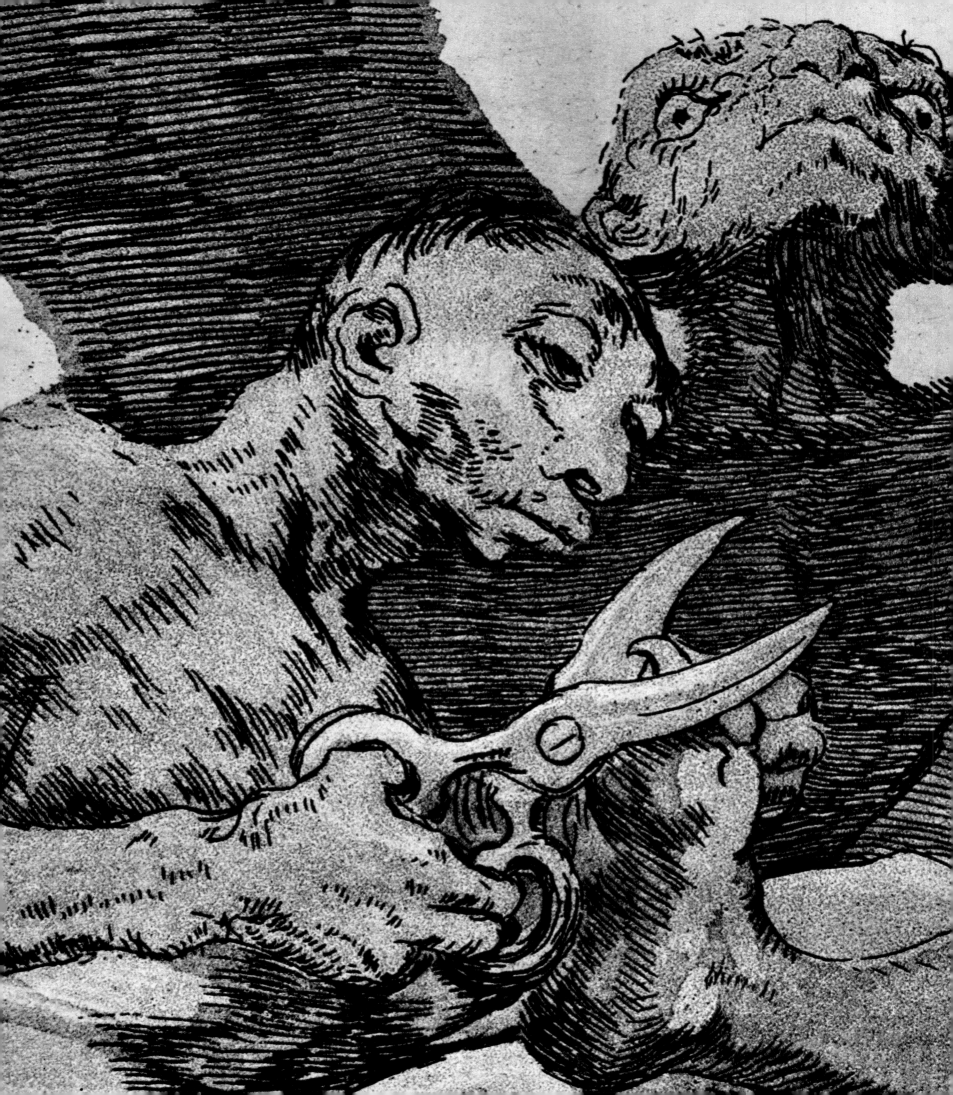

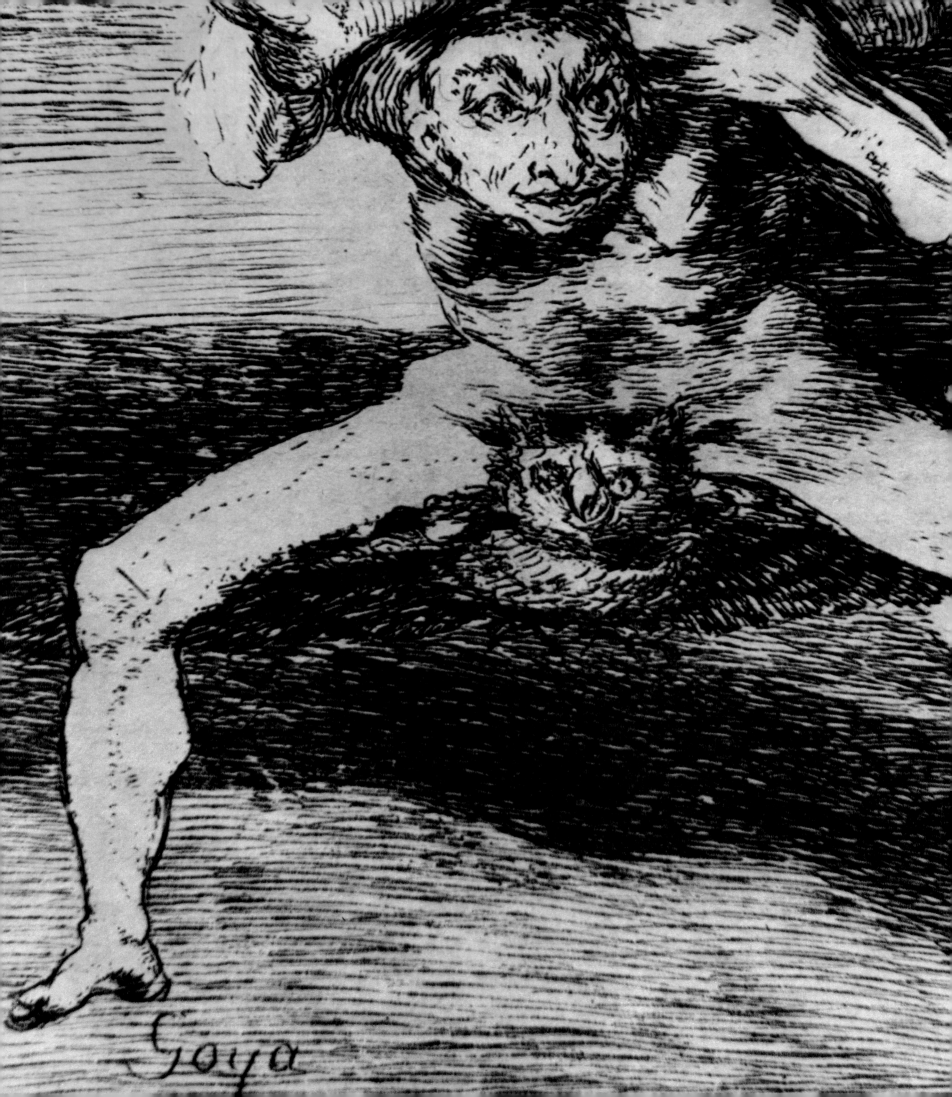

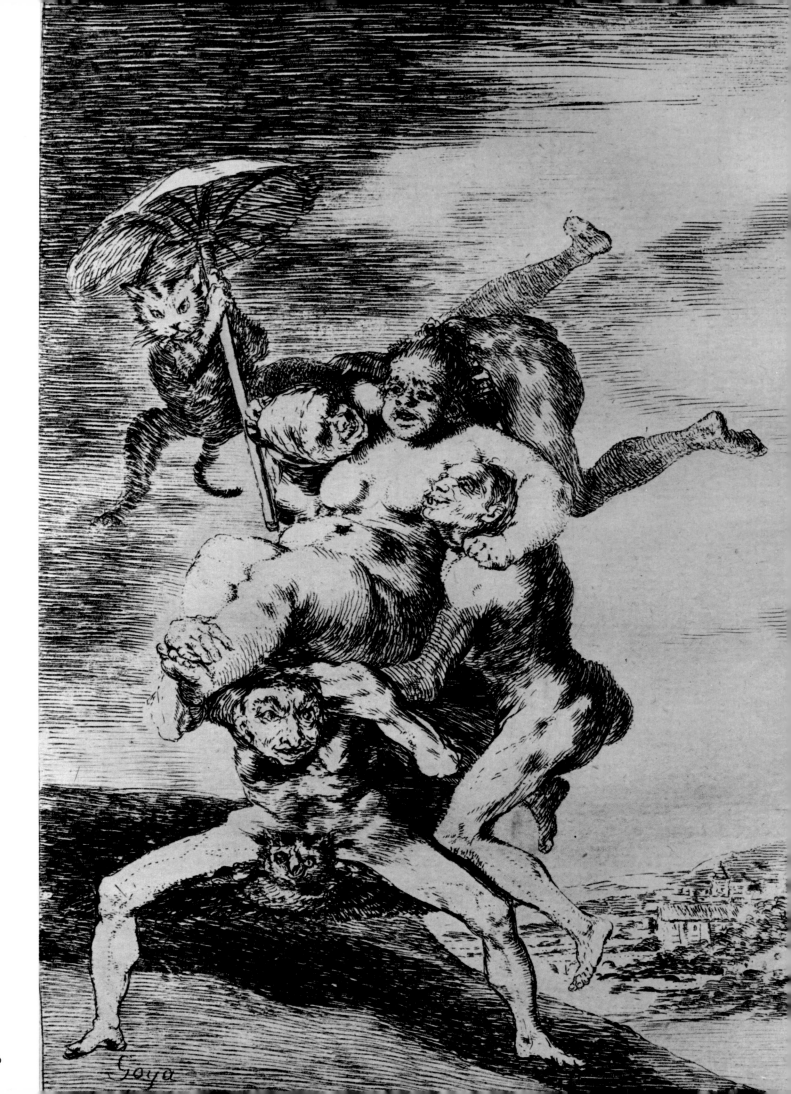

Goya

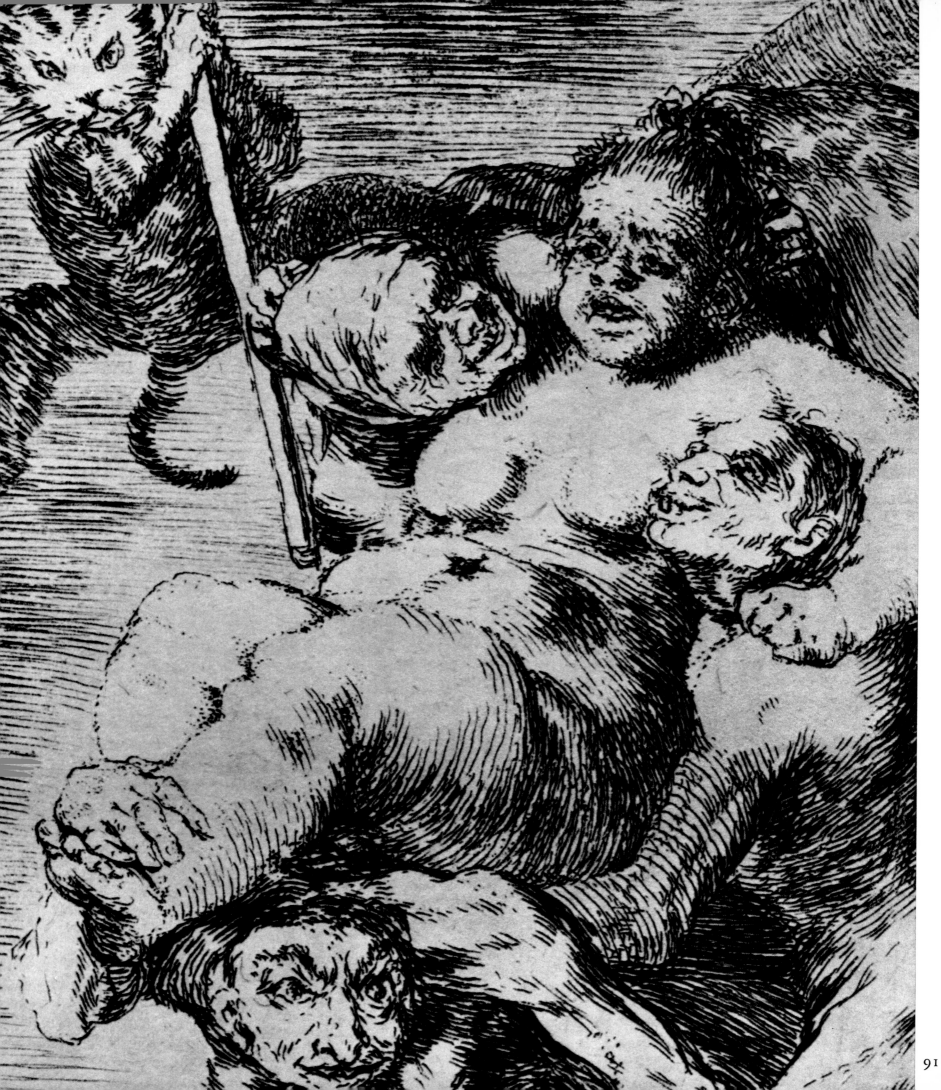

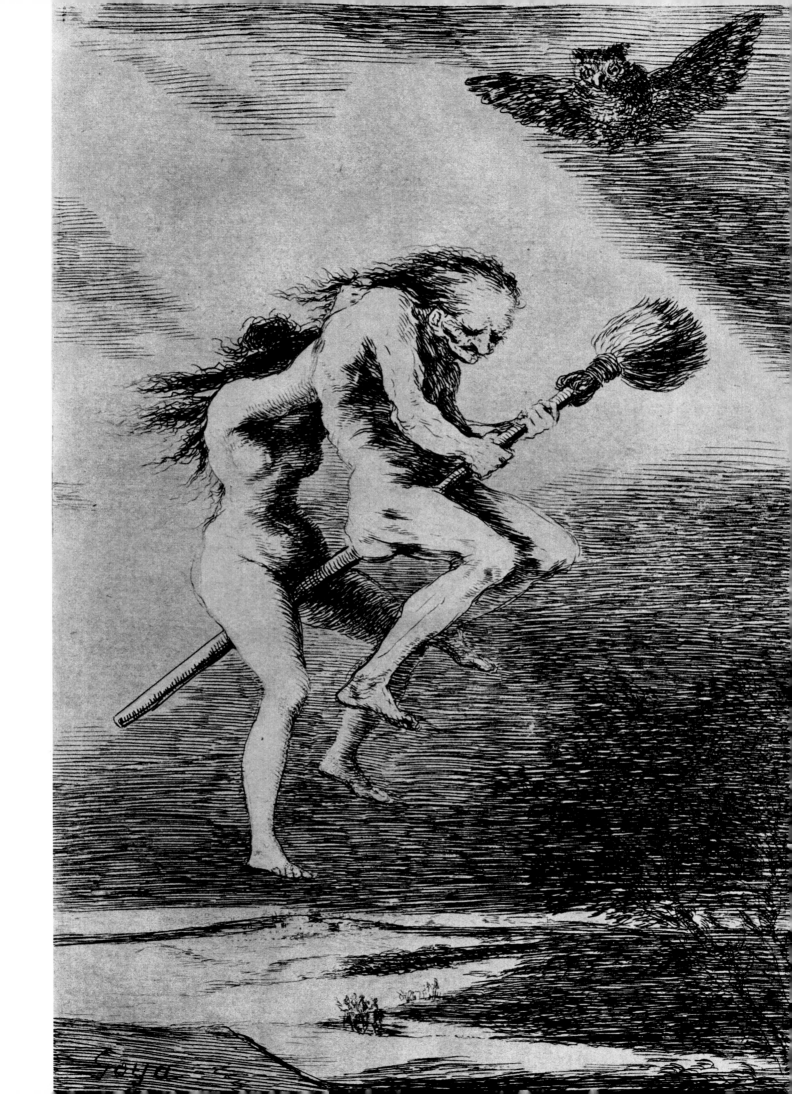

Goya

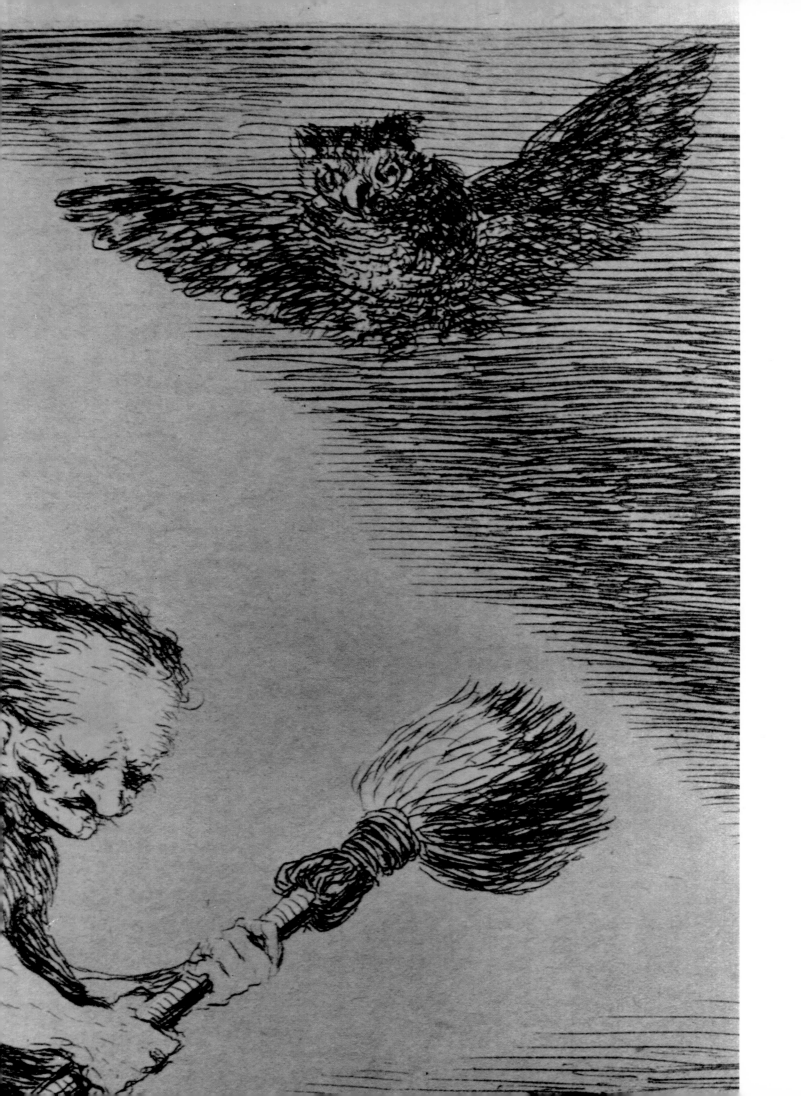

93

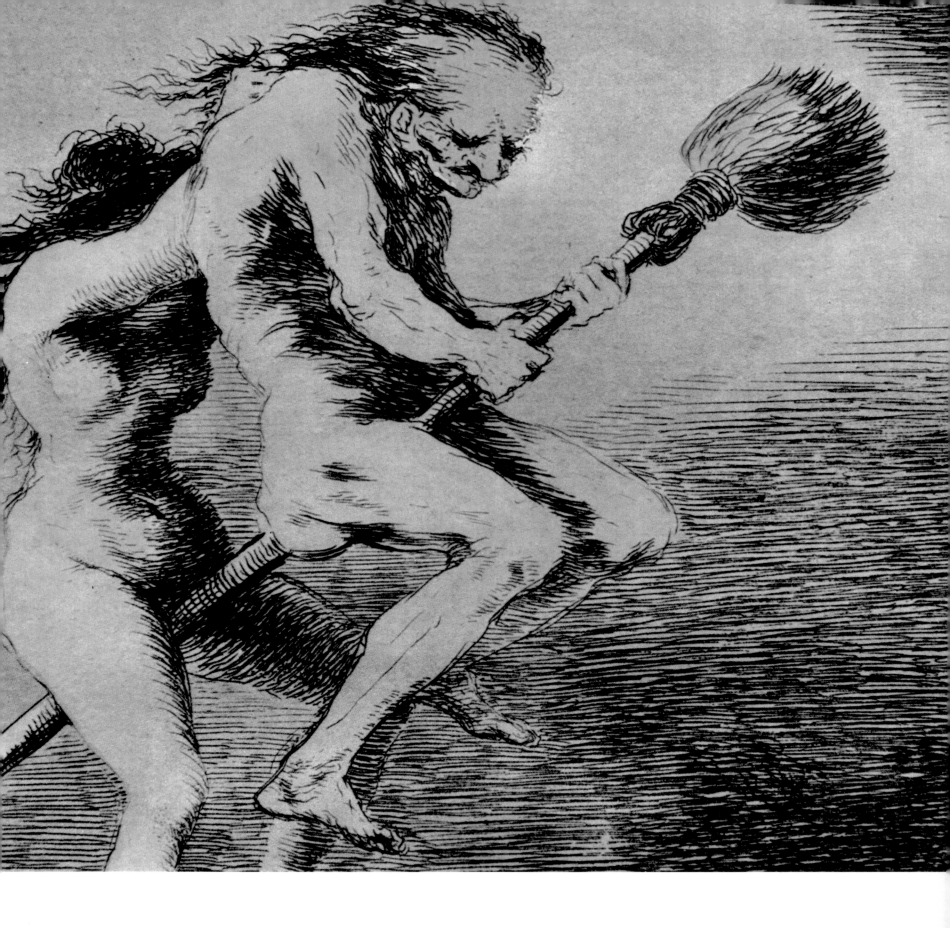

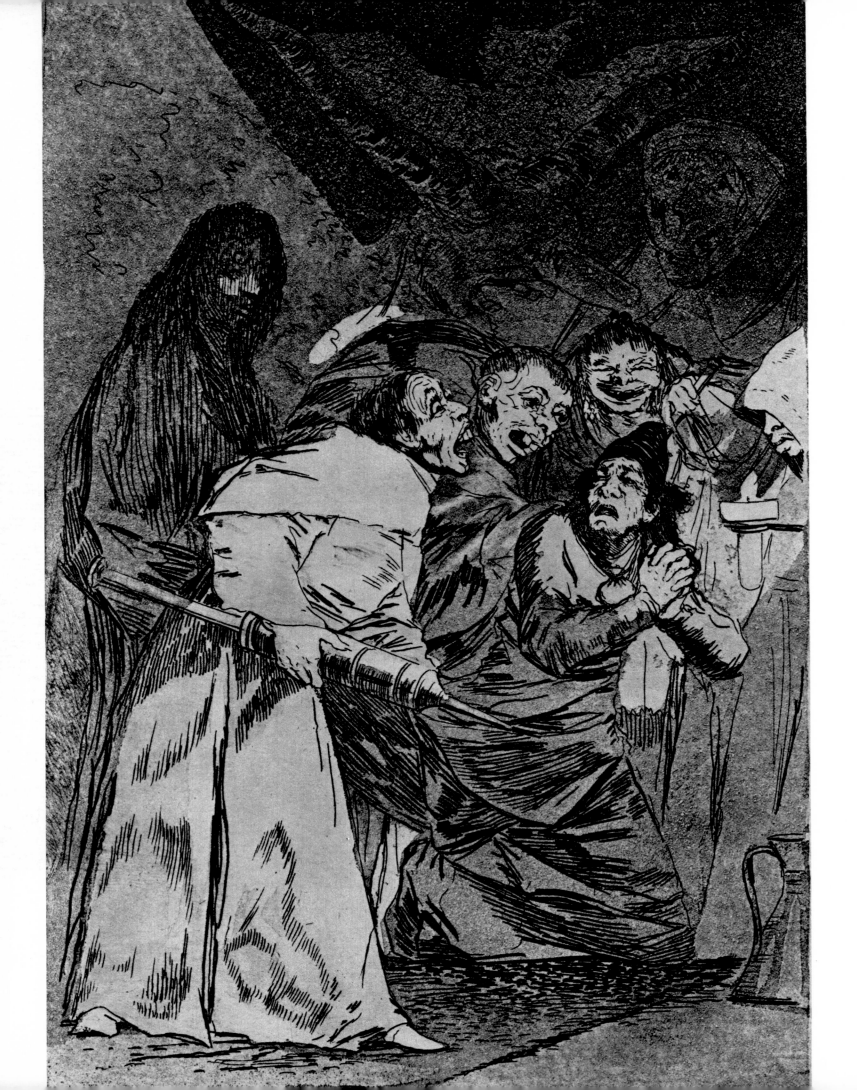

95

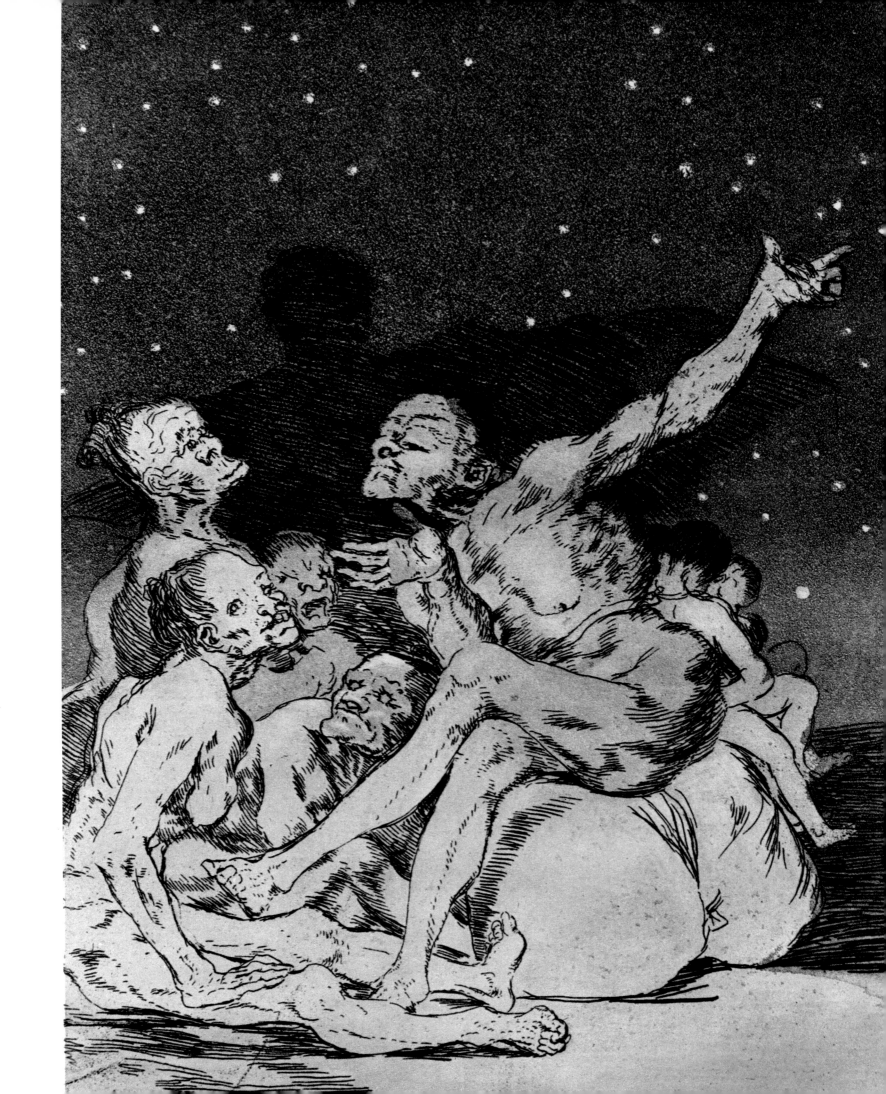

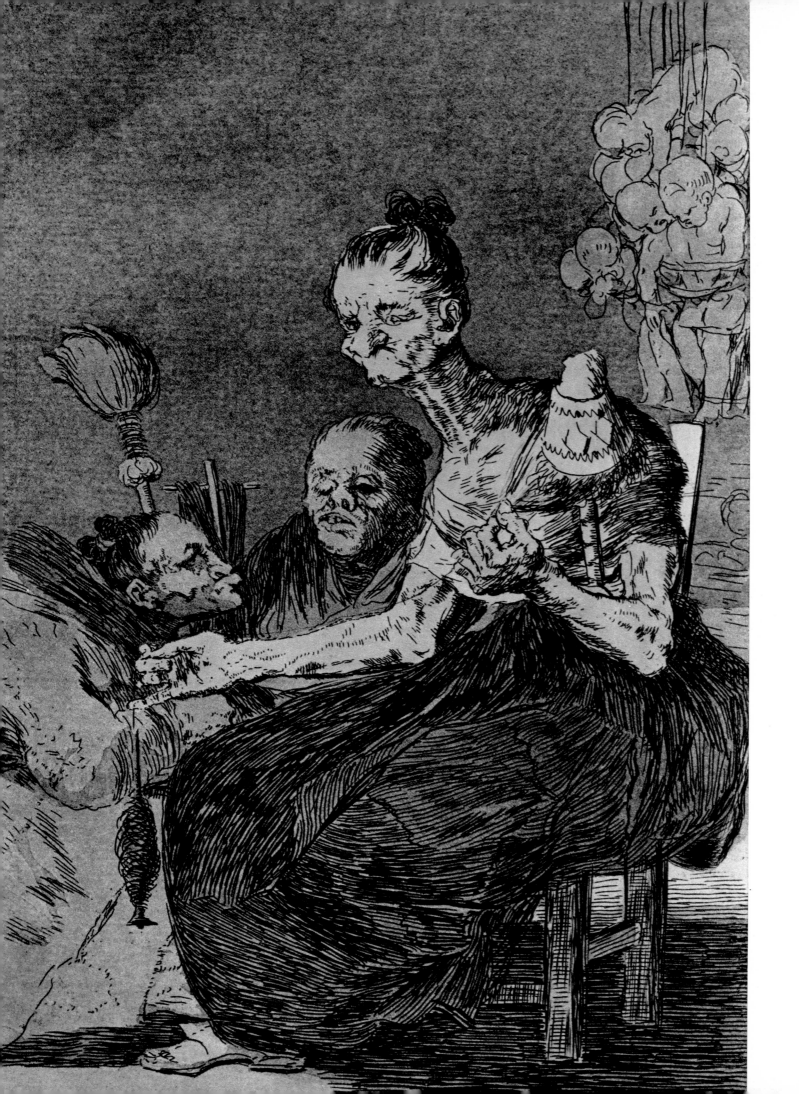

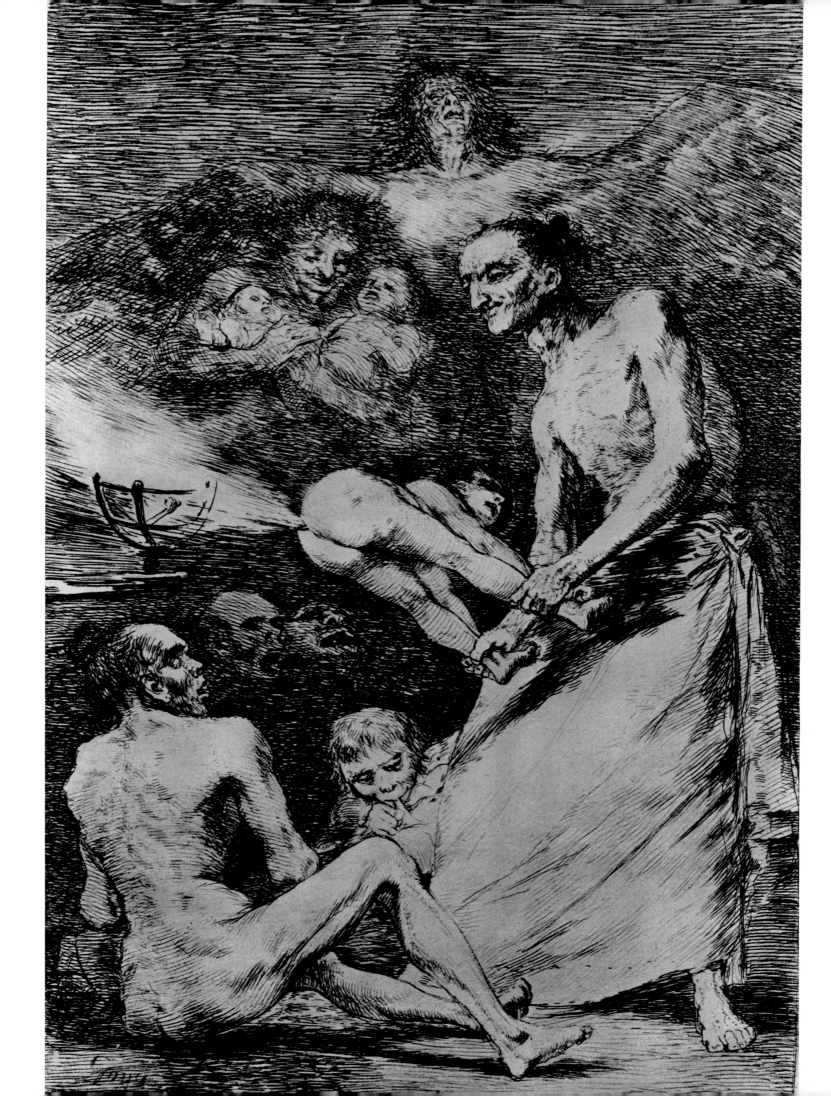

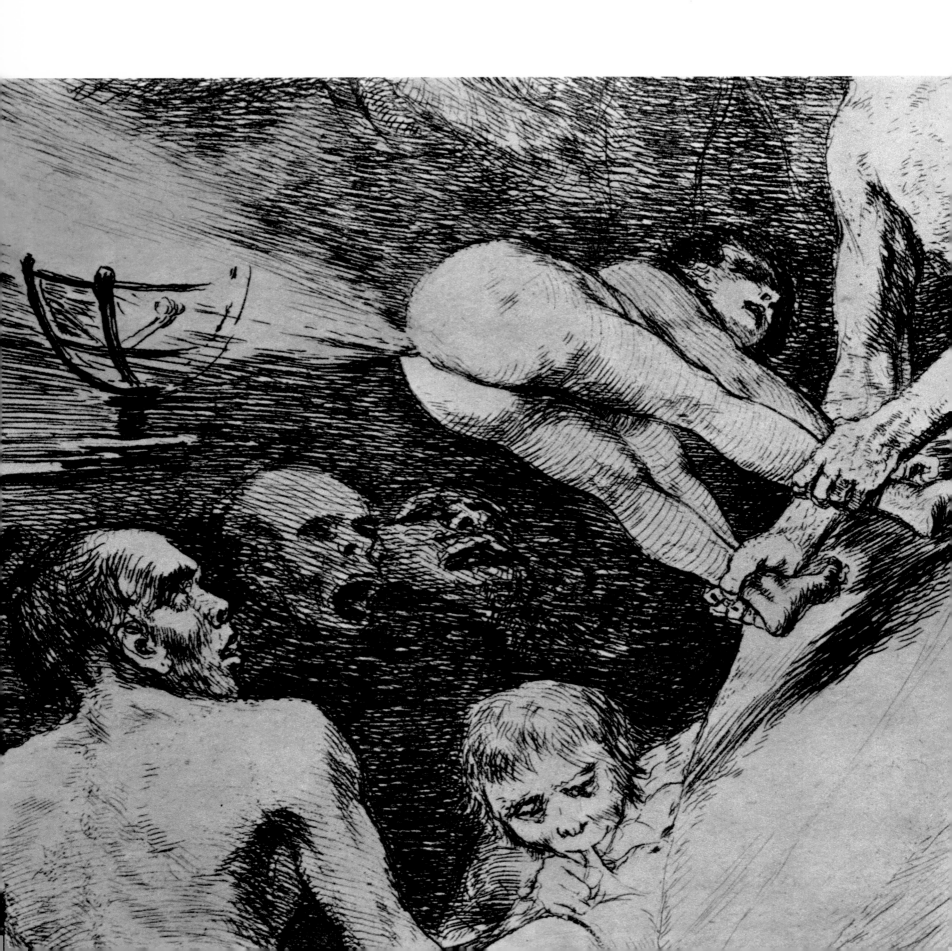

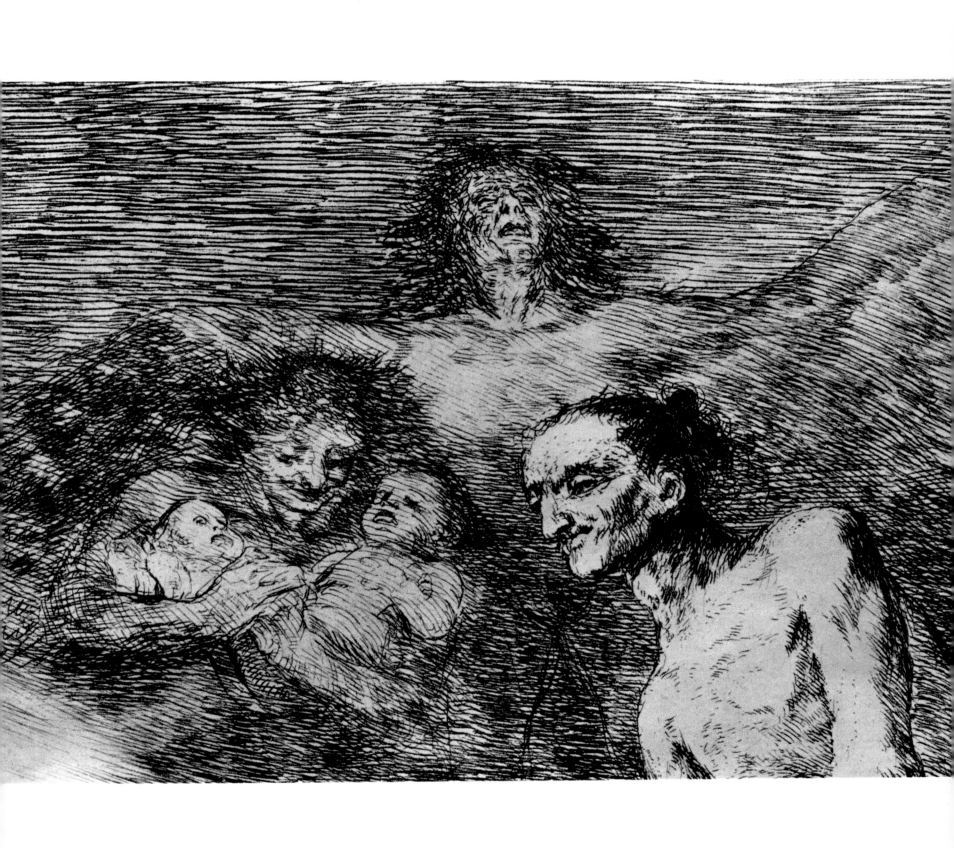

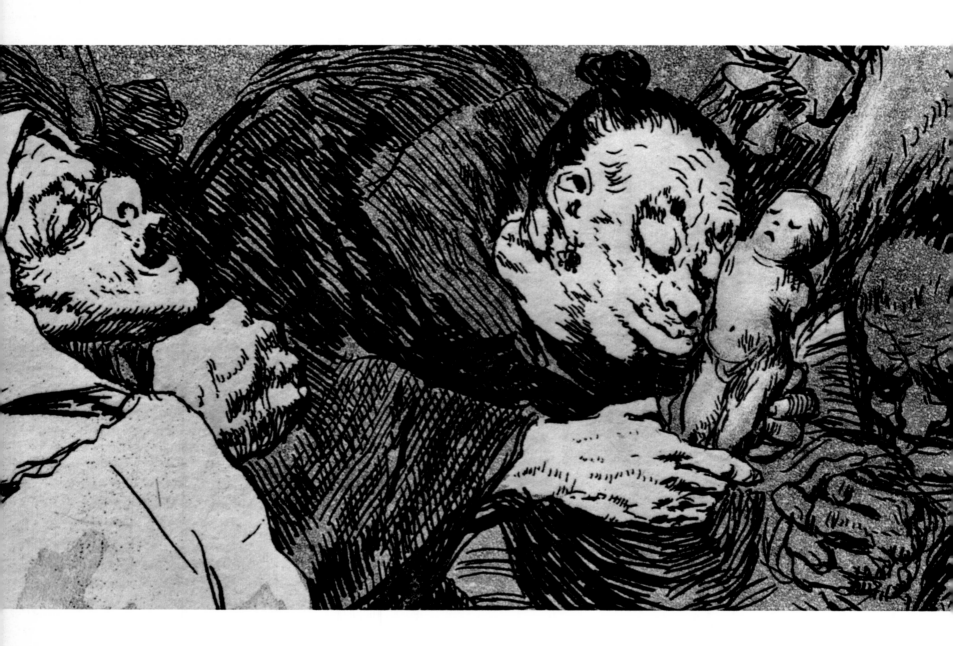

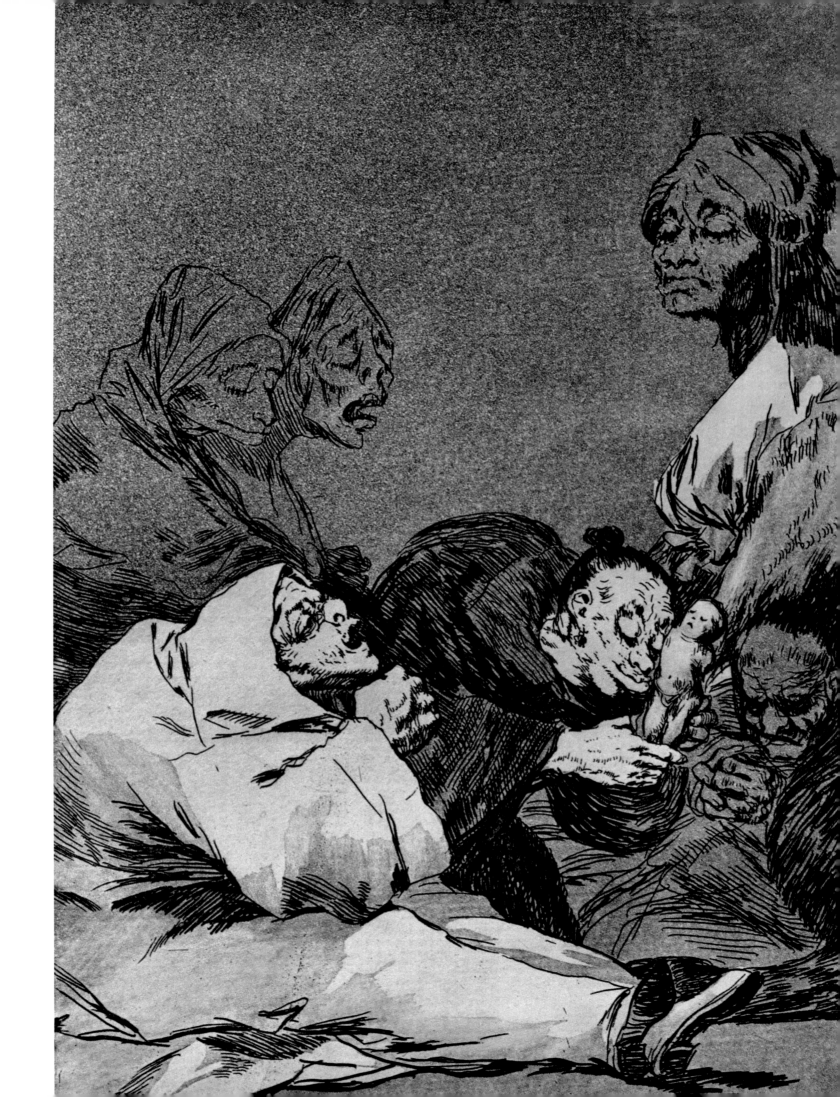

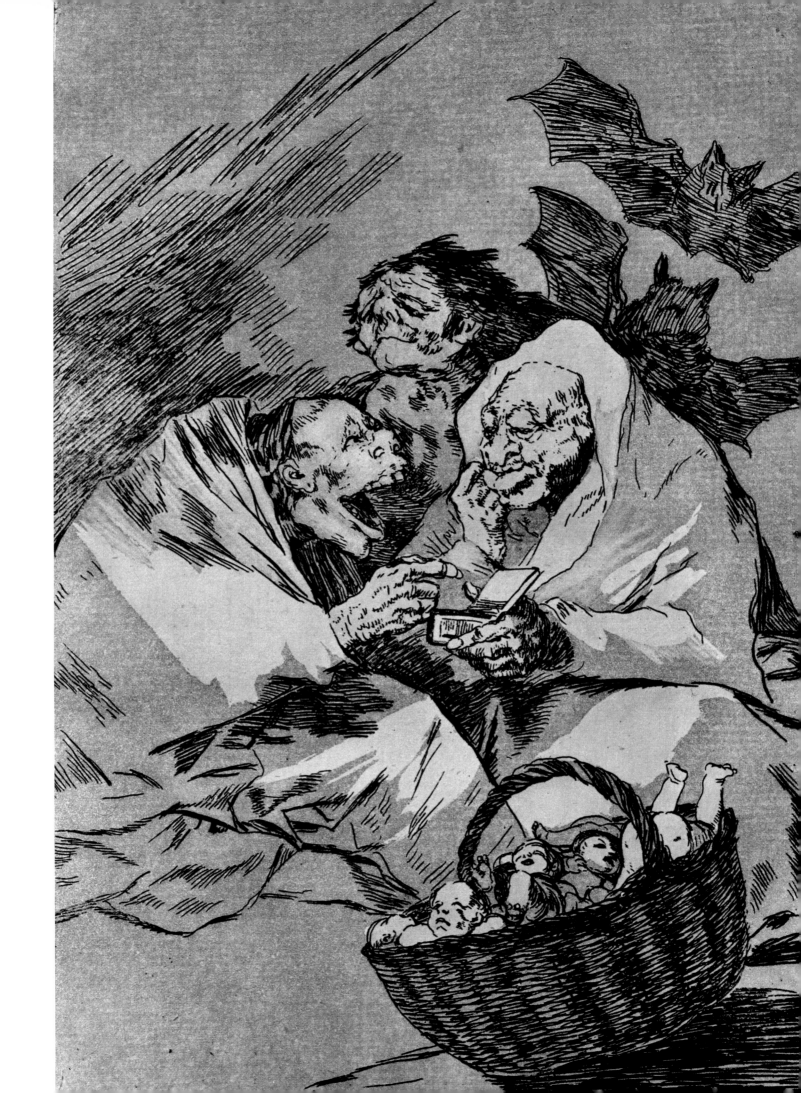

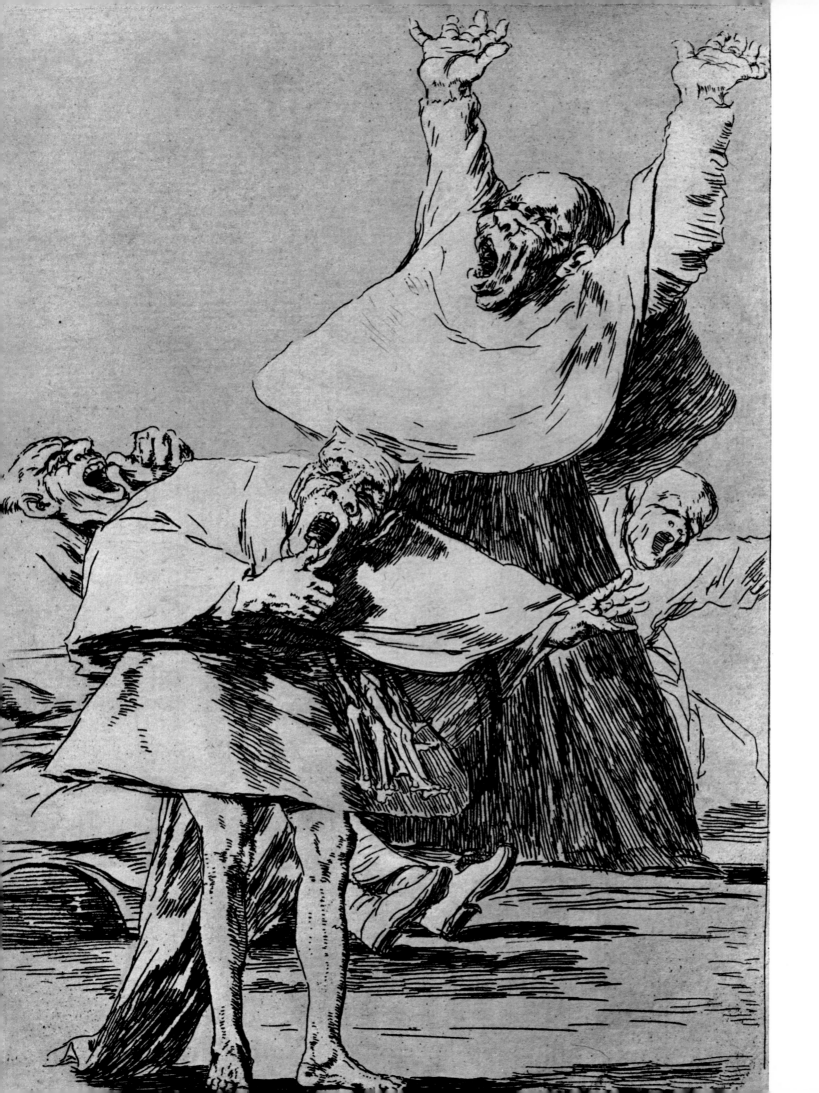

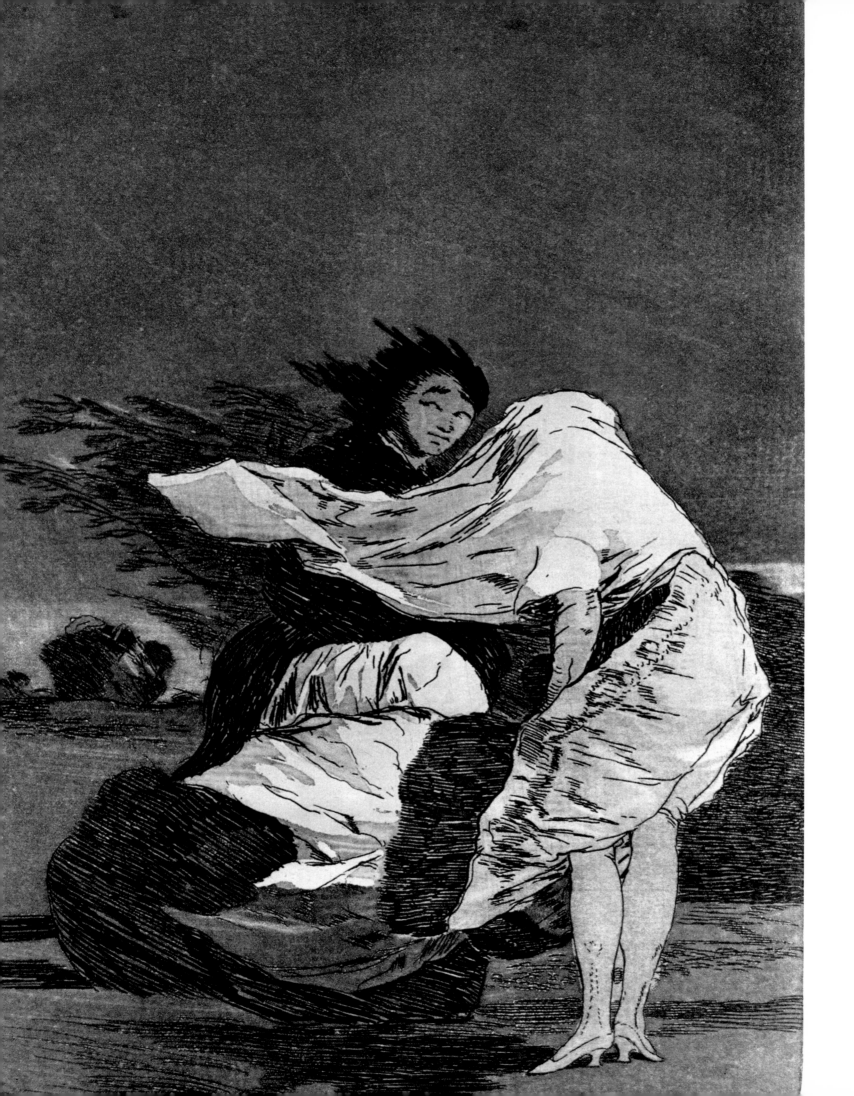

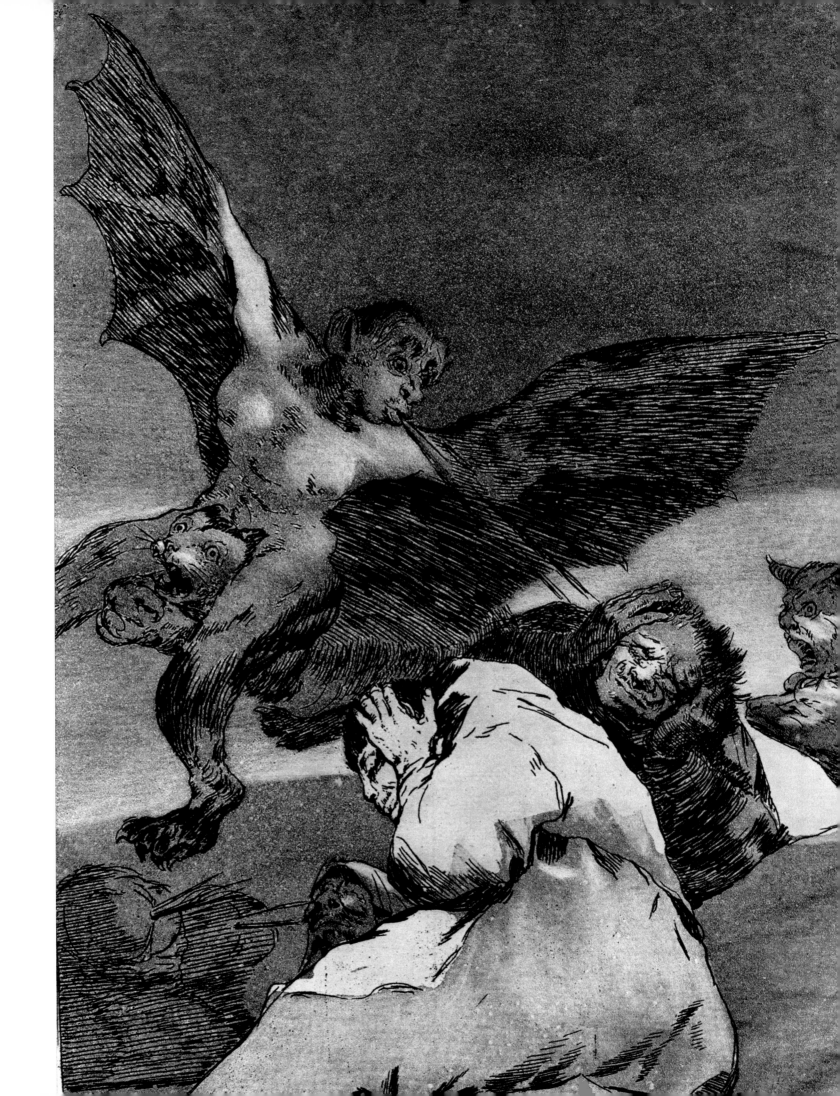

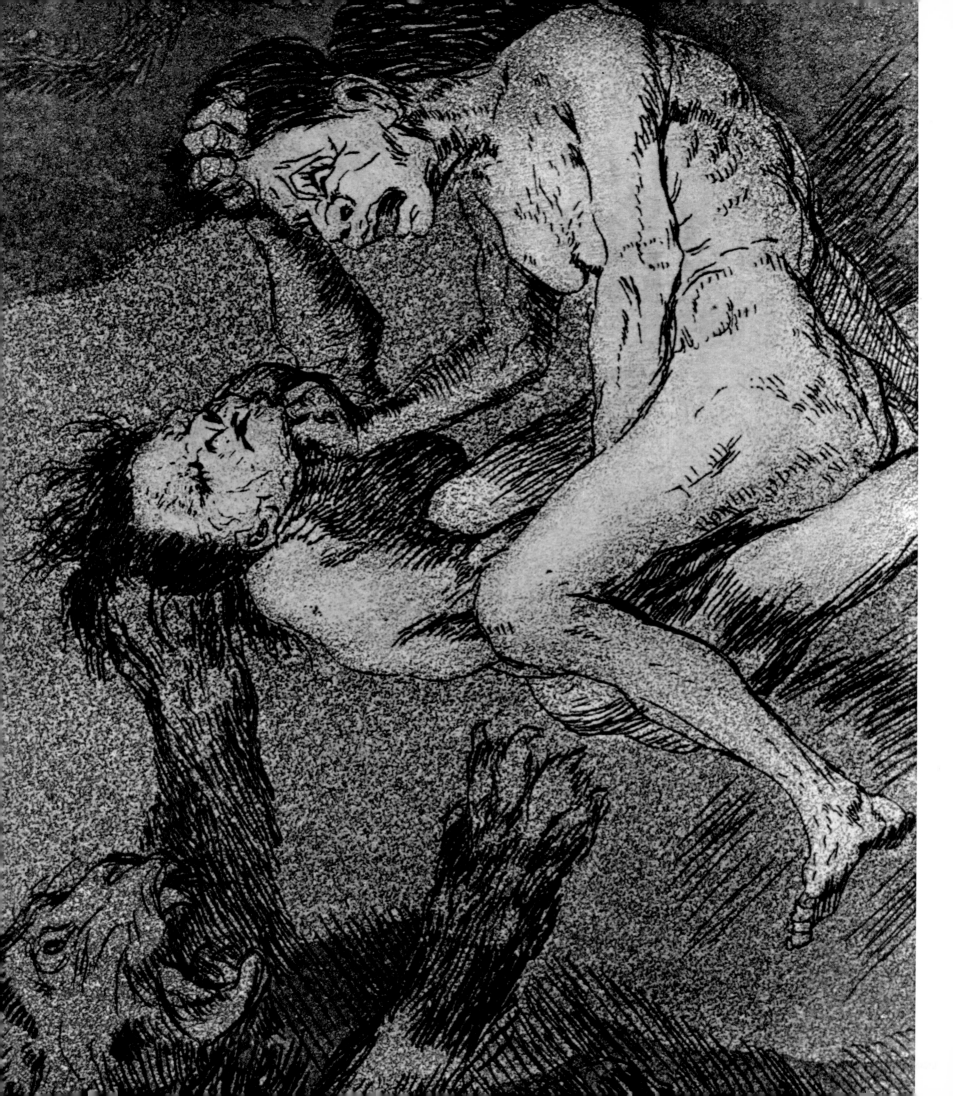

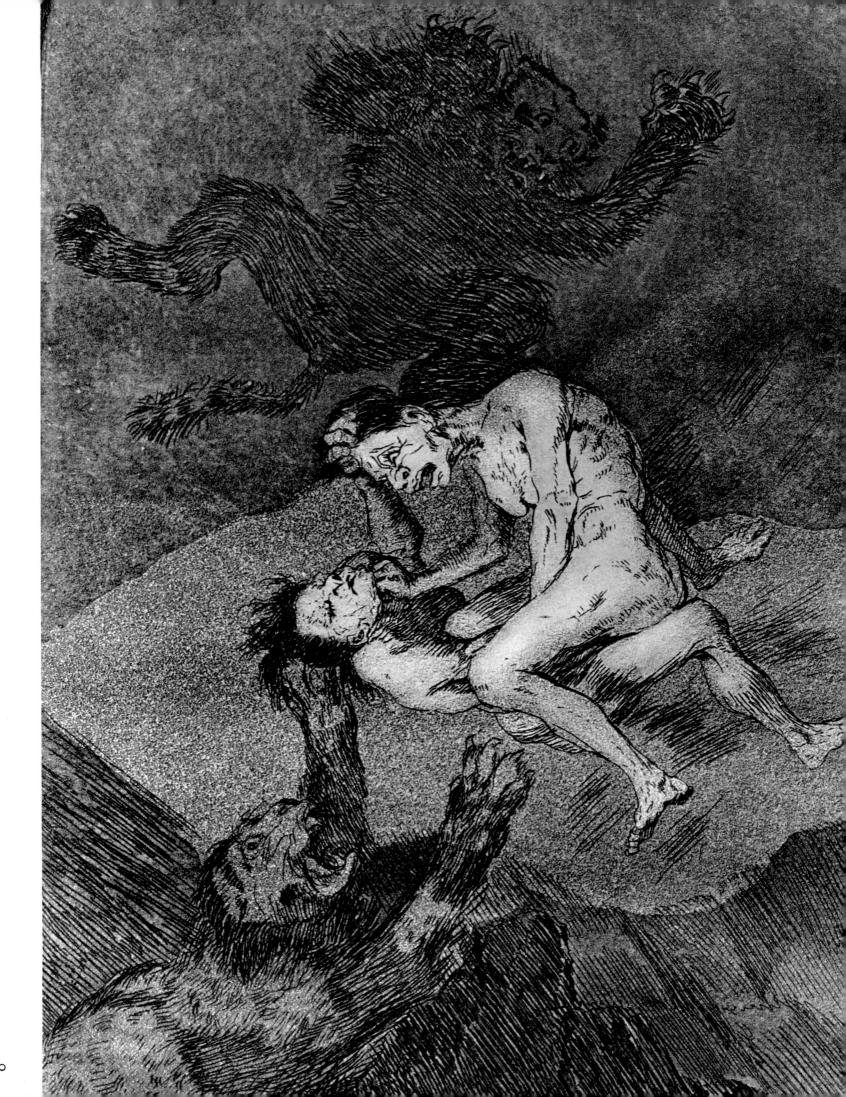

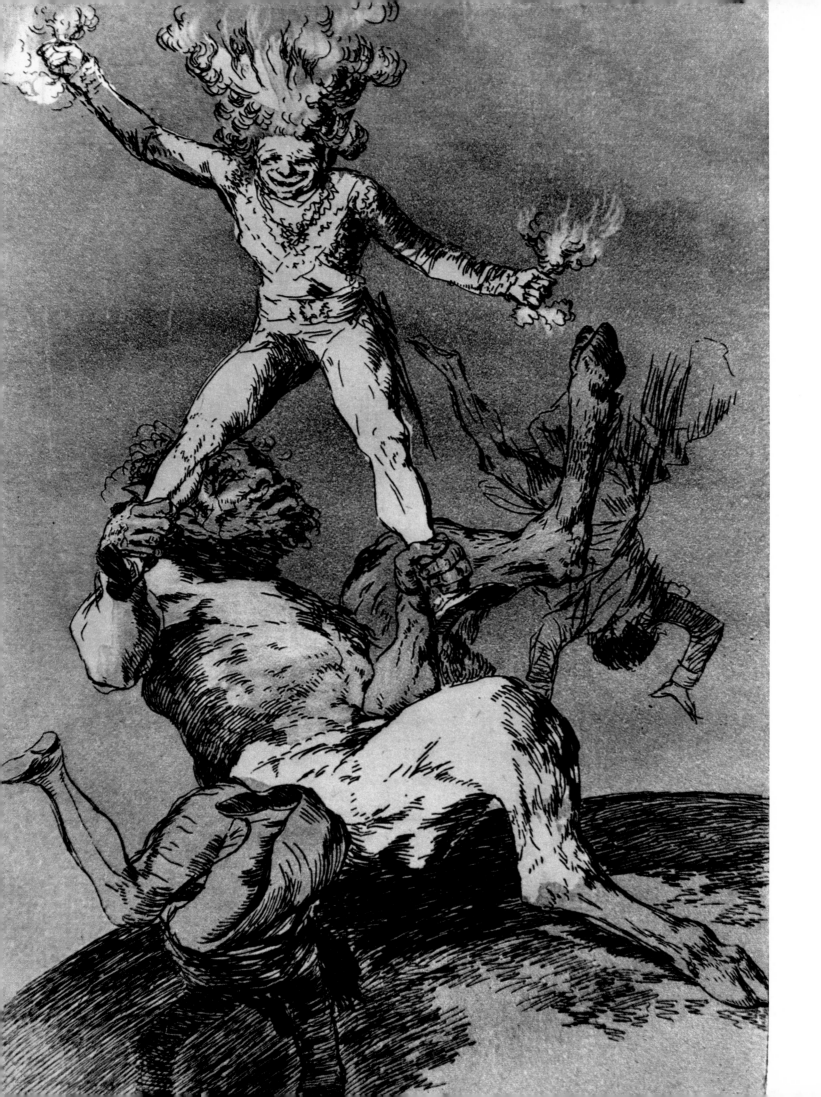

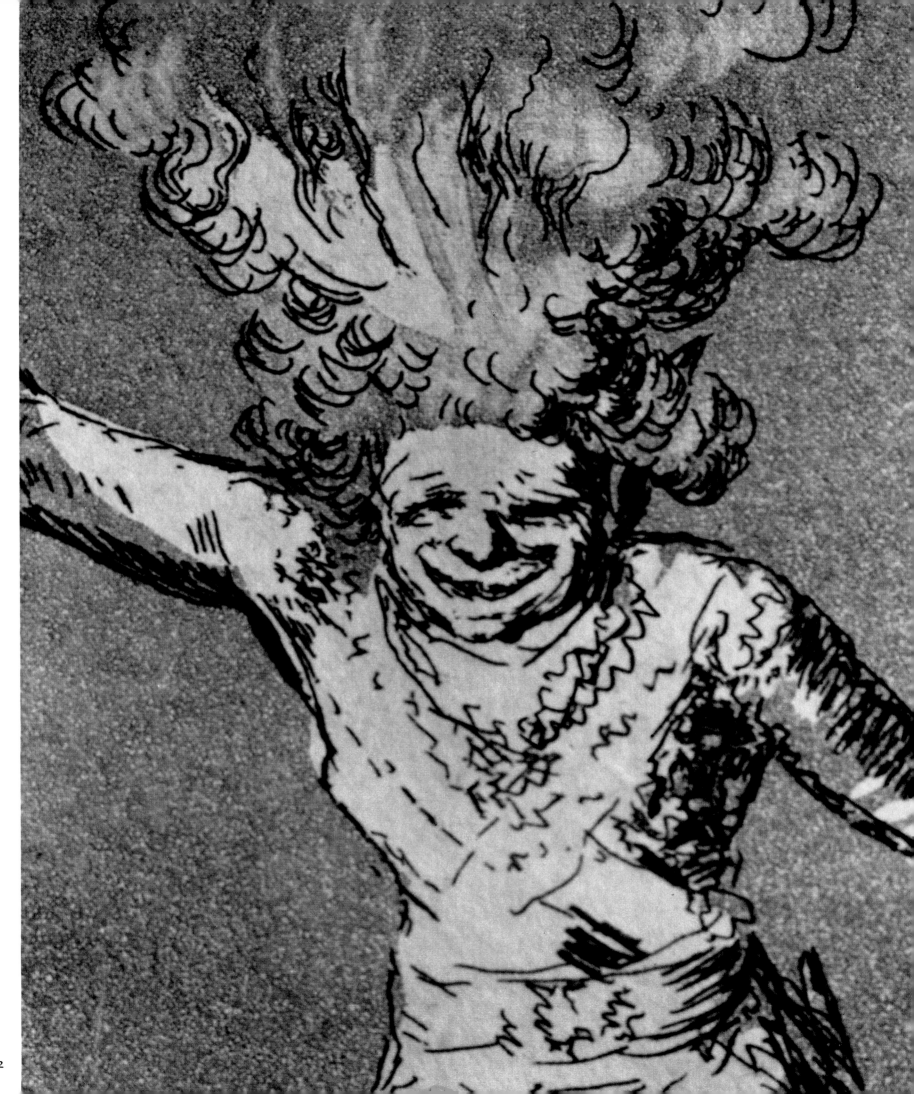

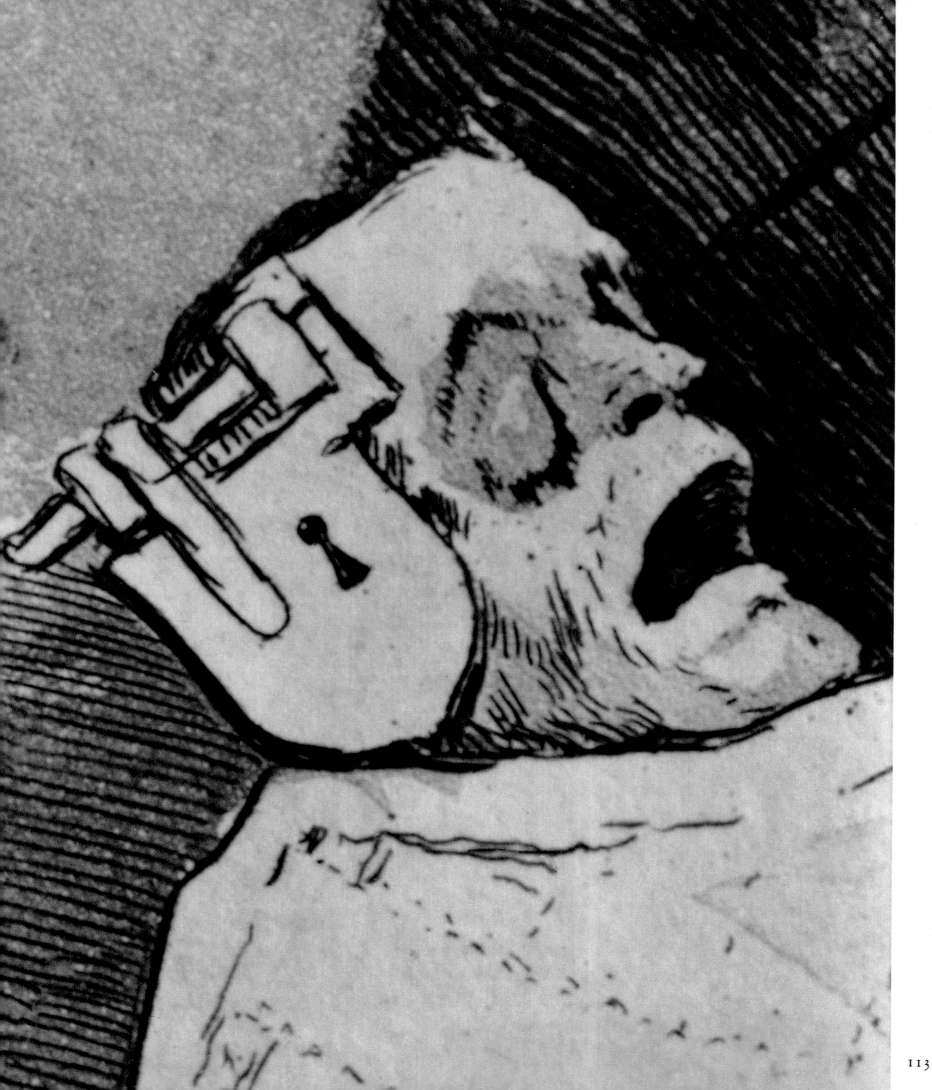

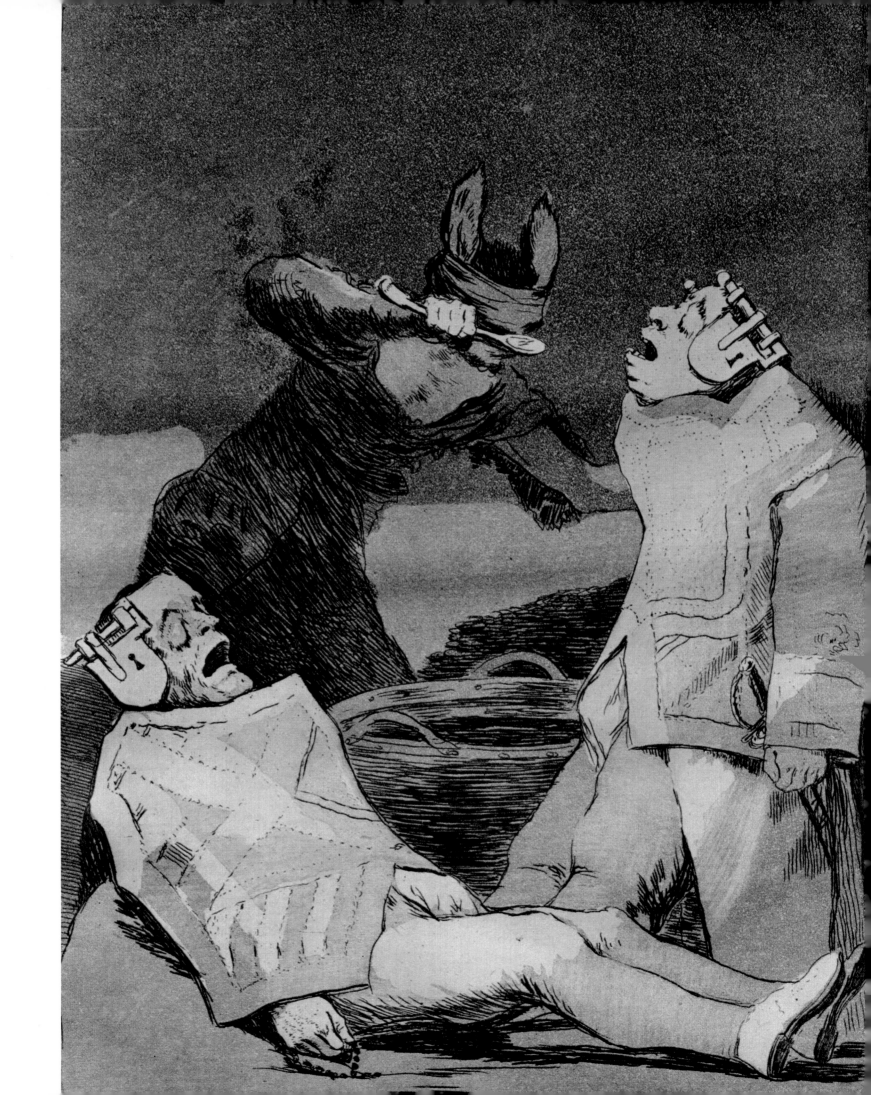

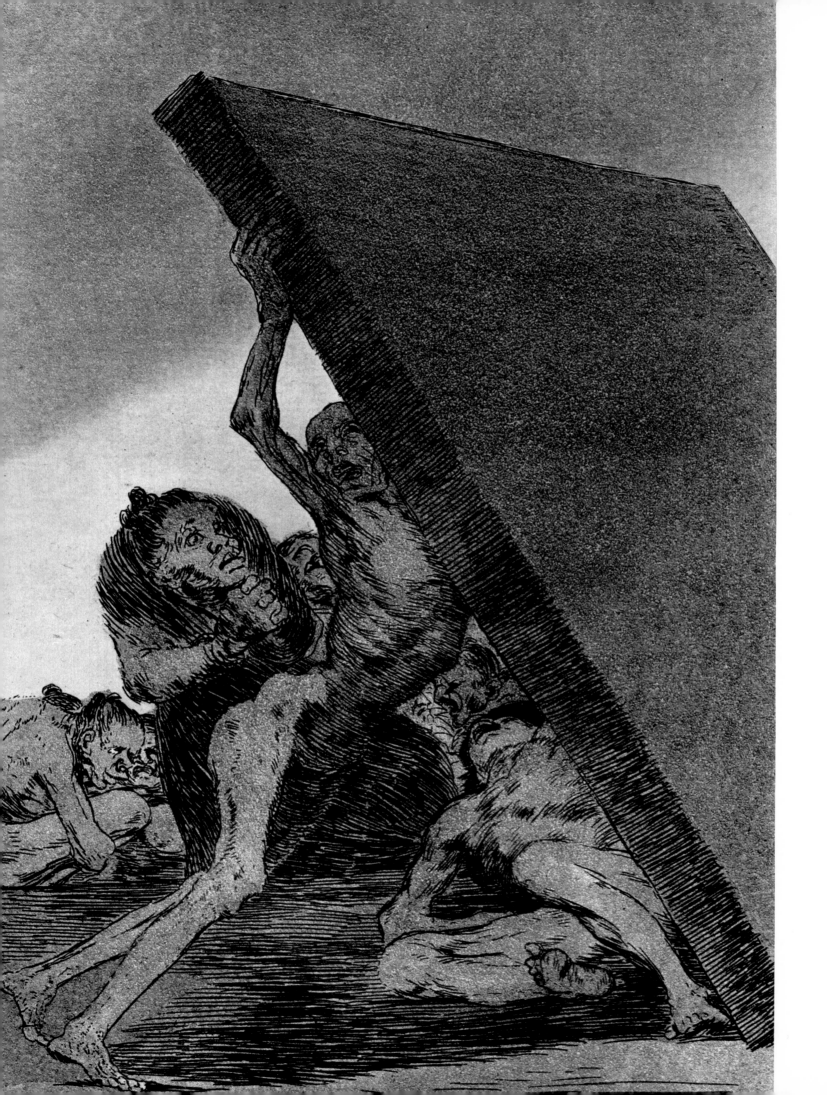

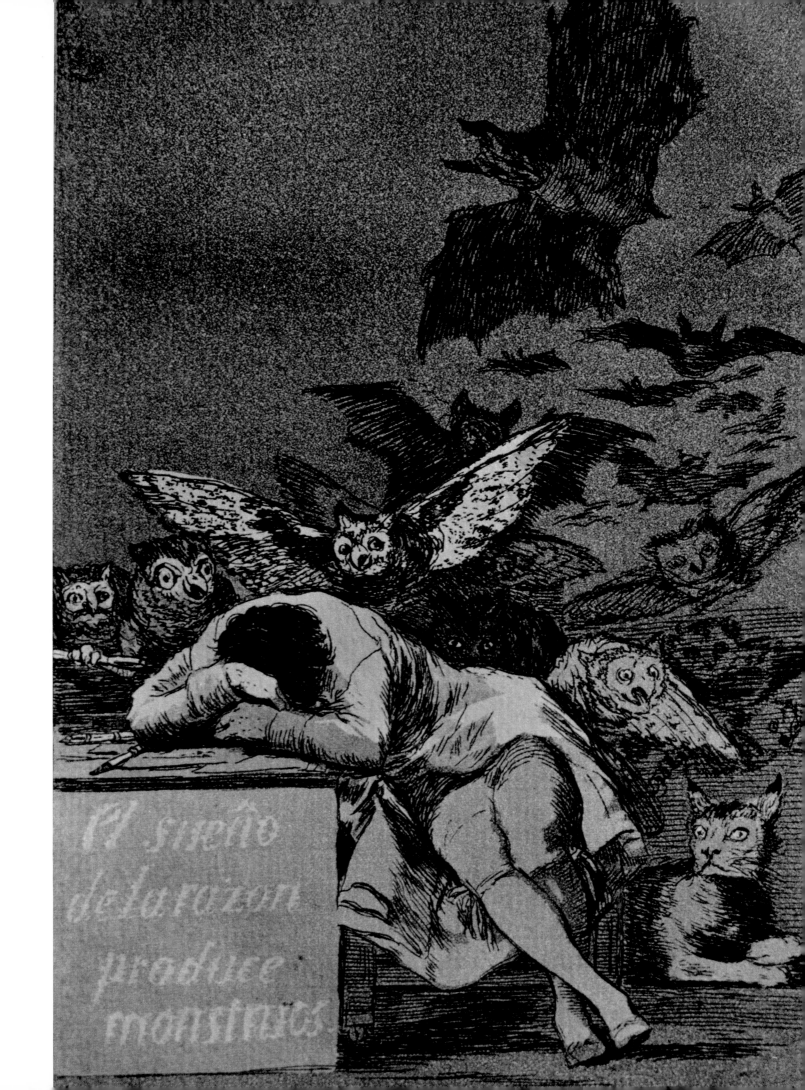

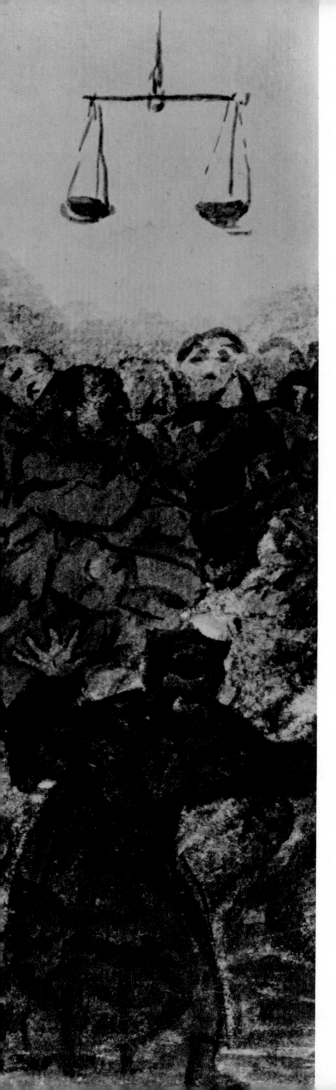

Drawings

From the riches of Goya's highly personal oeuvre of drawings, twenty-two sketches have been selected for this volume. Although they are not preliminary drawings for the etchings, they do function as both prelude and coda to the four great graphic cycles *Los caprichos, Los desastres de la guerra, Tauromaquia,* and *Los disparates.* At their head I have placed the fragment of a drawing, "The Light of Justice" (1820–24), which, with its cryptic, mysterious thematic content, may be taken as a symbol of Goya's work.

Scales balanced, held in an aura of light against the darkened sky: Is this the Last Judgment, or is it the new age that is to be ushered in by the year 1820? To the left stand the good, to the right the wicked, hopeful and despondent faces. Above the dark contours of the heads the scales hover motionless; they do not reveal their hidden truth.

For Goya, drawing was not merely a preparatory aid for the later graphic works and paintings. He considered drawing sovereign, a form of creative expression in itself. At times he drew on canvas with his brush or in the fresh plaster of a wall. Despite the spontaneity of his work, relationships inherent in the cyclical process are recognizable: stylistic harmonies, motifs, and periodic unities, which, though they can and do appear independently, emerge again and again in the complete work.

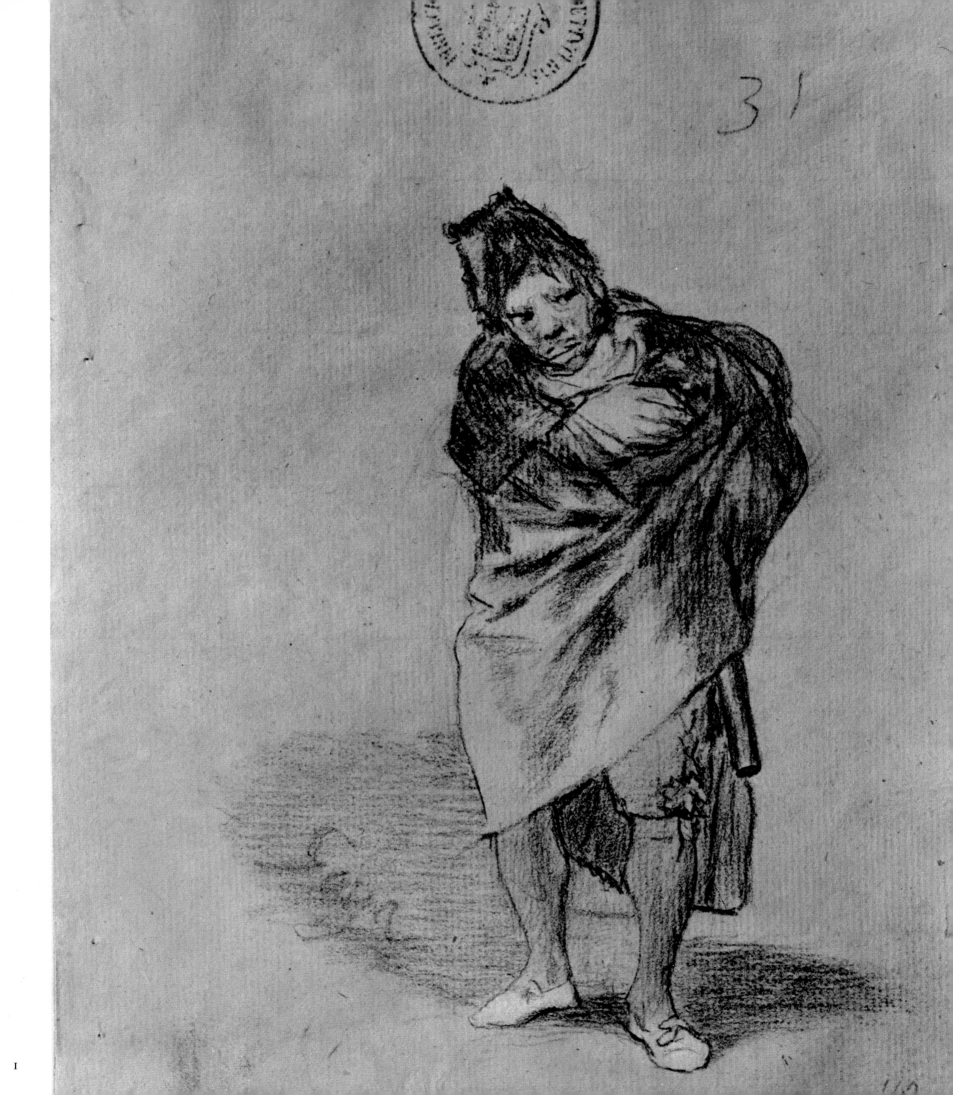

31

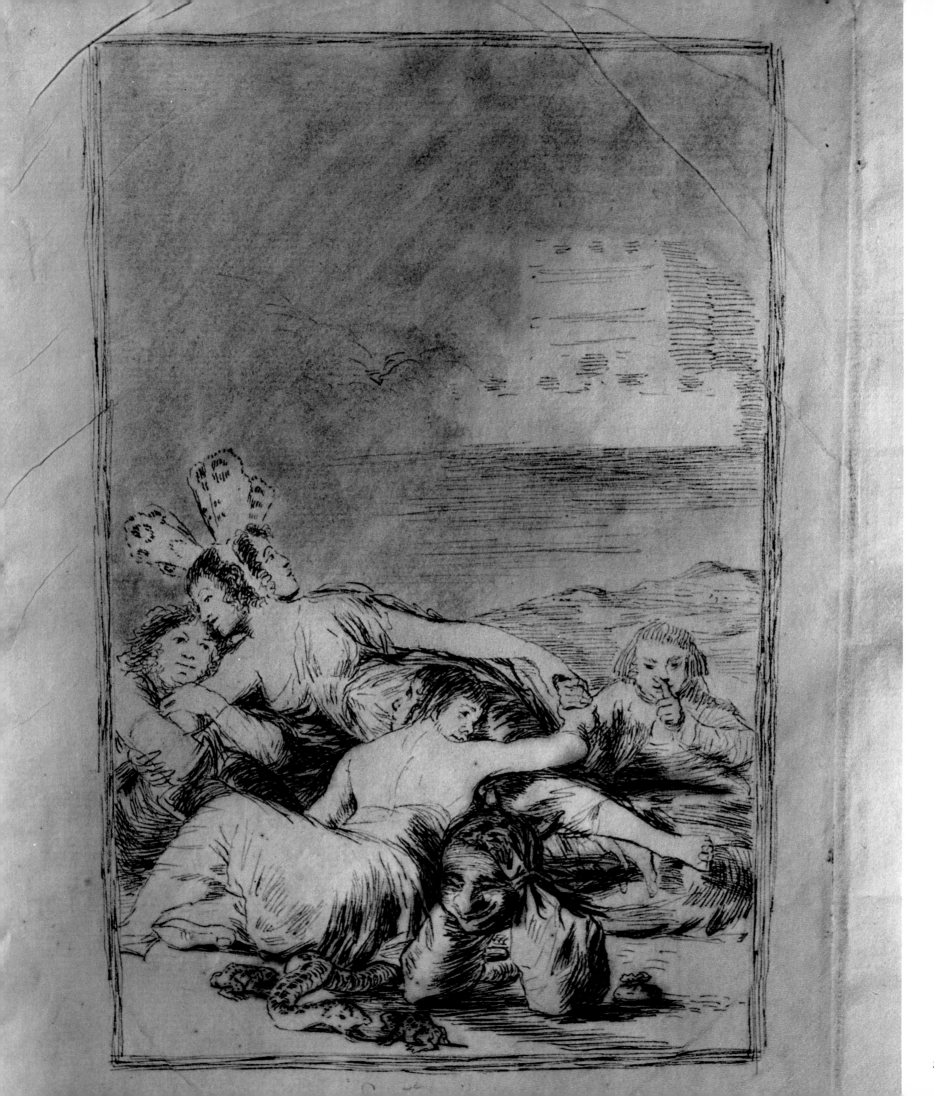

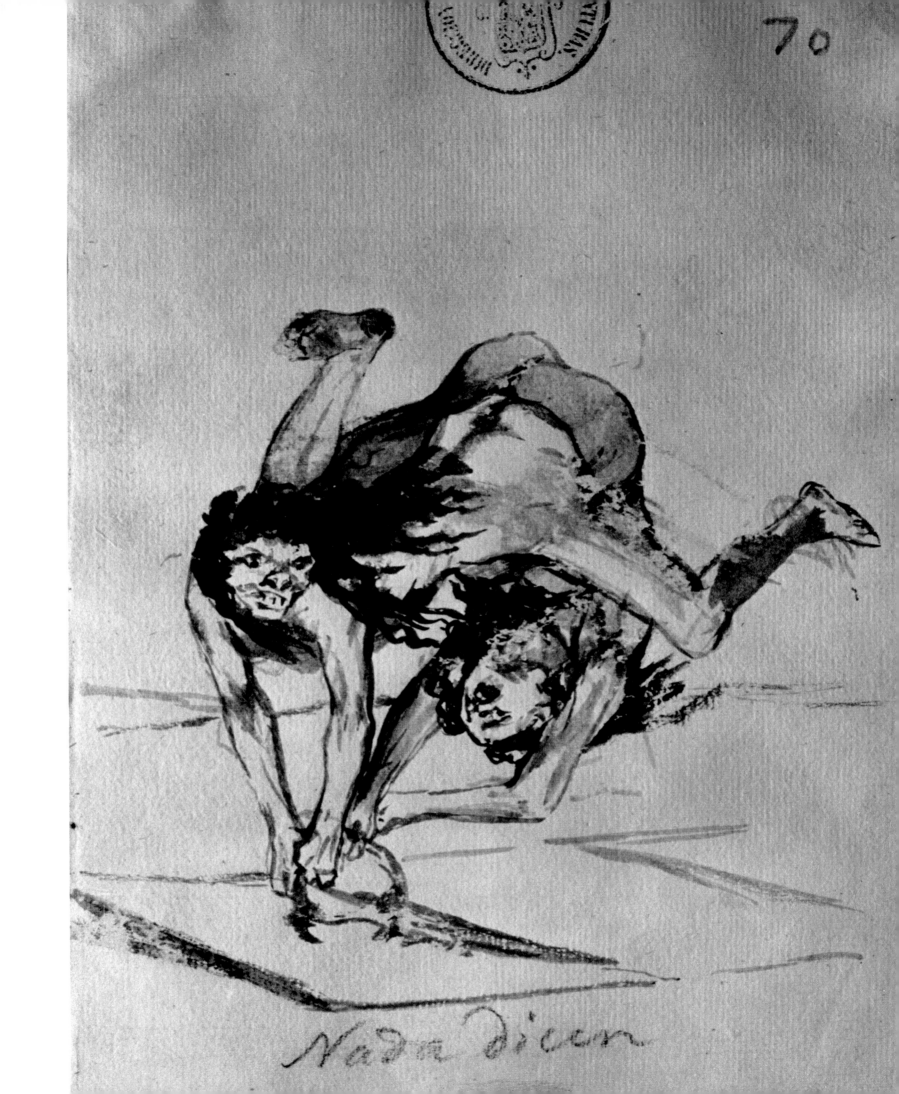

Nada dicen

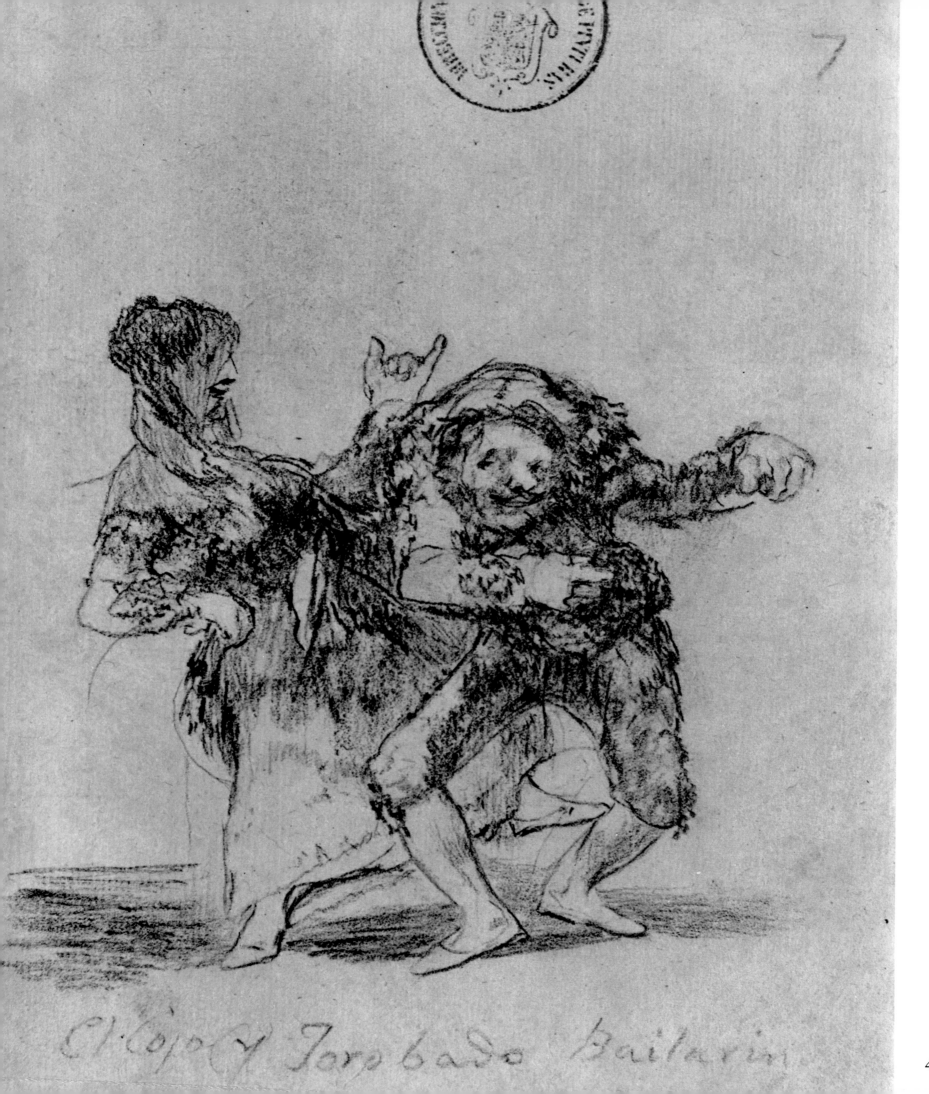

El Cojo y Jorobado Bailarines

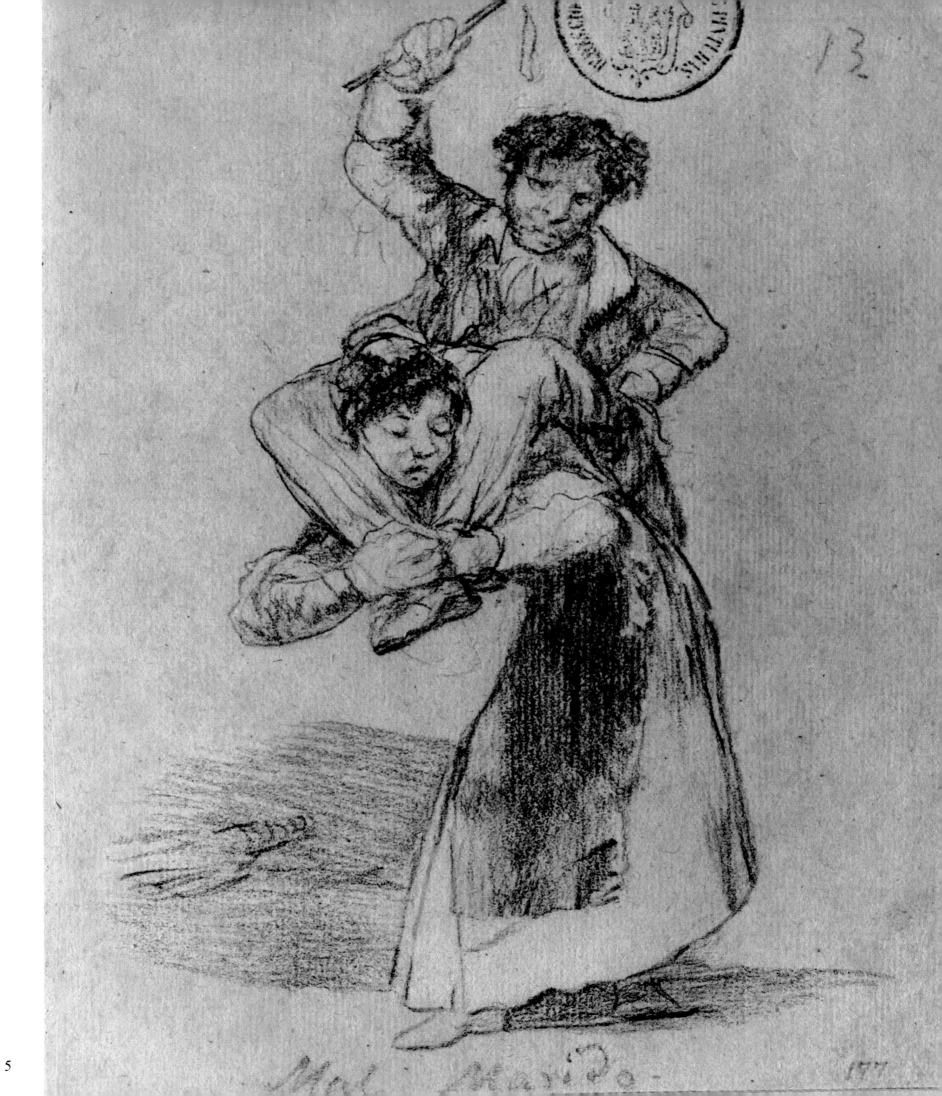

5

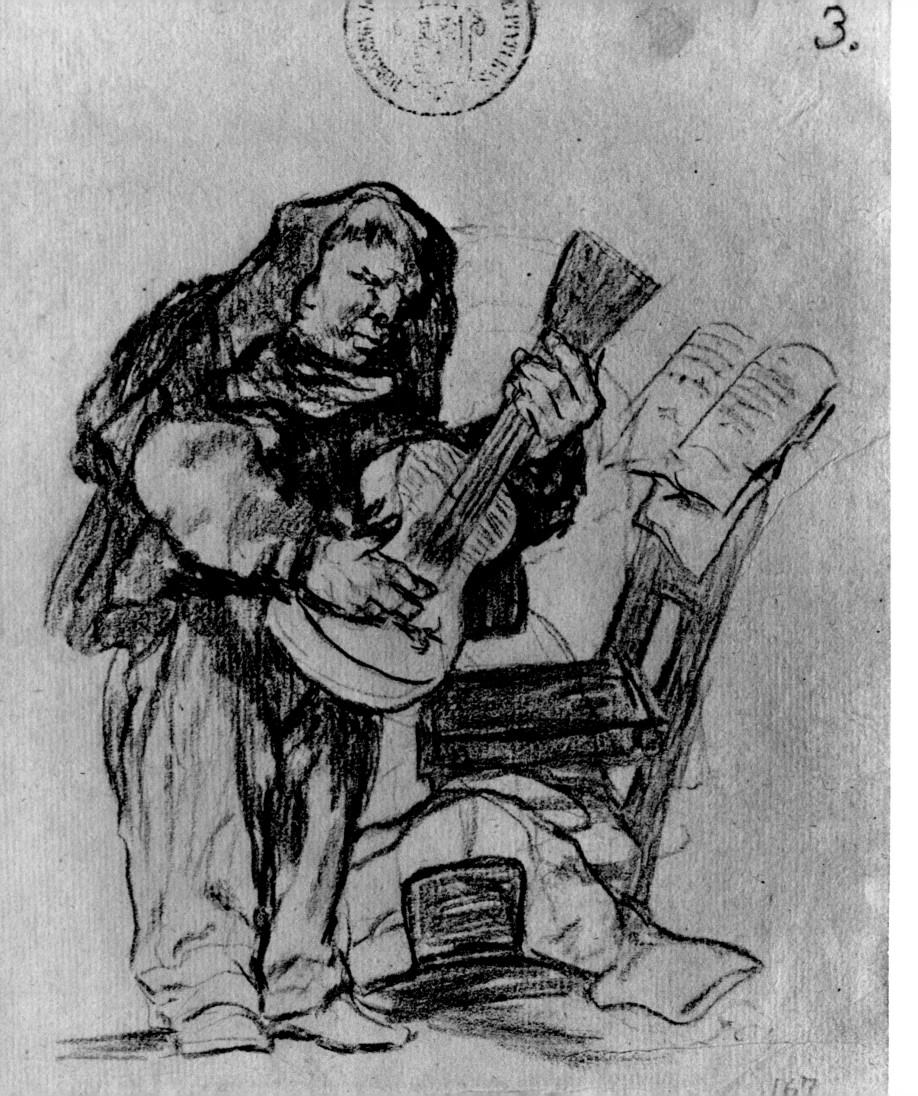

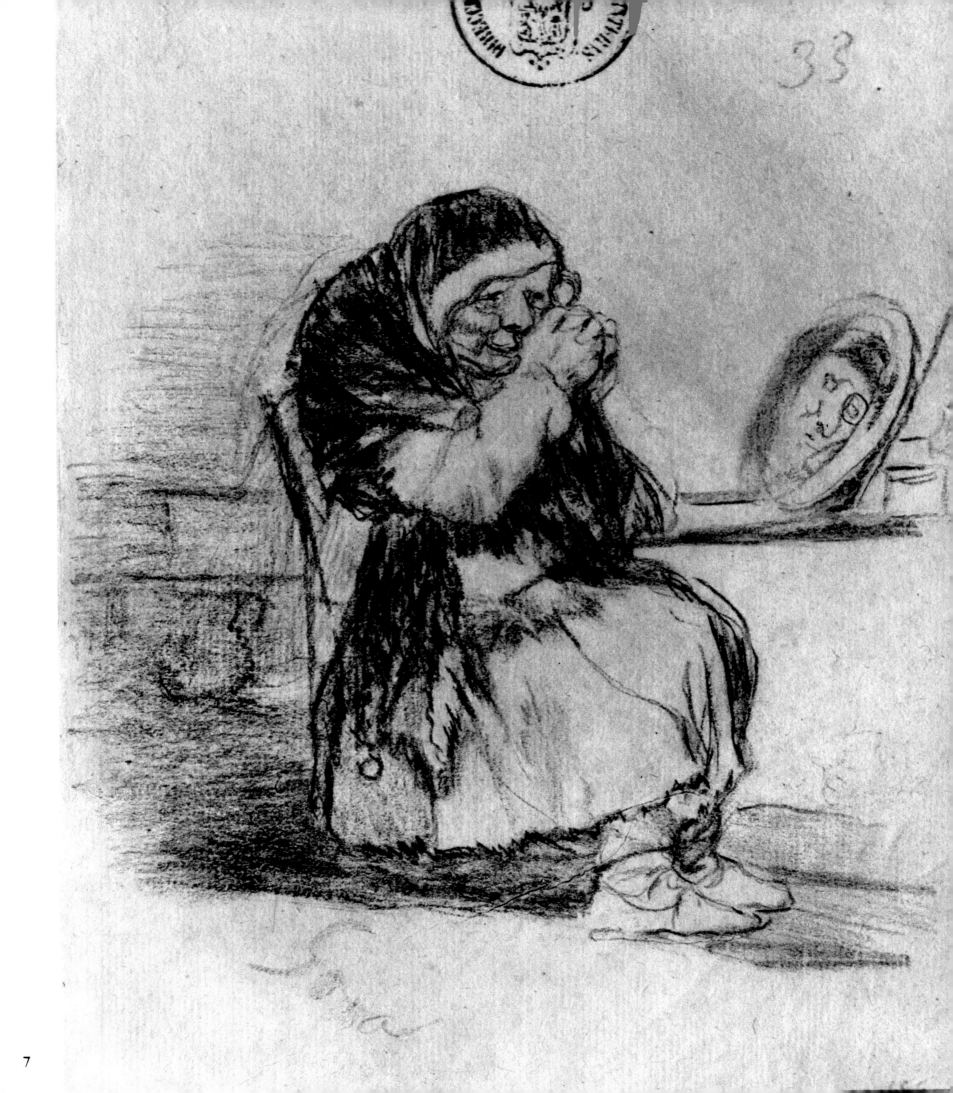

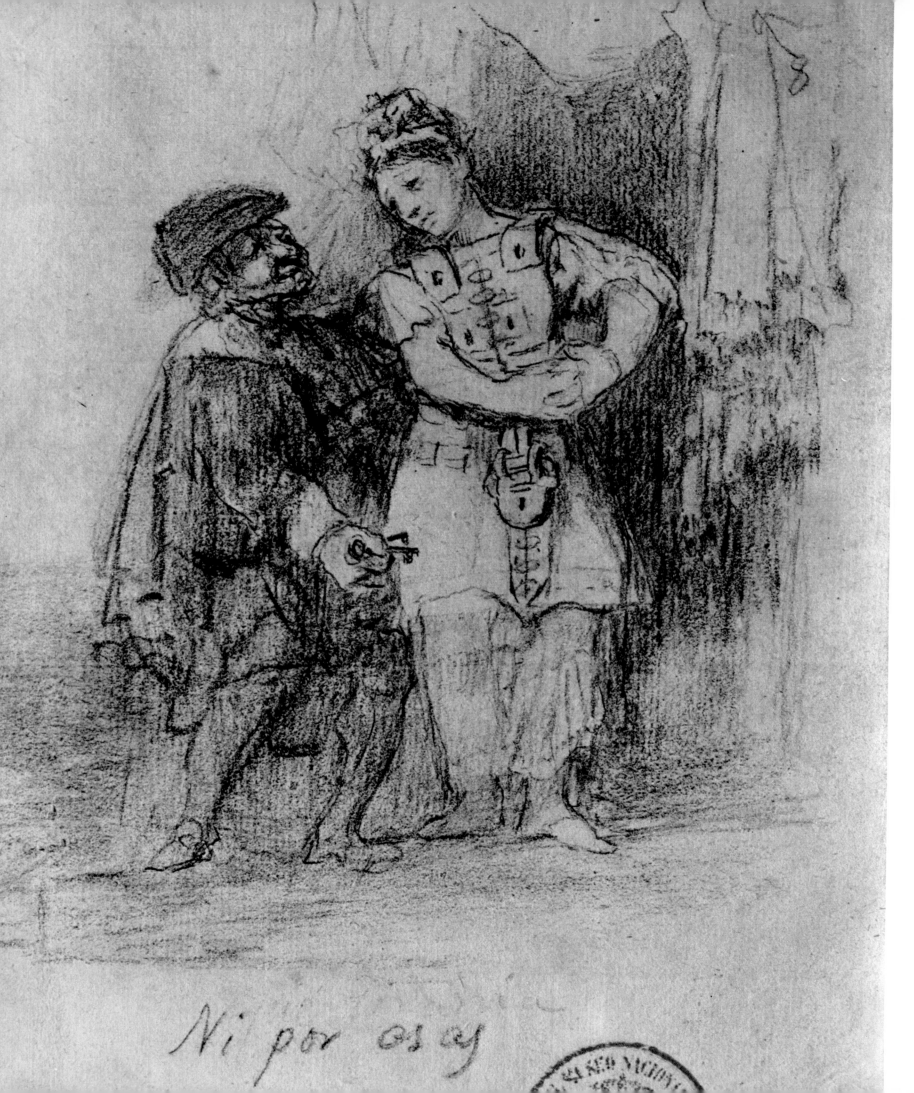

Ni por esas

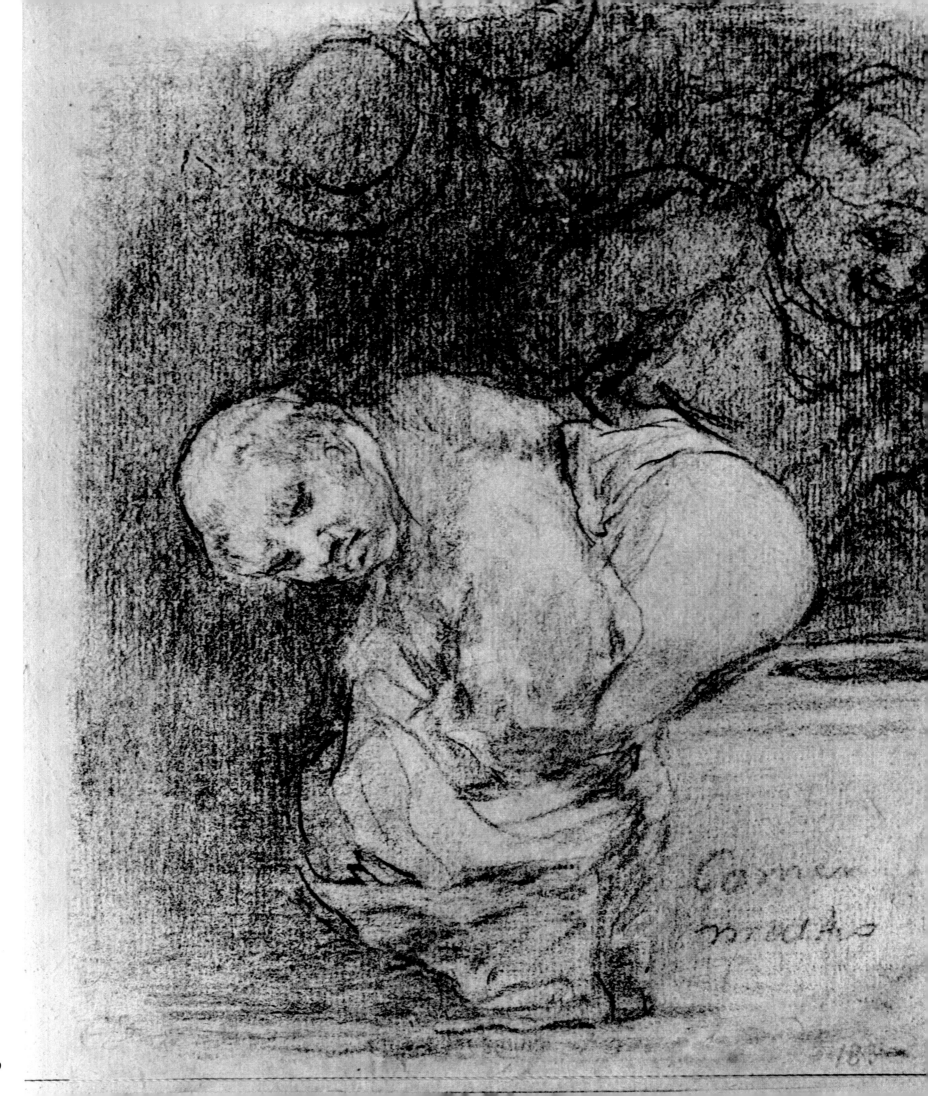

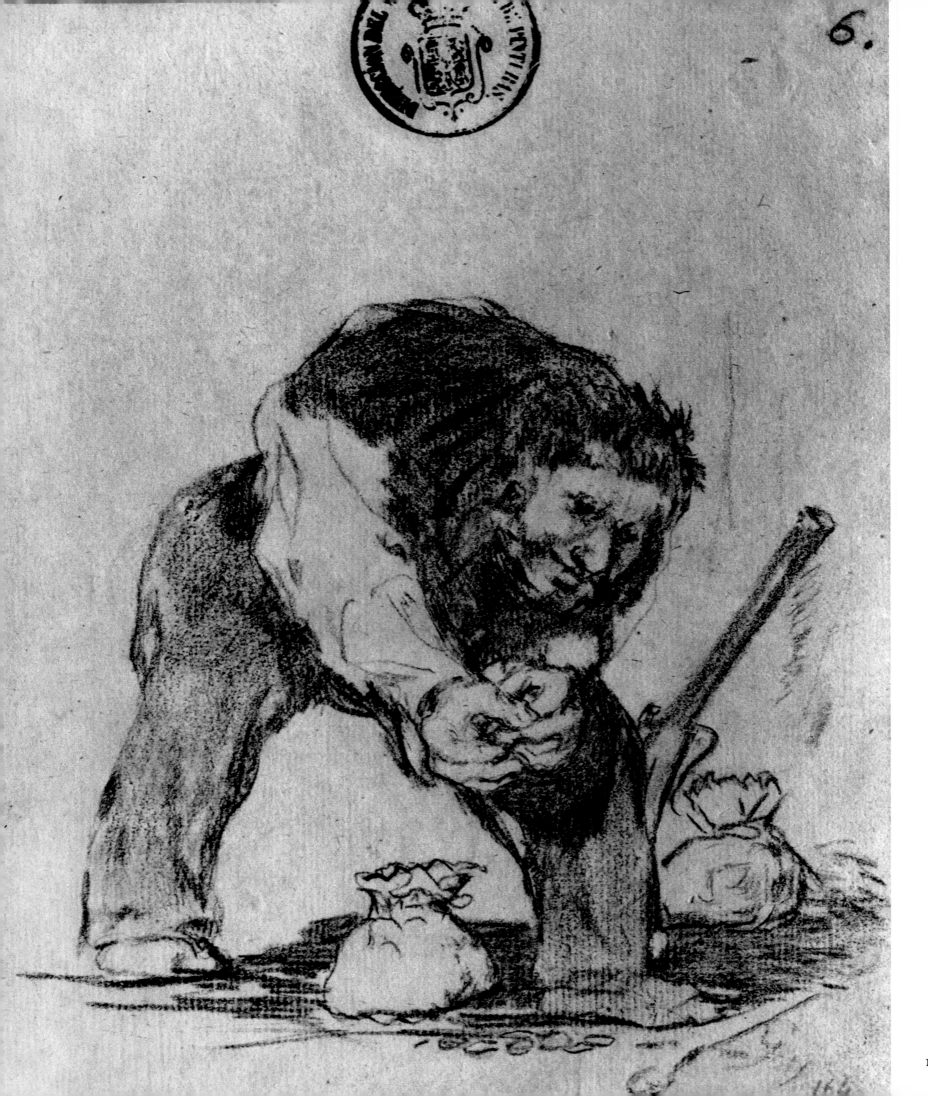

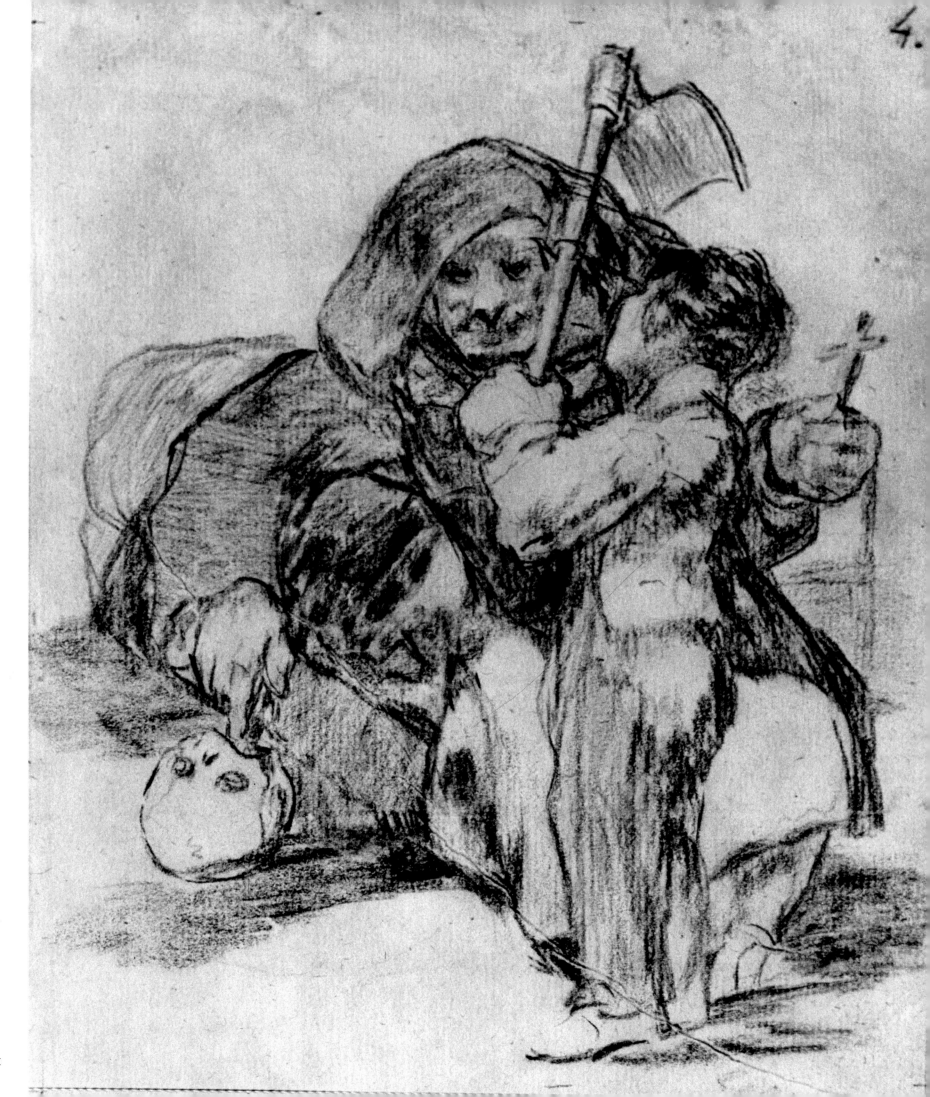

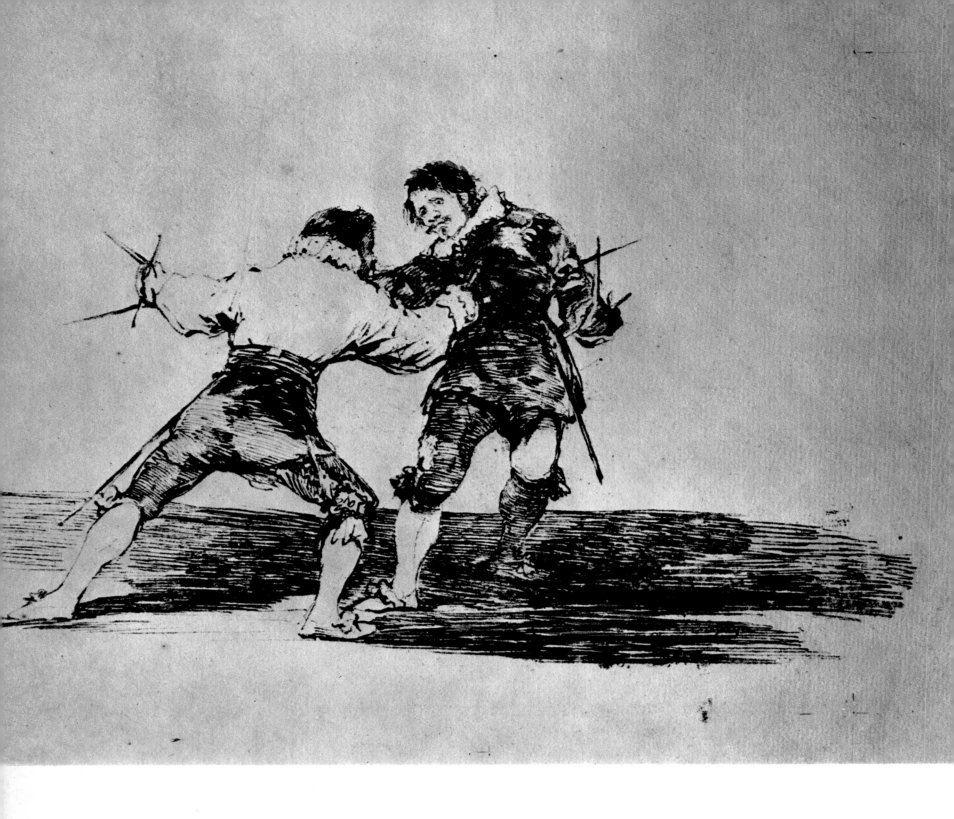

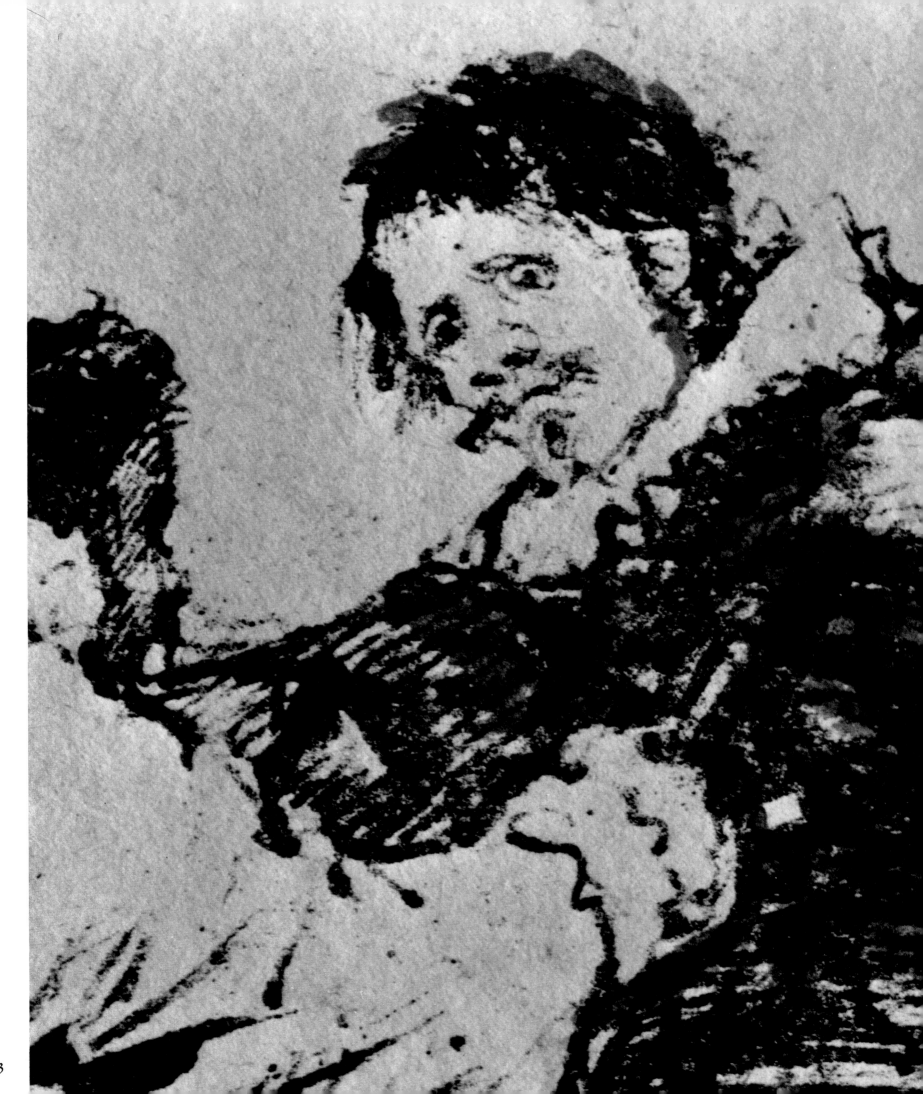

15

Habrazo Paternal

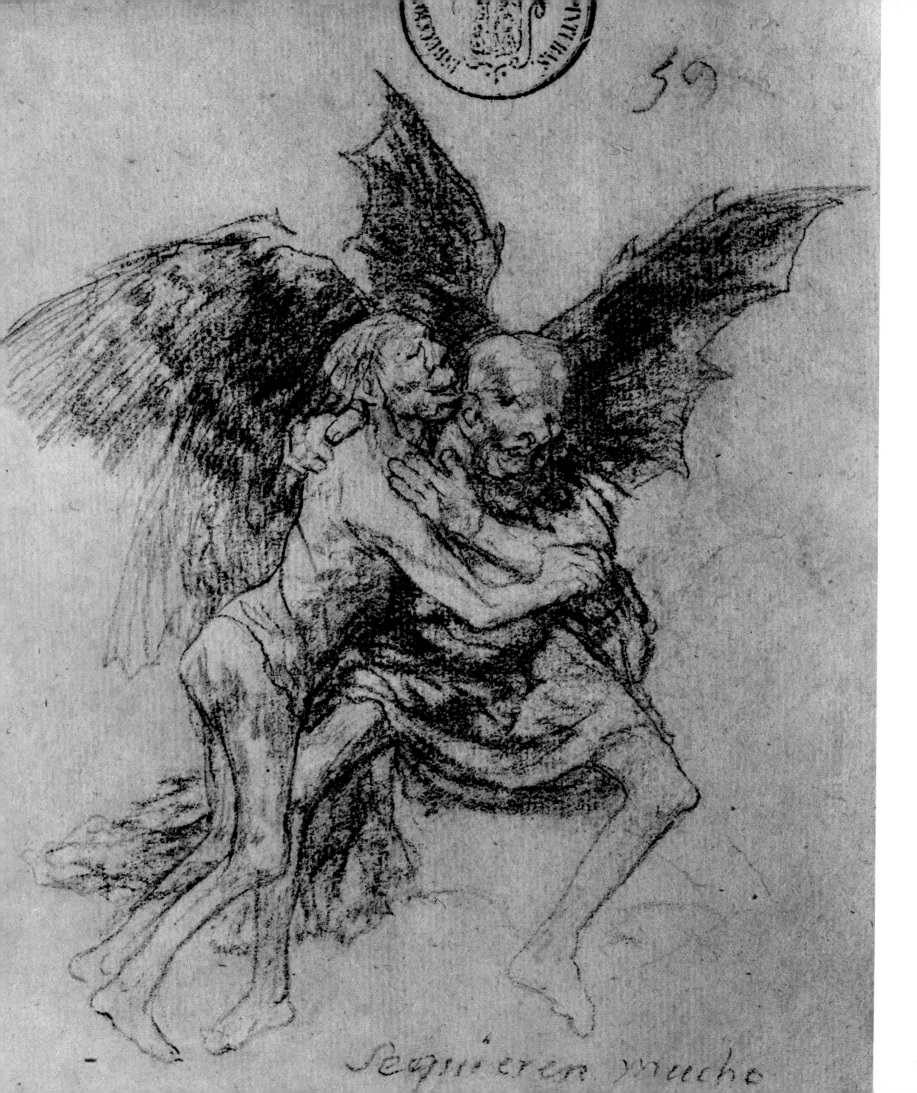

Seguiren mucho

16

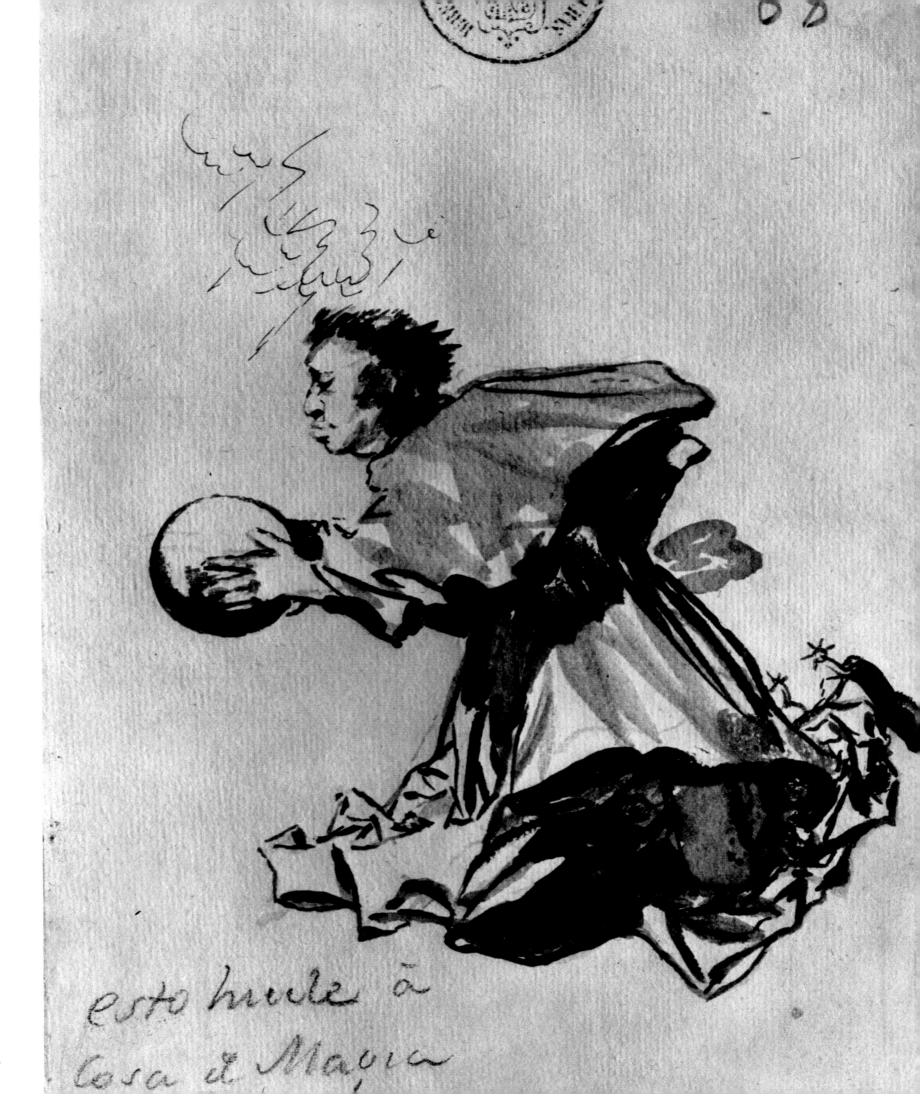

esto huele à
cosa d Mágia

17

¿q.ᵉ trabajo es ese?

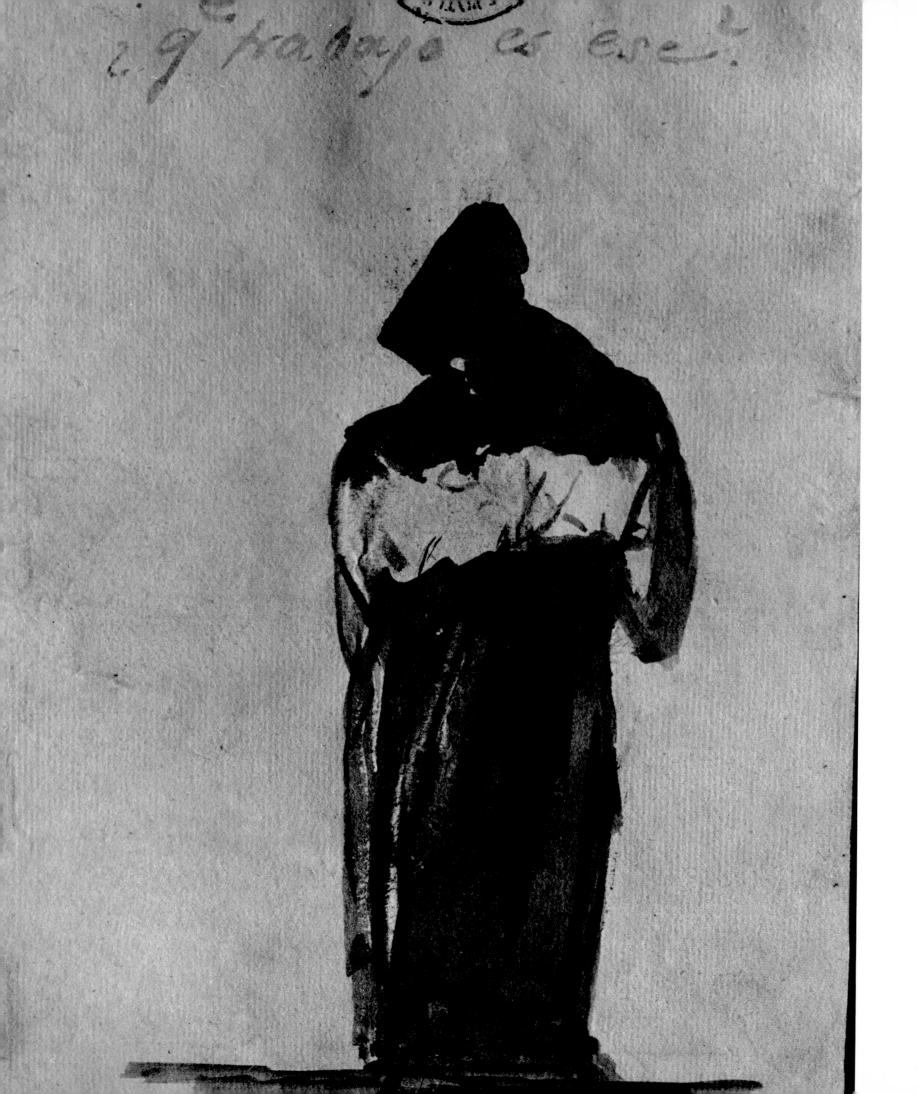

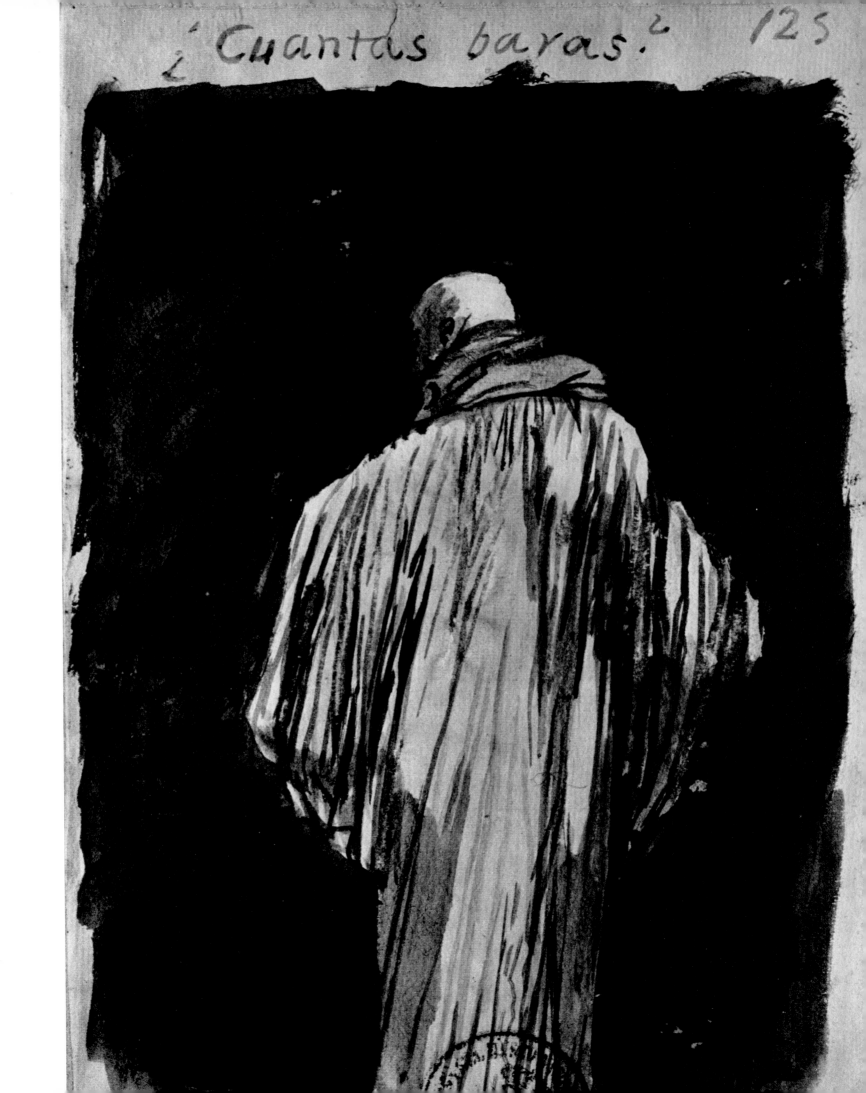

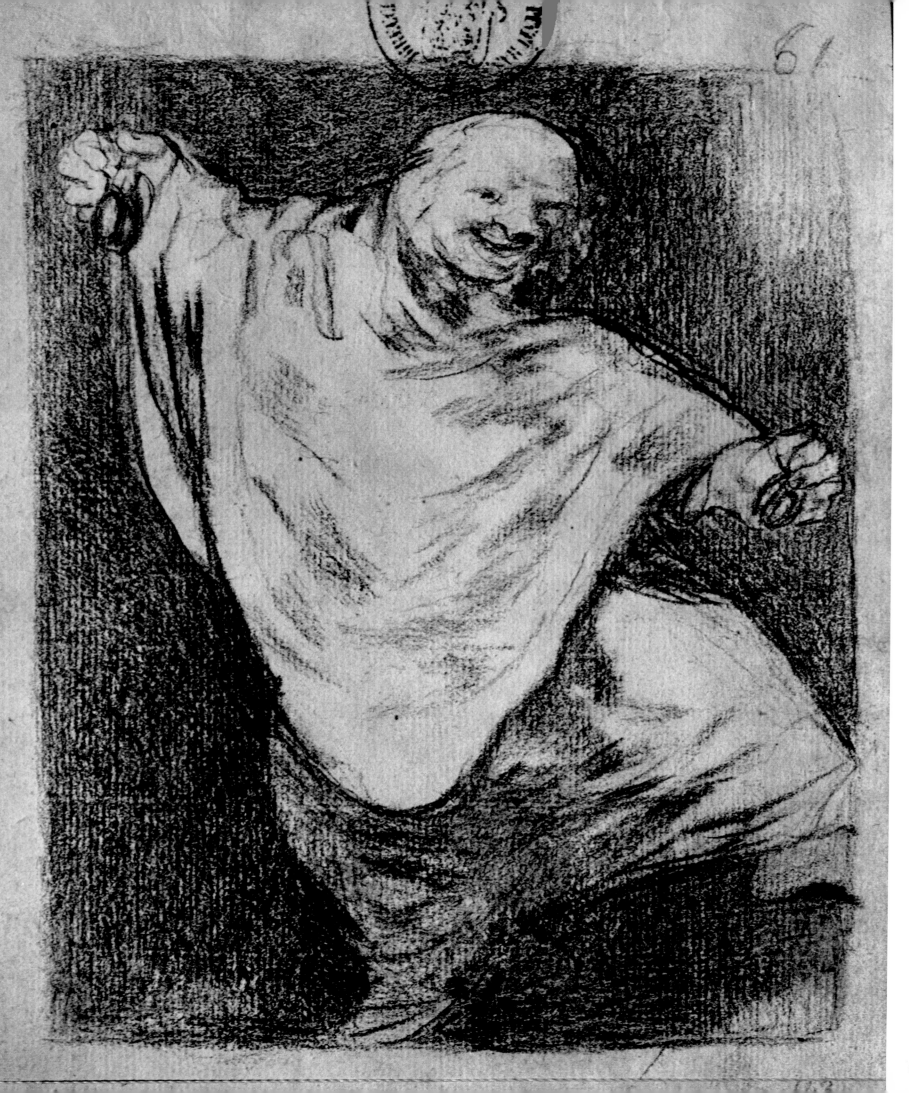

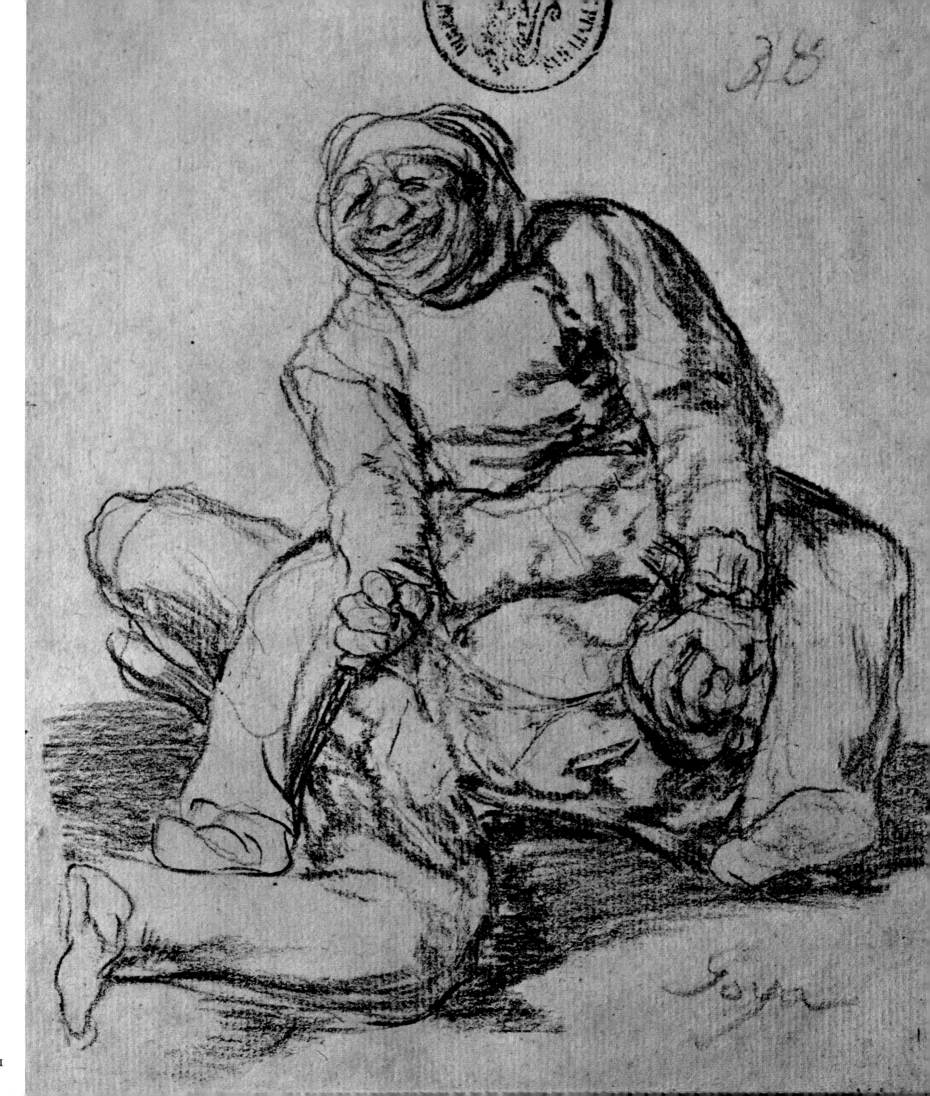

No lo encontraras.

Appendices

Al Conde Palatino.

Caprichos Plate 33

(Actual size)

Al Conde Palatino. (To the Count Palatine) 1797–1798
Etching and aquatint 215 × 150
G/W: 517 (To the Count Palatine). H: 68

Notes

The translations of the original captions, provided either by Goya himself or by his publishers, are widely divergent. The nuance of a single word or the delicate, often ambiguous, shades of meaning in a phrase—these are central to the meaning. Traces that might have led us back to Goya's own text have been obliterated in many instances. Important Goya scholars (e.g., Sánchez Cantón, Enrique Lafuente Ferrari, Pierre Gassier, and others) do not always provide uniform texts. Although for the most part this book has depended upon Pierre Gassier for technical information and dating, other solutions have been sought for the captions themselves.

Both the titles and the commentaries have been formulated only after careful consideration of the Spanish texts and of the various translations available in English. Consideration has also been given to the German translations provided in the catalog of the 1970 exhibition of Goya's graphic work in the Stuckvilla in Munich, since these appear especially close to the spirit of the Spanish titles Goya himself affixed.

1 Goya to Iriarte, January 4, 1794, MS Egerton 585, folio 74 verso, London, British Museum.

2 Ludwig van Beethoven, from his "Heiligenstadt Testament," October 6, 1802. In J. S. Shedlock, trans., *Beethoven's Letters* (1926; reprint ed., New York, 1972), p. 39.

3 F. J. Sánchez Cantón, *Los Caprichos de Goya y sus dibujos preparatorios* (Barcelona, 1949).

4 Charles Baudelaire, "Quelques caricaturistes étranges," first published in the magazine *Le Présent* (October 15, 1857), revised and reprinted in *Curiosités esthétiques* (1868), vol. 2 of his collected works, p. 426ff.

5 Aldous Huxley, "Variations on Goya," in *Themes and Variations* (New York, 1950), pp. 229–30.

6 Gaspar Melchor de Jovellanos, "Epistola satirica a Armesto," in Lafuente Ferrari, *Goya, Sämtliche Radierung und Lithographen* (Vienna and Munich, 1961).

7 Juan Riaz (ca. 1283–1351), Archpriest of Hita, *Libro de buen amor.*

8 C. Muñoz y Manzano, Conde de la Viñanza, *Goya: su tiempo, su vida, sus obras* (Madrid, 1887).

9 Baudelaire, op cit.

10 Fray José de Siguença, *Tercera parte de la historia de la Orden de S. Gerónimo* (Madrid, 1605), as quoted in R. H. Marijnissen, K. Blockx, P. Gerlach et al. (M. Seidel, photographer), *Jheronimus Bosch* (Brussels, 1972).

11 Translated in August L. Mayer, *Francisco de Goya* (London, 1924), p. 92.

12 Enrique Lafuente Ferrari, *Goya: His Complete Etchings, Aquatints and Lithographs* (New York, 1962), p. ii.

13 Thomas Mann, taken from a conversation with the author in Kilchberg bei Zürich, May 23, 1953.

14 Xavier de Salas, foreword to Pierre Gassier, *Francisco Goya, Drawings: The Complete Albums* (New York, 1973), p. 6.

Catalog of Illustrations

Los Caprichos

Introductory remarks

For this volume the sequence of the plates of the Caprichos has been arranged thematically. Further information may be found in the following two volumes:

Pierre Gassier and Juliet Wilson, *The Life and Complete Works of Francisco Goya* (New York, 1971) (abbreviated in the following catalog as G/W). Tomás Harris, *Goya, Engravings and Lithographs*, 2 vols. (Oxford, 1964) (abbreviated as H). The first edition of the Caprichos, the sequence of which was arranged by Goya himself, appeared in 1799. A total of twelve editions were printed from the original copper plates between 1799 and 1937. The final prints were preceded each time by several proof pullings. In addition to the preparatory drawings themselves and to the sketchbooks from Sanlúcar and Madrid, there are also drawings extant collected under the title *Sueños* (Dreams), which were preliminary to the Caprichos. Each of the eighty engravings is accompanied by a commentary. The Spanish titles were added directly by the artist either to the plates themselves or to the proofs. The originals of the etchings pictured here are in the Stiftung Oskar Reinhart, Winterthur. These are pages from the first edition of 1799 on heavy, soft, unwatermarked, handmade paper. The quality of the printing and the condition of the pages themselves would indicate that it is one of the later impressions from the first edition of approximately 300.

The average size of the pages is 320 × 220 mm. The size of the plates corresponds to the information provided by Harris and is given in millimeters, the height preceding the width.

The original copper plates are currently in the Calcografía Nacional in Madrid.

The English titles are those of the translator; those used by Pierre Gassier and Juliet Wilson are also noted.

Each catalog entry is arranged as follows:
The number of the Caprichos plate (or in some cases an indication of a detail view); the original title and the English translation; the year of origin; the technique (corrections with drypoint or burin are not noted); the size; the number and English title in G/W; the number in H; a notation of signature if one is present; a list of extant preparatory drawings.

1 Caprichos Plate 1

Fran.co Goya y Lucientes, pintor. (self-portrait)
1797–1798
Etching and aquatint 215 × 150
G/W: 451. H: 36
A preparatory drawing in red crayon, 1797–1798, is in a private collection in New York. On the verso of the same page are two self-portrait sketches in red crayon.

2 Detail of Ill. 1
(Caprichos Plate 1)

3 Detail of Ill. 19
(Caprichos Plate 35)

4 Detail of Ill. 5
(Caprichos Plate 17)

5 Caprichos Plate 17

Bien tirada está. (It must fit snugly) 1797–1798
Etching and aquatint 250 × 150
G/W: 485 (It is well pulled up). H: 52
A preparatory drawing in red crayon, 1797–1798, is in the Prado, Madrid (No. 52). The first version, in india ink wash, 1796–1797, is in the Sanlúcar Album (A. j).

6 Detail of Ill. 5
(Caprichos Plate 17)

7 Caprichos Plate 18

Y se le quema la casa. (And his house is burning)
1797–1798
Etching and aquatint 215 × 150
G/W: 487 (And his house is on fire). H: 53
A preparatory drawing, Sueño, in pen and sepia ink, 1797–1798, is in the Prado, Madrid (No. 21). The first version, in india ink wash, 1796–1797, is in the Madrid Album (B. 86).

8 Caprichos Plate 31

Ruega por ella. (She prays for her) 1797–1798
Etching and aquatint 205 × 150
G/W: 513 (She prays for her). H: 66
A preparatory drawing in red crayon, 1797–1798, is in the Prado, Madrid (No. 59). The preliminary sketch, in india ink wash, 1796–1797, is in the Madrid Album (B. 25).

9 Caprichos Plate 22

¡Pobrecitas! (Poor little things!) 1797–1798
Etching and aquatint 215 × 150
G/W: 496 (Poor little things!). H: 57
A preparatory drawing in red crayon, 1797–1798, is
in the Prado, Madrid (No. 54). The preliminary sketch,
in india ink wash, 1796–1797, is in the Madrid Album
(B. 82).

10 Caprichos Plate 7

Ni asi la distingue. (Even so, he cannot recognize her)
1797–1798
Etching and aquatint 200 × 150
G/W: 463 (Even so he cannot make her out). H: 42
Sig.: lower left: Goya
A preparatory drawing, Sueño 21°, in pen, sepia ink,
and india ink wash, 1797–1798, is in the Prado, Madrid
(No. 29). The preliminary sketch, in india ink wash,
1796–1797, is in the Madrid Album (B. 19).

11 Caprichos Plate 27

¿Quien mas rendido? (Who is the more devoted?)
1797–1798
Etching and aquatint 195 × 150
G/W: 504 (Which is the more overcome?). H: 62
Sig.: lower left: Goya
A preparatory drawing, Sueño 18°, in pen and sepia
ink, 1797–1798 is in the Prado, Madrid (No. 23). The
preliminary sketch, in india ink wash, 1796–1797, is
in the Madrid Album (B. 40).

12 Caprichos Plate 5

Tal para qual. (Birds of a feather) 1797–1798
Etching and aquatint 200 × 150
G/W: 459 (Two of a kind). H: 40
A preparatory drawing, Sueño 19°, in pen, sepia ink,
and india ink wash, 1797–1798, is in the Prado, Madrid
(No. 27). The preliminary sketch, in india ink wash,
1796–1797, is in the Madrid Album (B. 5?).

13 Caprichos Plate 16

Dios la perdone: Y era su madre. (God forgive her: it
was her mother) 1797–1798
Etching and aquatint 200 × 150
G/W: 483 ("So sorry . . ."). H: 51
A preparatory drawing, Sueño, in pen, sepia ink, and
ink wash, 1797–1798, is in the Prado, Madrid (No. 28).
The preliminary sketch, in india ink wash, 1796–1797,
is in the Madrid Album (B. 6).

14 Caprichos Plate 15

Bellos consejos. (Good advice) 1797–1798
Etching and aquatint 215 × 150
G/W: 481 (Fine advice). H: 50
A preparatory drawing in red crayon, 1797–1798, is
in the Prado, Madrid (No. 484). The preliminary sketch,
in india ink wash, 1796–1797, is in the Sanlúcar Album
(A. p).

15 Detail of Ill. 14

(Caprichos Plate 15)

16 Caprichos Plate 28

Chiton. (Hush!) 1797–1798
Etching and aquatint 215 × 150
G/W: 506 (Hush!). H: 63
A preparatory drawing in red crayon, 1797–1798, is
in the Prado, Madrid (No. 57).

17 Detail of Ill. 16

(Caprichos Plate 28)

18 Caprichos Plate 29

Esto si que es leer. (They call this reading) 1797–1798
Etching and aquatint 215 × 150
G/W: 508 (This certainly is reading). H: 64
A preparatory drawing in red crayon, 1797–1798, is
in the Prado, Madrid (No. 58).

19 Caprichos Plate 35

Le descañona. (She fleeces him) 1797–1798
Etching and aquatint 215 × 150
G/W: 250 (She fleeces him). H: 70
A drawing with a similar theme in red crayon and
sanguine wash, 1797–1798, is in the Prado, Madrid
(No. 111).

20 Caprichos Plate 55

Hasta la muerte. (Till death) 1797–1798
Etching and aquatint 215 × 150
G/W: 561 (Till death). H: 90
A preparatory drawing in red crayon, 1797–1798, is
in the Prado, Madrid (No. 72).

21 Detail of Ill. 20

(Caprichos Plate 55)

22 Caprichos Plate 73

Mejor es holgar. (It's better to be lazy) 1797–1798
Etching and aquatint 215 × 150
G/W: 599 (It's better to be idle). H: 108
No preparatory drawings are known.

23 Caprichos Plate 14

¡Que sacrificio! (What a sacrifice!) 1797–1798
Etching and aquatint 200 × 150
G/W: 479 (What a sacrifice!). H: 49
Sig.: lower left: Goya
The preparatory drawing, Sueño 15°, in pen and sepia
ink, 1797–1798, is in the Prado, Madrid (No. 22).

24 Caprichos Plate 26

Ya tienen asiento. (They've already got a seat)
1797–1798
Etching and aquatint 215 × 150
G/W: 502 (Now they are sitting pretty). H: 61
A preparatory drawing in red crayon, 1797–1798, is
in the Prado, Madrid (No. 56).

25 Caprichos Plate 2

El si pronuncian y la mano alargan. Al primero que
llega. (They say, "I do"...) 1797–1798
Etching and aquatint 215 × 150
G/W: 454 (no translation). H: 37
No preparatory drawings are known.

26 Detail from Ill. 25

(2 pages, Caprichos Plate 2)

27 Caprichos Plate 6

Nadie se conoce. (Nobody knows anybody) 1797–1798
Etching and aquatint 215 × 150
G/W: 461 (Nobody knows anybody). H: 41
A preparatory drawing in red crayon, 1797–1798, is
in the Prado, Madrid (No. 471).

28 Detail of Ill. 27

(Caprichos Plate 6)

29 Caprichos Plate 76

¿Está Vm̃ᵈ... pues, Como digo... eh! Cuidado! si
nó!... (Your excellency... hm, as I was saying...
yes, hmm! Be careful, otherwise...!) 1797–1798
Etching and aquatint 215 × 150
G/W: 605 (no translation). H: 111
A preparatory drawing in red crayon, 1797–1798, is
in the Prado, Madrid (No. 80).

30 Caprichos Plate 11

Muchachos al avío. (To work, boys!) 1797–1798
Etching and aquatint 215 × 150
G/W: 472 (Lads getting on with the job). H: 46
A preparatory drawing, Sueño 28°, in pen and sepia
ink, 1797–1798, is in the Prado, Madrid (No. 19).
A preliminary sketch, in india ink wash, 1796–1797, is
in the Madrid Album (B. 88).

31 Caprichos Plate 25

Si quebró el Cantaro. (The pitcher's broken) 1797–1798
Etching and aquatint 215 × 150
G/W: 500 (But he broke the pitcher). H: 60
A preparatory drawing in red crayon, 1797–1798, is
in the Prado, Madrid (No. 55).

32 Caprichos Plate 4

El de la rollona. (The spoiled child) 1797–1798
Etching and aquatint 205 × 150
G/W: 457 (Nanny's boy). H: 39
A preparatory drawing in red crayon, 1797–1798, is
in the Prado, Madrid (No. 49).

33 Caprichos Plate 30

¿Porque esconderlos? (Why hide them?) 1797–1798
Etching and aquatint 215 × 150
G/W: 510 (Why hide them?). H: 65
A preparatory drawing in red crayon, 1797–1798, is
in the Prado, Madrid (No. 445). On the verso of this
drawing are 3 sketches (heads) in red crayon (No. 450).

34 Detail of Ill. 33

(Caprichos Plate 30)

35 Caprichos Plate 12

A caza de dientes. (Out hunting for teeth) 1797–1798
Etching and aquatint 215 × 150
G/W: 474 (Out hunting for teeth). H: 47
A preparatory drawing in red crayon, 1797–1798, is
in the Prado, Madrid (No. 438).

36 Detail of Ill. 35

(Caprichos Plate 12)

37 Caprichos Plate 10

El amor y la muerte. (Love and death) 1797–1798
Etching and aquatint 215 × 150
G/W: 469 (Love and death). H: 45
A preparatory drawing in red crayon, 1797–1798, is
in the Prado, Madrid (No. 50). Another preparatory
drawing in red crayon and sanguine wash, 1797–1798,
is likewise in the Prado, Madrid (No. 93). Yet a third
preliminary sketch, in india ink wash, 1796–1797, is
in the Madrid Album (B. 35).

38 Detail of Ill. 37

(Caprichos Plate 10)

39 Caprichos Plate 9

Tantalo. (Tantalus) 1797–1798
Etching and aquatint 205 × 150
G/W: 467 (Tantalus). H: 44
A preparatory drawing in red crayon with traces of
black chalk, 1797–1798, is in the Prado, Madrid
(No. 51).

40 Caprichos Plate 8

¡Que se la llevaron! (And so they carried her away!)
1797–1798
Etching and aquatint 215 × 150
G/W: 465 (They carried her off!). H: 43
A preparatory drawing in sanguine wash, 1797–1798,
is in the Prado, Madrid (No. 92). The preliminary
sketch, in india ink wash, 1796–1797, is in the Madrid
Album (B. 61).

41 Detail of Ill. 40

(Caprichos Plate 8)

42 Caprichos Plate 77

Unos á otros. (Now one, now the other) 1797–1798
Etching and aquatint 215 × 150
G/W: 607 (One to another). H: 112
A preparatory drawing in red crayon, 1797–1798, is
in the Prado, Madrid (No. 81).

43 Detail of Ill. 44

(Caprichos Plate 53)

44 Caprichos Plate 53

¡Que pico de Oro! (What a golden beak!) 1797–1798
Etching and aquatint 215 × 150
G/W: 557 (What a golden beak!). H: 88
A preparatory drawing in red crayon, 1797–1798, is
in the Prado, Madrid (No. 71).

45 Detail of Ill. 46

(Caprichos Plate 19)

46 Caprichos Plate 19

Todos Caerán. (All will fall) 1797–1798
Etching and aquatint 215 × 145
G/W: 489 (All will fall). H: 54
A preparatory drawing in red crayon, 1797–1798, is
in the Prado, Madrid (No. 53).

47 Caprichos Plate 20

Ya van desplumados. (There they go plucked)
1797–1798
Etching and aquatint 215 × 150
G/W: 491 (There they go plucked). H: 55
A preparatory drawing in red crayon, 1797–1798, is
in the Prado, Madrid (No. 434). Another preliminary
drawing, in sanguine wash, 1797–1798, is likewise in
the Prado, Madrid (No. 95).

48 Detail of Ill. 49

(Caprichos Plate 72)

49 Caprichos Plate 72

No te escaparás. (You won't escape) 1797–1798
Etching and aquatint 215 × 150
G/W: 596 (You won't escape). H: 107
A preparatory drawing in red crayon, 1797–1798, is
in the Prado, Madrid (No. 458). On the verso is an
unfinished drawing in red crayon (No. 432), which is
probably the first preliminary sketch.

50 Detail of Ill. 49

(Caprichos Plate 72)

51 Caprichos Plate 61

Volaverunt. (Volaverunt) 1797–1798
Etching and aquatint 215 × 150
G/W: 573 (Gone for good). H: 96
A preparatory drawing in red crayon, 1797–1798, is
in the Prado, Madrid (No. 75).

52 Caprichos Plate 74

No grites, tonta. (Don't scream, stupid!) 1797–1798
Etching and aquatint 215 × 150
G/W: 600 (Don't scream, stupid). H: 109
A preparatory drawing in red crayon, 1797–1798, is
in the Prado, Madrid (No. 78).

53 Caprichos Plate 21

¡Qual la descañonan! (How they pluck her!) 1797–1798
Etching and aquatint 215 × 145
G/W: 494 (How they pluck her!). H: 56
A preparatory drawing in sanguine wash, red crayon,
and traces of sepia ink, 1797–1798, is in the Prado,
Madrid (No. 104).

54 Caprichos Plate 75

¿No hay quien nos desate? (Will no one untie us?)
1797–1798
Etching and aquatint 215 × 150
G/W: 602 (Is there no one to untie us?). H: 110
A preparatory drawing in red crayon, 1797–1798, is
in the Prado, Madrid (No. 79). Another preliminary
drawing, in red crayon, 1797–1798, is likewise in the
Prado, Madrid (No. 449).

55 Caprichos Plate 78

Despacha, que dispiértan. (Hurry, they're waking up)
1797–1798
Etching and aquatint 215 × 150
G/W: 609 (Be quick, they're waking up). H: 113
A preparatory drawing in red crayon, 1797–1798, is
in the Prado, Madrid (No. 442).

56 Caprichos Plate 79

Nadie nos ha visto. (No one has seen us) 1797–1798
Etching and aquatint 215 × 150
G/W: 611 (No one has seen us). H: 114
A preparatory drawing in red crayon and black chalk,
1797–1798, is in the Prado, Madrid (No. 77).

57 Caprichos Plate 13

Estan calientes. (Too hot!) 1797–1798
Etching and aquatint 215 × 150
G/W: 476 (They are hot-headed). H: 48
A preparatory drawing, in sanguine wash, 1797–1798,
is in the Prado, Madrid (No. 94). Another preparatory
drawing, Sueño 25°, in pen and sepia ink, 1797–1798,
is likewise in the Prado, Madrid (No. 20).
The first preliminary sketch, in india ink wash,
1796–1797, is in the Madrid Album (B. 63).

58 Caprichos Plate 54

El Vergonzoso. (The shamefaced man) 1797–1798
Etching and aquatint 215 × 150
G/W: 559 (The shame-faced man). H: 89
A preparatory drawing, Sueño, in sanguine wash, pen
and sepia ink is in the Prado, Madrid (No. 108).

59 Caprichos Plate 34

Las rinde el Sueño. (Sleep overpowers them) 1797–1798
Etching and aquatint 215 × 150
G/W: 518 (Sleep overcomes them). H: 69
A preparatory drawing in ink wash, pen and sepia
ink, and red crayon, 1797–1798, is in the Prado,
Madrid (No. 440).

60 Caprichos Plate 32

Por que fue sensible. (She was so easily influenced)
1797–1798
Aquatint 215 × 150
G/W: 515 (Because she was susceptible). H: 67
A preparatory drawing in red crayon and sanguine
wash, 1797–1798, is in the Prado, Madrid (No. 106).

61 Caprichos Plate 70

Devota profesion. (Pious vows) 1797–1798
Etching and aquatint 210 × 165
G/W: 591 (Devout profession). H: 105
Sig.: lower left: Goya
A preparatory drawing, Sueño 3°, in pen and sepia
ink, 1797–1798, is in the Prado, Madrid (No. 451).
On the recto of this page is another preparatory
drawing, in pen and sepia ink, 1797–1798, Prado,
Madrid (No. 444). The first preliminary sketch, in india
ink wash, 1796–1797, is in the Madrid Album (B. 56).

62 Caprichos Plate 63

¡Miren que grabes! (Look how dignified they all are!)
1797–1798
Etching and aquatint 215 × 150
G/W: 577 (Look how serious they are!). H: 98
Sig.: lower left: Goya
A preparatory drawing, Sueño 8°, in pen and sepia ink,
1797–1798, is in the Prado, Madrid (No. 38).

63 Caprichos Plate 46

Corrección. (Correction) 1797–1798
Etching and aquatint 215 × 150
G/W: 543 (Correction). H: 81
A preparatory drawing in red crayon, 1797–1798, is
in the Prado, Madrid (No. 66).

64 Caprichos Plate 57

La filiacion. (Ancestral lineage) 1797–1798
Etching and aquatint 215 × 150
G/W: 565 (The lineage). H: 92
A preparatory drawing in sanguine wash, 1797–1798,
is in the Prado, Madrid (No. 102). The first drawing
dealing with this theme, in india ink wash, 1796–1797,
is in the Madrid Album (B? 59). A drawing of the
same scene but which is not directly preliminary to this
one, Sueño 11°, in pen, sepia ink, and traces of red
crayon, 1797–1798, is in the Prado, Madrid (No. 30).

65 Caprichos Plate 39

Asta su Abuelo. (As far back as his grandfather)
1797–1798
Aquatint 215 × 150
G/W: 526 (As far back as his grandfather). H: 74
A preparatory drawing in sanguine wash, 1797–1798,
is in the Prado, Madrid (No. 96). Another preparatory
drawing, Sueño, in pen and sepia ink, 1797–1798, is
likewise in the Prado, Madrid (No. 25). A first sketch,
in india ink wash, 1796–1797, is in the Madrid Album
(B. 72).

66 Caprichos Plate 37

¿Si sabrá mas el discipulo? (What if the pupil knows
better?) 1797–1798
Etching and aquatint 215 × 150
G/W: 522 (What if the pupil knows more?). H: 72
A preparatory drawing in red crayon, 1797–1798, is
in the Prado, Madrid (No. 107).

67 Caprichos Plate 42

Tu que no puedes. (Thou who canst not) 1797–1798
Etching and aquatint 215 × 150
G/W: 534 (Thou who canst not). H: 77
A preparatory drawing in sanguine wash and red
crayon, 1797–1798, is in the Prado, Madrid (No. 98).

68 Caprichos Plate 40

¿De que mal morira? (What disease will he die of?)
1797–1798
Etching and aquatint 215 × 150
G/W: 529 (Of what ill will he die?). H: 75
A preparatory drawing in sanguine wash and red
crayon, 1797–1798, is in the Prado, Madrid (No. 97).
A first drawing, Sueño, 27°, in pen and sepia ink,
1797–1798, is likewise in the Prado, Madrid (No. 26).

69 Caprichos Plate 41

Ni mas ni menos. (Neither more nor less) 1797–1798
Etching and aquatint 200 × 150
G/W: 532 (Neither more nor less). H: 76
A preparatory drawing in red crayon (the inscription
on the block where the monkey sits is also in red
crayon), 1797–1798, is in the Prado, Madrid (No. 61).

70 Caprichos Plate 38

¡Brabisimo! (Bravissimo!) 1797–1798
Etching and aquatint 215 × 150
G/W: 524 (Bravissimo!). H: 73
A preparatory drawing in red crayon, 1797–1798, is
in the Prado, Madrid (No. 60).

71 Caprichos Plate 23

Aquellos polbos. (From such dust) 1797–1798
Etching and aquatint 215 × 150
G/W: 498 (That dust). H: 58
A preparatory drawing in sanguine wash and red
crayon, 1797–1798, is in the Prado, Madrid (No. 105).
A first version of Plate 23, an aquatint, 1797–1798,
was among the five additional plates of the Caprichos
which Goya rejected.

72 Caprichos Plate 24

Nohubo remedio. (There is no help) 1797–1798
Etching and aquatint 215 × 150
G/W: 499 (There was no remedy). H: 59
No preparatory drawings are known.

73 Caprichos Plate 52

¡Lo que puede un Sastre! (What a tailor can do!)
1797–1798
Etching and aquatint 215 × 150
G/W: 555 (What a tailor can do!). H: 87
A preparatory drawing in sanguine wash and red
crayon, 1797–1798, is in the Prado, Madrid (No. 101).

74 Caprichos Plate 3

Que viene el Coco. (Here comes the boogeyman)
1797–1798
Etching and aquatint 215 × 150
G/W: 455 (Here comes the boogeyman). H: 38
A preparatory drawing in red crayon and a bit of black
chalk, 1797–1798, is in the Prado, Madrid (No. 48).

75 Caprichos Plate 67

Aguarda que te unten. (Wait till you've been anointed)
1797–1798
Etching and aquatint 215 × 150
G/W: 585 (Wait till you've been anointed). H: 102
A preparatory drawing in red crayon, 1797–1798, is
in the Prado, Madrid (No. 76).

76 Detail of Ill. 75

(Caprichos Plate 67)

77 Detail of Ill. 75

(Caprichos Plate 67)

78 Detail of Ill. 75

(Caprichos Plate 67)

79 Detail of Ill. 80

(Caprichos Plate 60)

80 Caprichos Plate 60

Ensayos. (Experiments) 1797–1798
Etching and aquatint 205 × 165
G/W: 571 (Trials). H: 95
Sig.: lower left: Goya
A preparatory drawing in pen and sepia ink, Sueño 2°,
1797–1798, is in the Prado, Madrid (No. 36).

81 Detail of Ill. 80

(Caprichos Plate 60)

82 Detail of Ill. 80

(Caprichos Plate 60)

83 Caprichos Plate 64

Buen Viage. (Bon voyage) 1797–1798
Etching and aquatint 215 × 150
G/W: 579 (Bon voyage). H: 99
A preparatory drawing in red crayon, 1797–1798, is
in the Prado, Madrid (No. 441).

84 Caprichos Plate 49

Duendecitos. (Hobgoblins) 1797–1798
Etching and aquatint 215 × 150
G/W: 549 (Little goblins). H: 84
A preparatory drawing in red crayon, 1797–1798, is
in the Prado, Madrid (No. 69).

85 Detail of Ill. 84

(2 pages, Caprichos Plate 49)

105 Caprichos Plate 80

Ya es hora. (Time's up) 1797–1798
Etching and aquatint 215 × 150
G/W: 613 (Time is up). H: 115
No preparatory drawings are known.

106 Detail of Ill. 105

(Caprichos Plate 80)

107 Caprichos Plate 36

Mala noche. (A bad night) 1797–1798
Etching and aquatint 215 × 150
G/W: 521 (A bad night). H: 71
A similar drawing on this theme, Sueño 22°, in pen
and sepia ink, 1797–1798, is in the Prado, Madrid
(No. 24). The preliminary sketch, in india ink wash,
1796–1797, is in the Madrid Album (B. 81).

108 Caprichos Plate 48

Soplones. (Scandalmongers) 1797–1798
Etching and aquatint 205 × 150
G/W: 547 (Squealers). H: 83
A preparatory drawing in red crayon, 1797–1798, is
in the Prado, Madrid (No. 68).

109 Detail of Ill. 110

(Caprichos Plate 62)

110 Caprichos Plate 62

¡Quien lo creyera! (Who would believe it!) 1797–1798
Etching and aquatint 205 × 150
G/W: 575 (Who would believe it!). H: 97
A preparatory drawing, Sueño 10°, in pen and sepia
ink, 1797–1798, is in the Prado, Madrid (No. 37).

111 Caprichos Plate 56

Subir y bajar.(Ups and downs) 1797–1798
Etching and aquatint 215 × 150
G/W: 563 (Ups and downs). H: 91
A preparatory drawing in red crayon, 1797–1798, is
in the Prado, Madrid (No. 73).

112 Detail of Ill. 111

(Caprichos Plate 56)

113 Detail of Ill. 114

(Caprichos Plate 50)

114 Caprichos Plate 50

Los Chinchillas. (The chinchillas) 1797–1798
Etching and aquatint 205 × 150
G/W: 551 (The chinchillas). H: 85
A preparatory drawing in sanguine wash with some
traces of red crayon, 1797–1798, is in the Prado,
Madrid (No. 99). A drawing with a related theme,
Sueño, in pen and sepia ink, 1797–1798, is also in
the Prado, Madrid (No. 35).

115 Caprichos Plate 59

¡Y aun no se van! (And still they won't go)
1797–1798
Etching and aquatint 215 × 150
G/W: 569 (And still they don't go!). H: 94
A preparatory drawing in red crayon, 1797–1798, is
in the Prado, Madrid (No. 74).

116 Caprichos Plate 43

El sueño de la razon produce monstruos. (The sleep
of reason brings forth monsters) 1797–1798
Etching and aquatint 215 × 150
G/W: 536 (The sleep of reason brings forth monsters).
H: 78
A preparatory drawing, Sueño 1°, in pen and sepia
ink, 1797, is in the Prado, Madrid (No. 34). Another
preparatory drawing, in pen and sepia ink with a
light wash background, 1797, is also in the Prado,
Madrid (No. 470). The title of this page is plainly
legible in the lower left-hand corner where the aqua-
tint was not applied.

One additional etching belongs among the eighty
published plates:

Caprichos Plate 33

Al Conde Palatino (To the Count Palatine)
1797–1798
Etching and aquatint 215 × 150
G/W: 517 (To the Count Palatine). H: 68
A preparatory drawing in india ink wash, 1796–1797,
is in the Madrid Album (B. 68).
The commentary: "In all sciences there are quacks
who, without having studied a thing, know every-
thing and have a remedy for everything. You ought
not trust a word they say. The truly wise man is
always wary of their conclusiveness, of their predic-
tions: he promises little and accomplishes much.
The Count Palatine, however, fulfills none of his
promises at all."

Drawings

Introductory remarks

This catalog of selected drawings is based upon the following volumes:

Pierre Gassier and Juliet Wilson, *The Life and Complete Works of Francisco Goya* (New York, 1971) (here abbreviated as G/W). Pierre Gassier, *Francisco Goya, Drawings: The Complete Albums* (New York, 1973) (here abbreviated as G). Pierre Gassier, *The Drawings of Goya: The Sketches, Studies and Individual Drawings* (New York, 1975) (here abbreviated as Ga). The drawings for the most part are taken from Goya's sketchbooks: the Sanlúcar Album (Album A), 1796–1797; the Madrid Album (Album B), 1796–1797; an Incomplete Album (Album D), 1801–1803; the Black-edged Album (Album E), 1803–1812; the Diary Album (Album C), 1803–1824; the Sepia Album (Album F), 1812–1823; and the Bordeaux Albums (Albums G and H), 1824–1828.

The titles are the author's. If Spanish originals are known, the English title is noted in parenthesis.

The size specifications are those of the full page, given in millimeters; height precedes width. Collectors' marks are not noted.

The catalog is arranged as follows:
The title; the sketchbook reference and number (whenever it is from one of the albums); the date; the technique; the size; the location and inventory number; the signature and inscription, if such are present; the number in G/W and the English title when one is given; any cross-references to relevant etchings and other drawings.

1 Embozado with a gun hidden beneath his cloak

Album H. 31. 1824–1828
Black chalk 191 × 152
Madrid, Prado (No. 319)
Sig.: lower center: Goya
G/W: 1793 (Embozado, cloaked man with a gun).
G: 447 (Embozado, cloaked man with a gun)
Served as the basis for two etchings, both from 1825–1827.

2 Sueño. De la mentira y la ynconstancia
(Dream of falsehood and inconstancy)

1797–1798
Pen, sepia ink, and wash 237 × 166
Madrid, Prado (No. 17)
G/W: 620 (Dream: Of lying and inconstancy). Ga: 64 (no title)
A preliminary drawing for an unpublished plate of the Caprichos, 1797–1798.

3 Nada dicen
(They say nothing)

Album C. 70. 1808–1814
Sepia wash 205 × 142
Madrid, Prado (No. 369)
Ins.: Nada dicen
G/W: 1307 (They say nothing). G: 216 (They say nothing)

4 (El cojo y) Jorobado Bailarin
(The lame and hunchbacked dancer)

Album G. 7. 1824–1828
Black chalk 191 × 151
Madrid, Prado (No. 415)
Ins.: (El cojo y) Jorobado Bailarin
G/W: 1716 (The lame and . . .). G: 370 (The lame and hunchbacked dancer)

5 Mal marido
(Bad husband)

Album G. 13. 1824–1828
Black chalk 192 × 151
Madrid, Prado (No. 414)
Ins.: Mal marido
G/W: 1721 (Bad husband). G: 374 (Bad husband)

6 Monk playing a guitar

Album H. 3. 1824–1828
Black chalk 191 × 151
Madrid, Prado (No. 364)
Sig.: lower right: Goya
G/W: 1766 (Guitar-playing monk). G: 420 (Guitar-playing monk)

7 Old woman with a mirror

Album H. 33. 1824–1828
Black chalk 191 × 148
Madrid, Prado (No. 412)
Sig.: lower center: Goya
G/W: 1795 (Old woman with a mirror). G: 449 (Old woman with a mirror)
There are thematic connections with Plate 55 of the Caprichos (Ill. 20).

8 Ni por esas (Que tirania)
(Nothing doing! What tyranny!)

Album G. 8. 1824–1828
Black chalk 191 × 152
Madrid, Prado (No. 405)
Ins.: Ni por esas (Que tirania)
G/W: 1717 (Nothing doing. What tyranny). G: 371 (Nothing doing! What tyranny!)
Goya had already dealt with the same theme in 3 drawings from the period of the Caprichos.

9 Comer mucho
(Lots to eat)

Album G. b. 1824–1828
Black chalk 191 × 148
Madrid, Prado (No. 384)
Ins.: Comer mucho
G/W: 1759 (Come mucho—He eats a lot). G: 418 (Eat a lot)

10 The hidden treasure

Album H. 6. 1824–1828
Black chalk 191 × 157
Madrid, Prado (No. 406)
Sig.: lower right: Goya
G/W: 1769 (Finding or burying treasure). G: 423 (The hidden treasure)
There are thematic connections with Plate 30 of the Caprichos (Ill. 33).

11 Good advice

Album H. 4. 1824–1828
Black chalk 190 × 153
Madrid, Prado (No. 402)
Sig.: lower right: Goya
G/W: 1767 (Good counsel). G: 421 (Good counsel)

12 An old-fashioned duel

1819
Lithograph. Retouched with pen and ink or black chalk 130 × 230
Madrid, Biblioteca Nacional (No. 45626)
G/W: 1644 (Old style duel)

13 Detail of Ill. 12

14 Busca un medico
(She is looking for a doctor)

Album C. 121. 1820–1824
India ink and sepia wash 205 × 143
Madrid, Prado (No. 363)
Ins.: Busca un medico
G/W: 1356 (She's looking for a doctor). G: 265 (She's looking for a doctor)

15 Habrazo Paternal
(Paternal embrace)

Album C. 10. Circa 1803–1824
India ink and sepia wash 205 × 144
Madrid, Prado (No. 410)
Ins.: Habrazo Paternal
G/W: 1252 (no title). G. 160 (Paternal embrace)

16 Se quieren mucho
(They love each other very much)

Album G. 59. 1824–1828
Black chalk 192 × 150
Madrid, Prado (No. 392)
Ins.: Se quieren mucho
G/W: 1763 (They love each other very much). G: 415 (They love each other very much)

17 Esto heule à cosa de Magia
(This smacks of magic)

Album C. 68. 1808–1814
Sepia wash and pen 205 × 142
Madrid, Prado (No. 367)
Ins.: Esto huele à cosa de Magia.
G/W: 1305 (This smacks of magic). G: 214 (This smacks of magic!)

18 ¿Qe trabajo es ese?
(What sort of work is that?)

Album C. 124. 1820–1824
India ink and sepia wash 205 × 143
Madrid, Prado (No. 359)
Ins.: ¿Qe trabajo es ese?
G/W: 1359 (What sort of work is that?). G: 268 (What sort of work is that?)

19 ¿Cuantas baras?
(How many yards?)

Album C. 125. 1820–1824
India ink and sepia wash 205 × 143
Madrid, Prado (No. 362)
Ins.: ¿Cuantas baras?
G/W: 1360 (How many yards?). G: 269 (How many yards?)

20 Phantom dancing with castanets

Album H. 61. 1824–1828
Black chalk 191 × 150
Madrid, Prado (No. 385)
G/W: 1818 (Phantom dancing with castanets). G: 473
(Phantom dancing with castanets)

21 Deadly struggle

Album H. 38. 1824–1828
Black chalk 190 × 154
Madrid, Prado (No. 399)
Sig.: lower right: Goya
G/W: 1800 (Easy victory). G: 454 ("Easy victory!")

22 No lo encontraras

(You won't find it)

Album C. 31. Circa 1803–1824
India ink and sepia wash 205 × 142
Madrid, Prado (No. 419)
Ins.: No lo encontraras
G/W: 1269 (You won't find it). G: 178 (You won't
find it)

This catalog of illustrations was prepared by Monika
Seibold.

For Further Reading

Gantner, Joseph. *Goya, der Künstler und seine Welt*. Berlin, 1974.

Gassier, Pierre, and Wilson, Juliet. *The Life and Complete Works of Francisco Goya*. New York, 1971.

Gassier, Pierre. *Francisco Goya, Drawings: The Complete Albums*. New York, 1973

_____. *The Drawings of Goya: The Sketches, Studies and Individual Drawings*. New York, 1975.

_____. *Das graphische Werk von Francisco de Goya. Los Caprichos, La Tauromaquia, Los Proverbios, Los Desastres de la Guerra*. Introduction by Wolfgang Braunfels. Exhibition catalogue. Munich: Stuckvilla, undated.

Harris, Tomás. *Goya: Engravings and Lithographs*. 2 vols. Oxford, 1964.

Helman, Edith F. *Jovellanos y Goya*. Madrid, 1970.

Helman, Edith F. *Transmundo de Goya*. Madrid, 1963.

Klingender, F. D. *Goya und die demokratische Tradition Spaniens*. Berlin, 1971.

Lafuente Ferrari, Enrique. *Goya: His Complete Etchings, Aquatints and Lithographs*. New York, 1962.

Sánchez Cantón, F. J. *Museo del Prado: Los dibujos de Goya*. 2 vols. Madrid, 1954.

Williams, Gwyn A. *Goya and the Impossible Revolution*. New York, 1976.

Index of Names